Somalia

The last sunset
before my first death.
13 hours later, Saskia
slew away.
I slept with
Ralph.

The best ride I
ever had in
that red Fiat.

Dan Eldon

The Art of Life

by Jennifer New

CHRONICLE BOOKS

SAN FRANCISCO

Library of Congress Cataloging-In-Publication
Data available.

ISBN 0-8118-2955-3

Printed in China

Distributed in Canada by Raincoast Books
9050 Shaughnessy Street
Vancouver, BC V6P 6E5

10 9 8 7 6 5 4 3 2 1

Chronicle Books LLC
85 Second Street
San Francisco, California 94105

www.chroniclebooks.com

For more information about Dan Eldon go to
www.daneldon.org or www.creativevisions.org

Art direction & Design:
Alex Bacon & Dan Peterka
Buckboard 11 Associates Inc

epigraph

8 Mon.

I am on the airplane now. Virgin, London to L.A. I want to do great things in my life - I want the plane to land, so I can start. The only problem is where do I start. What do I do when I get off the plane to do great things?

Is University the best place for me. Should I take off with my camera to El Salvador. Listen to what your heart tells you, you say. Well I'd like to rip the little bastard out and interrogate him with a 12 volt car battery.

CREATIVITY + ENERGY

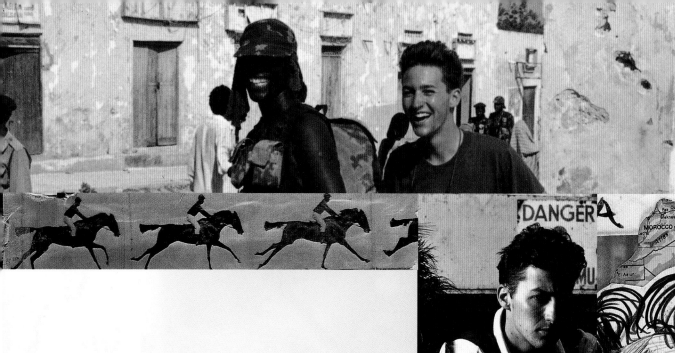

discovery

No one remembers exactly how the bag arrived at Mike Eldon's home in Nairobi, only that it took several weeks after Dan's death to get there. It was a black nylon military bag, something he'd come by in a trade with a Marine, the same way he'd accrued several pairs of combat boots and other military paraphernalia. Mike put the bag in the middle of Amy's bedroom floor. Along with Donatella Lorch, a *New York Times* reporter who had been stopping by the house regularly since the news hit on July 12, they slowly went through its contents.

At first Amy Eldon was reluctant to open it. As with so many things, she couldn't help but think, "This is the last time..." The last time she'd unpack her brother's bag. The last time these things would be sent. But then the converse feeling set in, the almost desperate need to tear into it, to touch and smell what was inside. She had already been in Dan's bedroom, laying her head against his pillow and sifting through his belongings. These things, however, had been with him last and bore the freshest remnants. What had been merely a tooth-brush or old pair of sandals now carried new significance; if one looked hard, they might reveal some truth or message.

The leather vest was on the top. Dan wore it so often that it had become his trademark—surely it had been too hot for Somalia. A pile of carefully folded T-shirts was also there, including several

of Dan's own design and a well-worn Tusker beer shirt. Under-neath, she found a *kikoi*, some blue jeans, and a pair of sunglasses, a cheap copy of the Ray Bans he always wore. She fished out some books farther down: Goethe, Vonnegut, and the explorer Wilfred Thesiger. Opening the latter, she saw that Dan had been underlin-ing passages, one of which caught her eye: "I have often looked back into my childhood for a clue to this perverse necessity which drives me from my own land to the deserts of the East."

Next to Amy, Donatella was rummaging through a box of cassette tapes that had arrived with the bag: Somali music, reggae, Dan's own mixes, and Edith Piaf. Donatella laughed at the sight of the Piaf tape, recalling how Dan had brought his small boom box down to the hotel cafeteria and they'd all sung along to "La Vie en Rose." Such funny music for a guy his age, she'd always thought. Amy stopped her excavation, remembering how the previous Christmas she and Dan got caught in a rainstorm on their way home from lunch in downtown Nairobi. Dan's Land Rover no longer had a top—he'd had it cut off—so they were thoroughly soaked as they cruised through the streets as Edith purred, "Je ne regret rien." Donatella smiled at the image. She was getting a fuller sense of the person she had known only in a war zone. Earlier, Amy had shown her photos of Dan's girlfriends and, to Donatella's amusement, there were dozens. Seeing Dan's bedroom had also been enlighten-ing; in so many ways, it was still a kid's bedroom. She had to remind herself how much of a kid she had been at twenty-two.

As though to cast a smirk on the high-mindedness of the books, some Somali daggers—additions to a weapons collection Dan had started in his G.I. Joe days—and several packs of Marlboro Reds were toward the bottom of the bag. Amy took the cigarettes and shoved them under her bed when her father wasn't looking. She had hidden Dan's habit from their parents for years, and although they both knew about it—the war in Somalia had made him a chain smoker—her gut instinct to protect him remained. Going through her brother's pockets, she pulled out wads of cash, not just tens and twenties, but fifty- and hundred-dollar bills.

"Yes," her father said, showing her several more bundles of cash he'd found. "It must be from the postcard and T-shirt business. He was doing well." Mike smiled at his son's innate entrepreneurial habits. Dan had started the business on the side about six months earlier, selling items he'd designed and had printed to UN soldiers and aid workers. It nicely augmented the money he made from his work as a stringer photographer for Reuters. Donatella added that

everyone carried pretty hefty wads of cash in Mogadishu. It took a lot of money to buy one's way around, she told them, recalling how hardly any bargain was sealed without a few hundred-dollar bills changing hands.

On the very bottom was something Amy and Mike both could have predicted would be there, though they had forgotten until now. Amy held the large black-bound journal in her lap. It was eight by eleven, the same size Dan had been using for years. This one was still thin, not yet stretched by the sheer mass of objects, glue, and paint with which he layered the books. Gently, she flipped through the pages. About fifteen of them, not even a quarter of the book, had photographs pasted in, either a single five-by-seven image or a series of smaller photographs. And then the pages went blank. Amy snapped it shut. The bareness, even the unadorned photographs over which he had yet to draw or glue more layers, was too strong a reminder of the life that would not be lived, the life that previously had been the inspiration for filling page after page. Suddenly, the pages had come to an end.

Less than a month before, Dan had been in his father's comfortable house where he had a bedroom, complete with a veranda as well as a private bathroom where he took long soaks while opera played full blast from the stereo and a collection of candles flickered. On the most recent visit, he had straightened some of his notorious mess, exposing long-covered surfaces. He had also given driving lessons to a friend and taken another to visit her family's home for a last time before the property was sold. The entire Eldon household, including the cook, gardener, and house guests, had played rounds of volleyball in the garden. In the evening, Dan had sat with his father, who was recuperating from a car accident, and the two had read the daily paper or Dan had worked on his journals. He'd called both his mother in London for her birthday and his younger sister, Amy, in San Francisco, where she was finishing up an internship before heading to Mexico City for a summer job. He listened with amusement to details of her urbane, American life. She'd been at a gay pride rally that day, taking in one of the city's biggest festivities with friends, and then had gone to a trendy little restaurant in the evening. Nairobi may not be San Francisco, he told her, but it felt quite cosmopolitan after Mog. "I went dancing last night and never even worried about having a gun stuck in my face," he quipped, taking a drag on his cigarette.

To some who saw him during that visit, Dan seemed tired and depressed. Twelve months of covering a grisly civil war and famine were surely wearing on him. He looked different. It wasn't only the slight beard he was sporting; his eyes were darker, his body more spare. Others, especially his journalist friends and his father, thought he was in good form. He wanted out of Somalia and was beginning to consider what to do next. His entire adult life—all five years of it since graduating high school—had been lived in quick bursts, from project to project. Another assignment for Reuters or film school in California were both on his radar, though as usual he would wait until the last minute to decide, leaving much to fate.

More immediate, however, was his desire to go on safari. Ironically, he'd been in Mogadishu longer than he'd stayed anywhere else. He was itchy to travel. A few of his old mates were in town and they had gone with him to the Carnivore, a favorite club, to make plans for the summer. Afterward, he'd called Soiya Gecaga, his old friend and sometime girlfriend, in London, encouraging her to come to Nairobi soon: "We have so many safaris planned. You've got to come!" Without telling him, she made arrangements to fly in as soon as he got back from his next stint in Mogadishu on July 13.

Instead of shorts and tank tops, Soiya's bag had a simple black suit in it when she arrived in Nairobi a few weeks later. She didn't come for a safari but for a funeral. As she'd readied herself to go home to Kenya, the call had come: Dan and three other journalists were killed on July 12, 1993, while covering the aftermath of a bombing in Mogadishu. Dan had worked extensively in the war-torn country for the past year, and Soiya had telephoned many times to wish him well, heeding him to take care. This was her worst fear come true.

Three days after his death, Soiya, and Dan's many other friends, and his family gathered at one of his favorite places. On the sloping backside of the Ngong Hills just before they give way more steeply to the dramatic expanse of the Great Rift Valley, they celebrated his life. Just the month before, his photographs had appeared in *Newsweek* and *Time* magazines, as well as on the front page of newspapers like the (London) *Times*. These successes were certainly mentioned, but there were many more facets of his complex, chameleon-like personality to celebrate as well: entrepreneur,

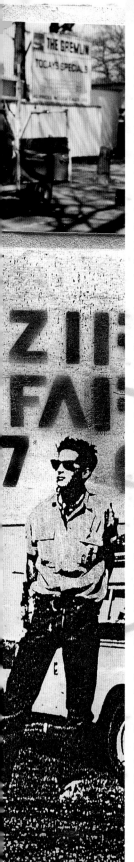

adventurer, artist, motivator, philanthropist, lover, friend, son, prankster, life of the party, master of disguise. With sobs, laughter, and song, in English and Swahili, his life was paid tribute.

Returning to Mike's house after the ceremony, friends and family looked through Dan's journals, the large books of collages and photographs he had been making since he was a teenager. There were about eight journals in the house that night, but over time more would be found—including several small ones he'd done as a child—bringing the total to seventeen. Held on the laps of American cousins, high school pals, embassy workers who knew the family, his paternal grandmother, and so many others, the books gaped open, overflowing with coins, feathers, rice, call-girl cards, and Christmas tinsel.

Like their author, the journals are big. They take up space in the way that people who are charismatic, brash, and youthful do. They are messy—which also describes Dan. "Dan didn't like things neat. He didn't like lines," many of his friends remembered about him that day. He was a chaotic mix of talents, moods, and destinations. And like his journals, in which he superimposed images from trips that occurred years apart, confounding the original order in which they took place, he resisted linearity at every turn.

Already on that sunny day at the celebration, a myth was being born—a myth of a person who was bigger than life, a saint. Just shy of his twenty-third birthday, Dan had traveled to more than forty countries, led a group of young people through southern Africa to deliver the sizable money they'd raised for a refugee camp, and been among the youngest Reuters photographers ever, helping to alert the world to the tragic famine in Somalia. His prolific, boundless energy is one of the first things people recall about Dan; he certainly accomplished a lifetime's worth in a brief period. But for all of his good, he wasn't a saint. Some of his best friends almost immediately rallied to remember Dan the regular guy, Dan their friend, who had his flaws. He could be moody and was almost obsessively protective and jealous of the women in his life. He was generous, providing loans and gifts without question, but could suddenly nitpick over a small sum. Overall, he'd been a strong student and a witty writer and orator, but his math skills were abhorrent; he'd teasingly threatened to excommunicate Amy from the family if she did better than him in math. His flamboyant style—he had a penchant for masks, disguises, and costumes—amused many, but made others uncomfortable.

While Dan may have had his regular-guy traits, he was undoubtedly blessed with an unusually good set of life circumstances, not the least of which were his family and his home. His immediate and extended family supported almost every new thing he wanted to try (sometimes after Dan charmingly convinced them) and every new place he wanted to see. They provided him not only with financial backing, but with love, encouragement, and role models. And they brought him to Africa. He moved there when he was seven, and no matter where he traveled, he always returned. There probably wasn't a better place in the world for someone with Dan's adventurous spirit to live. It challenged and delighted him; it served as both his teacher and his canvas.

Rather like his fondness for the 1930s French singer Edith Piaf, another quirk of Dan's that seemed out of place for someone his age was his frequent use of aphorisms. At nineteen, he'd even created a mission statement for himself: *Safari as a way of life.* He sometimes signed his letters "Live and die on safari" and repeated certain sayings throughout his journals: *Don't run your body like no gas station. Fight the power. Look for solutions, not problems. Seek clarity of vision.* Although Dan employed such grand statements with a wink, always underlining them with humor, he believed in them nonetheless. In the journals, he combined these words with vibrant imagery, exploring life's poles, good and evil, beauty and ugliness. The end result is a sort of road map for living, formed out of years of roaming.

15

Many people sensed, both during and after his life, that he had a clearer vision than most of us. Perhaps it was his impish, mischievous grin. Even more so, it was the way he managed to follow his dreams, no matter how unlikely they sometimes appeared. The questions he asked and tried so hard to answer through his art and his wanderings are the same questions many people ask when they plunk down money on therapy or self-help books. Instead of finding answers on the couch or in words, Dan was more apt to find them in a sweaty hotel in Casablanca, on a desert drive outside Los Angeles, or in the backstreets of Nairobi. Could it be that with his quick wit and singular way of looking at the world, he was closer than others to life's so-called answers? This certainly is the lure of the journals: the inquisition and revelation embedded in their pages, the vivid representations of his search and what he discovered in his short life but long journey.

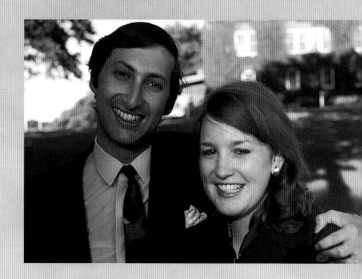

blind date

Friends and family who watched their unlikely relationship blossom must have wondered what kind of children Mike Eldon and Kathy Knapp might have. What would the overlap of two such different people produce?

Mike is a dark-haired Romanian Jew with the accent of his adopted British homeland. He has a knack for both Monty Python–like humor and impeccable manners, and can by turn be reserved or droll, dressing up as James Bond for a night on the town with his children and meeting the next morning with a minister of state. Kathy is an American midwesterner, tall with red hair and eyes that squint when she smiles, which is nearly all of the time. She lights up rooms with her raw vitality and has been known to topple over a glass of water or trip up the stairs in her exuberance. Mike weighs a situation; he listens and tests. Kathy plows ahead, assuming only the best, gambling on intuition.

The two would eventually fly around the world together, so it was no wonder their children would turn out to be vagabonds at heart.

But the romance started in a much more prosaic way. It was 1967, the Summer of Love in parts of the world. In Cedar Rapids, Iowa, it was another hot, long season of tennis matches and trips to the ice cream shop. When Mike Eldon, an economics student from London, showed up for an internship at the Quaker Oats plant, he was quite out of his realm.

When he had gotten the assignment, he'd been told that Cedar Rapids was "near Chicago." Anticipating occasional trips to the city, he was disappointed to learn that "near" actually meant a five-hour drive. Arriving in town via Greyhound on Fourth of July weekend, he found himself in a sleepy town that seemed downright provincial compared with London. Neither his accommodations at the YMCA nor his patronizing supervisor on the job made him enthusiastic about staying. He contemplated an early departure until a program for international students matched him with an interesting local family.

Soon, he was one of the more popular guests on the local social circuit. It was the height of Beatlemania, and a British accent went far in Iowa. He was sought after for church picnics, dinner parties, and badminton matches. One friend attempted to set him up on a date, thinking a French exchange student was a good choice. They were paired that evening with another blind-date couple, Kathy Knapp and a reporter for the local newspaper. Although the geography of the pairings made sense—like-continents together—chemistry is blind to maps or miles. By the end of the night, Mike and Kathy were clearly much more interested in each other than in their appointed dates.

Kathy was working for the summer at a girls' camp, sequestered away in the woods, and had little time for romance. After their first meeting, Mike impressed her by managing to penetrate the camp's long-standing rule against phone calls from potential suitors. The only men who ever got through were fathers. Again, a British accent went far in Iowa.

It was a brief romance, and all that Kathy was left with come August was a photograph of

Kathleen Knapp Is Engaged To Michael Eldon of London

Mr. and Mrs. Russell F. Knapp, 529 Knollwood drive SE, announce the engagement of their daughter, Kathleen Marie, to Michael Eldon, son of Mr. and Mrs. Bruno Eldon of London. A fall wedding is planned.

Miss Knapp, a graduate of Wellesley college, Wellesley, Mass., has been an art teacher at Pierce elementary school.

Mr. Eldon is a graduate of University college in London and is now affiliated with International Computers, Ltd., in London. He spent the summer of 1967 in Cedar Rapids on an economics exchange program, working at Quaker Oats, and living in the home of Dr. and Mrs. John Kanealy.

Mike standing on the banks of the Thames. She went back to Wellesley College and set up a jewelry-making business, the proceeds from which paid her way to London for Christmas. It was a fleeting visit but, along with many letters and a few costly, static-filled phone calls, it proved sufficient. In the fall of 1969, in an interdenominational service that employed the attending Methodist minister's entire knowledge of Judaism, Mike and Kathy were married.

Despite his initial misgivings about Cedar Rapids, Mike was happily impressed by his new in-laws. Kathy's entire family, especially her parents, Russell and Louise, were well-traveled, sophisticated people who would not be out of place in London. They also had commitments and a web of relationships that were particular to small-town life, which Mike found a refreshing contrast to urban anonymity. Their interests and support extended to the local college, the hospital, the symphony, and the Methodist church. It was a melding of business, family, and community that Mike would eventually emulate in Nairobi nearly a decade later.

By the time of the wedding, Mike was already employed as an account manager at a computer company for two years. He and Kathy got a flat in Hampstead, near his parents. She taught art at the American School, trying to meet people and stay busy while Mike worked long hours. Rather quickly, she was able to transfer her skills to motherhood. Dan was born on September 18, 1970, nine months after a tipsy Christmas party. The young parents painted his room bright yellow, built an indoor playground complete with a slide, and, presciently, bound and decorated little books in which to record family drawings and poetry.

For his part, Dan was an easy, cheerful child. Perhaps his most distinguishing feature was his very British-looking, plump, rosy

cheeks, which showed no hint of his eventual chiseled features. He attended a Waldorf preschool that emphasized the arts and later a British public primary school. Along with his sister, Amy, who was born when Dan was four, he spent time with his paternal grandparents and Kathy's sister's family, also living in London. To make more space following Amy's birth, the family left central London and moved to the suburbs. The uniformity of the new surroundings stifled Kathy. It was a reminder of the narrowness she'd gladly left behind in Iowa, though the London suburbs lacked the amiability of home. She felt hemmed in and dispirited. The kids were too young to mind, although she worried about what it might be like for them to grow up there; too gray, she thought, too quiet.

Soon enough, the monotony was shattered. It came by way of a job offer: a stint for Mike at his company's office in Kenya. Suburban ennui was suddenly the least of their worries. They were moving to Africa.

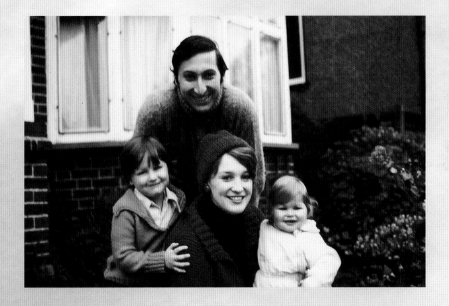

arrival

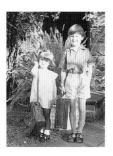

There are as many Africas as there are books about Africa—
and as many books about it as you could read in a leisurely
lifetime. Whoever writes a new one can afford a certain com-
placency in the knowledge that his is a new picture agreeing
with no one else's, but likely to be haughtily disagreed with
by all those who believe in some other Africa.
—Beryl Markham, *West with the Night*, 1942

As the Eldons drove up to their new home in September 1977, they were greeted by a small drama. Gesturing toward the side of 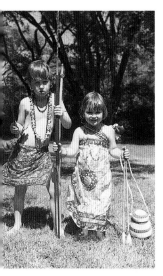 the house, the gardener yelled to the cook, William, to come quickly. The family craned their necks to see what African danger lay hidden in the tall grass. With great ceremony, William grabbed a *panga* and killed a small green snake. It wasn't much of a snake, a harmless garden variety, but it was a telling introduction, containing elements of the life they were soon to lead: uninvited house guests and theatrical servants. And there was a moral to the story: *always expect the unexpected*.

For Dan and Amy, ages seven and three, everything about Kenya was unexpected. Giraffes in the middle of the road, a sea of black faces at the market, the undulating rhythm of Swahili, brightly printed *kangas* tied around women's waists. Instead of enduring England's familiar drizzle, they were sent scurrying indoors by afternoon thunderstorms that produced torrents of rain and enormous mud puddles. Even the sky was different from the sky they'd known in London. There it had hung so low in winter that even a child had a sense of being able to stretch up and brush against it. But the African sky was an enormous and brilliant blue canopy that seemed to dangle from the heavens.

Mike and Kathy were struck as well by the intense colors and energy of Nairobi, which offered a feast for the senses following the blandness of the British suburbs. Still, they were relieved by the city's relatively urban skyline and the proliferation of British customs, such as afternoon tea.

Nairobi continues to bear the mark of its former colonists. Until about 1895, it had been a Masai watering hole called *Enkare Nairobi*. At the turn of the last century, the British erected a railroad line from the coastal city of Mombasa to Lake Victoria to open up fertile farming land to settlers, and Nairobi was roughly at the midway point. Indian laborers, imported to lay the tracks, established a large bazaar in the dusty village as a primary trading post for the region.

The European settlers were mainly the children of the British aristocracy who acquired the vast and inexpensive farming land of the central highlands that tower above the Great Rift Valley. The most famous among them was a Danish woman named Karen Blixen, better known as the author Isak Dinesen, who arrived in

1914 to oversee the coffee plantation she and her husband had purchased. In her biography of Blixen, Judith Thurman wrote, "The air was exceptionally clear and pure, and it was said, then, to produce 'euphoria' in white people, who were therefore not held strictly accountable for their behavior. British East Africa had a highly erotic atmosphere; it was a place where, with the sanction of Nature, civilized inhibitions were let go."

The term *white mischief* was coined to describe the behavior of some of the more notoriously promiscuous and high-living settlers, those affected by the "euphoria." Almost a century later, the term is still used to describe certain sections of Nairobi society, where ample money and sensual delights remain. Today, there are only about one hundred thousand whites in a city of nearly three million people. This small community comprises longtime Kenyan families, the offspring of original settlers; representatives from nongovernment organizations; the diplomatic corps, most of whom come for two- to four-year periods; wildlife preservationists and archaeologists; and business people representing such major corporations as General Motors and Shell Oil. None of these groups is mutually exclusive. Various short-term visitors include the very wealthy in search of Valhalla and those with an immediate mission: a journalist after a story, a filmmaker scouting locations, a tourist hoping to glimpse a lion.

Young and eager for change, Mike and Kathy and their children plunged into the middle of Nairobi society and set about learning it from every angle. They made friends with people in diverse circles, including elephant researchers, artists, journalists, and the famed paleoanthropology family, the Leakeys, and were quickly known for the novel and varied guest lists of their parties.

At seven, Dan thought their life abroad was a grand adventure. He went on safari with a family friend and afterward drew pictures of the lions and elephants he'd seen. He visited a Masai *boma* with his parents and tried to copy the deep-throated heaving song he'd heard there. After a family picnic, he wrote back to school friends in London about a baboon that had stolen his chocolate mousse. He was at once wide-eyed and nonchalant: awed by his surroundings but still a child who had no context for knowing how unusual his experiences were.

Despite its imposing brick façade, the family's first house in Nairobi was relatively small compared with some of the more palatial estates in the area. It had three bedrooms and a small

guest wing and although it sat on nearly two acres, the rather battered backyard had bare patches and a rickety garage filled with mysterious auto parts. An enormous tree hung over the driveway, and the family took advantage of its sprawling limbs by building a tree house that could hold fourteen for tea.

The family became accustomed to the sights and sounds that had been so exotic at first. The garishly colored birds with their wild squawks were as familiar as the flocks of pigeons in London's Trafalgar Square. In the morning, they awakened to the swish-swash of the gardener cutting the grass with a *panga*. The smell of *chai masala*—black tea and milk enhanced with ginger, cinnamon, and just a bit of pepper, a holdover from the early Indian laborers—greeted them in the late afternoon. Evenings were a festive blur of friends and visitors all gathered around the dinner table.

When Dan was eleven, they moved a half mile away to a low, white stucco house that was actually three dwellings strung together. The yard was full of tangled flower gardens and brilliantly blooming trees, and had a rusty water tower and a vast, tin-roofed storage hut, dubbed the *mkebe*, where Dan held a series of infamous high school parties. It was also the site of large dinners that Kathy frequently hosted for a tourist company, providing Dan and Amy early practice at cocktail banter. Dan had his own quarters in the house, complete with a small kitchen and bathroom, which stood apart from the main house. The entire home had twenty-three rooms, providing plenty of space for visitors, of which there were many.

Long-lost friends and distant relatives all materialized at their door at odd hours of the day and night, weary from international flights. In addition, there were all of the people Kathy brought home. As a writer for *The Nation*, Kenya's national newspaper, and several magazines, she was a well-known figure around town, darting to and from events in her MGB convertible. She made sure that all of the visitors she met had a comfortable place to stay and a good meal—even if it meant inviting them home. The meal might be leftovers from a similar melange served a few nights earlier, but as she was fond of saying, "Not to worry, it's no problem."

Kenya was a highly popular travel destination in the late 1970s and 1980s, due to its great natural beauty and its political and

Imagine a world without wheels or containers

my God!

20ᵗʰ Tuesday

We gave a party tonight. The rice and fish were terrible but everyone ate them anyway. The guests were, David Silberstein and his wife. He is the Presidents doctor. The ex editor for 'Drum magazine, the south African based political magazine, not for the white side. Sergai and his mother came with an white hunter who is staying with them. Alan Meyr, a U.S. Army Doctor (Major) was also there

economic stability. Sometimes it seemed as though the majority of visitors to the area made a beeline for the Eldons' door. A group of frog researchers set up tents in the yard. An American actor did his voice exercises early in the morning, awakening the household. An Australian photographer came for a weekend, enchanting the children with her travel stories, then stayed for six weeks when she spiked a fever and was diagnosed with hepatitis. A writer came and collaborated with Kathy on a novel. "Just another week," Kathy kept insisting, as the man became a permanent fixture at the breakfast table, monopolizing her time to discuss character development when Dan and Amy just wanted to chat about school. The granddaughter of Diana Vreeland, the American publishing doyenne, lived with them for nearly a year, as did a young woman who came to study the coffee export business. And then there was the journalist whom Kathy met years later at a party in London. Although she couldn't quite place him, he claimed to have lived in the back bedroom for a six-week stint.

Dan and Amy often came home from school to find a strange person sleeping in one of their beds, with only the tag on the accompanying luggage to serve as an introduction. At dinner, they learned the new person's stories and, once again, shared their own. The siblings protected and promoted each other. Amy would bring down Dan's art journals and show them off if she felt a visitor was worthy. When one grandam oohed and ahhed over them and then asked somewhat skeptically what talents Amy had, Dan quickly leapt in: "She can dance a hole in this floor!" Later at night, the twosome would compare notes, discussing which guests had been a success and which were annoying or dull.

Their comrade in arms was William, who, along with the rest of the staff, was preferable company to the never-ending household visitors. The cook, who worked for the family from the time of their arrival until after Dan graduated from high school, was a stout, middle-aged man who was not above giggling with the children or entertaining them with stories and theatrics. During long dinner parties, he was often the children's saving grace. As

Dan Eldon: The Art of Life

the wine bottle made its way up and down the table, the adults lost in debate over the latest political scandal or a hush-hush gossip session, Dan and Amy would sit facing the kitchen. Through the small serving window William used to pass the meal—fish curry, more often than not—they watched the performances he put on for them, cavorting with a tea cosy on his head and making silly faces. It sent them into giggles every time, and they'd kick each other under the table to regain their composure so no one else would realize their private joke.

During the week, Mike and Kathy were so busy that William was often the children's companion. He and Dan shared a similarly devilish sense of humor and were always joking around together. William called him "Britishy," short for the British High Commissioner. Amy, whom William doted on, was "Pretty," or, when she was grumpy, "Defenzi," short for the Minister of Defense. In turn, the children called him *mjomba*, or uncle, showing their respect for him as a parental figure. It was a feeling he shared. When William and his wife—who along with their seven children lived in a village in western Kenya, a long day's drive from Nairobi—had twins, they named them Dan and Amy. After school, he met their bus at the end of the long driveway and carried Amy on his back to the house. The three of them sat and discussed their day, enjoying chocolate milk and grilled cheese sandwiches.

William was always an enthusiastic participant in their games, dressing up in a series of silly costumes, including a floppy blond wig and a top hat. His shopping lists, creative amalgams of Swahili and English, became the stuff of family legends: *apricotis, dogu fudu, carosth*. William saw it as his role to look out for the family, his *wazungu*. When all four of them seemed to be having a spell of bad luck, he hired a *mganga*, or witch doctor, to visit. The man, who had tended to former president Kenyatta, prescribed a series of baths in a tarlike black substance for each of them, as well as a love potion for Amy.

Along with the gardener and the *askaris*, William lived in one of several small, spare, one-bedroom dwellings separated from the main house by a tall hedge. A tinny transistor radio broadcast the Voice of Kenya, and in the evenings a cooking fire glowed, while the children of visiting friends played on the grass. Dan and Amy enjoyed spending time there, listening to stories and holding the babies as they were passed from lap to lap. The siblings were different from many of their friends in this way. At school, they knew

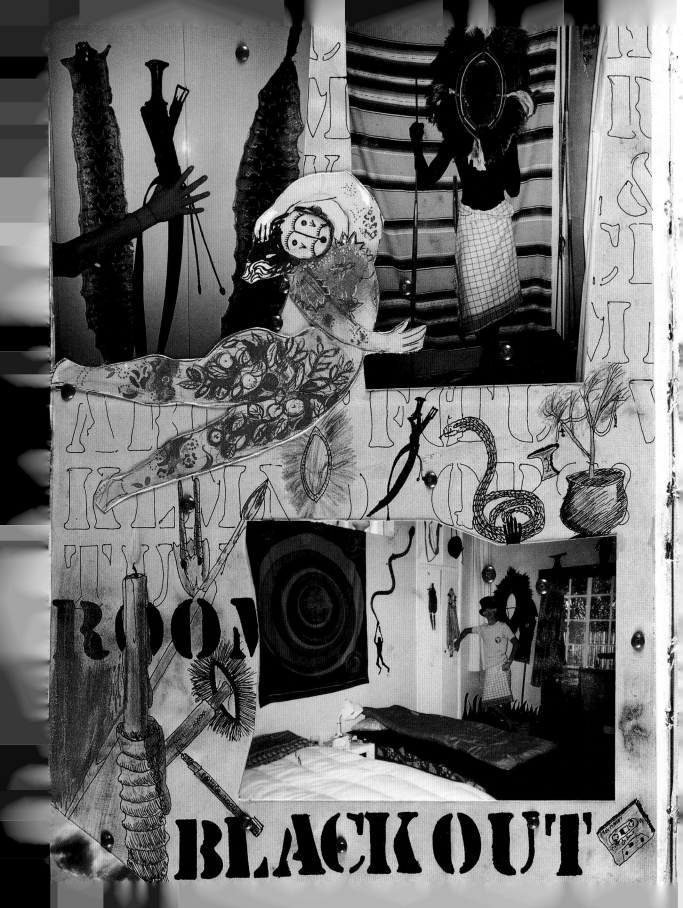

ROOM

BLACKOUT

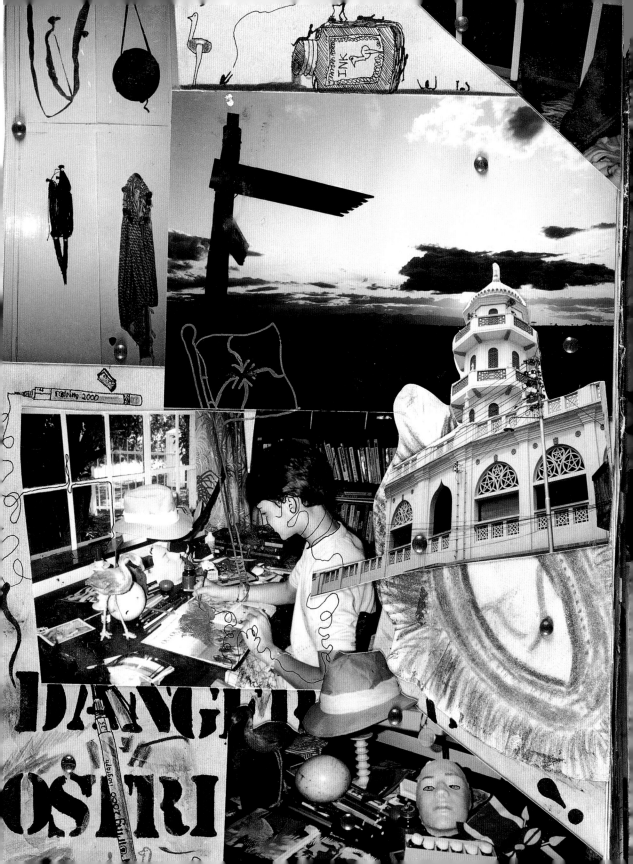

INK

radrino 2000

DANGER
OSIRI

the names of the groundskeepers, janitors, and cooks, people whom most students ignored. They entered the house through the back gate rather than the front door, so they could stop around to the servants' quarters to say hello.

Coming to a new continent together as children with busy parents and an ever-changing household made Dan and Amy closer than they might have been had they stayed in England. They served as each other's confidantes and partners in crime. From a young age, Amy was Dan's muse and he was her guide. Once, when she was about ten years old, he convinced her to let him teach her how to drive. It was a necessary safety precaution for quick getaways, he argued. Despite the fact that her feet hardly reached the pedals, she intently followed his directions, only growing frustrated when his lesson advanced too quickly. After she nearly backed into a tree, she blurted at her brother with momentary rage that she hated him. Characteristically, he argued that she did not hate him; in fact, she should never say something she didn't mean and should take back her words. Once she'd done so, reluctantly, he insisted she try yet again to back around the driveway. It was a moment that would be repeated many times, as Dan scolded her for behavior that he believed to be beneath her, but in the next breath encouraged and coaxed her through life's challenges.

Although Amy's friendship offered some reprieve from the household chaos, Dan's room became his sanctuary, a densely layered art studio-cum-archaeological dig. Masai headdresses, snake skins, and an Ethiopian painting adorned the walls, along with a collection of silly newspaper headlines culled from the Nairobi press and military garb of all kinds. He occasionally tried to keep a chameleon in a cage, but invariably the lizard grew ill and would have to be released. There was a big leather armchair in one corner and a sign that he'd had custom-made at a stall in Nairobi: "Dan's Room." The crown jewel was the bathroom, in which he'd meticulously painted figures on each of the tiny tiles.

By the time he was in high school, even his bedroom did not always provide Dan with enough breathing space. Short of hitchhiking up north or out to his friend Kipenget's hut, the only other respite was the roof. He would hoist himself up via the drainpipe and unfurl a sleeping bag onto the tiles for the night. "Are you all

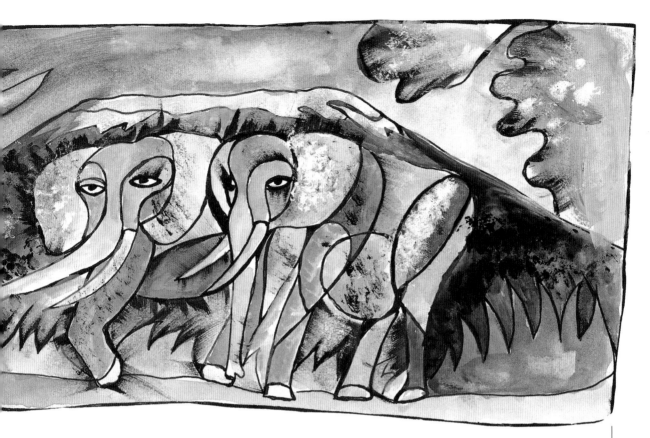

right, Dan?" his mother would yell up to him,
while the *askaris* made jokes that Bwana Dan had finally
lost his mind.

On the roof, with the stars swimming overhead and the sounds
of laughter and clinking glasses drifting up from the house
below, the teenage boy was becoming a bundle of contradictions:
a person who loved to travel but always missed home; a masterful
manager of people and events who planned memorable parties or
trips but was then content to sit back and watch; a curious and
engaging young man who was always eager to meet new people
but longed for his "true" friends. They were quirky traits, yet not
so unexpected. For the rest of his life, part of him would always
be that small boy sitting next to his sister at a long and noisy
table, captivated by the voices and stories flowing around him
while yearning for a moment of silence.

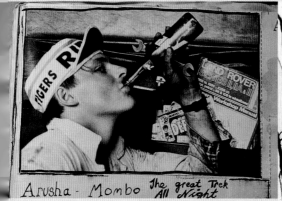

Arusha - Mombo *The great Trek All Night*

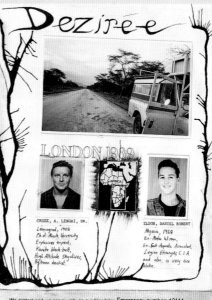

Dezirée

LONDON 1989

CROZE, A. LENGAI, DR.
Leningrad, 1902
Ph.d. Mush University
Explosives expert,
Karate black-belt,
High Altitude Skydiver,
Baboon dentist.

ELDON, DANIEL ROBERT
Algeria, 1968
Ex-Mafia hit-man,
Ex-Sub Aquatic Accountant,
Legion Etrangès, C.I.A.
and also a very nice
bloke.

We protect and we serve...rely on our friendship Emergency number: 10111

Dr. Croze, I presume

While Mike, Kathy, and Amy share Dan under their skin—they look like him and have certain familial nuances, all part of the genetic package—Lengai sounds like Dan. He can fall quickly into the queen's English, as the venerable Dr. Croze, or he can put on a rough Boer accent, becoming a doltish Kenyan settler. All of it is a seamless act, developed to both charm and shield, and while it's pure Lengai, it's also pure Dan. The two developed the pastiche of accents and madcap characters during years of boyhood games and adolescent high jinks. Now, when Lengai falls into this act, it's easy to imagine Dan's eyes shining with laughter, preparing to spin his friend's joke further.

Dan and Lengai were not an obvious pair, but they did what the best duos always do—they complemented one another. Whereas Dan was outgoing, the first to crash a party or to create one of his own, Lengai is more reserved, content to stay home for an afternoon, tinkering with a motor. Dan was a thin, sinewy bundle; Lengai is sturdy and muscular. Dan had soulful, dark eyes; Lengai's are sharp blue and angled. When Lengai was joining sports teams and excelling, the closest Dan came to organized athletics was playing in a rugby match in which he caught the ball but then quickly threw it away and ran in the wrong direction when he saw the whole defensive line coming at him.

When they were seven, however, these differences were irrelevant. What mattered were their reciprocal imaginations, Dan's brightly colored stencil collection, and Lengai's unorthodox home. At Hillcrest Primary School, a British-style private school, Lengai first gravitated toward Dan because of the smaller boy's abundant art supplies, purchased by Kathy on trips back to London and the States. They drew together in class and soon could be found spending recesses nestled in the complex root system of an enormous old tree at the far end of the playground. In their matching navy uniforms, they would wile away their time making up yet another round of the adventure game they'd invented, "Mars Willies." They had begun by creating a storyboard, which soon morphed into something requiring guns made of Legos and plenty of running and climbing.

They introduced their families to one another and the Crozes and Eldons became friends. Both couples were multinational unions, Americans wedded to Europeans. They were raising their children far from the support of grandparents and other family members and, thus, had to create their own familial bonds. Mike delighted the boys by playing along with their Monty Python routines, adding more accents and quirky characters to their repertoire. Lengai's mother, Nani, a German artist, became close friends with Kathy. Despite Nani's sometimes stern nature, Dan never tired of testing her and the two settled into a precarious relationship. While he loved her studio and shared her aesthetic nature, Dan's tendency to distract Lengai with play became a point of contention.

31

Ground zero for Dan and Lengai's escapades was the compound of buildings that the Crozes had built at Kitengela, a wild area adjacent to Nairobi National Park and about a half hour from downtown Nairobi. When Dan first met Lengai in 1977, the Crozes lived in a double-decker bus north of Nairobi, and sleepovers occurred on the upper level. In 1979, they bought property about fifteen miles south of Nairobi, dry brushland cut through by a deep river gorge. A tent served as their initial home, but they soon built a simple mud structure as a living room. Other rough buildings, decorated with whimsical stained-glass designs, were gradually added, a never-ending project. Their electricity came by way of a temperamental generator, and when Dan stayed with them, he sometimes did his homework by lantern.

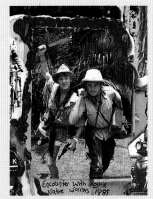

Encounter with hostile Native Warriors, 1985

Careening in and out of the series of fanciful buildings that Nani had designed (and which have since been added to by Lengai and his siblings), as well as the nearby gorge, the boys would play with their G.I. Joes or dress themselves up. One day they were fearless white hunters, the next American mobsters. Lengai's older brother and sister, Anselm and Katrinika, sometimes allowed themselves to be pulled into the fray, but they more often watched from the sidelines, amused by the younger boys' silliness.

Soon after the Crozes had moved to Kitengela, Kathy wrote a letter home to Iowa describing a mid-December scene at the compound. "We drove to Harvey and Nani's in a borrowed Land Rover, as it has rained and the road was nearly impassable. We arrived late, when the sun was behind the clouds, ringing each one with silver. The animals were all there: the crown crested crane, which always terrifies me, their monkey, assorted ducklings, geese, chickens, the monitor lizard, Egyptian vulture, and the funny little puppy. We ate supper together, sitting in the mud hut dining room and balancing plates on our laps. Then we moved into the sitting room, a vast space under a thatched roof, where we sang Christmas carols and had a traditional German advent service, before being presented with German cookies. We left early as the children had school the next day, but at least we got some Christmas spirit in!"

Meanwhile, Hillcrest Primary School proved increasingly unpleasant for Dan. Lengai and "Mars Willies" were about the only appealing facets. As part of the Dickensian environment, students were punished by being rapped on the knuckles with a ruler or subjected to tirades. The gym teacher, Mr. Evans, felt it was his special duty to see that Dan, the youngest in his class and also the smallest, progressed more quickly toward manhood. A few whacks with a sneaker on Dan's backside were meant to convince him that morning swims in Hillcrest's icy pool were an edifying experience.

When Dan was ten, he developed stomach pains and headaches that cleared up only when he stayed home from school. The attacks were frequent enough that he missed weeks of the term, compelling his parents to send him to a doctor. His diagnosis was "school phobia" and the prescription was a transfer to the International School of Kenya, an American-style school with a more open, creative approach to education. The move separated Dan from his best friend, but banished the aches and pains.

As much as Lengai needed Dan's endless energy and curiosity, Dan needed Lengai's careful nature and practical skills. Lengai spoke much better Swahili, and though the friends Dan later made were impressed by his knowledge of the language, Lengai never thought it was up to par. Lengai's parents had been wildlife researchers, tracking elephants for years, and he had more experience navigating difficult situations in the outback. He was also the superior mechanic, his patience and eye for detail better suited to the slow work than Dan's blustery energy. A mutual friend joked that Dan couldn't have gotten out of the driveway without Lengai.

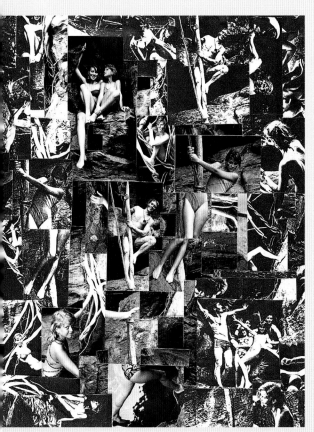

Lengai went to boarding school in England for high school, greatly reducing their time together. They hardly ever wrote letters or talked on the phone while apart. Sometimes a postcard arrived, filled with gibberish save for a time and date when they'd next meet. Dan once wrote, but never mailed, a postcard to Lengai that began: "Dear Legs, This is just a quick one to acknowledge receipt of the landmark unprecedented 'chatty letter.' An impressive style of communication. I'll have to try it sometime."

In Lengai's absence, Dan continued to go to the Croze compound and the gorge, taking friends from high school and later there. It forever had the pull of a child's special hideaway, and going there with newcomers could never be a simple outing. To do it justice, Dan made the visits playful and mysterious. Once he cajoled a group across the river in the midst of a downpour, each crossing on a slippery rope and then making a jump for a tree on the other side.

On another occasion, he drove a carload of friends from town, stopping at the side of the road for a picnic. With packs of food, pans, and blankets on their backs, they walked for at least a half hour before coming to the gorge. Holding on to tree branches and

rocks, they dubiously scaled down to the river. Finally, they reached a landing from which they could swim and sunbathe. After several hours of play, it began to get dark and they made gestures to head back. Dan wouldn't budge. "This is so perfect," he smiled at them, "how can you leave so soon?" At his insistence, they stayed until dusk settled into darkness, most of them apprehensive about the return trip. As they stood to go, they turned toward the steep wall, searching by moonlight for handholds. "Where are you going?" Dan called. Already he was headed in another direction, going slowly so they could backtrack and catch up to him. By this route, it was an easy five-minute walk to the car. The ambitious descent had been only for the sake of adventure.

As they got older, Dan and Lengai made adventures for themselves farther from home. Twice they drove together from Kenya to southern Africa, both times getting themselves in and out of difficult situations. On these trips, Dan tended to create waves— yelling at a cop in a Tanzanian police station who was roughing up a street kid or putting on a Halloween mask to perform for an entire village. Lengai's role was to toss beers out the back window to quell a riled crowd or work all afternoon next to a local mechanic after their vehicle broke down for the umpteenth time.

When longer trips weren't possible, Dan cooked up sprees: a weekend in Berlin or an overnight trip to Moscow. The latter, carved out of scant time over Christmas break in 1991, was chosen because the tickets were the cheapest they could find. For two days, with Dan freezing in a skimpy jacket, they explored the relics of Communism and the fast-incoming changes of capitalism.

"Lengai and I survived the Aeroflot adventure with one night in Moscow," Dan wrote to his then-girlfriend. "It was quite a safari. We had to bribe the visa officer with a carton of Marlboros to let us out of the airport. He had worked for the Soviet Embassy in Zanzibar so the whole transaction was done in Kiswahili with a Russian-Zanzibar dialect. We had just enough time in town to see the Kremlin, Red Square, Lenin's stuffed body (gross!) and have a McDonalds, after a little Black Market dealing 'à la *magendo*.'" There in Red Square, the old playground tree and "Mars Willies" were miles away. And yet it was still a game, a light, silly escapade played across continents and years.

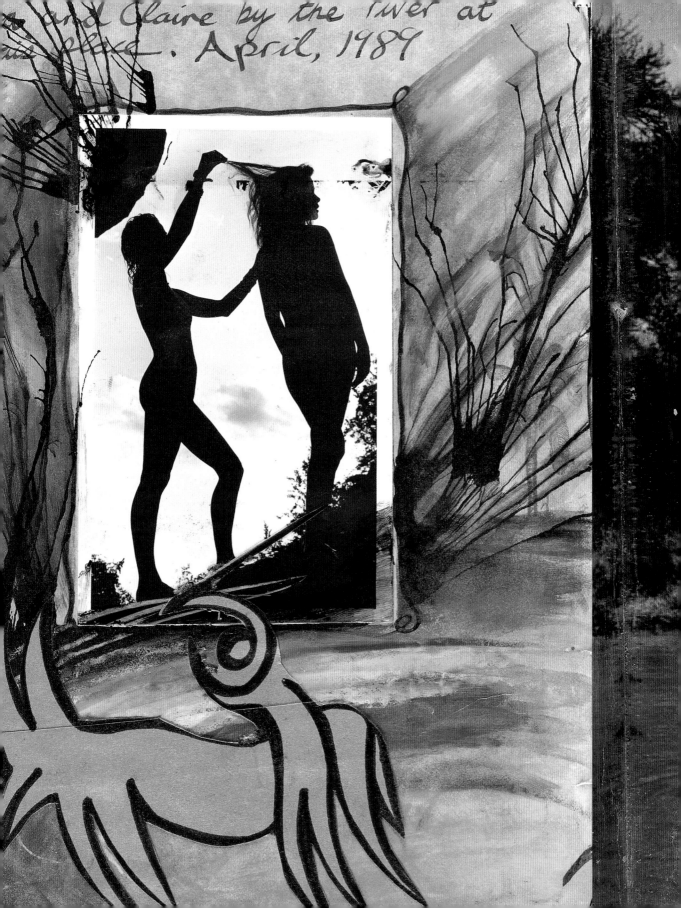

and Claire by the river at
the place. April, 1989

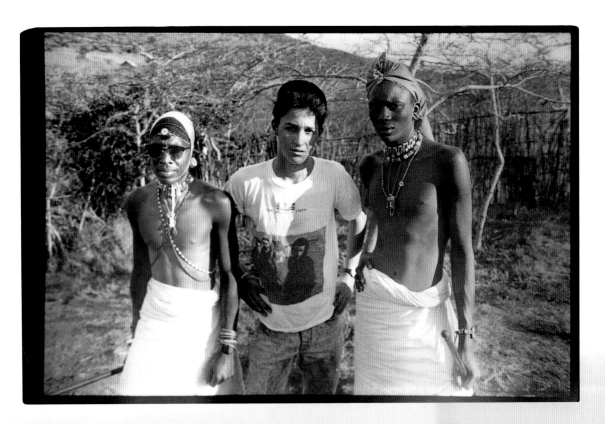

I gave them support and friendship. They gave me much more. They taught me how to survive with grace and fortitude. Count your blessings in the small, momentary victories that bring you to another day. Next week is in the lap of the gods.
—Mary Anne Fitzgerald, *Nomad*, 1993

lesharo

Kipenget's hut is on the edge of the Ngong Hills, looking out on the expanse of the Rift Valley. It is only twenty miles from bustling, car-clogged Nairobi, yet feels much farther. This close to the equator, day abruptly becomes night; within ten or fifteen minutes, light is extinguished, and the hut, which has lanterns but no electricity, is shrouded in darkness. Any news is announced by a friend on foot as there are no telephones. Rather than coming from a pipe and spigot, water is fetched by girls and women each morning, collected in metal drums from a well some distance away.

A tall woman with a round, friendly face and sparkling eyes, Kipenget wears the intricate beaded jewelry of her people, the Masai. Long loops dangle high on her ear lobes from piercings that she received in puberty; layers of brightly colored necklaces and pendants signify that she is a mother, and with thirteen children, she has earned the adornments. In the fiercely patriarchal Masai culture, however, she has few rights and has had to fight for her small plot of land against the wishes of her cantankerous, alcoholic husband.

The Masai are Kenya's best-known tribe, famed for the courage of their warriors and their refusal to bend to the British colonial society that so transformed other tribes in the early 1900s. Their existence is now a perilous balancing act between preservation of the customs with which they define life stages such as birth, manhood, and marriage, and the encroaching industrial world. As with American Indians and other aboriginal peoples, the Masai devotion to tradition has ostracized them from the larger Kenyan culture, even as they are mythologized, and has left them impoverished by contemporary standards. Theirs is a harsh life, with few amenities. Living with the Masai, as he sometimes did for brief periods, made Dan more aware of the ease in which most people, including white Kenyans, live.

Despite—or because of—her exceedingly humble life, Dan took to Kipenget immediately, sensing in her broad, welcoming smile a kindred soul. He was fifteen when he met her, introduced by Mary Anne Fitzgerald, a journalist and family friend. Dan had known other Masai and Samburu, a closely related tribe; they are hired by many Nairobi households as night guards because of their alleged ferocity. The friendship he forged with Kipenget, however, allowed him to become part of a Masai family. "Being with them, going down behind the Ngongs as Dan did," says Mary Anne, "well, you can't come back the same person to that sanitized, white world. It makes you very reluctant to return."

The beginning of Dan's relationship with Kipenget's family coincided with a nearly weeklong trip that his high school took to a Masai village in September 1985. Students attending the Cultural Anthropology Field Trip were responsible for keeping a journal according to the following instruction: "Whenever possible, the ethnologist becomes ethnographer by going out to live among the people under study. By

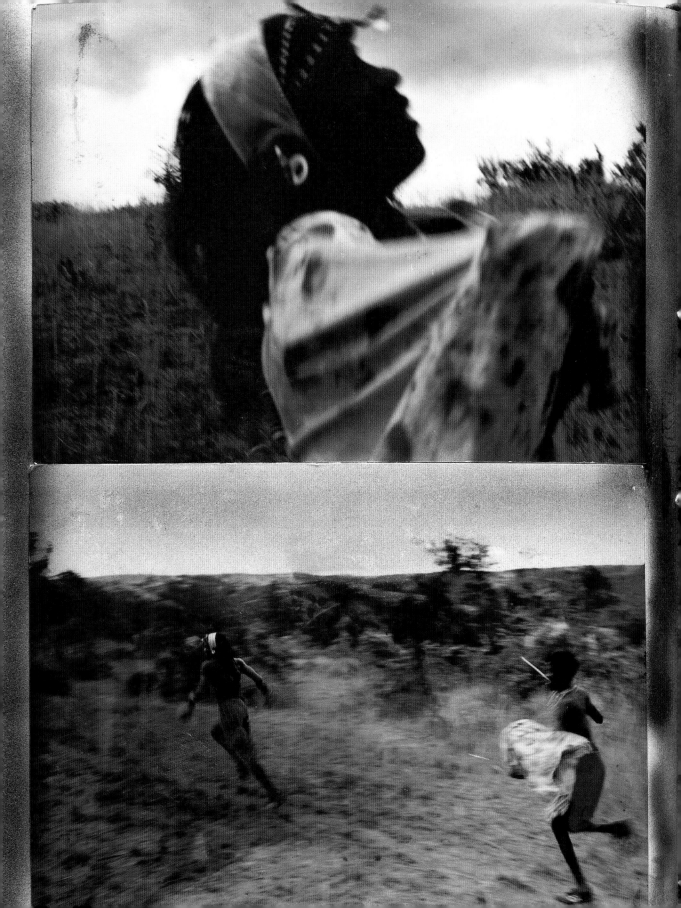

eating their food, speaking their language, and personally observing their habits and customs, the ethnographer is able to understand a society's way of life to a far greater extent than any 'armchair anthropologist' ever could."

Dan delighted in the experience, his enthusiasm evident in his journal. He went beyond the boundaries of the assignment, filling pages with shards of glass, feathers, intricate drawings, and swatches of cloth. He wryly pasted conflicting images side by side. It was the first of his many journals. His father calls the two events—meeting the Masai and starting the journal—"a spontaneous revelation."

After that initial trip, Dan hitchhiked to Kipenget's or took a bus. Later, when he could drive, he borrowed his mother's car. Children ran to see him, knowing that he brought gifts, often sugar and tea. He touched each of their heads in greeting and hugged Kipenget, who always met him with a smile so wide that it softened whatever bad news she had: her husband had gotten drunk and beaten her, a goat had died. *"Karibu!"* she'd say, taking his small frame in her arms: welcome.

Then the unlikely pair—the mother of many with a dusty cloth pulled over one shoulder, and the smiling boy—would spend a few minutes conferring about their business. Dan sold Kipenget's jewelry to schoolmates and tourists, giving her all of the profit and receiving a new assortment of bracelets and necklaces in return. No visitor to the Eldon house got away without purchasing one of the beaded leather bangles.

When the business conference adjourned, Dan took off with Meriape, Kipenget's oldest son and Dan's guide to the Rift Valley. They played with spears and loped for miles. The Masai are known for their walking prowess; there are many accounts of Masai appearing seemingly out of nowhere, having walked distances that few other people would undertake. Dan seemed to have emulated them well, as few friends could keep up with his long gait. In lieu of the hunting that is traditionally part of young Masai *moran*'s training, but which is now illegal, Dan and his friends chased herds of giraffes with a Frisbee. In the evening, Dan would often spend the night at the *boma*. After telling stories and singing around the smoky fire, he would share a cowhide hammock with several children.

39

Those days and nights with Kipenget split open his world. If moving at age seven to Kenya with its Technicolor plants and endless sky was the first revelation, this was the second. Along with the menagerie of animals and art he experienced at Lengai's house, these friendships expanded his understanding of Africa, home, and family. As he must have known, his experience as a white boy who was adopted and accepted by a Masai family was exceptional. He had an ineffable need to put it all down in the new books he was keeping—the blue of the sky, the patterns of the Masai, the red of their blankets, the bumping of their world against the modern world.

He was affected by what he saw there—the poverty, the eroding customs, and especially how the traditionally fearless hunters were reduced to working as *askaris*. "The application of bushcraft," he wrote in a school paper, "is limited to the lonely and unrewarding job of opening and closing gates at wealthy people's houses." One night, while talking to a group of house guards in Nairobi, Dan produced a spear, becoming an eager pupil as the men gathered around to demonstrate techniques for him.

He soaked in the pride and confidence of the *morans*, the young Masai and Samburu warriors whose physical prowess and self-confidence, bordering on arrogance, are legendary. On a *matatu* to Maralal, a sleepy, northern town to which Dan sometimes escaped, he met Enkroine, a Samburu who was about his age. The two boys spent time together, both in Enkroine's village and at the Eldons' house. Dan described his friend with awe and humor: "He combines the bravado of a medieval knight with the vanity of a *Vogue* model.... When dressed in Western clothes, he is of average height. But when he dons his warrior's garb, he soars." At a time when Dan was evolving from a shy, small boy to a school leader, artist, and explorer, the *morans* were surely significant role models.

At waist level is a beautifully beaded belt from his girlfriend, Susanah. Most warriors have many girlfriends, but he remains faithful to her. (When I traveled with him for eight hours in a *matatu* followed by a brisk fifteen-mile walk, he was going to visit her.) His arms are as strong as tusks, and on each one he carries an assortment of beaded bracelets and metal bangles. He has had his heart set on a watch to add to this collection—not for improving his punctuality, but as an extra *maridadi*—I convinced him to resist buying one from a con man, pushing time pieces on the bus to Maralal. He almost always clutches a small bundle of *miraa*

sticks, a traditional mild drug, which he chews constantly. One morning we had to catch a bus at five. We had no alarm clock (obviously), so his solution was to stay awake all night under the influence of *miraa*. He also has a secret passion for Orbit chewing gum, which fills his mouth when it is void of twigs.

Kipenget's son Meriape and his friends must have sensed Dan's earnest interest in and respect for their culture, because they held a spoof initiation ceremony for him. The ceremony is a definitive moment for Masai men, culminating in a circumcision ceremony, or *Emorata*. Boys who are age-mates undergo the ritual around the same time, after years of preparation and learning to show neither fear nor pain. Dan's ceremony, by comparison, was a spontaneous occasion. In the photos taken that day, one can see the laughing face and squinting eyes that must have prompted Kipenget to give Dan the Masai name Lesharo, the "laughing one." They were boys frolicking in the sun-baked hills, yet the pride of having been included, of having been found worthy is written large on his face.

Stare. It is the way to educate
your eye, and more. Stare, pry,
listen, eavesdrop. Die knowing
something. You are not here long.
—Walker Evans, *Many Are Called*,
1966

trap door

Забывчивость или умысел

Трудно поверить, чтобы президент США Р. Рейган не знал очевидных фактов международной политики. Тем не менее его ответ на один из вопросов в ходе встречи с прессой в Лос-Анджелесе можно оценить как провал в памяти, хотя скорее всего это все же было умышленное искажение фактов.

И действительно, вопрос был таков: г-н президент, король Иордании Хусейн добился в Западной Европе позитивного отклика на предложение о созыве международной конференции по Ближнему Востоку. Как мыслится, в такой конференции будут участвовать Советский Союз и палестинцы. Поддер-

живают ли сейчас Соединенные Штаты такую конференцию?

Вопрос выглядел вполне логичным и злободневным в нынешней обстановке, когда всюду звучат голоса в созыва конференции.

вет... Ответ заставил перо.

— Мы со своей стороны чаем эту идею, — ган. — Мы не мо ровать того обсто до сих пор Израи торой степени об возражал против иде двух названных сторо му что обе они отрицают прав ществование

Вот и судите как все это пони рошо извест Со ле

Прошедше в ее комитете ствам привлекли обоснованно: н вается «зеленая мической помо

Львиная дов по шую в отставил ные огра помощи ин ствам, пр прёт на не не проводятся нию ядерного блюдают ущемлена

Более то индийские раз без всякой риканские диплом о долгосрочном н се такой поли индийский пу Чакраварти, не ся из США, там вопрос: так упорно ра вооружений? От канского специали народным делам он очень четкое разъяснение. наши действия, — сказал то подчинены главной цели: б мировой военной державой, рать роль, которую мы взяли на себя после второй мировой войны. Наше отношение к демократии, к правам человека, нераспространению ядерного оружия не должно мешать нашему

За ская ад н ло

ратно к зывали св ше к Инди

Так, на тех же программы помощи государствам где та одобрили миллиардные суммы

ди ть мо ковано. На днях сторона пошла на «ко предложив поставить шую модель с туманным о нием реконструировать эту ма шину в будущем. История с су перкомпьютером еще раз рас

Куба
на марше

Издан сборник речей
Ф. Кастро

ГАВАНА, 20. (ТАСС). «По правильному пути» — так назван сборник речей и выступлений Первого секретаря ЦК Компартии Кубы, Председателя Государственного совета и Совета Министров республики Фиделя Кастро, который был вчера, в день 26-й годовщины победы кубинского народа над контрреволюционными бандами наемников США на Плая-Хирон, представлен широкой общественности. Выпущенный издательством «Эдитора политика» сборник вызвал живой интерес кубинцев.

Похороны
Йоргена
Енсена

КОПЕНГАГЕН, 20. (ТАСС). Сегодня здесь состоялись похороны видного деятеля датского рабочего движения, Председателя Коммунистической партии Дании (КПД) Йоргена Енсена, скончавшегося после тяжелой продолжительной болезни.

В церемонии похорон приняли участие представители общественности Дании, руководство КПД, делегации братских партий, в том числе делегация КПСС.

Out of necessity, Africa is a recycling haven. Old tires are turned into sandals, becoming so-called hundred milers; car parts are swapped, mended, and reswapped; street kids transform old pieces of metal into dustpans or toy trucks; Masai use socks as wallets. Even with their comfortable upbringing, Dan and Amy had very different experiences than their American and British counter-parts. There was no Sega or the latest board game. Television shows and movies were old, transatlantic hand-me-downs. When they went to their grandparents' house in Iowa for holidays, they often got their older cousin's castaway clothing. It made sense that Dan, even as a kid, viewed life's leftover artifacts as viable art supplies: re-use was all around him.

Dan came to journal making through school. During his sophomore year in 1985, he was assigned journals for two classes, English and Cultural Anthropology. He went overboard with both assignments, adding to the books long after they were due and ignoring other schoolwork. When he finally turned them in, he pilfered an old hardbound sketchbook from his mum and unleashed his full powers, as though he'd been holding back when he knew the end product would be graded. (One teacher had offered the following assessment: "Creative journal—good expressions—how about a bit more writing?") He packed it with outrageous newspaper head-lines ("Boy Wins Battle with Python") and photos of Amy and her friend Marilyn Kelly—little girls dressing up in costumes and makeup. There were photos of himself, too, revealing a boy caught between the softness of childhood and the angu-lar lines into which he'd soon grow. The three were kids having fun with art, making something out of nothing.

From the beginning, the journals were a home for ephemera. He pillaged the house for odds and ends: food labels, cloth, string, ticket stubs, old magazines. When he'd exhausted that supply, he expanded his search zone. The more bizarre or rare the object the better—an Arabic newspaper was more valuable than one in English, the wrapping from a Russian caviar canister better than an everyday soup label. He discovered that locating these objects entailed a search and often meant going to unusual places.

The journals were also a home for his photographs. He had received his first camera, a little automatic, when he was six years old. As an adolescent, he had learned how to use his parents' 35-millimeter cameras. Kathy often had hers with her for work, while Mike was always taking photos on family vacations to such places as Brazil, Egypt, and Israel. In high school, his parents bought Dan a used Nikon, and he began to carry it with him. When he saw that the photos could be a key ingredient of the collages, he was spurred to take more.

As with his desire for novel objects, he sought more interesting backdrops and subjects for his photographs. He began traveling farther from home, exploring the backstreets of downtown Nairobi and visiting Masai and Samburu friends outside the city. The journals united Dan the Explorer, Dan the Pack Rat, and Dan the Photographer.

They were an extension of the visual exploration Dan had been doing since he was a small child. His mother had been an art teacher before his birth, and she presciently provided Dan with blank books for poems and drawings when he was a toddler. She filled his room with art supplies and took him to a Waldorf preschool where art was central to the curriculum. In addition to travel photography, his father introduced him to stamp collecting, and the two created albums together. At his first school in Kenya, Hillcrest, art was his escape. His head was always buried in a notebook during classes as he doodled compulsively. Little dancing men, ostriches, water buffalo, and other animals covered the margins of his schoolbooks and assignments. His parents worried that the drawing took his focus away from his studies, due to his struggle with spelling and math. Eventually, it was discovered that he was dyslexic, accounting for the spelling but not the dancing men. When a high school teacher later reprimanded him for drawing in class, thinking it a sign of distraction, Dan explained that he couldn't listen unless his hand was moving.

No matter how much Dan loved to draw, he couldn't execute lifelike renditions. The hands of people he drew were a bit clumsy; his buildings were out of proportion. The journals, however, were a place to explore with humor, color, and shapes, away from judging eyes. There was no pressure to excel or get anything just right. Lines could be crooked, words misspelled. He soon discovered that messing up and starting over again, gluing a new set of images over the old, often improved a collage rather than indicated a botched job.

45

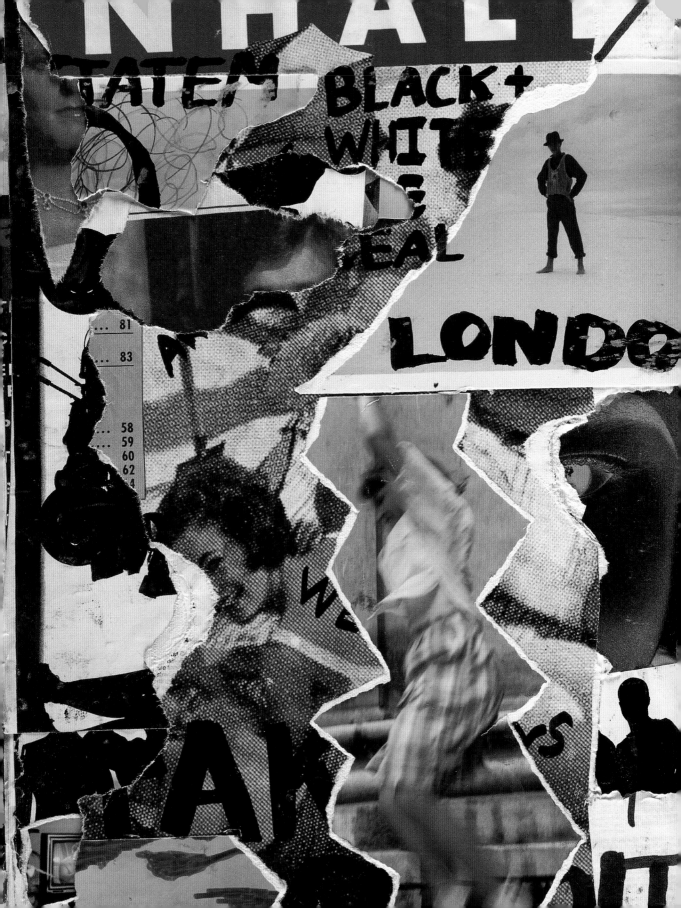

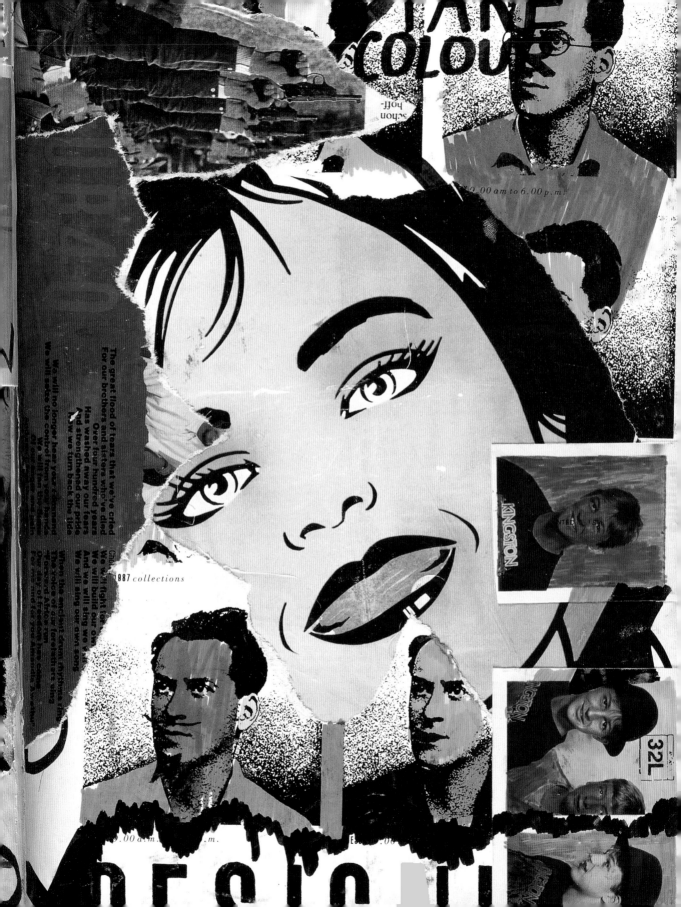

He was dedicated to the journals in the same way that another young person might be dedicated to a sport or a musical instrument. They were so omnipresent that his family took relatively little notice of them, as though they were a soccer ball or much-played trumpet. He always had a journal with him, including during his frequent travels, and made sure to spend time working on it at least every few days. Sometimes he would halt a trip for a morning to put down a semblance of the recent days' events or would work into the night, guided by a flashlight or fire.

At home, he worked sitting cross-legged on his bedroom floor, oblivious of time, often with someone else in the room. His father, for example, sat with him, recounting the day's events while Dan snipped away at a pile of magazines. Once, a girlfriend came to pick Dan up for what she hoped would be a romantic evening, but he motioned her to sit down, then pushed a pile of photos in her direction. "Tear these up," he instructed. She sighed, knowing that it would be impossible to disentangle him from the project at hand.

In high school, he took the International Baccalaureate art class with a small group of friends. They spent the year experimenting with various mediums and styles. Robert Hughes's *The Shock of the New* was their text, and its spirit of frontier art and boundary pushing served as inspiration to the class for everything from creating the most accurate reproductions of dollar bills they could to playing with chemicals in the darkroom. Dan would bring his journals to class 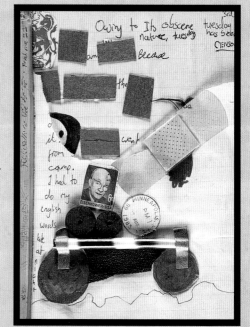 and unload a knapsack full of supplies. Then he'd perch on a stool, one of his books opened in front of him, and roll his fingers with the Elmer's glue he used to stick everything into his books. He became almost hypnotized by the work, lost in the pages.

Friends were sometimes invited to add something to a page— maybe a drawing or some text. Invariably, when the person looked back through the book weeks or months later, he or she could no longer recognize the entry; Dan would have worked over it, making it his own.

Dan's room became his art studio. In addition to the layers of boyish trinkets on the walls and bookshelf, his desk was covered with little jars of beads and interesting colored spices, such as saffron. He had boxes of colored pencils, watercolors, pastels, and pens of every sort, including old-fashioned fountain pens, metallic markers, and fine-tipped architectural pens. He collected coins and bills from every country he visited, along with postage stamps and official documents. Even animal parts—snake skins, egg shells, and feathers—were saved.

Whatever wasn't stored in stacks in his bedroom he kept in metal boxes made out of recycled beer containers. He traveled with the boxes, hauling supplies with him wherever he went. As he got older, 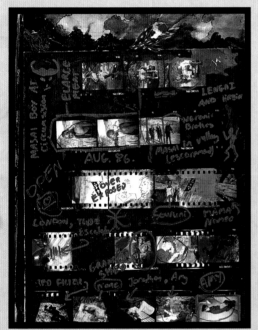 not only was his Nairobi bedroom filled with the collection of paper, pens, and found objects but also his mother's apartment in London and other places he called home, if only for a week or two. When he showed up at his cousin John's house in Iowa in February 1992, he brought with him an astonishing array of materials, including the detritus from recent trips to Japan, India, and Moscow. About six weeks later, he left for Kenya, boxing up much of what he'd brought and leaving it on John's porch.

Dan kept the journals with him, shoving them in his knapsack or tossing them in the back of his Land Rover. As he added more layers, the books became heavier. Several are small, the size of a paperback book, but mainly he used eight-by-eleven, black, leather-bound art books that his mother bought for him on trips, along with other supplies he couldn't find in Kenya. One of his finished journals, about four to six inches thick, weighs as much as a hardbound dictionary. Scraps emerge from the pages like tendrils searching for air and light: loose photographs, foreign currency, and frayed string.

He usually worked on two or three books at once, always revisiting earlier pages and making additions. Their lack of linearity makes them a mystery to unravel. The overlay of objects—a condom covering some writing that seems to be in Dan's hand; a photograph

from Morocco, circa 1991, pasted over pages from his high school yearbook—gives the effect of geological strata. Despite his propensity for weaving time and place, it is possible to look at the journals chronologically and follow certain stories for pages at a time. There is his trip to Berlin with Lengai, his safari to Uganda—each relatively intact.

The journals also progress stylistically. The early books are a happy cacophony, pure experimentation without restraint. His exploration of color, shapes, and mediums is unbridled, the images unabashedly silly. During the end of high school and immediately afterward, the pages grow darker, the artwork more controlled and complex, a reflection of his parents' separation, his burgeoning sexuality, and the art he was studying at school—the work of a boy becoming a man.

The fall after high school, while Dan interned at a magazine in New York, his style progressed further as he learned about principles of design and layout from the graphic artists around him. The pages, particularly the double spreads, have a greater sense of preconception; they are no longer jumbled experiments, begun without forethought. At the magazine, a bevy of supplies and tools was available to him, including a color copier, a relatively new and expensive technology in 1988, which he used with abandon.

Like many passions, the collages began because they were fun, something for which Dan discovered he had a knack. Over time, they became an escape, a haven, a place to test and question. In addition to silly jokes, they are filled with the soft underbellies of hurt and anger, sometimes veiled in symbolism and mysterious imagery. The emotion he experienced in relationships with girls is there, the raw vitality of love and sex but also the crash-and-burn pain to which he opened himself. "Agony and Remedy" was the phrase he used to express both the ache and the hope he had in relationships; he used the phrase often. The horror of war and of the many injustices he witnessed in Africa also surfaces repeatedly.

The journals were like private diaries, yet were sufficiently oblique that Dan felt comfortable sharing them. If anything, he hesitated to show them more from a lack of confidence in his skills than a sense of privacy. He was thrilled, for example, when an art director at the American fashion magazine where he eventually interned asked him to leave his journals behind while he toured the rest of the office. His face lit up in a grin when he returned to find the entire art staff wearing T-shirts they had

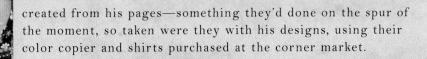

created from his pages—something they'd done on the spur of the moment, so taken were they with his designs, using their color copier and shirts purchased at the corner market.

While living in New York, he wrote on a journal page: "I have three things here. #1. My house ($400 per month). #2. My book (100 pages). #3. My head (2 eyes). I share my house with my roommate. I'll share my book with you. My head is my own."

He seemed to understand that while he could let people look at the journals, there was no way they could see the same things he did in the pages. The unbridled thoughts and passionate feelings that lived in his head were the ultimate material for the collages. What he wrote is like a dare: go ahead and look, the ideas are mine but just try to make sense of them.

Roko Belic, who became a friend on a 1990 trip through southern Africa, first met Dan at a party a few months before that journey. They had hardly been introduced when Roko noticed a girl looking through one of the journals. As an art student, Roko had similar books, though his were mostly blank. Sitting down in a corner of the apartment, he went through two of the journals, hardly aware of the roomful of people around him. He was utterly captivated by the colors and abundant array of artifacts; time slipped away and he felt as though he'd fallen through a magical trapdoor. The journals are like that—an entryway to another world, a rabbit hole.

So full are they of stories and photographs, of kernels of rice, the images of laughing children, and animal parts that the books seem to pulsate with life. The echo of laughter from a platinum blonde, her head reared back in a smile, floats off the page, as does the scent of chocolate from a Toblerone wrapper. Going through a single journal—many of which Dan gave titles, such as *Less Is More* and *Another Book, Another Time*—is exhausting. At the end, the reader feels as though she has just driven all night or reentered the daylight after a long movie—except for the last book, which is more like a quick, sharp jab to the gut.

Glued symmetrically and neatly to the first handful of pages are Dan's photographs of Somalia. He had not yet added any layers, though maybe he never would have. The images are so stark and shocking that it's hard to imagine what more he could have put on the page. These alone achieved messages of horror, irony, and disbelief. He may, in fact, have been done already.

51

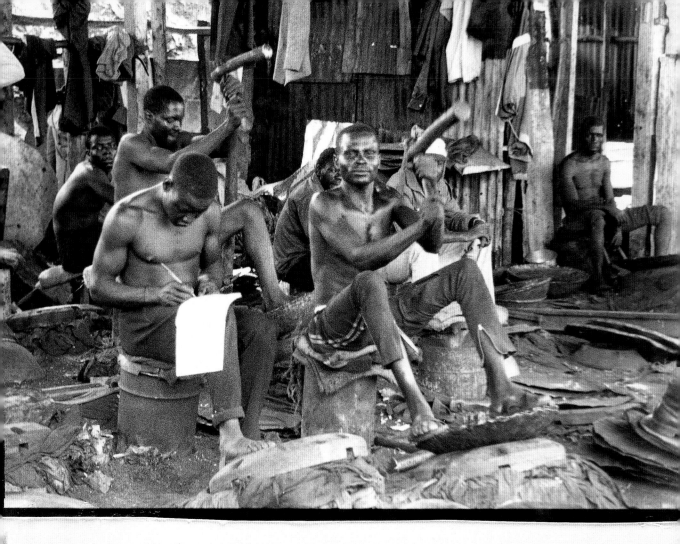

Nairobi streets

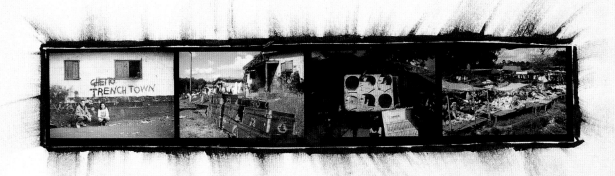

On his first day at the International School of Kenya, Jeff Worden was asked by the teacher to stand and say something about himself. Handsome and soft-spoken, he hesitated as the class turned its attention to him. "I'm from Austin, Texas, at least most recently that's where I'm from."

Before he could continue, a head bobbed up from the last row of desks. Without introduction, Dan stood and proudly pulled his T-shirt out for Jeff to see. "Don't mess with Texas," it read. "I've always wanted to meet someone from Texas!" he exclaimed in the rough sherifflike drawl he'd been perfecting. When Dan reverted to his regular voice, Jeff noticed that he had a different accent than others he'd heard—a bit too full and rough to be British, almost Australian. "Girls go crazy for it," Dan would tell him later when Jeff's American voice began to morph.

By the end of the day, Jeff had been rechristened "Tex," and Dan had all sorts of plans for him: yearbook, newspaper, art class. In the short term, though, he was intent on properly orienting the newcomer. "This weekend we'll go on a little safari," Dan promised.

Jeff wasn't sure what to expect as they sped out of the Eldons' driveway on Saturday morning in a little red Fiat. Very quickly, he noticed the beautiful lawns and large homes of the suburb fade into dirt huts made of every conceivable recycled material: corrugated metal, old wood planks, cardboard. The paved road had ended and in its place was the reddish Kenyan earth, pocked with holes and heaps of garbage. Whorls of oil floated in standing pools of water. There was a stench unlike any he'd smelled before.

Nearby the squatter area, Dan pulled up to a small shopping arcade with peeled yellow paint. Before they could go into the *duka* to buy sodas, they were surrounded by a horde of long-limbed boys. "Dan, come play with us! I bet you and your friend can't beat us," they dared, throwing the "ball" they'd made of plastic bags and rubber bands into the air.

Downtown they encountered more kids, many of whom recognized Dan and gravitated around him. A group of children sitting on the sidewalk called to Dan to see the collection of little airplanes and trucks they'd made from old wire and soda cans. Listening to their sales pitches, Dan took off his sunglasses and crouched down on the pavement. He lined up several of the vehicles and gave them the once over, checking to see which was the most ingenious,

spinning propellers and flipping over the cars to inspect their undersides. The kids watched with rapt attention, anticipating who would get the final sale. A Land Rover was eventually declared the winner and Dan plopped down fifty shillings in the outstretched hand. Later, when Dan chucked the vehicle into the back of the Fiat, Jeff saw a collection of the little trucks, purchased on earlier outings.

As they walked down the street, Jeff could hardly keep up with Dan's long strides. While Dan was not large—a thin frame and under six feet tall—he took up the space of a much bigger person. They darted into a sandwich shop, where Dan was greeted with a big *"Jamba!"* by the older proprietress, who reached across the counter to tousle his hair. As Dan asked about various members of her family by name, Jeff realized that the young man behind the counter was already in the midst of preparing a ham-and-cheese sandwich. It was obviously a standing order. "One for my friend as well," Dan said, motioning to Jeff.

On the street in the glare of the midday sun, Dan declared that an important lesson lay ahead of them: transportation. "These are *matatus*," he grinned, pointing to a series of vans that clogged the streets. "Think of them as the Kenyan subway. Whites don't ride them much. But what a bore not to!"

The larger *matatus* looked to Jeff like oversized American-style minivans. They held up to fifteen people, but counting was a challenge, as people heaped themselves in, skin against sticky skin, with small children being passed out the back window when a door was blocked by too many passengers. Some riders and the turnboys, the kids who collected fares and drummed up business, hung off the side, reaching out as far as they could in a show of urban acrobatics. Each *matatu* had a fanciful name, like a racehorse, painted garishly across its front: "The Hot Needle," "Tarragon the Road Veteran."

Jeff, wobbly on his first trip, tried hard to keep his balance but finally succumbed to the sharp turns and fell into an old woman's shopping basket. For an hour, he followed Dan as they leapt on and off *matatus*, seeing the city roll by in the process. *"Jua Kali,"* Dan said, pointing to a row of what appeared to be open workshops for welding, bicycle repair, and the like. "It means 'hard work.' You can get anything made there."

They finally landed at a busy corner where people were buzzing about, loaded with packages, suitcases, and even small animals in cages. "This is the upcountry *matatu* stand," Dan told him. "Lovingly referred to as 'Machakos Airport.' If you want to go out of the city, this is where you catch a ride. I'll take you up north to Maralal sometime, and the coast of course."

Jeff had arrived in the country but a week ago. His mother, who was single and raising three kids, had gotten a one-year job there and taken a risk by moving the family to the other side of the world, despite never having been out of the U.S. herself. Now, Jeff realized, he'd stumbled onto one incredible guide; Kenya would be much different with Dan at his side.

They sat down on the curb and watched the chaos of the *matatu* stand across the street. An older man gestured to Jeff: "Play?"

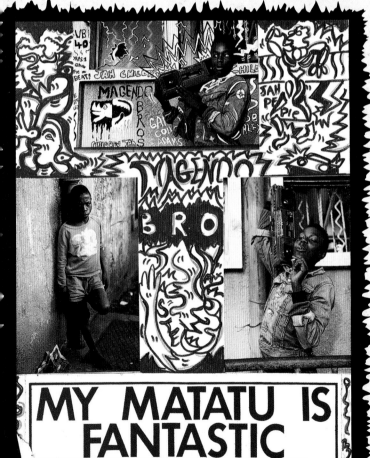

He'd turned over a carton and drew a crude checkerboard on the backside. He handed Jeff a bunch of Coca-Cola bottle caps; the man used Fanta caps. Dan ran into a nearby stand and came out with a handful of oily *chapatis*. He settled down on the curb to watch the game, offering the *chapatis* all around.

"Alright Tex, my man. You can take this guy!" he cheered, his eyebrows raised over the top of his dark glasses. Tex smiled while the old man just laughed. "Crazy *wazungu!*"

55

MY MATATU IS FANTASTIC

karass

I have attended ISK for eight years and believe that it can be a destructive experience. It is destructive to ignorance, racism, and parochialism. A student who comes to the International School of Kenya will encounter an impressive cross section of the people of the world. In my time here, I have been impressed by countless acts of harmony. I have seen sports teams that resemble United Nations meetings. I have heard a Norwegian explain to a Japanese the Masai way of starting a fire. I have felt the excitement as Israelis and Arabs work together to find a settlement for the price of chocolate at the student store.

In his royal blue cap and gown, Dan stood behind the podium to address his graduating class. His friends had elected him to the task, something that could never have been foreseen when he first transferred there as a scrawny eleven year old. If his first school had been old-style British in character, ISK was closer to *Beverly Hills 90210*. Complete with monkey bars, baseball fields, and a college prep curriculum, the school seems to have been dug out of

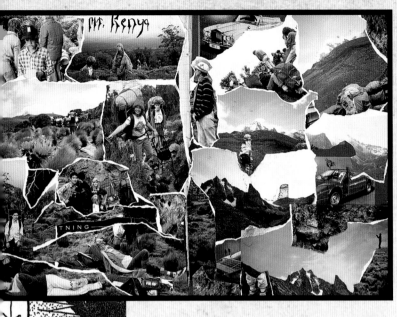

the ground of Middle America, trucked across the globe, and plopped down on forty-nine acres of lush coffee fields north of Nairobi. It is owned by the American and Canadian embassies, and though the majority of its students come from those two countries, as many as forty nationalities are often represented in the student body. As an eight-year veteran, Dan attended the school longer than most students. Many of his friends were the children of embassy employees or aid workers assigned to the country for two-year stints—"two-year wonders" in local parlance.

People ask, "Doesn't it get boring going to the same school for so long?" But because of the huge turnover of students and teachers, it feels almost like you are in a different school every year. And after every year, your friends disperse to every continent and if you have kept in touch, the world practically becomes your school. There are only three or four people here today who were in my sixth-grade class, but there are only 30 or 40 countries where I don't know anyone.

Being a longtime student allowed Dan to get to know the staff and to charm them all. He was one of the only students who stopped to chat not only with the principal but with the groundskeepers, janitors, and cafeteria staff, almost all of whom were native, black Kenyans and who remained essentially invisible to most students. He had started at ISK in 1980 as a relatively small, quiet sixth grader—a nerd even—but by the time he graduated in May 1988 he was one of the most well-known and well-liked students. He moved effortlessly among various cliques and mingled comfortably with the adults at the school. Already, he was an artist, producing a prolific array of photographs, collages, paintings, and prints. But he was known for much more.

He had been an enthusiastic member of the intercultural trips offered by the school, including an arduous climb up Mount Kenya during which he encouraged several other students to the top when the weather turned bad. Another trip, a five-night stay with Masai families in the Loita Hills, prompted Dan's first journal. While many of the participating students would never again visit a Masai *boma*, viewing it as an interesting but fleeting glimpse into another culture, Dan visited Masai friends for the rest of his life.

E V O L U T I O N

Dan Eldon Studio Prints
Po Box 53441 NAIROBI **KENYA**

On campus, he was always selling something. He discovered that he could have almost anything produced for a small sum in Nairobi's Jua Kali area. Beginning in middle school, he had nunchaku—a martial arts weapon of two sticks connected by a chain—manufactured, and sold them to boys at school. Next, he had boxer shorts made out of wild print fabrics. For years, he sold Masai jewelry on behalf of his friend Kipenget. It was common to see him roaming the grounds of the spacious green campus before and after school, talking up his latest enterprise to various students and teachers.

The physical beauty of the country together with the quality of the people make the place irresistibly appealing and so hard to leave. The school has give us the chance to venture north to Turkana with the vast desert and the Samburu tribe. We can travel east to Lamu, with mosques, *dhows*, and the Swahili people. We have gone west to visit the people of Lake Victoria in their homes and schools. We even go up, to the top of Mt. Kenya with rugged mountain guides and a case or two of frostbite. On these trips, it is always interesting to see which aspects of culture rub off on whom. It is just as funny seeing a boy who has lived his whole life in Ohio gulping down a *sulfiria* of blood with the Masai as it is seeing the warrior standing next to him brandishing a spear and an ISK baseball hat.

Beginning junior year, he threw a series of parties that became legendary among expat high school students all over the city. They were named after the tin hut in the Eldons' garden: the *mkebe*. Dan cleaned it out, hauling away the boxes of prosthetic limbs that the previous owners, nuns who ran a clinic, had stored there. Various teenage musicians, most of whom had more enthusiasm than talent, provided live music, and Kathy and Mike patiently chaperoned as many as a hundred dancing, partying international students. Rather than charging at the door, Dan cleverly sold artful invitations to the *mkebe* in advance so that even those who didn't attend could make a contribution. The profits from the first parties went to pay the hospital bills of Atieno, a girl from Kibera who had attended ISK on a scholarship until she had to drop out to have a heart operation. Later party proceeds went toward a clinic.

I have recently read a book by Kurt Vonnegut in which he describes a group of people such as a class, religion, or even a country as being Granfalloons. These are groups of people joined together by a common characteristic or by chance but not necessarily by choice.... When people are together because of friendship or love alone, Vonnegut calls their relationship a Karass. I see many members of my Karass here today: students in the senior class, other friends, and my family. When dealing with people, it is important to know who you care about and who are just members of a Granfalloon.

Having grown up in Africa, Dan knew that "no" often meant "let's talk." He used his persuasiveness to get the best price on whatever wares he was peddling or to ingratiate himself with every possible social clique or political niche at school. Once, when he breezed through a sociology exam with plenty of time to spare, the teacher would not let him leave the room. Dan argued with him that other than a sense of control, the man had no reason to keep him there. "You're wasting my youth!" Dan bellowed playfully, eventually gaining his freedom.

Whether he was cajoling someone in a smattering of Kikuyu or flirting (often the same thing), he loved to negotiate. He managed to redesign the school newspaper, transforming it from an exercise in desktop publishing to a poster-size foldout of graffiti-like drawings. Many classmates felt that only Dan would have been able to get such a radical change past the school's administration.

I am happy that Kiswahili will be offered next year because communication is essential when reaching out from a Granfalloon. I am

disappointed that I am graduating alongside so few Kenyan students because with their insights and knowledge of their home country, they could be as valuable as teachers. I hope that the school will encourage more local enrollment in the near future.

He was bent on introducing friends to the place he knew as home, hitchhiking with them out to Kipenget's, exploring the gorge at Lengai's house, taking *matatus* north to locate the caves where Kenya's legendary Mau Mau revolutionaries had hidden in the 1950s (Dedan Kimathi, a leader of the independence movement, was one of Dan's greatest heroes, and his image appears repeatedly in the journals), or exploring the alleys and rooftops of downtown Nairobi that many whites never see.

Play was at the heart of everything he did, be it school work, making money, or finding a way to spend a potentially dull evening. Outings with his friends turned into excuses to dress up. Whether they were going to someone's house for a party or to Bubbles, an underage club, they decked themselves out as flappers from the twenties or disco queens from the seventies.

Once, Dan invited several people to meet at a restaurant in honor of a friend's birthday. When they got there, Dan and Tex were nowhere to be found. After nearly a half hour of waiting, the group got ready to leave when a priest and a long-haired man in dark glasses sitting nearby began arguing loudly, revealing their true identities: Dan and Tex.

Residents of Africa have many challenges to face: droughts, famine, disease, and bad driving. I have been chased by a buffalo to within one inch of my life but have hardly thought for one minute about the dangers of acid rain or nuclear threats. As many of us return to the West, we can tell of the sanctuary in which we have lived. Many people have never known the feeling of security that we know here. In that sense, Africa can be an example to the West.

While Dan's creativity, his penchant for exploration, and his openness to other cultures were strong seeds planted by his family, Dan always credited ISK with fostering these aspects in himself. It was a secure community in which to explore and evolve in a way he may not have done elsewhere. He flourished: winning awards for service and leadership, exhibiting more works than any other student at the senior art show; and being selected by his classmates to speak at the graduation ceremony, allowing him to pay tribute to the years he'd spent there.

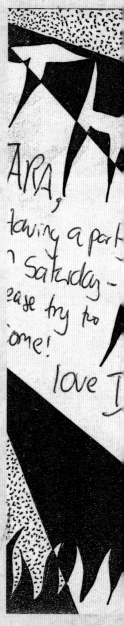

We leave much behind tonight, hard wooden chairs, asking permission to go to the rest room, raising hands before speaking. But I hope that we can bring with us our friends, our Karass. Finally, I ask the parents and teachers here tonight, "Were your high school days some of the best in your life?" as I have heard so many times. If it is so, I hope it will not be the case for us. School days are fun, but I'm looking forward to things getting better and better for us until our last days. Because our fiftieth class reunion is going to be at the *mkebe* and it's going to be wild!

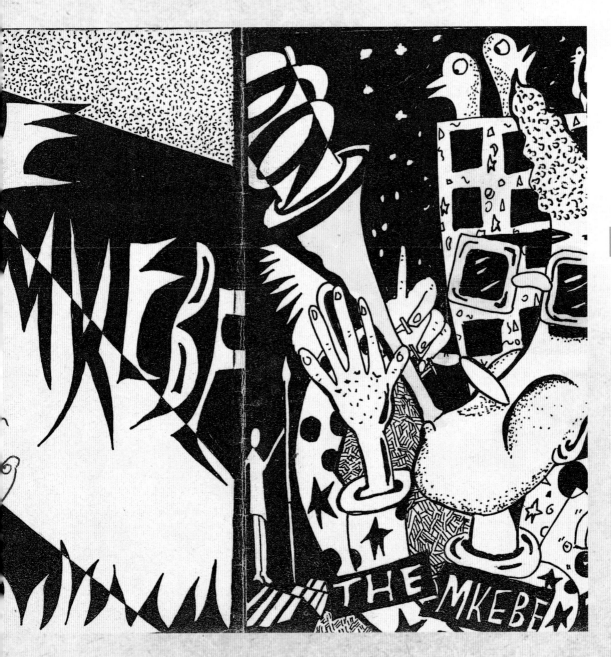

61

White men has doe fer ...

Evil vs. Good

photos taken of Dhow captain left and school boy right in Lamu when I went with Roberta. Late 1988.

Standing on the beach killing the Arab.

Will you spend eternity with **Christ or Satan?**

FOR COLONEL

Student's Name

DANIEL ELDON

I.D. #

INTERNATIONAL SCHOOL OF KENYA
P.O. BOX 14103
NAIROBI

Students Signature

May 1988

Date

good
vs
Evil

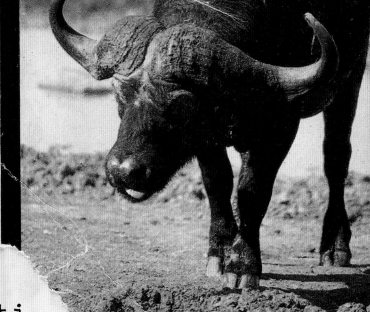

nyati

A recurring figure in Dan's art was the buffalo, *nyati* in Swahili. The African buffalo has similar physical characteristics to both the American buffalo and the bull. It's a massive animal, weighing as much as fifteen hundred pounds. African buffaloes are herbivores and tend to ignore people if left alone, but with their sharp horns and surprising speed, they are considered by many hunters the most dangerous of the so-called Big Five, which also includes the elephant, leopard, lion, and rhino.

Dan made many renditions of "good and evil" in his journal pages, with the buffalo being the most obvious and ongoing symbol of darkness. Other subjects moved ominously between the two polarities. A little girl labeled "good" in one collage might be labeled "ugly" in another. More tellingly, he sometimes drew two arrows to the same person, one for "good" and one for "evil." What captivated Dan most about binary opposites was that they could be embodied in the same person or place, including those he loved most—and himself. One photo he labeled in this manner is of a boy, the right side of his body in a dark shade, the left bathed in intense sunlight.

Just after his graduation, Dan's parents separated. The unexpected disruption forced Dan to reassess many key relationships. If what he believed he knew best—his family, his mother—could suddenly turn, how could he trust others? After her departure, his already highly developed code of ethics became more absolute. He valued sincerity above all else and bore Holden Caulfield-like contempt for those who were fakes, that is, untrue to themselves or others.

During that last year of high school, as his family life frayed, he took a weekend trip to the north with a group of friends, including his first serious girlfriend. She was American and had come to Kenya recently, sent to live with her grandmother after misbehaving back home. Dan, as always, relished the chance to show a newcomer around. He also took solace in her gentle spirit. That night, with the sky a bowl of stars above, they spread out a blanket on a rocky outcrop of desert and made love—Dan's first time.

The day would remain memorable for more reasons than its finale, however. They were at a friend's ranch, a place Dan loved for its remote, stark vistas and its solitude. Earlier, while others lounged by the swimming pool in the afternoon sun, Dan went exploring with the family's small dog, Obelix. The two strolled over the burnt earth, Dan in his flip-flops, Obelix with a customary rock in his mouth. They didn't see the buffaloes until the massive animals

had already gotten wind of them, first smelling the dog that had roamed into their territory. The animals' nostrils flared and their eyes widened. Almost immediately, they gave chase. Dan tore through the bush in retreat, the dog keeping pace next to him, as the dry thorns and twigs of the brush scraped his feet and legs. In the race, he lost one of his sandals. *Pata potea* is what the Kenyans call the ubiquitous, cheap plastic shoes; Dan stole the name to title an account he wrote about the encounter.

The chase had been oddly thrilling, reminiscent of Winston Churchill's remark that "nothing in life is so exhilarating as to be shot at without result." How could life and death be so closely bound, Dan wondered. He could easily have been killed by the giant animals; instead, his senses had been electrified.

From that time on, his journals were filled with buffaloes: pen-and-ink buffaloes, elaborate watercolor and pastel renderings, cartoons, and photos. He looked for the buffalo's power and menace in himself and others. The animal became not only a sign of death but a reminder of how he hoped to lead his life: head-on in a wild chase.

☺ ☺ ☺

PATA POTEA

In Africa this rhythm is more common than any drum beat ever was. Translated from Swahili, "pata potea" means "find one, lose one" and is the word given to flip-flops because of the noise they make.

PATA POTEA. PATA POTEA.

Flip-flops vanish just as frequently as socks that are traditionally "eaten" by the washing machine in Western culture. I have lost many pairs of flip-flops, maybe two pair for each of my ten years in Kenya. WHERE DO THEY GO? For the most part, people take them. Sometimes borrowed and never returned but usually stolen. When at the coast, many are abducted and make their way to India by high tide.

PATA POTEA. PATA POTEA.

I am walking through heavy bush at a ranch in northern Kenya. I tried to make the dog stay at home with the others. I failed. He

waddles along next to me with a stone gripped in his mouth. He always does this. That's why this call him Obelix, after a cartoon character. He is the father of puppies, who he trains to horde rocks too. I look up from Obelisk and see two buffalo. I hate buffalo. Even walking past the stuffed buffalo in the museum makes me cringe. I am glad I saw those old bulls first. They devour bushes thirty feet away.

Noiselessly, I back off. Obelix does not. He prances after them, waving his tail like bait and barking. They ignore him and look for me. After years of being hunted, they know that where there is a dog, there is man. And where there is man, there is a gun. Like a crane lifting a demolition ball, they raise their massive heads and peer around. They inhale the bouquet of the bush, like a connoisseur checking for impurities.

PATA POTEA. PATA POTEA. PATA POTEA.

They pound after me. Their hooves hammer into climax. I have lost a flip-flop. It sounds like this: "Pata, pata, pata." I eject the other as it only hinders me. Now the sound of crunching as my bare feet absorb thorns like a Hoover. I veer up the incline of the hill, thrash straight through a wait-a-bit bush. Its fish-hook thorns shred my shirt and decorate my skin with intricate patterns of scratches and of blood. I risk turning. The bulls are nowhere in sight. Obelisk has appeared beside me. I pry the stone from his mouth and plunk him on the head with it.

I am still in danger and my body knows it. I feel sight, sound, and smell like a lifelong veil has been lifted from my senses. Because of this, I feel great.

PATA POTEA.

My heart beats, enriched with adrenaline. Every tree is a possible escape ladder. In every wind change, a fear of betrayal. My destination lies at the end of this labyrinth of bush, guarded by now-invisible Minotaurs. Obelix senses my feelings and grabs a stone. I boot him in the head.

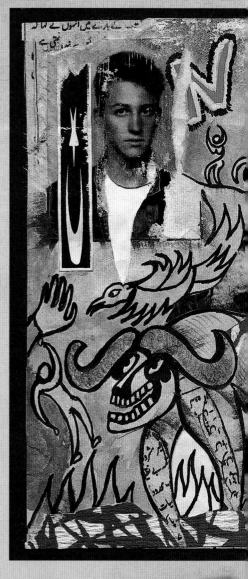

Together we approach the house, and I begin to feel pain in my feet and corrugated back. The last ten yards are a tightrope of barbed wire. I hobble into the kitchen and the Samburu cooks stare at me. "Buffalo," I laugh, lurching for the sink. As I wash my feet, one of them asks, "Where are your shoes?" I tell them I lost them out there. My feet are clean and I look around. One cook is already gone. Later that night I hear him walking to his hut. PATA POTEA. PATA POTEA.

By Dan Eldon

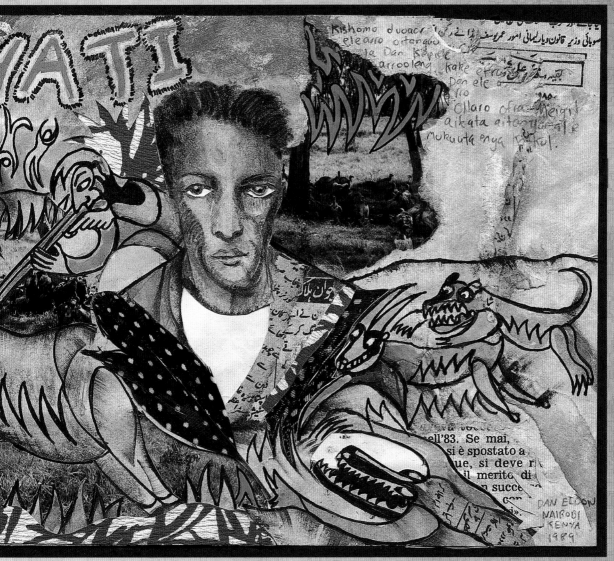

Nyati

searching for open sky
in an urban jungle

All my past had been but a prelude to the five years that lay ahead of me.
—Wilfred Thesiger (passage underlined by Dan in his copy of *Arabian Sands*, 1985)

"Nobody should be able to tell you when you can walk," Dan complained of the pedestrian traffic lights in New York. Africa had instilled in him a need to live his life like an off-road vehicle: rules were meant to be questioned, paths to diverge. He'd gone to New York precisely because it was a diversion from the well-traveled path of many recent high school graduates. Instead of heading straight to college, as most of his ISK classmates were doing, he decided partway through his senior year to do something different.

When he told his guidance counselor of the several roads he was considering, the man asked if Dan was planning to take a year off. "No," Dan corrected him, "I prefer to think of it as a year on."

The Year On had several sources. There was his desire for adventure, to see more of Africa and to spend time with the Masai and other peoples who lived in traditional pastoral ways, not consumed by urban, Westernized life. He also had an opportunity to get some valuable practical experience as an intern at a major magazine in New York. Added to the mix was his abysmal SAT math score, a result of his dyslexia, which decreased his chances of getting into a top American college.

Looming in the background, casting a definite shadow over Dan's plans, was his parents' separation. Throughout his senior year, the marriage had been dissolving, coming apart in a way he hadn't foreseen. Unbeknownst to any of them, his mother was deeply unhappy and, in trying to understand why, had begun to feel that she should leave both their home and Kenya. After months of trying to sort things for herself and explain her thoughts to her bewildered and hurt husband, she shared the news with her children. Dan was incredulous and resolute: she couldn't leave; life wouldn't be the same without her.

Some time after that, as Kathy teetered on making a final decision, Dan sat with her and asked her to draw what she was feeling. He'd been angry and distant since she broke the news, but now he made an effort to understand her by reversing their roles from childhood, when she had invited him to use art to express what he couldn't say. As she drew, she talked about a trip she'd made recently to Greece for a magazine assignment. She'd visited the ancient city of Delphi, she told him, as her hands stayed busy with a pastel crayon and Dan hunkered over a journal page, carefully smudging lines of ink. "It's amazing—all crumbled away, and yet you can still imagine how it must have been. There was an inscription on the temple wall: Know thyself." She stopped to look at him; he was listening and seemed to follow where she was headed with the story. "That's what I'm trying to do, Dan, to know myself. 'To thine own self be true.'" He studied his mother, seeing not only the parent who was disrupting his secure world but the very confused, sad woman. He told her that he understood; he wasn't happy about it, but he saw that what she was doing took real courage, and he'd do what he could to be supportive.

Despite that moment of understanding, Dan was often moody, his anger escalating more quickly than it had in the past. He took refuge in his darkroom—where he spent hours—and his most recent journal. After the ISK graduation in May, Kathy made a final decision and left Nairobi for good, resettling in London. Mike, Amy, and Dan—finding release in being away from the house, the place of such recent tumult—took an already planned vacation through eastern Europe without her. They visited some of the many Eldon cousins who had scattered across Europe after the Holocaust, bartered for Persian carpets, and tried to regroup. On the trip home, the suitcase carrying Dan's journal, the one in which he'd expressed the hurt and surprise of the year's events, was lost or stolen en route from Turkey, never to be found.

If his parents' marriage was not the incontrovertible fact Dan had thought it was, then what else should he question? What else might not be as solid as it appeared? Nothing, including college, felt like an obvious choice any longer. Rather than do the rote thing, he needed to establish new rules that made sense to him, to prove to himself that he could get through difficult situations alone. He also needed time and space to sort out his very raw emotions. But New York, he would soon learn, is not the place to find time and space.

Dan had been excited by the city's energy when he'd visited New York and toured the offices of several Condé Nast publications (a visit arranged by one of the Eldons' long-term house guests); he especially liked the talented art staff at *Mademoiselle* magazine. They, in turn, were blown away by his journals, paying homage to his craft by making impromptu T-shirts from his designs and telling him that he would be welcome on their staff anytime.

When he left Nairobi in late summer of 1988, his destination sounded hip and unlike anything most of his friends were doing. He had a job and an apartment, a small one-bedroom near the magazine's offices in midtown Manhattan, sublet from an out-of-town staffer. The Year On was under way.

He arrived in the office, a gangly kid with a funny accent and hardly any possessions but the tin box of art supplies that he carried everywhere. In short order, he charmed the all-female art staff with his combination of naiveté and worldliness. Each wanted to mother him or escape with him to Africa on a romantic interlude.

Dan soon had the run of the department, with its central workspace and big windows looking down on Madison Avenue, forty-four stories below. Everyone worked together, without cubicles or computers throwing up barriers, and Dan wandered from one staffer to the next, learning about her work and the process of creating a magazine. His journals from that era began to take on a more design-savvy layout, showing that he was intent on soaking up everything he saw.

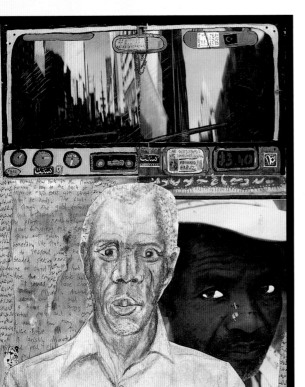

He was responsible for errands, making copies, and other minor tasks, allowing him plenty of time to take advantage of the main perks of the job: access to art supplies and a brand-new color Xerox machine. He made hundreds of copies of his work, some of which he shared with fellow workers, who continued to produce T-shirts from his designs. (By the time he left, even the editor-in-chief had one.) He also pocketed scraps that were headed to the trash: old Pantone swatch books, paper samples, and translucent sheets of brightly colored plastic, all of which showed up in journal pages for years to come.

As a kid at summer camp near his grandparents' house in Iowa, he had transfixed fellow campers with tales of Africa. He did the same with his new adult friends. To many of them, whose lives revolved around the eastern seaboard of the United States, his tales of Kipenget and hitchhiking sounded like something from another era, even another planet.

A few times, they also got glimpses of how he spent his time outside the office. For lunch one day, Dan suggested they all go to his favorite sidewalk burrito stand. More accustomed to restaurants, the group followed cautiously, looking on as he fell into a quick and familiar repartee with the cart's owner. In broken English, the man warmly teased Dan, clearly enjoying the interaction, and then made him "the usual" with hot sauce and extra sour cream. Along with an Indian cabby and several homeless people, he was one of

Dan's "friends," people with whom he'd regularly stop to chat. Weekends and nights Dan spent on the street, watching people and wondering at the odd culture into which he'd fallen. Although he took a different route to work every day, trying to see something new in the neighborhood, Midtown bored him. He would hop on a subway down to Brooklyn or to Chinatown. As always, he sought out less-affluent neighborhoods, sometimes trekking through Harlem or Alphabet City. On one late-night expedition, a man with a knife approached him outside Penn Station, demanding his wallet. Dan dropped his metal art box, spewing its contents and making a crash that distracted the thief, then reached into his pocket for a twenty-dollar bill. The man took it and fled, leaving a relieved Dan still in possession of his camera and wallet.

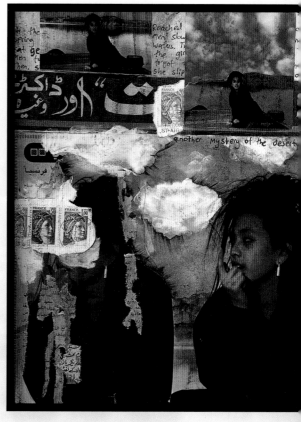

More omnipresent than physical danger was the emotional malaise he experienced, a reminder of the sadness he'd felt as a kid at Hillcrest. Truly alone for the first time, he was overwhelmed by the city. He took photographs out the window of his apartment, catching small pieces of blue sky in his lens among the myriad skyscrapers. In one image, his feet are at the bottom of the frame, poised ominously on the windowsill. "New York on fifty brain cells a day," he wrote in his journal, and "Blow yourself up." He felt claustrophobic, as if both his physical surroundings and his emotions were about to implode. When he called and wrote to friends, they worried about him; he sounded out of it, not himself.

His loneliness was broken by periodic visits from his cousin Amy Wellso, who lived in Washington, D.C., and his high school friend Laurie Diaz, who was at college in Virginia. On one trip, Amy propped herself on the bathroom sink, leaning as far out the window as possible to take photos of Dan launching paper airplanes from another window. They went to a street fair where Dan was taken with beautiful girls in skimpy Brazilian outfits. He lit up the most when he saw an African man selling jewelry. When he spoke

Swahili with the man, his entire body relaxed and expanded, as though this small interaction with Africa allowed him to be his true self.

He got a much-needed respite from the city when Laurie took him to a lake for a weekend—an opportunity to gaze at the open sky he desperately missed. Back in the city, the two old friends played a game of trust, each one taking turns closing his or her eyes, while the other led the way through the subway and in and out of alleys. These brief interludes brought Dan warm relief.

There in the tiny Manhattan apartment, his African masks and artwork hung for company, he thought of his family: Amy and his dad back in their house; his mum alone in London; himself, here in this enormous city. They were scattered for the first time, and it was still completely unclear where each of them might be a year later. Their infrequent conversations were short, wisps of voices seeping across crackling phone lines. Each tried to be brave for the others, no one wanting to expose their wounds. It unnerved him. It broke his heart.

Dan could have stayed in New York longer—his co-workers clearly would have welcomed him back after Christmas—but he was eager to go home. Although he wasn't prepared to abandon the Year On concept, he realized that he'd gone too far too quickly. He longed to be back on familiar ground, a plate of starfruit for breakfast, a midday interlude of a quick thunderstorm, evenings spent with old friends. He longed to walk under the open African sky without a traffic light in sight.

sunrise

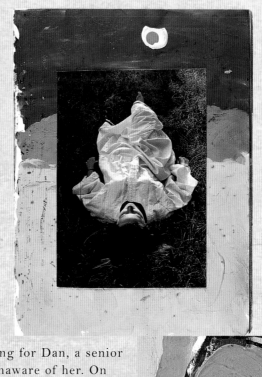

Marte Ramborg had spent two years in Kenya during high school. It was the first time she'd lived outside Norway, although her father's work with an aid organization had taken the family far from home before. At ISK, she spent much of her sophomore year pining for Dan, a senior who seemed relatively unaware of her. On those occasions when they spoke, he made her feel like the center of his attention. She saw, however, that Dan could make anyone feel this way—girls, boys, teachers; it was like turning on the high beams of a car.

When her family moved back to Norway, she missed Nairobi immediately. After only a few months, she decided, against her parents' wishes, to go back for a Christmastime visit. Maybe it was the light she missed, or the warmth, or just her friends. Gossip had catapulted from Kenya to Norway that Dan was back from New York, and she wondered if she might see him.

After two weeks of immersing herself in the city, seeing her school friends and soaking up the golden sun, she was due to go home. She hadn't seen Dan but figured it was for the best—she was over him. Then, on her last night, he came into a club where she was meeting friends. His wavy hair was rumpled and he gave her that crooked smile that always made her melt. Looking gen-uinely pleased to see her, he suggested that they go on a safari together. "That would be wonderful, but I leave tomorrow," she replied, pleased that he'd asked but bitterly disappointed.

"Then we'll go now," Dan said, making it seem like the obvious answer. Since the entire trip had been one of spontaneity, she decided why not do this last, crazy thing.

The hum of the African night was all around them; Marte could make out the glimmer of yellow eyes. They drove up to the Ngong Hills, the four undulating hills that are visible from all over Nairobi. Climbing the steep and curvy roads, they stopped in the thin light of dawn to pick up a young Masai with a red plaid blanket over his shoulder and a spear in his hand. He was headed for his home village. At the top of a hill, Dan parked the car, and the three clambered onto the roof to watch the sunrise, wrapping the Masai's blanket with its smoky smells around them for warmth. The equator runs through Kenya and there, on that cartographer's line, the sun always rises around 6:40 in the morning. Just at the ordained time, the immense expanse of the Great Rift Valley—miles and miles of flat, chartreuse plains dotted with *shambas* and herding animals, the place where life on Earth first percolated—came into focus and was spread before them, a carpet being rolled out for another day.

They drove to the Masai village and went into their new friend's hut, where nine children were still sound asleep, draped in cattle hides. Chickens scratched and chortled as the village came to life. Dan gave the *moran*'s mother some money for sugar, as was his custom, and then he and Marte got back in the Fiat to retrace their route. When they again reached the top of the Ngongs, a cloud, huge and diaphanous, rested on the crest of a hill. More clouds cascaded down the slopes into the valley, looking like a waterfall or the lava of a quietly erupting volcano. They got out to walk through the misty billows, watching the sun's rays play with the vapor and create rainbows.

"I'm really happy I didn't bring my camera," Dan said, his eyes creased by a wide smile. "Sometimes the camera can be a distraction and I want to remember this." He folded Marte into a bear hug as they stood watching the continuing spectacle. Two hours later, after eating freshly sliced mangoes on the Eldons' veranda and packing her bags, Marte was on the airplane. Despite the lack of sleep, she didn't feel the least tired; her mind was still flying over the plains of Kenya.

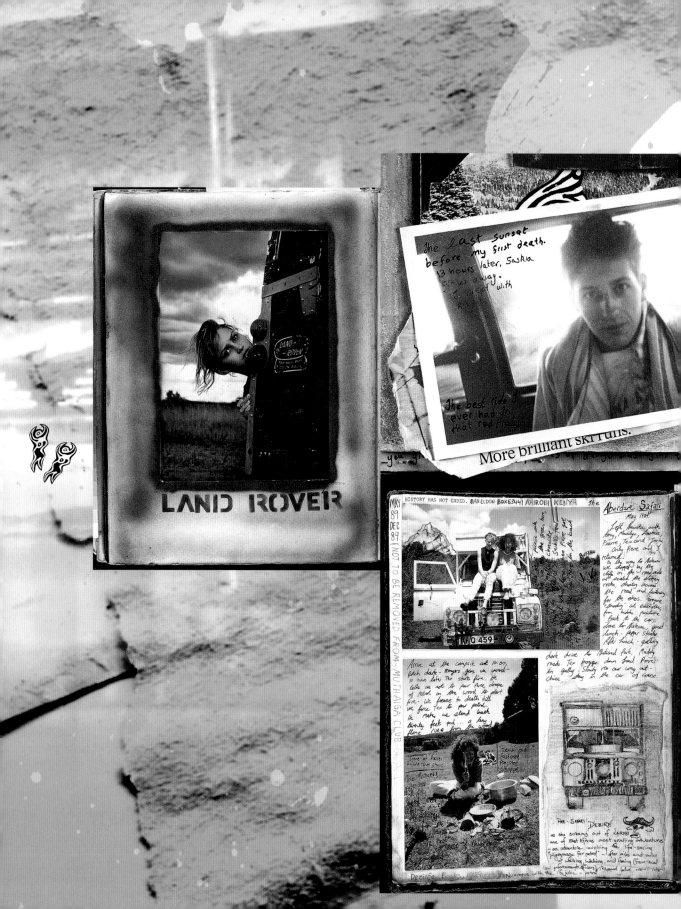

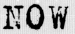

NOW

Arriving back in Nairobi from New York, Dan immediately wrote to Laurie:

I'm back home! I'm sitting in my room in our new house. I have a big desk overlooking the garden. The room is very bright. Last night I slept on the veranda and woke up at 7:00 A.M. because the sun was so hot. It feels really good to be back. I've seen Tex, Lengai, and lots of other friends. Lengai and I went climbing at the gorge and made videos and went driving around the bush and got our legs scratched up from running in the thorns...

While he'd been in New York, his father had moved to a new house, and Peter Lekarian, a Masai the same age as Dan, had moved in with them. They were already close with Peter. Their friend Mary Anne had sponsored him for high school. Now that she had moved to London, Mike took Peter in as a foster son, and Peter, Dan, and Amy quickly came to consider each other siblings.

Kathy's absence, although seldom discussed, was strongly felt. It was a sad gap, but was preferable to the tension that had lurked around every conversation, every meal, prior to her departure. Dan was relieved to be in a place so familiar, so beautiful, away from New York's anonymous crowds. Here, he could make his dad laugh by running through their age-old jokes. Although he grumbled about it in older-brother fashion, he liked ferrying Amy from school to play rehearsals and parties with friends, hearing how her life mimicked the one he'd recently left behind at ISK.

Sorting out his feelings for his mum was more difficult. After his final day at *Mademoiselle*, she had met him and they'd traveled to Iowa together for the holidays. Her hooded eyes, so often squinched into a cheerful grin, were rung with circles that belied her exhaustion. She appeared to listen to conversations, but he could tell that she was actually distant, her thoughts floating far away. Yet he was unsure what to do about it as his feelings for her were a tangle of concern and anger.

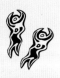

Once Dan was back home (at the new house, without his mum, "home" had become amorphous for him), he needed to reincorporate her into his daily routine and gamely wrote her a letter, describing a typical day.

I woke up outside, rising to the sound of the invisible mosque. I look over the railing and see the *askari* turn in his baseball bat and coat after defending us for another night. Soon Join emerges, wearing his turban, new gum boots, and new uniform. He strides over to bwana's car and vigorously scrubs invisible dirt off the roof. Murdoch, Simba, and the gang trot around the *shamba*, exploring the new day. Deli is so dumb that it takes him the whole morning to relearn his way around the compound, his memory of yesterday blurred in a hangover from the night's rubbish eating activities.

After I eat, I exchange my *kikoi* for a pair of shorts and step outside to see Deziree. I spend the next few hours cleaning, sorting, fixing this great machine, learning a lot, paying a lot, improving a lot. When I'm finished, she's going to be a stomping car.

...In general, life is good. In specific, it is excellent. I go everywhere with music and take pictures, talk and joke with people, learn auto mechanics, watch the sun go down, have fun with friends, make plans, help Tex with his new bird—a falcon, drive Amy around, plan trips, eat good food, do exercise, get up early, go to Toona Tree and Bubbles. Yes, life is bloody good!

Dan made some money through assignments for airline and tourism magazines that Kathy couldn't complete since she was out of the country. He conducted interviews for her and shot photographs, some of which were featured on covers. The bulk of his time was spent with his two loves: Deziree, the Land Rover he'd just bought, and Saskia Geissler, the Australian girl he'd met through friends who were still at ISK.

He had wanted a Land Rover for years; it was a prerequisite of the Year On philosophy. What a Chevy pick-up is to a midwestern gravel road on a summer night or a sports car is to California's coast-hugging Highway 1, a Land Rover is to Africa. Unleashing his persuasive powers, he convinced his maternal grandfather, who had offered to pay for his college education, that such a vehicle was indeed an educational investment. It offered the key to travel and adventure, to learning on the road rather than by the book. Although neither his grandfather nor his mother were entirely sold on his educational philosophy, they eventually allowed themselves to be swayed by his enthusiasm.

As soon as Dan handed over the money to the seller, a New Zealander who was regretfully hanging up his knapsack and returning to a more civilized life, everything else fell away from his line of vision. There in front of him was his dream materialized: a cream-colored, seventeen-year-old Land Rover, complete with two beds, a camper top, a gas grill and small refrigerator, and jerry cans. He named her Deziree after a wild Italian girl he used to see around Nairobi. Soon, the vehicle was yet another surface for his collected ephemera. A cow's skull was mounted just above the front window. The eye of the *dhow*, a Muslim symbol for good luck, was stuck to the storage box on the roof. After the gearshift broke, Dan replaced it with a cow's shin bone. Mexican playing cards, fortunes, newspaper clippings, and postcards were glued around the inside ceiling.

The steering wheel was repainted whenever the words peeled off. For a long time, it read "Fight the Power."

Right away, Dan wanted to go on a safari. That it was a Wednesday and many of his friends were in school didn't hamper his plans. They would leave from the Eldons' house in the afternoon, camp near ISK overnight, and then drop people off at the school's gate in the morning. "Go in the kitchen and grab whatever looks good," he told Amy, as he rounded up sleeping bags and other gear. She rummaged through drawers, ignoring William's attempts to shoo her away from certain boxes and cans. "Brilliant!" Dan pronounced, after inspecting the bag she'd filled with spaghetti and canned sauce, pancake mix, syrup, and some sodas.

They picked up Tex and cruised out of town, enjoying the final few hours of sunlight by taking a few hills and messing around with Deziree. As the stars popped out, Dan pulled into a gas station where the nearby *askaris* were meeting around a bonfire. They ate spaghetti and stayed up late talking, all of them charged with ideas for future trips. "Let's go to Malindi!" said Amy, eager to go to the coast without any adults. Tex suggested Naivasha. Dan was thinking bigger: "Zimbabwe. Egypt. The Sahara."

In the morning, Amy brushed her teeth in the gas station parking lot, spitting the foam out just before her regular school bus rumbled past. A few kids spotted her and waved, no doubt curious about what she was doing on the side of the road at that hour. They broke camp and started off toward ISK, only to have Deziree stop cold after a few yards—the first of many deaths. After pounding on the steering wheel and issuing a long whistle of a curse, "Shhhiiit," Dan calmed himself, ready to spend the day dealing with repairs. It was a routine to which he'd soon grow accustomed. Amy, who caught a ride with her math teacher, was also learning that traveling with Deziree meant being able to improvise.

Mainly, he learned how to patch her together long enough to limp to a mechanic or, if he was around, to Lengai's. "You can always find someone to fix your car in Africa," Dan was fond of saying. "Besides, while they're fiddling, you can be off doing something fun!" This philosophy extended to his safari mission statement: "The most important part of vehicle maintenance is clean windows, so if you are broken down you will enjoy the beauty of the view."

It takes strength and skill to navigate a Land Rover on bumpy, steep roads. While descending an escarpment on a solo trip to Naivasha one day, he lost control of Deziree, smashed into an acacia tree, and came to an unglamorous halt in a ditch. He got a tow to the local police station where he spent the night and assessed the damage: he needed a new radiator. After-hours, he began chatting with the policeman on duty. As the two sat outside in the warmth of the night, sharing a beer, Dan gestured to a truck parked under a tree. One tire was deflated, and a trail of moss had grown over the hood. "I see that truck must be essential to the protection of the greater Naivasha region," he said, with only his raised eyebrow belying a terribly serious tone. The cop chuckled and, at Dan's continued prompting, admitted the department had recently acquired a newer truck. It was all the opening Dan needed: "But I bet the radiator is still good?" It didn't take long before a deal was made, and the old radiator removed and fitted into Deziree. In the morning, Dan was off, with only a dent to mend when he returned home.

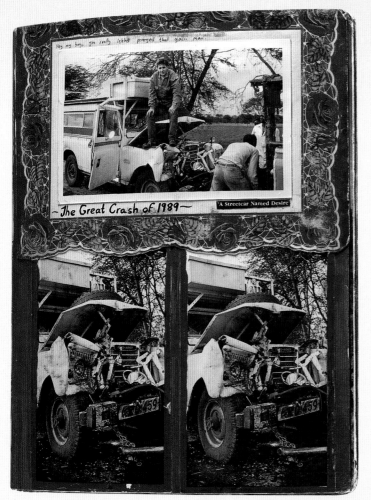

- The Great Crash of 1989 -

'A Streetcar Named Desire'

Dan's other love that spring was healthier than Dez but just as impetuous. Amy called Saskia Dan's "wild child." A bubbly, peroxide blond, she was giddy with life, full of mischief and a sense of freedom, without any desire to tie Dan down. Rather, she wanted to do as much as she could with him in the short time before returning to Brisbane. They made a pact to live NOW. It was their mantra, a constant reminder that the present moment was all that counted.

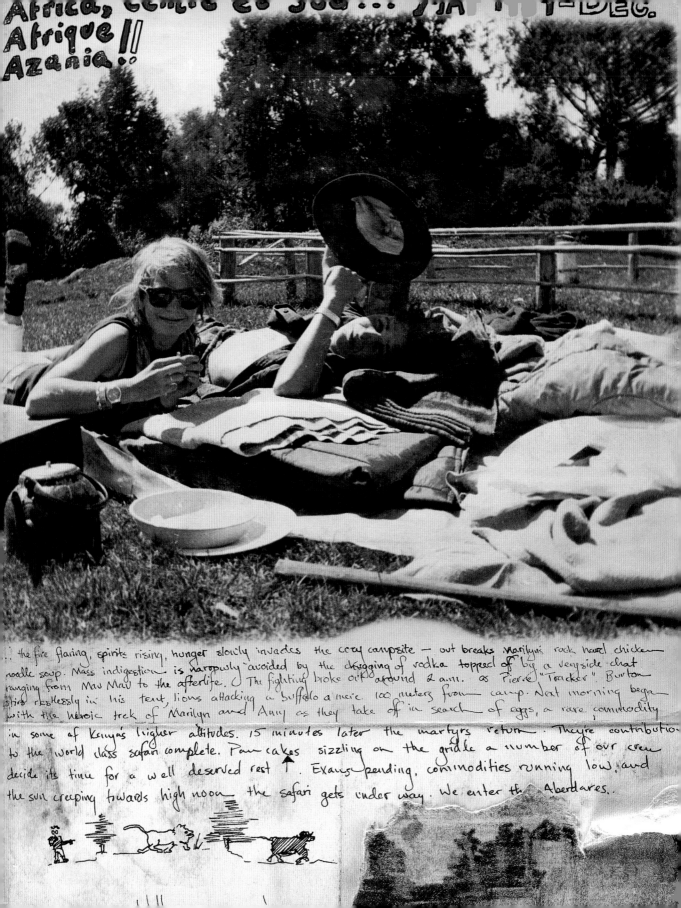

!! the fire flaring, spirits rising, hunger slowly invades the cozy campsite — out breaks Marilyn's rock hard chicken noodle soup. Mass indigestion is narrowly avoided by the chugging of vodka topped off by a wayside chat ranging from Mau Mau to the afterlife. The fighting broke out around 2 a.m. as Pierre "Tracker" Burton stirs restlessly in his tent, lions attacking a buffalo a mere 100 meters from camp. Next morning began with the heroic trek of Marilyn and Amy as they take off in search of eggs, a rare commodity in some of Kenya's higher altitudes. 15 minutes later the martyrs return. They're contribution to the world class safari complete. Pancakes sizzling on the gridle a number of our crew decide its time for a well deserved rest ↑. Exams pending, commodities running low, and the sun creeping towards high noon the safari gets under way. We enter the Aberdares.

Along with high school friends Tex and Claire Johnson, and sometimes Amy and Marilyn, they took to the road on daylong picnics and overnight trips. It didn't matter whether they had a destination in mind; more often, the pleasure was simply in going.

On Saskia's last weekend, the group enjoyed a sunny, riotous time on the coast. Not wanting to face the reality of their imminent separation, Dan and Saskia waited to return to Nairobi until the last minute. Running into Saskia's bedroom at the Johnson house (her own family had already moved back to Australia), they shoved clothes in duffel bags and clumsily rolled up the oil canvases she'd recently painted. Desperate with emotion, they made a dash to the airport and said their final good-byes.

"The last sunset before my first death," Dan wrote on a photograph he took that day. "Thirteen hours later, Saskia flew away. I slept with rage." Memories of Saskia would haunt him for months: "She made me feel good and she made me feel dead. I've never felt so much." His heart was beginning to crack, stretch, and press against its cage, flopping outside its previous boundaries.

departure

Dan negotiated the morning commuter traffic on Nairobi's Uruhu Highway, while Lengai fiddled with a stack of maps and cassette tapes, arranging them for the long trip ahead. Pursing his lips, Lengai adopted a high-pitched, mocking voice: "Boys, boys—how on earth do you expect to make it halfway across Africa if you have a flat tire on the way to lunch?" Dan and Patrick repeated the question with the same shrill inflection as they burst into laughter. With one hand extended out the window grabbing at the already hot air and the other on the steering wheel, Dan shouted to the quickly departing urban landscape: "Live and die on safari!"

Just two weeks earlier, Dan and Lengai had been on their way to meet Lengai's father and stepmother when Deziree had a flat tire. The purpose of the meeting was to gain support for the trip, but the flat had only increased their parents' skepticism. Thus far, the two friends had Dan's father, Mike, behind them, but other adults in their lives were wary of a nearly month-long trip through at least three countries in a rickety Land Rover. War, malaria, and banditry had all been cited as potential setbacks. Undeterred, Dan and Lengai invited Patrick Falconer, a friend from ISK, to join them, presenting him as their chief medic. Despite the fact that Patrick had yet to enter medical school, his addition had a calming effect on parental nerves.

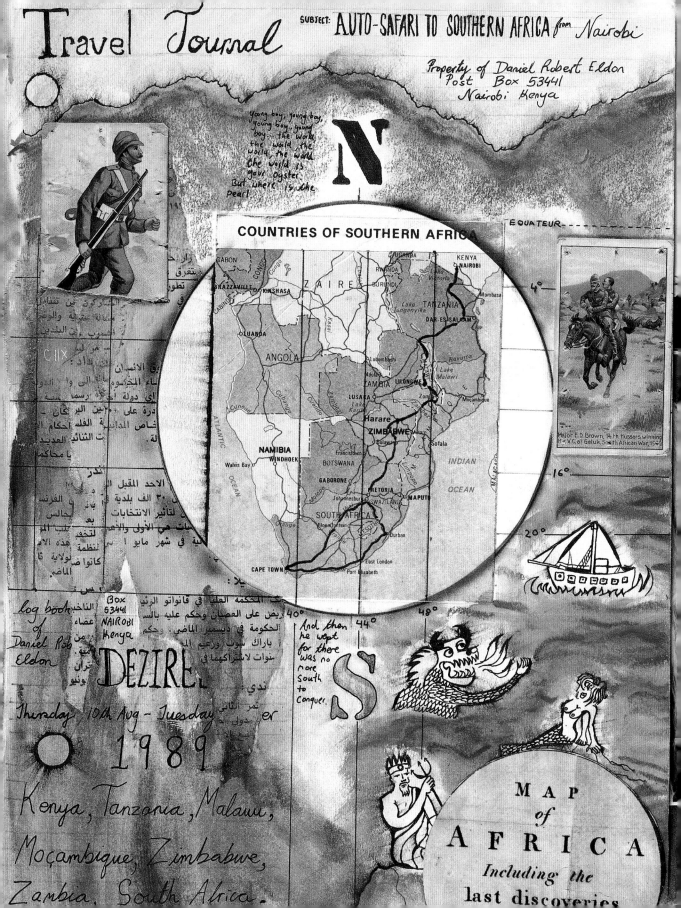

Travel Journal

SUBJECT: AUTO-SAFARI TO SOUTHERN AFRICA from Nairobi

Property of Daniel Robert Eldon
Post Box 5341
Nairobi Kenya

young boy, young boy,
young boy, young
boy — the World
the World the World
the World is
your Oyster
But where is the
Pearl.

COUNTRIES OF SOUTHERN AFRICA

Major E.D. Brown, 14th Hussars winning
his V.C. at Geluk, South African War, 19

EQUATEUR

And then
he wept
for there
was no
more
South
to
Conquer.

log book
of
Daniel Rob
Eldon

Box
5341
NAIROBI
Kenya

DEZIRE

Thursday 10th Aug - Tuesday

O 1989

Kenya, Tanzania, Malawi,

Moçambique, Zimbabwe,

Zambia, South Africa.

MAP
of
AFRICA
Including the
last discoveries

Convincing Lengai's dad was a very complicated negotiation, but eventually he saw the light and even gave us a bottle of whisky. At this time, we also contacted Patrick Falconer, an old school mate of mine; he would be the so-called third man. Patrick is a qualified medic and immediately set to work on compiling a first aid kit.

Lengai and I plodded through the endless paperwork and bureaucracy involved in such an adventure—government permits and such like. We also fixed, packed, tested, varnished, washed, buggered up, and repaired all of our equipment. This whole vital process was constantly hindered by the showing up of Jessica and Claire, who always wanted us to go to discos or play dolls or something. We retaliated by talking about the most boring details of the internal combustion engine.

The idea of a grand safari had begun to percolate in Dan's mind soon after he'd bought Deziree. Following the cooped-up isolation of New York, he wanted to demonstrate that he could make it on his own and gain an education in the process. In June, he had approached Lengai with the idea, unfurling a large map of Africa. They had studied possible routes with two goals in mind: to go as far south as Deziree would take them and to visit Lake Malawi, where they'd heard there was awesome jet skiing. Lengai had time for a trip in late August, although he'd have to fly back to England as soon as he found out where he was accepted for college in the fall. (Patrick, it turned out, would have to leave early for school as well). They thought they could make it as far as Victoria Falls on the Zambia-Zimbabwe border. From there, Dan would go solo, to where he wasn't yet sure.

Barely outside of Nairobi, they stopped for their first hitchhiker, an overly eager American wearing a backward baseball cap.

№ 253569 Form RT.02

THE UNITED REPUBLIC OF TANZANIA
THE TREASURY

ROAD TOLL TICKET

Received the sum of Shs. 50/- or US$ 3 being road toll in respect of pick-up/passenger vehicle No. KRQ

A № 253423 Form RT.02

THE UNITED REPUBLIC OF TANZANIA
THE TREASURY

ROAD TOLL TICKET

Received the sum of Shs. 50/- or US$ 3 being road toll in respect of pick-up/passenger vehicle No. KRQ 459
Carrying capacity 1.5 passengers/tonnes

Date 15/8/89
Station Katmandu Toll Collector

A

THE UNITED REPUBLIC OF TANZANIA
THE TREASURY

ROAD TOLL TICKET

Received the sum of the Shs. 150/- or US$ 3 road toll in respect of pick-up/passenger vehicle No. KAQ 459
Carrying capacity passengers/tonnes

Date 13/8/89
Station Toll
Form RT.

ANIA UNITED REPUBLIC OF TANZANIA
THE TREASURY

ROAD TOLL TICKET

US$ 3 the sum of the Shs. 150/- or US$ 3
nger ll in respect of pick up/passenger
No. KRQ 459
59 capacity passengers/tonnes
tonnes

1/8/85
Sego Toll Collector

He explained that he was headed to Mtitto Andei, where he hoped to trade his camera for some carvings. "Bloody bastard," Dan laughed, once they'd let the man off. He was the first in a long series of odd passengers who included a pair of British phys ed teachers, an Australian in dreadlocks who claimed to be a lawyer despite his questionable hygiene, and two elderly ladies who seemed to be producing an odd odor until Lengai traced the scent directly to Deziree's ice box.

Along the way, we stop and slice open a cushion to use as a safe. We hide money inside the foam, then zip up the pillow case. We arrive at the border post. We are all nervous because it's the first one we will do.

Lengai has to surrender his four-color changeable pen to the customs officer. On the Tanzanian side, the first question is: "Do you have a stereo?" Then, "Do you have any cassettes?" Then: "Do you have any Julio Iglesias tapes?" The answer was "no." So I had to give a beer instead. We try to get out of buying the sixty-dollar license fee. Giving out beers right and left. This is the beginning of the famous, historical Kenya-Malawi beer trading route, circa 1989.

They drove through the night, changing drivers every few hours to stave off drowsiness. As the sky turned milky with first light, they were forced to stop at a police check. Following a series of rote questions and another beer "payment," the officer in charge asked them to drive his friend to the next toll. As they dropped off their impromptu passenger an hour later, he too confiscated a few Tuskers. "How's the supply holding up anyway?" Dan asked.

"To hell with money," Lengai hollered from the backseat, his voice muffled through the bandana covering his mouth to keep out the copious dust. "We obviously should have brought more Tuskers!"

Their first vehicular setback occurred in Morogoro in east-central Tanzania. They stopped for lunch—tepid beans and rice—only to be met by the sound of a dead engine when they climbed back in the rig. Lengai worked all afternoon next to a mechanic at the local garage, taking apart the gearbox to soak every part in diesel. Finally, an errant roller bearing was located. Though it would take much of the next morning to put back together what they had undone, a celebration was called for: kebabs and Cokes and vodka. "Dr. Croze, you've earned your keep!" Dan proclaimed, clinking

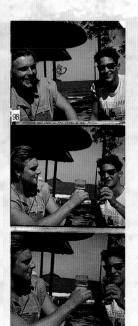

glasses with his friends, before showing off the work he'd done on his journal that afternoon.

The days ran together, the dusty tracks all looking the same, the hitchhikers increasingly bizarre. They fortified themselves with tins of pineapples and biscuits, stopping at village *dukas* for cold sodas. At many stops, Dan made an entry by bursting out of the back of Dez with his ghastly old-man mask over his head. His dad had brought the Halloween mask back from a trip to the States years earlier and Dan had found it to be useful while traveling. Donning the mask during treks to Maralal and around Nairobi, always attracted a crowd of children who shrieked in delight at the *wazungu* with the awful face. Occasionally, these moments of street theater went over less well. At one stop, the village elders chased them out of town, forcing Lengai and Patrick to cast Tuskers out the back window as fast as they could while Dan made a quick getaway.

Our next stop was a roadside bar, frequented only by truckers. We all indulged in warm Safari beer and were introduced to Angel Face and her lovely daughter. As we discussed road conditions with some truckers, Angel Face and her daughter moved in for the kill. They used all of their female persuasions on Lengai, Patrick, and myself, but we bravely resisted.

We pushed on and after a few hours I was startled to find that the gear stick was not connected to the car. It had snapped from its base. I immediately woke Lengai from his dreams of Angel Face and presented him with the snapped gear. He ordered me to stop the vehicle and, since we were in neutral gear, with no gear stick, I could hardly stray from these instructions. I had been driving for several hours, so I stopped the car, handed the stick to Patrick and dove onto the mattress in the back. In the next few hours, while I slept, Lengai and Patrick removed the cover of the gear box and managed to manipulate the gears into position with a long screwdriver. They drove for one hundred kilometers like this and by the end of the ordeal the box was becoming white hot and indeed agonizing to the touch. It was a joyous moment for Patrick when we drove into Tringa and he could relax his scalded fingers.

Bit by bit, Deziree was overhauled. Along with giving her a new shift, they welded iron bars over the back window in lieu of the glass a would-be thief had broken. To improve ventilation, they removed the driver's side door, which Dan estimated increased air-

flow by "six hundred percent!" Despite the help of several mechanics in various villages, the starter doggedly refused repair, forcing them to hand-crank the Land Rover to life each time. Although a nuisance, it became another ritual of the journey.

☺ ☺ ☺

After about a week on the road, they reached Lake Malawi. With little fuel left in the tank, they risked the arduous drive to Livingstonia, a small town perched high on an escarpment. Once at the top, they had a stunning view of the shimmering, deep blue spectacle, one of the continent's largest lakes. Getting to the water entailed a slow and heart-stopping descent down the same road. Each of the twenty-one hairpin turns was well marked, lest one forget how much farther it was to the end: "Bend 18," "Bend 19," and so on. Deziree's brakes managed to hold out, though her steering was not always tight enough to make the turns, so that

Deziree - Le Château - forte - sud-est

Dan had to reverse a few yards toward the craggy precipice before making it around. They cursed at each new obstacle and then whooped with delight when they'd succeeded.

Finally down at the lake, they splashed into its cool, freshwater waves, happy to wash off the layers of dust that had been accumulating on their darkly tanned bodies. They drove along the water until nightfall, in search of just the right beach for camping. Guided by the light of the full moon, they finally inched down a boulder-filled road toward a beach that a fisherman had recommended. Lengai and Patrick got out to direct Dan over the enormous obstructions. Driving onto the soft white sand, the moonlight dancing on the water's surface, they knew they had found Paradise. Just twenty feet from the lake, they dined on ravioli, rum, and Cokes before turning in for the night.

We dug Deziree out of the soft sand, crank started the engine, and then drove her out on the sand ladder. We then locked the free wheel hubs and drove up the impossible road. Deziree waltzed up effortlessly. When we reached the top, a beautiful, blond English girl asked, "You made it up that?" It was with pride in our hearts that we began the drive to Nkhotakota.

☺ ☺ ☺

At about the two-week mark, Lengai called home to his mother. The news about college was good—he was accepted to Sheffield in England—but it was also bittersweet as he would soon need to return. Patrick also needed to get back for school, as planned, and would have to leave even sooner than Lengai. Crouching by the side of the dusty road, they spread out a torn and grubby map. Dan and Lengai would drop off Patrick at the airport in Lilongwe and then continue on to Zimbabwe, where they could catch a plane to Victoria Falls prior to Lengai's departure.

An impressive obstacle lay in their path. The Tête Corridor, also known as the Gun Run, was the only route across war-torn Mozambique to Zimbabwe. The dusty path was cleared for land mines every Monday, keeping it somewhat safe. Reaching the Mozambique border, they found a line of about two hundred cars and trucks awaiting the official go-ahead.

"Convoy of Death Through Marxist Utopia," Dan wrote in his journal, describing the crazy, chaotic road race from one edge of the country to the other. When the herd of vehicles finally took off, they sped through the wasteland, stopping halfway in Tête to refuel and calm their nerves. There, Dan and Lengai had their first glimpse of the glazed, hollow-looking people who were victims of the decade-long civil war. It was a different face of Africa than any they'd yet seen. Although they were happy to leave it behind, the congestion of Harare, Zimbabwe's capital city, was nearly as unsettling.

Dr. Croze and myself arrived in Harare late Tuesday night and sought asylum at the Holiday Inn. We docked the U.S.S. Deziree outside the aforementioned establishment and camped in what was admittedly the most urban location that we had habitated to date. Gone were the cries of distant hyenas and lions; instead, the colorful language of street people could be heard, bargaining for female flesh, and the magical clattering of some bastard trying to pull the shovel off the back of the car.

We both knew that the time had come to play mini golf, so we made our way to the "Mini Put-Put" and did a quick twelve holes. This was not what we had driven across Africa for, so we went to the water slides and chatted up the "cleavage sisters," two young ladies with much more bust than racial understanding. In fact, they were racist bitches. But you must understand that Dr. Croze and myself had been living in very harsh bush conditions and a quiet desperation had set in.

The Rat Eaters of Central Malawi
Africa's new and horrific social health crisis.

In America, it is Crack, heroin and Cocaine. Here in Malawi, there is another threat to the youth. A more evil, addictive, verminous drug, known as Mbewa is rearing its ratty head.

More and more teenagers are looking to Mbewa as an easy way out of life's pressures.

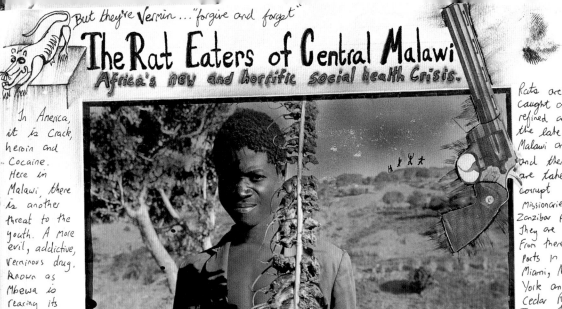

Somewhere in Malawi, 1989

89

Rats are caught and refined around the late Malawi area and then are taken by corrupt missionaries to Zanzibar port. They are shipped from there, to ports in Miami, New York and Cedar Rapids Iowa. The rats are sold to clients ranging from Wall Street Brokers to Puerto Rican school kids.

And those who sell the vermin are becoming Millionaires overnight. **Above,** a road side rat pusher displays his wares. Customers are given small rats to begin with and as their addiction escalates, so do the prices and sizes of rat. What has been done to fight Malawi's own Drug War while the U.S. pumps millions into Colombia?

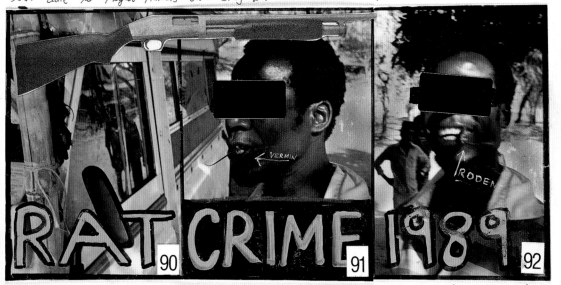

VERMIN

RODENT

RAT CRIME 1989

90 91 92

Following their quick side trip to the falls, Dan took Lengai to the airport in Harare. As they waited for his flight, they both agreed to think of a safari to undertake at Christmastime when they would next see each other. "Don't melt back there in bloody wet England," Dan said, giving Lengai a final quick hug and then turning back to the parking lot. Awaiting him was his one remaining companion, Deziree. Back in Malawi, they had strapped bamboo shoots to the Land Rover's side to add a well-worn, jungle flare, but these were now partly broken and hung limply. Dez was caked with dust, inside and out, and dirty blankets and towels, wadded-up food wrappers, and empty bottles littered the interior. Worse was what the naked eye couldn't see: the weakened engine. Crummy timing, Dan thought, now that his chief mechanic was gone. But it was a challenge too. He was on his own, ready to put his Year On philosophy to the test.

☺ ☺ ☺

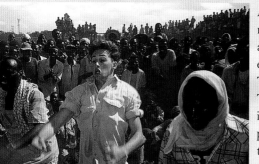

Although he was traveling solo, he was rarely alone. Just hours after leaving the airport, he wandered around an agricultural exhibit and met a local girl named Nancy Todd who took Dan home to meet her family. They hit it off so well that Nancy's parents invited him to stay for a few days while he prepared for his future travels. With their ten children and workers from the nearby mine that Mr. Todd managed, it was a lively household, and Dan fit in, enjoying the home-cooked meals and an opportunity to do laundry. On his third night, he followed a family friend to the meeting of a secret dance society.

September 4
Bertie comes and tells me to come quick. I run down the hill, see guys with horrible masks. Devil baby face, pink monster, red devil, bangles on feet. Gurai dance society—masks and rattlers from Zambia....I sit on the car and am surrounded by sixty kids. They ask me to dance. I give it like crazy. They form a circle. They sing, drum, and cheer. They sing for me, then I sing for them. I shake one of their hands then I almost swim across their mass of hands as they touch and grab me—in a nice way....Berti tells me to hold on because they are going to give me an African name and it could be frightening. I see them gather up stones. I am led to the center of a crowd and thrown to the ground. Volvo lights shine on me.

Dust, moon, and fire-drums reach frenzy. Devil dancer comes out and beckons me. Kisses me by rubbing the mask against my face. The old man is holding me down and the woman is screaming in front of me....I am pulled up, given three coins, and named Auraga Chikawati Chata after the three dancers. It means "he who kills the one who messes around with his wife." The crowd cries out my name.

After several days spent watching mechanics unsuccessfully try to revive Deziree, Dan decided to leave her in Harare and continue on his own. He told the Todds that he'd be back in several weeks and gave them money to pick up Deziree if and when she was finished. All he took with him was his knapsack, filled with a few extra T-shirts, his camera, his journal, and two books: *The Prince* by Machiavelli and *1984* by George Orwell. He diligently recorded the events of the coming weeks in his journal, filling it with more words than usual, and also pasting in the usual receipts, visas, and photographs.

He caught a ride in a Mercedes-Benz to the South African border. In many ways, this was the most challenging border-crossing of the trip. In 1989, before the fall of apartheid, it was still very dangerous to have a South African stamp in one's passport because many other countries wouldn't accept a traveler if they saw the infamous mark, so Dan was relieved when the guard gave him a separate sheet of paper for the stamp.

From there, he headed straight to Soweto, the notorious black township outside Johannesburg. It was already dark, and he needed an inexpensive, safe place to sleep. Earlier in the day, he'd phoned his grandmother, Gaby Eldon, in London. "Grandma, what family do we have in South Africa?" he asked. On a number of occasions, she'd helped him locate a distant cousin with whom he could stay during a trip. But not this time. "Sorry, Dan. Our people didn't get that far," she laughed. "Where will you stay?" He told her not to worry and then, seeing no other immediate options, went to the local jail where the amused police were willing to provide him with a cell for the night.

September 10
Very large room, 30 square feet. Heavy barred door in one corner. Step to the right of it, elevated area containing toilet and sink. Walls painted a light brown. High barred ceiling open to the nights. Spotlights from above throw shadows of bars artistically below—enveloping me in a spider's web....I remember some other students

South African
— Police —
offering accomodation
to students since
— 1976 —
in
SOWETO

CELL
5

my age who had no place to go back in 1976 in Soweto and the lucky ones ended up in cells. The buzz in my head was from Carlsberg; theirs was from clubs or tear gas....A black cop unlocks my cell and passes me two extra blankets and politely asks me if I was finished writing or if I would like the light switched off now. I asked him to leave it on. I pulled my *kikoi* over my head, put my bag under me, slid my watch into my pocket, and braced.

"There is no avoiding war. It can only be postponed to the advantage of others." —Machiavelli

"Room service" woke him up before dawn, forcing him into the dark, rain-soaked streets. Half dazed, he began to hitch. A black trucker stopped first. As they bounced along, he told Dan about the disparity between his wages and those of white truckers. An older couple offered the next ride. On hearing that Dan had been in Zimbabwe, they said it was a filthy country since blacks had taken over. His final lift of the day, coming after a three-hour lull of standing by the roadside kicking rocks, was from a mother and her daughter. They bought him dinner and let him sleep on the cold floor of their apartment. It was hardly comfortable, but it kept him within his goal of spending only five dollars a day.

September 12

Drive with Mrs. De Lange to the sea. She starts with outburst on blacks. She didn't miss a thing. They are dirty, are not Christians, do not buy magazines, do not have radios, uneducated, do not wash. She said that she would not go to restaurants with blacks.... of course she said that two percent of them are OK. She drops me at the Sea Point. I walk around—looks like English seaside town.... I feel grubby like a tramp. Still no visible signs of apartheid. It must be cunningly concealed. Walk past job wanted for shampooing. Think it over....Go to *Cape Times*, look for photo department. AP guys refuse to take me to march. Find out about mayor marching on Parliament against apartheid.

In Cape Town, he headed to a nearby church where a crowd bearing placards was gathered. A man directed the crowd to be calm as they marched and to sit down if the police made any trouble. Dan had his Nikon ready. The protesters chanted as speakers, including Archbishop Desmond Tutu, came to the podium. As the crowd grew, Dan climbed on top of cars for a better view. He saw photographers scamper up trees and yell down at the marchers to turn their banners toward their lenses.

That night, he treated himself to *samosas* at an Indian restaurant and recorded the day's events: **Hundreds and hundreds of students, old people, fat mamas, young guys: marching, dancing, good spirits. Hot blue sky. Hear speeches—"Historic Day: Today Cape Town belongs to the people, tomorrow South Africa belongs to the people." ...Tutu makes crowd join hands. Calls for de Klerk to listen to the peaceful people. Holds up hands—shows they are empty. "He will be the last white South African Prime Minister!" I walk around town feeling high.**

September 17
Start hitchhiking with Afrikaners to Mosselbaai. Stop at Riversdale, catch lift to George in lorry carrying 34 tons of beer bottles. Sleep in back of cab. Check into hotel—South African Police. Another cell. Get back room with mattress this time—luxury. "Clean, elegant lines. Dramatic, functional bars, tastefully lit from an overhead light. Beautifully highlighting the cement bench protruding from the baby-blue walls. Modern toilet bowl and trendy black designer-styled bed. All in all a very thorough penal institution."
—*House & Garden*, September 1989.

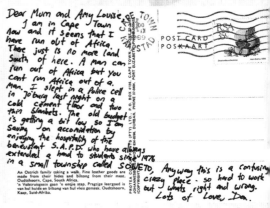

Dear Mum and Amy Louise
I am in Cape Town now and it seems that I have run out of Africa. There just is no more land South of here. A man can run out of Africa but you cant run Africa out of a man. I slept in a police cell in Jo'burg last night on a cold cement floor and two tarn blankets. The old budget is getting a bit low so I am saving on accomidation by enjoying the hospitality of the benevolent S.A.P.D. who have always extended a hand to students since 1976 in a small township called SOWETO. Anyway this is a confusing crazy place - so hard to work out whats right and wrong. Lots of Love, Dan.

The next day, September 18, was his nineteenth birthday, and it was cold and rainy again. Standing on the roadside, waiting for a ride and trying to stay warm, he put on his old-man mask and danced around, mainly for his own amusement.

September 19
Lift from Port Elizabeth to freeway with identical sales representatives wearing identical jackets. Lift with crazy truck driver from Swaziland. Kicking out Zulu music, driving through Transkei, looks like Africa again—goats in road, pineapple sellers....Ditched in the middle of nowhere—walk 1 km. Pitch black night through township. Barking dogs, not a soul in sight. Locate hotel after misleading information. Sleep in lobby.

"The object of power is power, the object of persecution is persecution, the object of torture is torture." —Orwell.

He spent about two weeks in South Africa—enough time to make his head reel from the omnipresent racism and the power-keg atmosphere of apartheid's waning days. One of his final rides

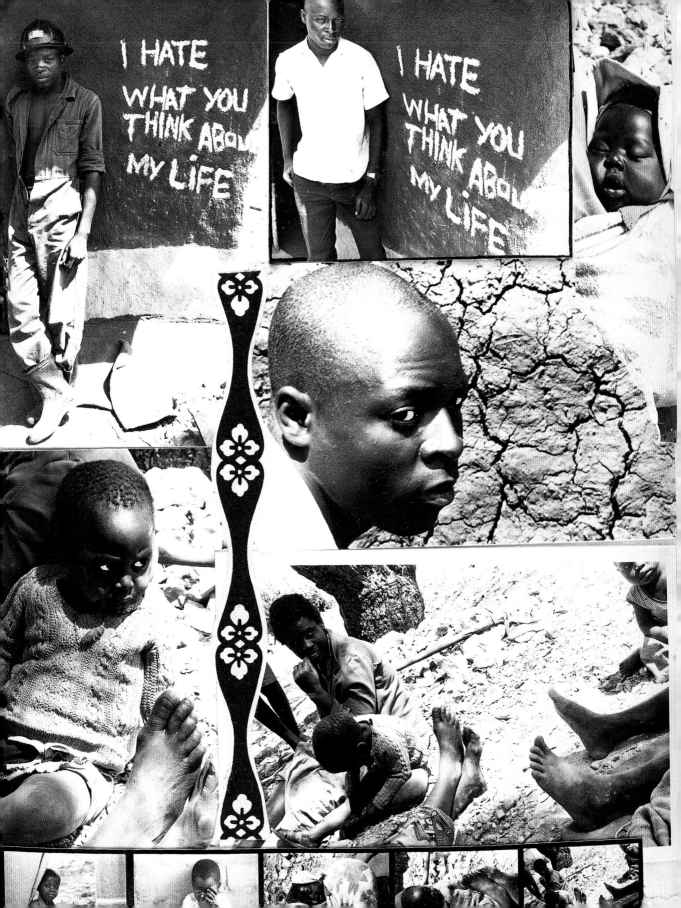

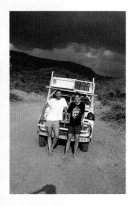

was with a blond, mustached man ("my first real Nazi") who told him that every white must kill nine blacks in order to maintain control. Dan felt that change was imminent, but whether it would be catastrophic or propitious remained to be seen.

Dan returned on September 29 to Harare, where he was reunited with a newly repaired Deziree. Saying good-bye again to Nancy's family, he took off, retracing the path that he and Lengai had cut nearly a month before. Tête proved more of an adventure this time, with Dan picking up a daredevil hitchhiker and staying for a night with a Danish aid worker and his family. What he saw would convince him to return and help.

He had called his father and convinced him to meet him in Malawi. Mike hedged; he was busy with work and wasn't sure if he could get away. "Just come dad. Trust me, you won't regret it."

The two spent several nights together, the liveliest of which was in Nkhotakota, where they checked in to the excessively modest Pick 'n' Pay Motel. Father and son launched their evening revelries with a curbside taste of *chipuku*, a local brew made of fermented corn, and then, guided by the sounds of a raucous band, made their way to a large open area where a crowd had gathered. As people waited patiently to be let into a hall where the band was still rehearsing, Dan gave his father a knowing look and reached for the rubber mask he'd stuffed into his back pocket. His ensuing performance with the garish latex face delighted everyone except the band members, who felt they'd been upstaged. "Who has authorized you to do this thing?" one yelled at Dan.

Accommodations the following night were far more comfortable. Once again, Deziree made it down the boulder-laden road to the beautiful, sheltered beach on the shore of Lake Malawi. "It's hardly Fortnum and Mason," Mike laughed when he saw the one choice they had for the evening meal: baked beans. But rinsed down with Malawi gin, he had to admit they weren't half bad. The crackling fire and moonlit lake greatly enhanced the sparse meal as well. They talked until very late, sometimes sharing serious thoughts, but then drifting effortlessly to the absurd, their laughter echoing long into the night.

After a final night spent high on the spectacular Livingstonia escarpment, Dan dropped his father off on the road south to

Mzuzu, from where he was to catch a plane down to Lilongwe. Dan drove the last leg home alone, cruising through Tanzania, stopping only for the pesky road tolls. On the final night, he camped outside a school next to an American family just starting their own African journey. As they talked, they realized they had some connections: the father had taught at ISK and had also worked with Kathy at *The Nation*.

Dan captivated them with his tales of nine weeks on the road, masterfully weaving in the broken gearshift, the border crossings, Tête, the prison cells and rallies in South Africa. He was in fine form, lean as a cheetah and full of confidence. The following spring when he contacted them in California, having written their home address in his journal, they would recall him immediately and fondly.

Mike was still at work when Dan pulled into the driveway the next afternoon. "Bwana Dan, you're alive!" William laughed and clapped his back. They hauled his gear out of the Land Rover, then the two settled down to swap stories and drink *chai masala*. Being back—the familiar bed, clean toilets, home-cooked meals— was a relief. Yet Dan knew now that he could leave whenever he wanted, safely getting himself to beautiful, exciting places and then home again. Falling asleep that night, with his photographs, daggers, and other knickknacks hanging overhead, he felt that the four walls were a little too close. For the first time, the bed was a bit small.

Republica Pop

"Come, my Boss wants to see you," he said firmly. How well an AK-47 assault rifle can emphasize such a simple request when it is so accurately pointed at one's chest. Two camouflaged soldiers walked around to the passenger side of the Land Rover and with-drew my hitchhiker. He was transferred into the depths of an armored personnel carrier and the soldiers followed him in, pulling the heavy doors shut with a clang. When the doors were closed, a painting of a skull was revealed on the matte green body.

The Sergeant with the AK-47 climbed into my vehicle and com-manded me to start the car. She roared to life and I trailed along behind the hulking Zimbabwe Army tank. As soon as I turned my engine on, my cassette player started up and some hard-core funk music came thumping through the speakers above our heads. The soldier's eyes narrowed and his grip tightened around the wooden

handle of his carbine. "I don't like funk." He sounded like he meant business so I quickly ejected the tape and made an apology, telling him that I didn't like funk much either but it was actually my sister's tape and so on.

With one hand, I reached behind me and brought forward my cassette box. He was watching me as I carefully made my selection. Thinking that a wrong decision could be my last, I pushed the tape into the machine and waited. He listened for a few seconds.

It seemed like hours had gone by before he said slowly, "Yvonne Chaka Chaka." His face remained inscrutable, but I noticed that his combat boot was tapping along with the music. I was going to ask him to stop stomping my carrot cake when he suddenly raised his weapon and ordered: "More volume!" I panicked. My stereo was already throwing out as much sound as nine hundred and twenty shillings worth of Korean technology could manage. He was disappointed, but did not fire upon me.

His large hands reached down under the wounded carrot cake and pulled out my map of Africa. He opened it fully, covering almost the whole cab. He tried to find Mozambique, the country I was then having the pleasure of crossing. After working his way down via Libya, Burundi, Madagascar, and Zaire, he finally located Mozambique and then Tête, the town we were approaching. His look of satisfaction quickly turned to suspicion as his keen eyes noticed a series of black dots marking random locations all over my map. The black marks were where some varnish had splattered over it one day, but he was convinced that these were detailed plans for mine laying. "You are a spy," he accused. "You are going to mine this road!" I calmly explained that I was not a spy and that half of the dots were in the ocean and there were even some on the kilometer scale at the bottom left corner, which was hardly a likely terrorist target for bombing.

I decided to ask why I had been captured. He told me that "the boss" has not liked me taking photos of the Zimbabwe Army convoy that accompanied us through the Mozambique corridor between Malawi and Zimbabwe.

The convoy had left at five that morning for the Malawi border and over one hundred trucks set off, going absolutely flat out. The convoy is like a deadly grand-prix race, as huge lorries jostle and fight for front positions. Drivers overtake recklessly and many accidents occur, ranging from wing mirrors being sheered off to trailers jack-knifing and rolling off the road in flames in true Mad Max road warrior style. Zimbabwe Armored Personnel Vehicles bristling with weapons drive up and

down the convoy attempting to monitor this anarchy. Sometimes, when they see a driver getting too far out of line, they stop his truck and beat him with a stick before sending him on his way.

The reason for the haste is that when drivers reach the Zimbabwe side, they are given a number by the Mozambique officials, showing in what order they arrived. Those who arrive late may have to spend the whole night waiting in Mozambique, as two customs officers plod through thousands of papers and stamp documents for the hundred plus vehicles.

"Turn here," the soldier said while still trying to fold the map. We drove past the Armored Carrier and stopped beside some barracks. The soldier told me to wait in the car. He got out, scraped some sticky carrot cake off his boot, and glared at me.

I waited until he turned away then dove for my camera bag. I whipped out the Nikon and started rewinding the film. It was still half wound when I saw "the boss" approaching, so I hid the camera in the bag and continued winding. Just as the captain reached the window, I yanked the film out and stashed it in my safari boot.

The sharply dressed officer leaned inside and took a long look around the interior of the Land Rover. He smiled and introduced himself as the Convoy Commander. He asked to see my passport and wrote down my name and address. He wanted to know why I was taking photos and I told him that I was a student and that I took pictures for fun to show my friends. Satisfied with my explanation, he apologized for what he had to do. "I am sorry but I need to confiscate your film ... and I hear that you also have the new Yvonne Chaka Chaka album."

I handed him the blank film and the requested tape. The soldiers in turn handed me over my much-shaken hitchhiker. The Convoy Commander gave me a salute, a smile, and a friendly warning not to spy on his convoy again—or he might have to shoot me.

They waved good-bye as I speedily drove off. When I was a safe distance away, I celebrated the lack of military presence in my car by whacking my funky tape back into the player and cracking open my last bottle of Kenyan Tusker.

We drove back into town and decided to have a look around Tête, which does not take very long. After so many years of civil war, this sun-baked town on the Zambezi River is in a very sad

state. There is very little in the shops, with even bread, milk, rice, and sodas unavailable. The only cars around are clapped-out heaps that would be in scrap yards in most other countries. Marxist slogans are crudely stenciled in Portuguese on crumbling walls. They denounce capitalism and praise the glory that the people's revolution has brought to their country. The currency, *meticai*, is practically worthless. I saw an old woman passing a huge sack full of notes over the counter in exchange for a few groceries. The shopkeeper did not even bother to count the wads of cash. He told me, "If I has to count all this paper, I would have time for nothing else."

It was already fiercely hot outside when we left the house at eleven, thinking that the convoy crossed the bridge at twelve. If you are in a passenger vehicle, you are allowed to drive to the front of the convoy and start the "race" ahead of the trucks. While we waited for the Commander, we tried to talk to the soldiers about their job, but they were only interested in trying to change Zimbabwe dollars for Malawi Kwacha.

One soldier gave me a quick lesson on how to aim a rocket-propelled grenade launcher. He detached the telescopic sight and held it to my eye. I could see a frail mud hut. The soldier made a whooshing noise, then mimicked an enthusiastic explosion, which left my ear covered in saliva. I gave back the scope and noticed instructions on the case printed in Russian. Asking him if he could read the writing, he grinned and said, "Da, comrade!"

I always travel with the gorilla mask, and now seemed like a good time to have some fun with it. I pulled it over my face and charged at the soldiers. Half of them took off running toward the bush while the other half almost died laughing. I removed the mask but they begged me to put it on and chase them around some more. It was total chaos. There were armed soldiers everywhere being scattered by a smiling gorilla with white arms wearing Levis and safari boots. They gathered around me in a circle and clapped their hands in unison. I danced a funny gorilla dance for them, which was received with much cheering and whistling.

One Sergeant asked if he could wear the mask and perform his traditional dance, called "Chigure," where a masked dancer moves his feet around and kicks up clouds of dust creating a dramatic effect. The soldiers crowded around the Sergeant and danced along.

When the celebration was in full swing, the Company Commander's armored car pulled up. The Captain stared down on the scene from his cab. The singing and dancing stopped suddenly and I was called over. "What inside the earth is going on?" he asked sternly. A soldier passed up the grinning plastic ape face. The captain looked it over and burst out laughing. "Oh, so you know Gure dancing? I am a member of a secret Gure dance society in Zimbabwe but I did not know that you people did masked dancing overseas. Very good." He tossed the monkey head down to me, banged the side of the car twice and the convoy was ready to roll.

We ran back to the car and my hitchhiker asked if he could drive. I was tired so I agreed. He had told me that he did some racing back in New Zealand and it showed. We started overtaking the other passenger cars, one after another. He was getting some good speed out of the old girl. Some cars would try to overtake us, but he would pull over and block them. They would try and sneak past on the left-hand side when we slowed down for potholes, but he quickly cut them off.

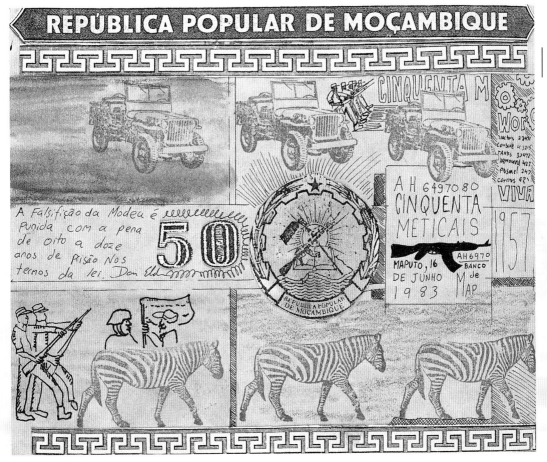

We were doing well with the Land Rover in second position. In front of us were the Company Commander, whose vehicle was generally accepted as the pace car, and behind him a huge Afrikaner from Transvaal. We could see his enormous pink face and handle-bar moustache looking back from time to time in the rear view mirror of his red Mercedes 240. He was a ruthless driver.

While our efforts were concentrated on overtaking the Red Benz Baron, we failed to notice a nimble V.W. Golf overtake us. He had wormed past us on a sharp corner and it looked like he had stolen second place.

This is when our luck changed. There was a jagged patch of road ahead that had been severely mined, and both the Mercedes and the Golf had to slow down considerably. We took this opportunity to fly past the Golf and try for the infamous Merc. I saw the driver's eyes widen as he noticed our offensive. He spun the wheel, sending up a cloud of dust as his car skidded into the bush but then recovered and held second place until we crossed the border. We congratulated ourselves and I asked the New Zealander what sort of racing he did back home. "Demolition Derby" was his reply.

The Company Commander had been watching the whole rally. He sent his Sergeant over to us with a message: "The boss says that he doesn't want to see you guys in Mozambique again." He smiled. "You make the country dangerous to live in." From somewhere inside the armored personnel carrier, the music of Yvonne Chaka Chaka could be clearly heard.

By Dan Eldon

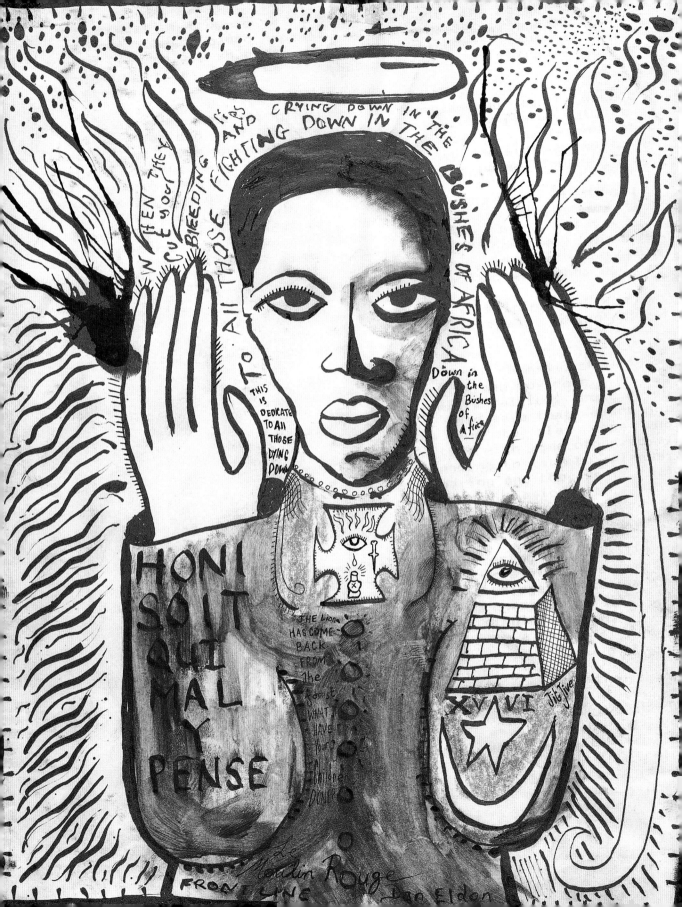

snap!

I try to make people feel special about the fact that, out of everyone there, I want a picture of them.
—Dan Eldon

As a tool, the camera matched Dan perfectly. It gave him an excuse to be in the world, exploring and meeting new people; it was his entrée. But it was also the object that stood between himself and others, like a shield. It framed his vision, sometimes blocking out the messy stuff going on beyond the viewfinder's border.

According to family lore, he was three years old when he took his first photograph using his aunt Carolyn's camera. His parents gave him a simple automatic for his sixth Christmas, and he continued to have a fascination with his parents' cameras as he got older. It wasn't until the latter part of his high school years that

he started carrying a camera with him on a regular basis—a used Nikon his parents had bought from a *National Geographic* photographer passing through Nairobi. With his friends Long Westerlund, Robert Gobright, and Tex, he spent many evenings and weekends taking pictures and messing around in the darkroom. They went all over Nairobi, looking for deals on camera film, experimenting with various filters and chemicals. If the package said not to do something, they'd do it just to see what effect they could get. It was photography as both science project and male-bonding opportunity.

Of course, picture taking was also a way to woo women. Dan quickly found that most girls perked up at the opportunity to be in front of the lens. He could make anyone feel beautiful, prompting his models to have fun and relax: "Pull down your sweater just a little. Throw your head back. Ah, you're gorgeous!" What seemed okay in the spontaneous moment sometimes felt different a day or even months later. One girl wrote to him from Sweden, asking that he return a set of nude photographs. She appears partially clad in a series in one of Dan's journals, but there is an empty space where one photo was torn from the page.

Although many of the women he photographed had model good looks, he made others who weren't the natural targets of photographers feel beautiful too. He loved to flirt and coax women to show their best sides and to feel more confident about their appearance. When he was living in New York and working at *Mademoiselle*, he told his cousin Amy how upsetting it was to him that women were so misportrayed. He'd recently had his first sexual experience, he said, and was interested to discover that "real women" don't look like the nudes displayed in magazines: "They're much more beautiful and interesting. It's too bad they don't feel this way about themselves."

He had to use other forms of coaxing with his Masai and Samburu friends. Traditionally, members of the two tribes refuse to have their photos taken unless they are paid. Dan would turn their arguments inside out, saying, "I'm not going to pay because you're beautiful; beauty is beyond money." He'd follow up the compliment by offering to bring the person a copy of the photograph as a form of payment. Another trick he used was to give the camera to other people, especially children, in order to get photographs taken in situations where it might otherwise be difficult. He allowed his camera to be passed around, as if it were a plaything or an oddity, and people quickly learned how to release the shutter and capture

odd-angled, fresh views of village life. Later, he used the same ploy with soldiers in potentially tense situations, bringing out the camera as a device to draw people in rather than make them suspicious.

Dan was a keen observer of patterns and visual metaphors. His letters were covered with sketches and collage elements, the words an afterthought. Through his artist's eyes he saw shapes, colors, and light. He noticed the way in which a white garment stretched over some sticks in Morocco resembled a Ku Klux Klan cloak. A telephone reminded him of a buffalo's head. An old man he photographed in East Berlin looked like Death personified, while an older Samburu, cloaked in red and caught with a flash on a dark road, appeared to him as the Devil.

Stopping at small-town restaurants in the American Midwest, he noticed signs for "home cooking" and asked the waitresses whose home the food had been cooked in. He loved the incongruity of a Masai *moran* wearing Ray Bans, and he recognized the tribal-like decoration in an east London punker, with

his nose rings and spiky, dyed hair. He sought out the worst parts of cities, finding more to look at in the chaos than in the well-scrubbed surfaces of wealthier areas. When he discovered cubism, he suddenly saw the entire world in angles and boxes: a cheetah's head and his own eyes became geometric spaces to rotate and exaggerate on paper. He photographed a crowd at an American football game the same way he photographed a row of police officers at a Nairobi demonstration, seeing menace in both. And in the drunken revelers at a fraternity party, he found echoes of an African mob.

Dan had relatively little training for someone whose photographs would eventually make the pages of major newspapers and magazines. Early on, he learned from his father, an avid hobbyist. He went on to take several college photography classes. The B-minus one professor awarded him angered him so much that Dan demanded an explanation. The man said that Dan had failed to do the assigned work, spending more time on his own interests, including his

journals. Much of what Dan knew about film, filters, and chemicals
he picked up in photography shops, where he was a regular. As a
teenager, he took photographs to accompany some of his mum's arti-
cles for *The Nation*, Kenya's main newspaper, and had spent time in
the darkroom and offices of Sam Ouma, the paper's photo editor.
Years later, Sam would print more of Dan's work and continue to
mentor him, as did the photojournalists Dan met in Somalia.

For years, Dan posed many of his photographs, already
seeing in his mind the angle and lighting he
wanted. It was a habit that more experienced
journalists would help him break. Some
of his friends were uncomfortable with
the way he positioned his subjects,
many of whom were everyday people
caught unawares on the street. Once,
while a group of traveling companions
looked on, a woman with fire-
wood balanced on her head
walked toward Dan in the middle
of a dusty village. He stopped her
and, without speaking, adjusted her
head by cupping her chin in his
hand, then took several photos. His
friends exchanged wary looks. They
could feel other villagers watching the scene:
the white boy holding the black woman's face
and making it his own.

When his mother encouraged him to print and
publish his photographs unadulterated, he insisted
that he wasn't good enough. The photos were meant for the pages
of his journals. Not until he was in Somalia, when his photos
appeared in major newspapers, did he begin to regard them other-
wise. He called home one day to insist that the entire household
turn to page 21 in *Newsweek*. There was a double-page spread of a
photo he'd taken of a tank in a burned-out section of Mogadishu.
"Can you believe it? Bloody amazing!" he bellowed over the line,
thrilled at the material confirmation of his skills, but still harbor-
ing some disbelief.

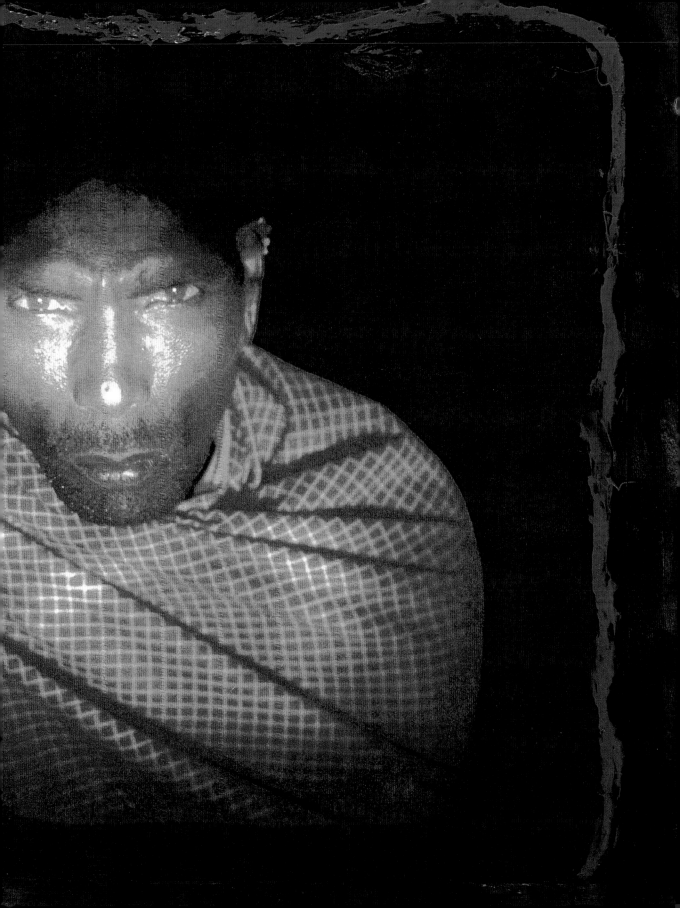

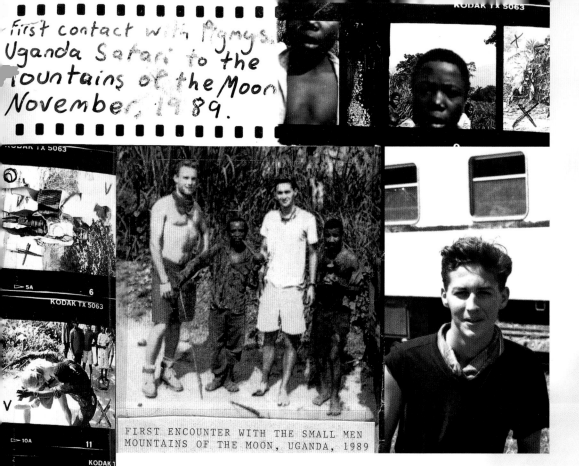

First contact with Pygmys.
Uganda Safari to the
Mountains of the Moon
November 1989.

KODAK TX 5063

FIRST ENCOUNTER WITH THE SMALL MEN
MOUNTAINS OF THE MOON, UGANDA, 1989

mountains of the moon

When he returned in late October 1989 from his nine-week sojourn
across Africa, Dan found his future was waiting for him. The Year
On clock was ticking down. He'd already missed the chance for fall
enrollment at the prestigious Parsons School of Design, to which
he'd sent an application after returning from New York. His trip
had led him in a different direction—particularly the experiences
he'd had at the demonstrations in South Africa—and now he was
leaning away from design and toward photography and filmmaking.
News. Politics. Strife. Real-life events stirred him more than ever.
Knowing that the University of California at Los Angeles offers
one of the strongest American film programs, he began to make
plans to go there the following semester and position himself for
acceptance.

To earn money, he got some local magazine assignments. Kenyan publishing, while provincial compared with what Dan had experienced in New York, is sophisticated by African standards, with a readership that extends throughout the eastern part of the continent. His mother had worked for a number of publications, and Dan had assisted her on occasion, so he had contacts.

He was hardly home, however, before he was plotting another safari— a small one this time. He was eager to visit a tribe of Pygmies in eastern Zaire and had interested his friend Tex, still a student at ISK, in the trip, as well as another friend, Chris Favro.

As Dan liked to say, "The journey is the destination." That could not have been more true than for this trip. Although it took nearly a week altogether to travel to and from the Pygmies' home in an area called Mountains of the Moon, Dan and his friends stayed for less than half a day. The real adventure came from hitchhiking and the surreal trip on a dilapidated train. After their first day of thumbing rides—which had begun after a friend took them for a picnic in the Ngongs and then dropped them on a road about an hour outside of Nairobi—Dan took out a small, unadorned notebook he'd brought with him and jotted down the first in a series of daily observations.

November 3, 1989, leave Nairobi
Easily catch a lift with golfers. Cruise to Naivasha and onto Nakuru on the back of a pick-up. Strong wind, blue sky streaks of white clouds over the Rift Valley. Drop us at Nakuru and we catch a *matatu* headed for Kisumu. We have to wait for forty-five minutes until it was packed and then we took off. All Africans keep the windows closed until people start dropping from lack of oxygen. We keep our windows wide open on principle, even though it got quite cold.

November 4, Kisumu to Jinja, Uganda
The hotel bursts into a frenzy of violence during the night as everyone is awoken by the screams of a woman and the savage growling and thrashing noises of a drunken man. I, along with all of the other guests, rushed outside to the room. The woman was grasped by her hair by a strong man in a towel.

Haggle for *matatu* and drive to Busia and then to Malaba. Both rides were extremely uncomfortable. At Malaba, we book train for following Saturday. Sort out our money, roll it into the cuffs of our jeans, and head for the border. Kenyan side very easy. Waved on through with no problem. Walk through no-man's land and are

accosted by hordes of dodgy looking characters holding fistfulls of notes. "Black market?"

Following some haggling with Ugandan border officials, they took a *matatu* to Tororo. The driver refused to turn on his headlights, so they crept along bumpy roads past rice paddies in the moonlight. In Jinja, they checked into the Victoria View Hotel, which Dan described as "not very squalid," and found some kebabs for dinner. From the roof, they were able to see the source of the Nile. Later that night, the sound of automatic rifles echoed through the streets below.

November 5, Jinga to Kampala
Take *matatu* to Kampala. Drive through thick forests. In bus station, see men selling women's wigs and displaying them on their own heads. Meet madman who claimed to be Jesus before things "became broken."

Find cheap hotel and argue for hours over rate. Try every line. Decide to take two singles. We get two cupboards. We complain and call the old guy, who sends his son up and shows us to another room with a bullet hole in the window. We sleep there.

It would take them twenty-five hours to travel just under two hundred miles. The next morning they boarded the train. The windows, mostly jammed closed, were covered in moss and slime. Occasional bullet holes riddled the train's body. The doors were missing, leaving gaping spaces in their stead. To get from one car to the next, even while it was moving, a person jumped out the open doorway to a ladder and climbed around to the side door of the next car. It was tricky, but Dan, Tex, and Chris discovered that they could climb onto the roof, an excellent perch for stargazing.

They had gotten a second-class compartment, a small room that they shared with several other men and several chickens. The bunk beds hung by chains from the ceiling. From the window, they watched a sea of little kerosene lanterns swoosh by like candles floating in the darkness. Slowing to a stop, they saw the lights emanated from food stalls set up especially for the train. Passengers quickly disembarked, a bowl and a cup in hand, and bought some tea and a serving of *matoke*, a Ugandan staple of cooked plantains.

As the train lurched to life after the brief stop, they stepped gingerly over the sleeping bodies of women and children in the dark aisles. A giant basket of dried fish—someone's baggage—served as

a difficult obstacle. Settled in their narrow beds, they were lulled to sleep by the train's gentle sway. A sudden crash snapped them awake in less than an hour. Chris' bunk had fallen directly onto Tex, the rusty chains giving way from the weight. "It's not the Orient Express," Dan laughed, as he pushed a chicken out of the way and arranged his *kikoi* under his head again.

November 7, Nowhere
Look out train window in the morning and see Land Rover full of troops. Spend morning wandering train, photographing, climbing around derails. We ask why it is forbidden to take pictures even of baboons. I photograph a fifteen-year-old soldier and KGB-looking guy starts to chase me. I jump for the train. He follows me all around the carriages. He yells at me, accusing me of espionage. I deny it and show him my passport and student ID. He says that it is forged. He appeals to the crowd to condemn me. As the train starts, I jump into a carriage filled with troops and police—most are on my side. He finally leaves after I act humble enough. Stop and play Frisbee. Crowd of five hundred watches us.

Sitting side by side in the open door of their compartment, Dan and Tex let their legs hang over the edge, lifting them up whenever they approached a bridge. A veritable village of toddlers, nursing mothers, *qat*-chewing men, and various loose animals was behind them in the car. By contrast, the scene rushing before them was beautiful and serene: a sun-filled landscape of banana groves and vibrant green rice paddies. The tranquility in no way belied the bloody dictatorship Uganda had endured just a decade earlier.

November 8
Hundreds of troops march past our breakfast site, some fourteen and fifteen years old. We negotiate a Land Rover for six dollars each to take us to the Pygmies. Drive through jungle. Pick up first Pygmy, under five foot, tiny body and tiny feet. He takes us to the village. Pygmies waving at us from all over. They offer us pipes filled with cannabis. Buy lizard feet. Talk to Pygmies. Trade T-shirt for bow and arrow.

Dan took several rolls of film of the Pygmies, communicating with them through a rough sign language. Given the train's irregular schedule, they needed to leave almost as soon as they'd arrived. For three days, they journeyed back to Nairobi. In the immense darkness of the African night, the tiny lanterns once again floated past, signaling the way home.

115

safari

Mtu hujua atokako, hajui aendako.
—Swahili proverb
("One knows where they are coming from, not where they are going.")

To Western ears, "safari" conjures up visions of a hunting adventure: Teddy Roosevelt or Ernest Hemingway on an apocryphal sojourn, packing a couple of Remington shotguns, a supply of good gin, leather camp chairs for gathering around the nightly fire, and an intrepid guide, surrounded by lots of wild beasts prowling ominously in the bush. But look up *safari* in a Swahili-English dictionary or talk to anyone who has spent time in East Africa, and the many definitions begin to disturb that romantic picture. It is a word with many nuances, a word to be understood at several levels.

Safari: departure, expedition, journey, moment, time, turn, trip.

Africans tend to use the word as Westerners use the word *trip*, imbuing it with nothing grander. Dan, however, fully appreciated the word's power and multiplicity. A weekend trip to the coast with high school friends was a safari. A tube ride to east London, camera in hand, was a safari, as was a thousand-mile trek through southern Africa or a midnight drive to Las Vegas. A trip down River Road in Nairobi, stopping on the curb to snack on some ham sandwiches—in Dan's hands that was a safari too.

A safari is about more than the sum of a trip, the getting from point A to point B. It is about the power of departure, that feeling of cutting oneself off from the day-to-day routine and entering new time zones, different landscapes, other people's lives—all of which, at the moment of departure, are totally unknown and unexpected. Safari is also about living in the moment and the way that travel forces you into the present, be it through extreme pleasure or hardship. Being wedged into a bus for which you've waited hours and then having someone steal your wallet is, without question, unpleasant, but it's every bit a part of the experience as that first glimpse of the ocean stretching out against the sky or popping off the cap of a cold Coke as you stand on a sweltering, dusty road.

Like any traveler, Dan cursed the less sublime parts of his trips, but he also recognized how they contributed to the overall experience. You could learn a lot about yourself and others by sitting around a mechanic's shop in Casablanca for weeks on end, even if it took months to realize as much. Travel was like collage in that way: the dull and the ethereal, the mundane and the unexpected all came together, combining in the traveler, shaping and changing him.

Dan thrived on safaris; they provided him a way to enter other people's lives. After his first day at Pasadena Community College in 1990, Dan wrote that he must begin planning his next safari. There, near Los Angeles, one of the largest cities in the world, having started school for the first time in a year and a half, with new roommates, new friends, and new possibilities all around him, he was already scheming. Driven by restlessness, he needed the prospect of an adventure dancing on his horizon; without it, his enthusiasm dwindled.

Safaris were Dan's way of constantly encountering himself and others. From his earliest days of hitchhiking to Kipenget's or to Maralal, he was pushing his boundaries. If a safari of great magnitude (the greatest of all being to cross the Sahara Desert) wasn't available, he was happy to make due with his immediate surroundings, going places and seeing things that others were apt to ignore. His friends and roommates soon learned that he had little patience for television on a sunny afternoon. He prodded them to get out and be in the world, something that at first annoyed them and then endeared him to them.

☺ ☺ ☺

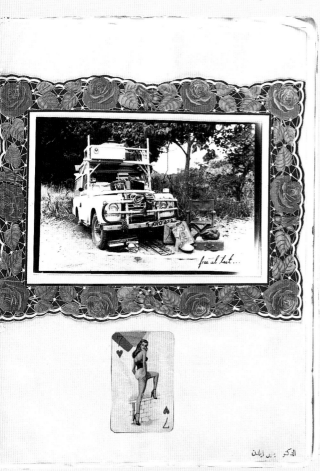

"Get your butt up out of that chair, Major Weisel!" Twumasi nearly dropped the remote control at the sound of his name being barked across the room. He was still groggy from a party the night before, even though it was well past noon. "It's a beautiful day! A fine day! We're going to get that brother of yours and go for a little safari," declared Dan in his Texas Ranger twang. Twumasi Weisel, a diplomat's son, had known Dan in Kenya, but sharing the close confines of a Pasadena apartment during the 1989–90 school year had made them closer. Now he groaned with anticipation of a battle already lost. Driving over hell and gone in Dan's Ford Tempo, stopping at some greasy falafel or taco stand, en route to god only knew where had little appeal. He also knew there was little point in arguing with Dan, who would quickly move from pep talk to badgering: "Man, I'm absolutely dying of boredom here! Come on, help me out here."

Within a half hour, Twumasi was dressed and feeling relatively awake in the back of the Tempo, his brother Kwame at his side. They headed south to a part of Los Angeles he'd never seen

before, a part he'd been clearly told to avoid. He asked Dan where they were going, yelling to be heard over Bono's scratchy voice emanating from the boom box: "I still haven't found what I'm looking for..." Twumasi was sorry he'd asked when he heard Dan's reply: "Watts!"

No matter how brown his skin was next to Dan's pale body, Twumasi did not want to go to this neighborhood. Any place that is best known for a race riot could not be good. Dan, set on checking out the Watts Towers, the unusual folk sculpture, rolled his eyes at Twumasi's protests.

Pulling off the freeway, they began to snake through the nearly deserted, litter-strewn streets before coming to a sudden stop. Looking across the street, Twumasi saw an enormous, muscular black man clad in leather, with a bandana around his forehead. At his side was a Harley Davidson. Actually, Twumasi saw with horror an entire row of bikes gleaming in the afternoon sun outside a bar, looking very much like horses waiting for cowboys at the saloon. Dan grabbed his Nikon from the floor and motioned to his passengers to get out. "No way! I'm staying right here—in one piece," Twumasi said, slumping down in his seat. Dan gave him a teasing smile and a little salute with two fingers to his forehead, then got out of the car and, in his long-legged, sauntering style, approached the man.

Peeved with Dan for getting them into this situation, and concerned for their safety, Twumasi watched closely from his perch. He was amazed by what he saw. Within minutes, the man smiled and posed with his bike, as Dan clicked away with his Nikon, making gestures of encouragement to his latest model. Feeling rather silly about their earlier trepidation, the brothers got out of the car and went over to meet the biker, who invited all three inside the bar to meet his friends. The men, leather clad to the last, seemed genuinely delighted to meet the trio of world travelers with their hodgepodge of accents and collection of exotic homelands. They were peppered with questions and hospitality, including an invitation to happy hour the next night. Dan took them at their word and wanted to return, but Twumasi thought that Watts at night might be a different experience, one he didn't plan on having.

Who could have foreseen that biker and his barroom of friends? One thing Dan loved about safari is that it implied an unknown ending. Having the sensibility not only to expect the unexpected, but to relish it, is wholly un-Western. But in Africa, where there's not a gas station on every corner and a tow truck isn't often a phone call away, it's impossible to operate this way. As Dan's friend Tara Fitzgerald, who has lived in both Kenya and England, says: "In London, you plan to go to the bank, and you go to the bank. It's so simple, you hardly think about it. But in Africa, you make a plan for the day or for a trip and, sure as eggs are eggs, it won't pan out like that."

Why plan too extensively when the plan is bound to change? There's always a turn in the road that you can't quite see around, and waiting on the other side could be a sweeping, magnificent vista or, just as easily, a spilled box of nails poised to poke a hole in your tire.

"At the moment, the most utopian feeling that I have found is the excitement and freedom of exploration, as Safari as a way of Life," Dan wrote to his grandparents. "This is what makes me happy now." Freedom to make one's own successes and mistakes. Freedom to meet every sort of person, from waitresses to dancers involved in a tribal ceremony, from AK-47-toting soldiers to schoolchildren. Freedom to sleep in your car or stay up all night talking with a new friend. As Roko Belic, one of Dan's safari friends who has traveled around the world since their first journey together, reflected, "Safari is about constant play, constant curiosity, constant resourcefulness. It's a perspective on life, a life lived in eternal exploration."

Santa
Monica
Beach

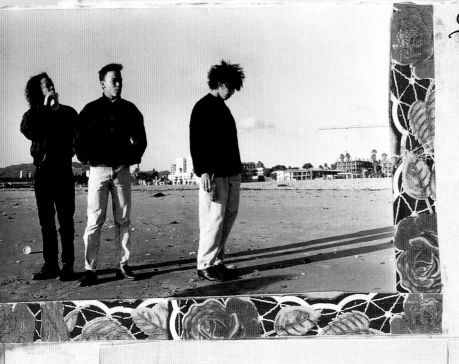

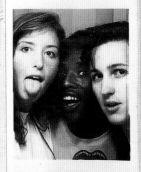

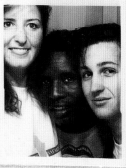

+ Tara Limbasuta

Select your team with
care, but when in doubt, take on
some new crew and give them a
chance.
—Dan's mission statement

California dreaming

Over the 1989 Christmas holiday, Dan flew from Kenya to Iowa,
where he bought an old brown Ford Tempo from a friend of his
grandparents. It looked like a grandparent car, but he didn't mind
as it was his ticket to a solo trip across the country. Since Dan
had visited only a few parts of the U.S. before, Interstate 70 was
as full of curiosities for him as a trip through the African bush
would be for an American teenager. He paused at truck stops and
scenic overlooks. Semis towing everything from livestock to
mobile homes amused him, as did the mom-and-pop motels where
he stayed. When he arrived in California, he headed for one of the
only familiar faces he knew in town, another ISK pal.

Twumasi had gone to ISK and was now finishing high school in an L.A. suburb after he'd chosen not to join his parents, American diplomats, when they were transferred to Liberia. A college student named Hayden Bixby, a friend of friends, had stayed with Twumasi's family in Kenya while attending the University of Nairobi; now he would stay with her family. Dan spent the first few nights with them, getting to know Hayden and her brother Ryan. They introduced him to the city and suggested that he attend Pasadena City College while waiting for the in-state status that would make UCLA more affordable.

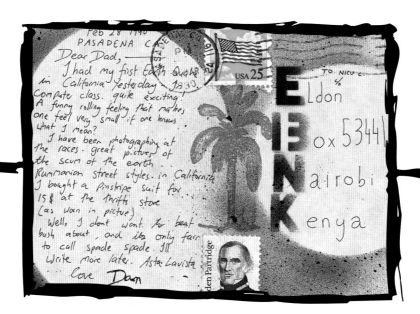

Money wasn't an issue as his college expenses were paid by his mother's parents, but he was loath to spend any more than necessary on traditional learning when he could save instead for safaris, the best form of learning he knew.

During his first week in California, Dan met Eiji Shimizu, a Japanese student who had, ironically, just transferred from a university in Iowa, finding there to be too many other Japanese students there. California, he thought, would be better. Meeting at the college housing office, Dan and Eiji replied jointly to a request for roommates from another Japanese student, Nori, who already had an apartment. Eiji was initially skeptical of his new friend, whose plethora of funny accents and penchant for disguises unnerved him. In his six months in the States, he'd gotten used to

American humor, but this was totally different. And who was Monty Python?

Within hours of his first day of classes at Pasadena Community College, Dan was thinking about the next safari, though he wasn't sure where it would be. In the same situation—a new apartment, return to school, new friends—most people would have been content to sit back and relax while putting down some roots. But he seemed nearly incapable of such calm; his mind was always roaming the backroads of Africa.

Pasadena, 1990 California Highway Patrolmen are explained the "chai" theory by prof D. Eldon MBA. author of "The Economics of Magendo"

One night while watching a documentary about Africa with Eiji, an idea came into focus. As Dan told Eiji what he'd seen the summer before on his long safari, especially the suffering and horrible conditions endured by the refugees from Mozambique's civil war, they began planning how they could help. Both were interested in business and showed acumen for fund-raising; at the very least, they could help financially. As their brainstorm blossomed, they set off for a middle-of-the-night drive into the Pasadena Hills. Beneath them, Los Angeles pulsated with light, as they made a pact to help the refugees.

They recruited their friends and soon the apartment became headquarters for Student Transport Aid (STA), as the relief project was dubbed. Next to the front door, they kept a large

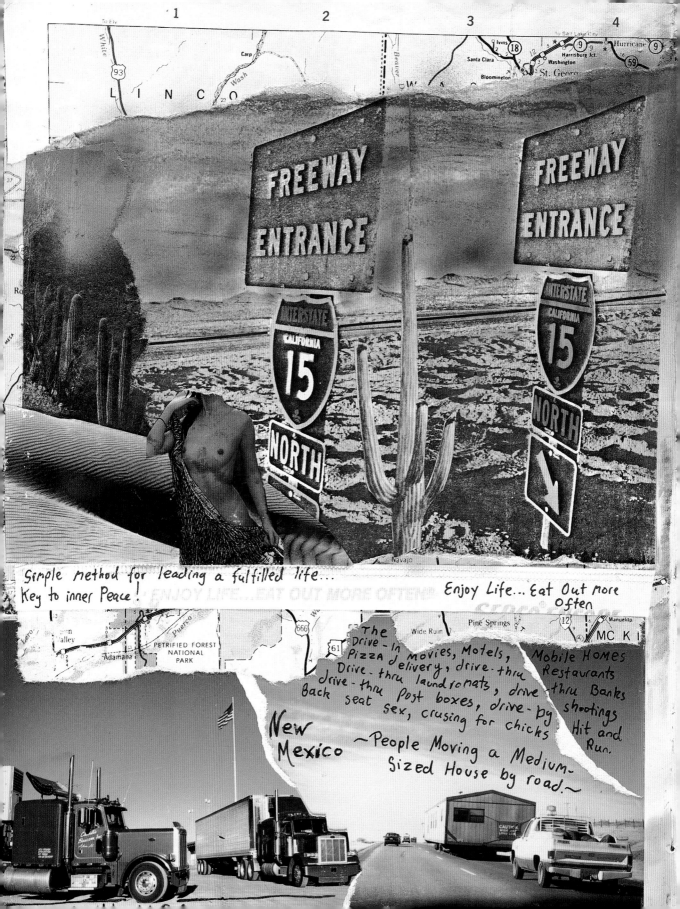

Simple method for leading a fulfilled life...
Key to inner Peace!

Enjoy Life... Eat Out more
Often

The
Drive-In Movies, Motels, Mobile Homes
Pizza Delivery, drive-thru Restaurants
Drive-thru laundromats, drive-thru Banks
drive-thru Post boxes, drive-by shootings
Back seat sex, crusing for chicks Hit and
 Run.
New
Mexico ~People Moving a Medium-
 Sized House by road.~

jug into which everyone who visited had to empty his or her pocket change. Eventually, they netted over a hundred dollars in jug money.

Although Dan missed Kenya, as he had while living in New York, the homesickness was not as acute and the California sunshine was kinder on his moods. His new group of friends—all of whom were part of the STA effort—provided him with steady companionship. With Twumasi, he shared the familiar names and jokes of high school. Hayden had lived with the Masai, and she and Dan had mutual respect for the Kenyan people and landscape. In Eiji and Ryan, he found outlets for humor, art, and adventure. He saw a few girls too. The one he spent the most time with, Akiko Tomioka, was visiting from Japan, a friend of Nori's. Several nights a week, the group cooked together, practicing what Dan called "sincere cooking," meaning that although a meal was humble (rice and beans often), it was the cook's best effort and must be thoroughly appreciated.

Dan and Eiji's initial idea had been to raise money and donate it to an aid organization. As the group talked to aid groups and learned about the world of nongovernmental organizations, they became concerned that the money would be misappropriated or spent only on administrative costs rather than as direct aid. Instead, they would take the money to the refugee camps them-selves, a plan that had the added attraction of a glorified road trip.

The group spent many hours on fund-raising and planning trip logistics, to the point that Ryan even dropped a class to make more time for STA. Although many of them were driven initially by Dan's charisma and the romance of the adventure, as they better educated themselves about the appalling conditions in Mozambique and neighboring countries to which the refugees had fled, their commitment grew. During late-night runs to Kinko's, they copied fliers describing the refugees' situation and the need for aid. Mike Eldon mailed them five hundred Masai beaded bracelets from Kenya (many of them made by Kipenget), which they sold at weekend swap meets and at a table on campus, along with T-shirts that Dan designed. He printed the shirts clandes-tinely during several all-night sessions at the studio used by his silk-screening class. When the professor questioned him about his long hours and the fast-dwindling ink supply, he relied on the Kenyan art of *magendo*, slipping him twenty dollars to stifle his concern. In addition to these wares, which were popular with

127

students and sold quickly, they organized a dance performance and approached church groups, businesses, and family friends for direct contributions.

They settled on a Kenya-to-Malawi route, essentially the same route that Dan, Lengai, and Patrick had taken the previous summer. In addition to Deziree, they'd need a second vehicle. Dan contacted the former ISK teacher he'd met while camping in Tanzania at the end of his previous trip, asking to buy his Toyota Land Cruiser, which was in storage in Kenya. After sealing the deal, he came up with a name: Arabella Mentirossa.

He called Amy and Lengai in England, and they both eagerly signed on to the project and tried to recruit their school friends to join them. One of Lengai's best friends, Chris Nolan, had been to Kenya the year before and was happy for the opportunity to return. He mentioned STA to Roko Belic and Jeff Gettleman, two of his childhood friends who were desperately trying to get to Africa. They'd spent much of their freshman year applying to pay-for-work programs, always coming up empty-handed. Hearing about "a guy named Dan planning a relief trip to Mozambique," Roko pictured an experienced, thirty-something professional who'd led many such excursions. Two weeks later, when he and Chris drove to Pasadena from Roko's university in Santa Barbara, that image was shattered when a lanky guy who looked their age or possibly younger opened the door and showed them into an apartment filled with pizza boxes and other debris of college life. Roko was impressed by the array of people there, a veritable melting pot of nationalities and accents. What's more, in the midst of classes, romances, and trips to the beach, they had raised nearly ten thousand dollars.

Meanwhile, other team members were recruited from afar. Dan wrote to Marte, the Norwegian girl he'd shared an amazing sunrise with in the Ngong Hills the year before. They'd stayed in touch and he had hopes of something more happening between them. It was already April when Marte accepted; in order to make money for her plane ticket and the hundred-dollar-per-week allowance that Dan had recommended for each member, she worked long, dull hours at a 7-Eleven in Oslo, considering it well worth the adventure she knew awaited her.

In Sweden the summer before, another meeting eventually produced an STA member. The Eldons' good friend Mary Anne Fitzgerald met Elly Tatum, an American girl who was eager to learn about

Africa. The two talked about the possibility of her working as Mary Anne's assistant. Back at college in New York state, Elly had given up on hearing anything from Mary Anne by May. But then, in the last week of school, she got a letter from her with an STA flyer and Dan's phone number. Elly called immediately, failing to notice that it was six in the morning on a Sunday. Annoyed to be awakened, Dan gave her the merest details of the trip, accepted her sight unseen, and told her to book a flight. She did all of this within an hour, stopping only then to call her parents and tell them of her plans. Later, they were anxious enough to have a long phone chat with Mike Eldon, but at the time they offered only enthusiasm, as well as a generous financial contribution to the aid relief.

Others had more trouble convincing parents. Amy and several friends, who were just sophomores at the time, assembled a briefcase of information to present to worried families, highlighting the trip's merits and relative safety. Their effort proved unconvincing. Several of Dan's oldest friends turned down the opportunity because of previous summer plans—work, school, travel. Many, including Mary Anne's daughter Tara ("one of the worst decisions of my life!"), came to fiercely regret the decision. One team member, Twumasi, had to drop out because his parents were caught in the civil war in Liberia and he needed to be available as they tried to get to the U.S.

As the trip fell into place—they were very close to their goal of twenty thousand dollars by the end of the school year—Dan continued to explore his immediate surroundings. He loved donning one of several navy blue blazers he'd bought at second-hand stores and going to shoot pictures at the racetrack. The people, the "dodgiest characters in L.A.," fascinated him. Longing for the disorder of Kenya, he took Akiko to Mexico for a weekend. Someone shot a gun just over his head, a case of mistaken identity, and they went to seedy little bars and drank cheap beer. It was as good as being home.

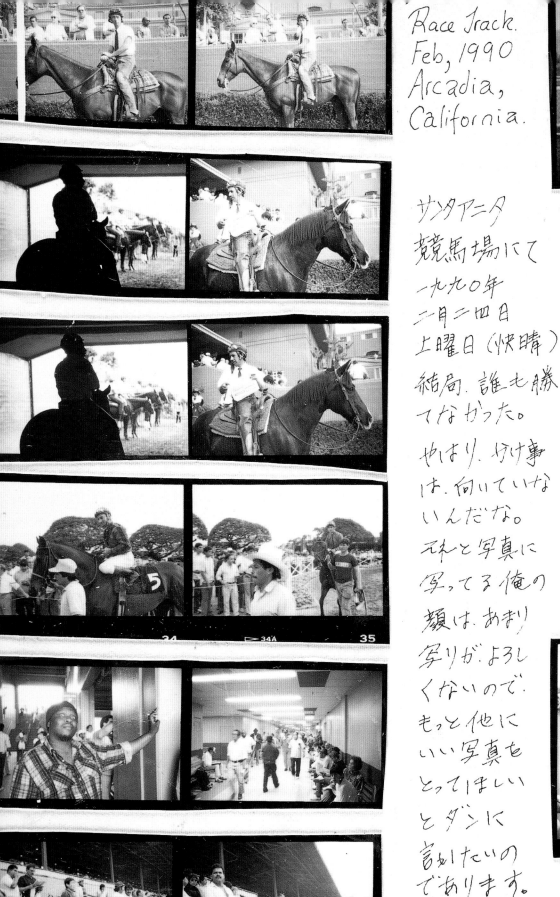

Mexican Man
and baby

サンタアニタ
競馬場にて
一九九〇年
二月二四日
土曜日（快晴）
結局、誰も勝
てなかった。
やはり、かけ事
は、向いていな
いんだな。
それと写真に
写ってる俺の
顔は、あまり
写りが、よろし
くないので、
もっと他に
いい写真を
とってほしい
とダンに
言いたいの
であります。

Eiji Han
Japan

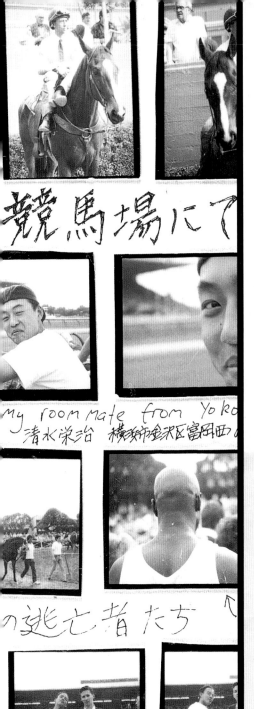

競馬場にて

My room mate from Yoko
清水栄治 横須賀市金沢区富岡西

の逃亡者たち

ダン と ティモシー

Mainly, he liked Los Angeles, especially the absurd mixture of cultures. He wrote to his dad: "The great thing about the U.S. is that you can go anywhere in the world not far from your house. Last weekend was the Thai New Year. I went to the park and saw the whole scene with dancers, monks, etc. I was the only *mzungu* there except for some sleazy fellows who had mail-order Thai brides. On May 5, the Mexicans had their party and I went to Santa Monica beach and, again, I was the only *mzungu*."

In June, with part of the team accompanying him and others soon to follow, he headed to Kenya. He got on the plane with the same expectancy he always felt when returning excited to see the giant sky and smell the hot, dusty air; eager to hug his father and William—but also with a wad of hard-won cash and a new sense of responsibility. With just three classes under his belt, he was hardly a college freshman, but he was taking his second extensive trip through southern Africa. This time, thirteen people would be looking to him for guidance.

131

muthaiga strategy

"What could go wrong?" Mike had taken the pen and small pad the waiter had left on their table for drink orders and was poised to jot down the answers. When Dan wasn't forthcoming, he began: "Traffic accident. Illness. Mugging or theft. Border problems. Lost passport. Danger near Mozambique."

Momentarily daunted, Dan ran his hand through his unruly hair and swore under his breath. He took the list and pen from his father and added his own: "Random arguments. Jilted lovers. Bad food. Vehicles break down incessantly."

Mike looked at the list and burst out laughing. "Well Dan, that's a given! It is a safari after all."

Dan had arrived several days earlier from California and gotten right to work. There were visas and travel permits to organize and gear to assess. He'd rescued Arabella from storage and taken her for a test run. He hadn't even tried turning Deziree's ignition, knowing that after having sat in the driveway for six months, she was sure to need work.

But he was becoming increasingly worried about the interpersonal end of the trip. For the past months he'd been so eager to go, ensconced in route planning and fund-raising, that he'd practically forgotten that thirteen other people would be along, most of them looking directly to him for guidance. He'd accepted everyone who had expressed an interest in going, sometimes sight unseen. Now they were beginning to arrive in Nairobi and staying at his home, each with complex personalities and needs in tow.

Sensing his son's nervousness, Mike had offered a strategy session over dinner at the Muthaiga Club. Muthaiga is a Nairobi institution, its low-slung, pink stucco structure nearly as old as the city itself. The stuffy country club—complete with a swimming pool, squash courts, and men's bar—was started by the settlers of the early 1900s, some of whom were notoriously high-living bon vivants. Stories abound, many of them no doubt hyperbolized, of great white hunters seducing socialites behind the club's potted plants. The writer Isak Dinesen, aka Baroness Karen Blixen, caught her own husband in such a compromising situation at Muthaiga several times. Today, it is a fairly staid place, more predisposed to decorum than wild parties. Dan, amused by its stodginess, had his father send him club newsletters so he could keep up with the latest oversights in etiquette by various members.

"There may be bedlam on the streets, but all I can say is thank god he's still here; makes me sleep easier about the direction this country is taking," said Dan in a mock serious tone as they entered the club's lobby and stood face to face with its mascot, the front half of a mangy old stuffed lion behind a glass cage. Dan was alluding to the growing tension among Kenyans, who were clamoring for multiparty elections. There had recently been a smattering of demonstrations.

After Dan waited for Mike to stop and greet several people he knew, they were escorted to a corner table in the wood-paneled dining room. With gin and tonics in hand, they scanned the room for old-timers, the characters Dan was fond of satirizing in letters to his father. "No sign of Mrs. Sydney Biddle Wallingworth Highsmith today," he sighed.

Over pepper steaks—Dan's favorite—they reviewed the people with whom he'd be traveling, ticking off their possible strengths and weaknesses as road warriors. He counted them on his fingers as he went. "Lengai and Amy are givens—we already know too well their abominable weaknesses, but I'll just have to suffer along with them." Mike immediately confirmed the ironic quip, "Oh yes, absolutely hopeless those two. Neither is to be counted on in any situation!"

"Then there's the California crew. They're ready. We've been working together for months. Hayden has been here before and knows her way around. She's older—twenty-one, I think. Eiji is crazy, completely mad, but in the best possible way. Likewise, Ryan is a good one. I'm a bit worried about Lorraine, his

girlfriend, though; she's young, still in high school, could be difficult, though she sold a hell of a lot of bracelets for us! Akiko—that's the girl I was seeing in L.A. Her English isn't so good, and I think she's just been in the U.S. and Japan—like Eiji. But she's so happy, laughs at absolutely everything! I took her to Mexico and she was great; hardly even flinched when that guy tried to shoot at me."

Mike wasn't sure he recalled the shooting story, but he let it pass for the moment, making a mental note to inquire about it later. "Sounds good so far," he said instead, already trying to keep straight all of the names and nationalities.

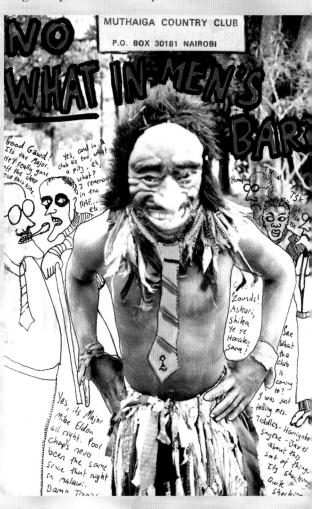

"Marte is coming from Norway. She was at ISK. Her dad is an aid worker, mum's a journalist. She'll be fine."

"And she's quite pretty, as I recall," said Mike, sensing a possible complication in the making. "Any worries about having both Akiko and Marte on the trip?" Dan gave only a mischievous smile and continued.

"Chris has been here before. Seems a sensible chap. Lengai vouches for him up and down. Robert Gobright was a friend from ISK." Mike nodded, recalling the young man who had spent much time at their house during his and Dan's senior year in high school. "He knows the country and he's tough, street smart, but with a temper. I'm a bit worried about that, but I need him as a mechanic so people will just have to deal. Then there's this girl Mary Anne recommended, Elly, a New Yorker. I've no idea how tough she is." By the count on his fingers he could see he was missing two people. "Who else?"

"Oh yeah, two guys from Chicago: Roko and Jeff. They have some connection to Chris Nolan—all too complicated to keep straight. I

met Roko in California. He's a nice guy, an art student. He and his friend are into filmmaking and photography."

Mike agreed that it was quite a crew, with different languages and cultural expectations. He and Dan discussed the management techniques he used in his office to unify people behind a common goal. Really, though, he knew that Dan's tremendous leadership skills would kick into gear and all would be fine; when it came to motivating people, Dan was downright masterful. "Just tickle them along, Dan," he kept advising.

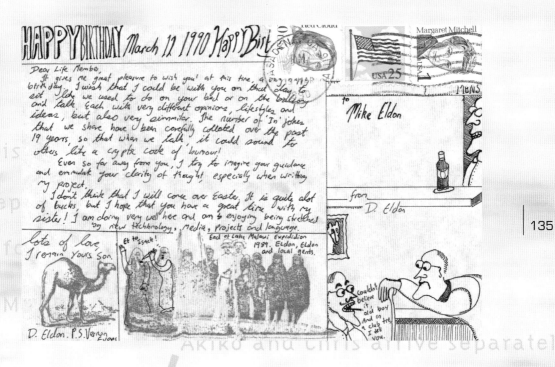

After Dan looked further at the list of possible worst-case scenarios, he began to feel better. He didn't think the dire things his father had listed would happen. He and Lengai had gotten through the previous summer without incident, so why should something happen now? Looking at his own list, he laughed and told his father that it was no worse than what happened between any group of kids holed up together in a small space: "It'll be just like a dormitory on wheels."

MEETING

A.J. Hans and Dr. Croze deiiver their powerfull speech to the House.

The Mechanics report on the state of the vehicles

NEEDS

scab

COWBOY JUNKIES

Student Transport Aid Meeting 1990 Blantyre Sports Club car park.

For the previous two days, we had split into groups of two or three and had gone to the various aid groups operating in the area.

Each group tried to get an idea of what the needs of the organizations were in terms of money and transport.

Leagan, Dan and AJ went to the Red Cross and had the displeasure of meeting Matel Furbie the director who told them how insignificant the contribution would be for such a large organization like theirs. Aratella then proceeded to stall and refuse to start in the driveway. Ryan had positive feedback from Sam the children who had great need of a vehicle.

Akiko and Eli visited ONHCO and did not find out too much but were given a nice map. Hayden went to AFRICARE and Amy and Marie went to the Norweigen Refugee Council who were very receptive.

> Later on I had many other Safaris, but for some reason, this particular expedition was dear to the hearts of the people who had been on it. Those who had been with me came to look upon themselves as a Safari-aristocracy.
> —Isak Dinesen, *Out of Africa*, 1937

the great one

137

The two vehicles kicked up dust as they bounced along a Tanzanian "highway." Loaded down with people and supplies, not to mention their own bulk, Deziree and Arabella could only go so fast. Already, some of the group members had taken to wearing bandanas over their faces to cover their mouths and noses from the pervasive soot. "It's even in my belly button," one person exclaimed at a pit stop.

After hours of watching palm trees whiz by, Dan, who was behind the wheel of Deziree, signaled to Rob, driving behind him, to stop in the next town. The group piled out of the cars and onto the streets of Tanga, a Muslim town on the coast. Eager for food and happy not to be moving, they followed Dan like a gaggle of duck-lings down the street until he chose a restaurant. Chinese food in sub-Saharan Africa felt like a gamble, but they were all quickly realizing that the trip would have no standard for normalcy.

They burst into the small dining room, where the handful of patrons and the two staff members looked up in unison, astonished by the sight of fourteen Western kids—black, Asian, and white—in T-shirts, shorts, and sneakers coated with dust. Commandeering over

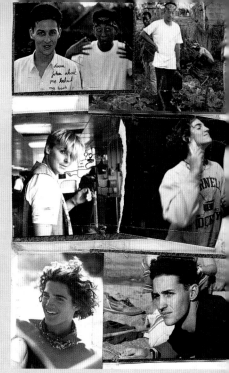

half of the tables, the group rowdily vied for seats, already beginning to divide into subtle cliques. As Lengai encouraged them to try the banana fried rice—really, it's good—Dan grabbed a cassette from his pocket and asked the proprietor if he could pop it into the tape player, which was emanating a scratchy radio news program. The quirky soundtrack to the film *Betty Blue* quickly filled the room. Somehow it was the perfect backdrop to the scene; as always, Dan could both match and create a mood.

He pulled up a chair next to Lorraine Govinden, Ryan's girlfriend. "Chaka Chaka, I hear you had a scare back there?" he asked, using the nickname he'd adopted for her since watching her phenomenal dance moves at a Nairobi nightclub the previous week.

It was July 10, just two weeks after he and his dad had met at the Muthaiga Club, and already one of the dangers on his dad's list had happened: illness. Several of his own worries had come to life as well, including people not getting along, and Rob's temper. He was trying to assess just how serious the situation was.

After they'd crossed the Kenya-Tanzania border a few hours earlier, Lorraine had fallen into a severe coughing fit. As she wheezed and gasped for air, several other passengers had yelled at Rob to stop driving, but he'd refused, claiming there wasn't a safe place to pull over. Finally he stopped and she caught her breath, gulping down some water to clear the dust. Rob would not explain his actions and Arabella's passengers drove on for an hour with their arms crossed in simmering silence.

After Dan heard several versions of the story, he decided that Rob was as much of a hot head as he'd been in high school but had meant no harm, and that Lorraine had probably suffered a minor asthma attack that scared her more than anything. He chalked it up to first-day jitters and sat back, watching the funny, unlikely scene unfold at the restaurant.

☺ ☺ ☺

Most people's jitters had begun a week earlier as they arrived in Kenya. It was late June, and many were just a few weeks out of

school. After they'd tucked themselves into any open niche of the Eldon house—a sofa here, a guest room there—Dan busied them with preparation. They checked the tents for leaks and headed into town to buy supplies. With sideways glances, they delicately tried to assess one another.

Some of them were as new to each other as they were to the country. They all spoke English, although some had heavy accents. Elly, a vegetarian, fretted over what to eat. Marte, who had not seen Dan since their sunrise kiss a year and a half earlier, wondered whether their relationship might spark again. Hayden, the oldest, doubted whether coming on a trip with a bunch of teenagers was such a good idea.

For each, the trip was a gamble that came with its own set of risks. It was impossible to predict how each would fare.

Dan was in the center of the commotion but also outside it. Everyone came to him for direction, but no one was really with him. It felt much different than the summer before when he'd had only himself to worry about. One afternoon he stood in the driveway, his nerves frayed by his hopeless tinkering with Deziree's tangle of hoses and valves. Finally undone, he stomped inside and snatched the phone off the wall: "Legs, where the hell are you? I need you here! *Haraka!*"

When Dan could no longer entertain his crew with the usual Nairobi amusements—chicken *tikka* on River Road, a visit to Kipenget's, a romp in the gorge at Kitengela—he decided to leave for the Kenyan coast, about two hours away, with everyone who had arrived already. Chris volunteered to wait behind for Rob, Jeff, and Roko.

At Diani, they stayed in the beach house of one of Dan's high school friends. It was an idyllic vacation before the hard work of the journey began. They went horseback riding and played in the waves. A few began to take on roles. Eiji created an accounting system. They were carrying a large sum of cash to donate directly to the refugee camp and wouldn't want to declare it as they crossed borders, for fear of some hidden road tax or entrance fee gobbling it up. Instead, they planned to hide it in the two cars. Elly quickly took over many of the cooking duties, doing shopping in town and making tea in the morning.

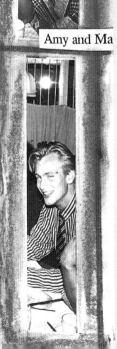

Amy and Ma

The Great One

For Amy's sixteenth birthday, she made a cake out of crepes and ice cream.

After several days of play, the Nairobi contingent arrived. When Hayden saw Jeff and Roko, both of whom had shoulder-length hair, she briefly mistook them for girls. With enormous grins, they introduced themselves all around. Just days ago, the two friends had been painting houses in Evanston, Illinois; they still had white specks on their hands to prove it. Now they were in Africa. The drive from Nairobi had been wild. Despite the fact that Deziree was leaking gas, much to Rob's consternation, they'd whooped and hollered the whole way down, growing especially ecstatic whenever a baboon or giraffe crossed the road.

Roko, Jeff, and Chris had already had an electrifying introduction to Africa. On their first day in Nairobi, two days after the rest of the group had taken off for the beach, they'd been roaming around downtown when they were caught in a violent political demonstration.

"The streets were quiet—too quiet," described Roko, the whole group listening intently to the tale. "And then suddenly—wham! —there were people everywhere, running and screaming." The three had run too, with Jeff becoming separated from the others in the chaos. Eventually, all three had made it safely home. Watching the news reports on TV in disbelief, they saw that several people had been killed in what came to be known as Saba Saba Day—*saba* being Swahili for "seven" and it being the seventh day of July.

As they enthusiastically re-created the scene, excited by the adrenaline rush of the riot and alarmed by its obvious danger, Rob pulled Dan aside to air a few complaints. A month ago, Dan had called him in the U.S. and asked him to be STA's head mechanic. Rob had very much wanted to get back to Kenya, but now he was having doubts. Already, he'd been forced to buy parts for Deziree, dipping into the little money he had. Jeff and Roko's childlike enthusiasm had only compounded Rob's frustration. He couldn't foresee the two doing any of the hard work that a trip of this magnitude would entail and did not hesitate to tell Dan that he considered them to be dead weight. Dan shrugged. To him, Jeff and Roko seemed funny, a sort of comic relief. Besides, they were here; he couldn't get rid of them now.

Later that night, after they'd reviewed their route for the next day—the first real day of the trip in most of their minds—Amy awoke to see a light still burning on the porch. She got up to put it out, pulling a *kanga* around her shoulders for warmth against the night air. There at the table was Dan. With a map strewn at his feet and one of his metal boxes of art supplies open next to him, he was working on a journal.

"Hey Mutz," he greeted her with a yawn, using her childhood nickname. The two had found barely a second to talk. It had been months since they'd seen each other—too long. "Back rub?" she asked, standing behind him and beginning to rub his slight muscles. When they were kids, their mum had rubbed their backs as they sat at the table in the evening doing homework. In her absence, they continued the tradition.

"Do you think we'll pull this off?" he asked. It was like him to say "we," she thought, including everyone in the responsibility. But she knew he was asking about himself. "Of course we will. *Enshalla*," she reassured him, using the Arabic phrase—*it is fated*—they both used often, to reassure him. To seal it, she leaned down to give him a quick kiss on the crown of his head, just as a breeze blew in from the ocean and the light in the hurricane lamp flickered out.

☺ ☺ ☺

Lorraine's coughing fit turned out to be the biggest incident during those first few days. As with most road trips, events swirled together—long blocks of time spent crammed together in the bouncing vehicles with people swapping childhood stories from New York, Yokohama, and Oslo were broken with pit stops. Pulling into a little village, they'd usually find cold sodas at the lone *duka*. Dan would get out his old-man mask and attract a crowd of laughing children and bewildered adults. They traveled slowly; the large, heavily weighted vehicles moved slowly and the roads were awful. Over the course of eight to ten hours, they averaged about two hundred miles.

At night, they were tired and dirty. Their exhaustion sometimes caused tiffs but, more often, slap-happy goofiness. Their sleeping arrangements were unpredictable. Once they stayed illegally in a national park, bushwhacking their way out in the morning to avoid paying a fine. Many times, they found cheap motels with thin mattresses and clogged sinks. To cut expenses, they slept

two to a bed, with a few people sprawled on the floor or out in the Land Rover.

The schedule was frequently broken by emergency maintenance stops. Lengai and Rob, perpetually covered in grease, would crawl under Deziree or Arabella, trying to assess the problem. If they couldn't do the job themselves, they were forced to seek out a village mechanic. During these stops, Hayden often grabbed a book and perched on top of one of the vehicles—whichever one wasn't in need of mending. It was a chance to get away from the others for a moment and also allowed her a vantage point from which to play anthropologist.

On one of these occasions, Dan was sitting below her, trying to sort through some paperwork, despite constant interruptions. First it was Elly looking for the bag in which she kept the mangoes; never one to be overly concerned with food or neatness, Dan had no idea there was such a bag. Then Lorraine needed an aspirin for a supposed fever (she went so far as to put Dan's hand to her forehead). Eiji, in need of nothing in particular, stuck the video camera into Dan's face, only to receive a hand placed over the lens: "Watch it!" Then Roko, 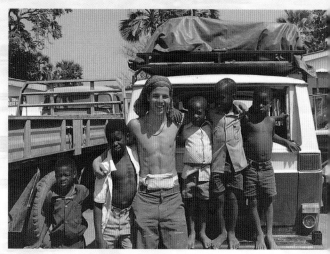 looking for a translation of some Swahili he'd heard at the market, rested a hand on Dan's shoulder. "Cut it out, man!" Dan said, brushing aside the hand. He called Roko and Jeff "the shoulder pat boys" and was impatient with this American habit.

Hayden was glad to be alone on the roof. She wondered to herself how long Dan could deal with every question, every missing item, every complaint. Had he realized what he was getting into with this leadership routine?

As personalities continued to collide, Elly and Rob had a running spat that flared every morning when Elly tried to make breakfast and Rob, a late sleeper, complained about the noise. After he'd been especially harsh one day, Dan took off after Elly, who had fled in

tears. He tried to explain that Rob meant no harm, that he was going through some difficult times. Then he pulled the eye of the *dhow*, the Muslim crescent moon and star symbol, off Deziree's storage container. "This is for you," he said, putting it in her hands. "It will guide you through rough weather and over rocky places." Elly brightened, wiping her eyes.

Dan sensed that Elly's raw nerves were indicative of a greater group strain. Spending day after day in the heat and dust, eating strange food and sleeping in uncomfortable spots, was growing old for some of them. A rarely successful search for hamburgers and Diet Coke had begun to take on monumental proportions whenever they entered a village.

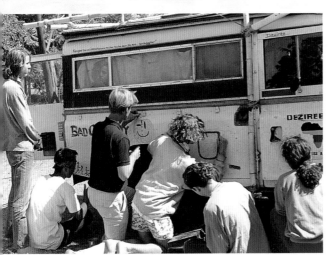

One evening, as they spread out their tents and prepared to camp, Dan decided to try some art therapy. He yanked out his supply boxes and began tossing watercolors to team members. "We need a little color here, don't you think?" he yelled, rallying them around the Land Rover and insisting they decorate her. When they stared at him blankly, he grabbed a brush and painted one of his trademark dancing men on the hood. Soon, they formed a ring around the vehicle, each working intently on his or her design, while Dan sat on a cooler watching, beer in hand.

"Aren't you going to paint?" Jeff called to him. He nodded and said that he was just the "facilitator."

After an hour of heated work, they all stepped back to inspect their metal canvas—the girls' side full of rainbows, the boys' ridden with dark, warlike imagery. Lorraine complained that it would all wash away in the rain, but Lengai reminded her that rain was uncommon this time of year, hence the parched earth. Dan beamed. "That was a brilliant idea you all had!" he said, and almost no one remembered that it had actually been his.

☺ ☺ ☺

143

The biggest source of tension—of long, fiery glances and occasional outbursts—was not Elly and Rob, nor any of the other little factions that formed, but Dan himself. He had invited Marte on the trip hoping that something might work out between them. He'd also invited Akiko, figuring he had an auxiliary plan either way. What he hadn't foreseen was Marte with Lengai.

Since the trip to the coast, both Dan and Lengai had been flirting with Marte, each insisting that she sit next to him while he drove or taking her to dinner in the evening. Confused by the attention, she reciprocated with both of them. Dan, especially, was growing unnerved by the not-so-subtle game the three of them were playing.

As the rest of the crew sat around a campfire one night, he led Lengai down a pitch-black road. With not a soul in sight, much less a car, Dan laid down. Towering above him,

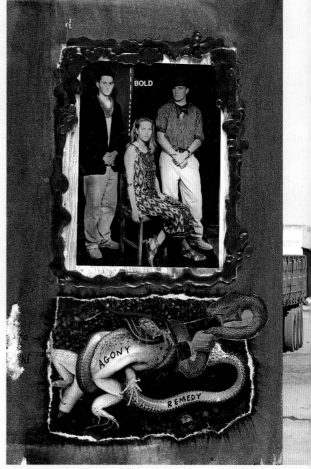

Lengai heaved a sigh: "What are you doing, Eldon?" Dan didn't stir. Lengai lay down next to him and stared up at the cosmic sea. He suddenly remembered a night at Kitengela from their childhood. Dan was not used to the wild calls and night noises of Lengai's family's remote property, but he knew the stories of the Masai who'd led raids against them. "What's that?" Dan would call to Lengai across the dark room, his voice full of excitement. Roaming elephants and Masai *morans* weren't on tonight's agenda, however. "What are we going to do?" Lengai finally asked.

"Well, as I see it," Dan said, his long fingers gesturing in the air between them, "She wants you. AND she wants me. I don't know what the hell she wants. But I don't think we're going to find out until we both lay off."

Lengai considered this for a moment. If they both stopped paying attention to her, would Marte choose? He wasn't sure, but he didn't

have a better idea. "All right. That's what we'll do." They remained there for another half hour, surrounded by darkness that seemed to take on weight and matter. Then, in the distance, they heard Amy laugh. It brought them back to the moment, propelling them to their feet and back toward camp.

The morning of July 15 began poorly. It was just five days since they'd left the coast. The previous night, they'd been unable to find a hotel until 3:00 A.M. People were slow to wake up, despite needing to prepare for the crossing into Malawi later that day. As they groggily packed the vehicles and drank tea, Lorraine let out a series of gasps. No one paid much attention, assuming it was her illness of the day, until she announced that she couldn't find her passport.

In his head Dan clearly saw the items halfway down the list his dad had made at the Muthaiga Club: "Troubles at border. Lost passport." He cursed under his breath and rallied the group, sending two people back to the hotel to search and another two to the police station. After an hour, the passport still missing, he and Lengai hatched a plan. Rather than drive back two hours to the nearest American embassy, they'd risk crossing the border without it. From the summer before, they knew that the crossings were often crowded and chaotic late in the day; if there was a good time to fool the guards, that was it.

At the border, Lorraine performed perfectly, re-creating the coughing attack she'd suffered five days earlier when they had entered Tanzania. As Lengai insisted that they had to get to a hospital, the guards unceremoniously waved them through. The group let out an audible sigh, but almost immediately, Dan began to prepare them for the next challenge.

"Malawi is really strict," he said. "Women must not show their legs. No long hair on the men. And by all means, hide your copies of *Africa on a Shoestring*. It's illegal." Ryan, Jeff, and Roko, all of whom had longish hair, scrambled to find hats under which to stuff their manes. The girls spread *kangas* over their legs.

Dan and Lengai spoke briefly with the fez-wearing guard, then gestured to the others to get out of the vehicles and line up against the wall. The group exchanged worried glances, noting that

Dan looked grim. After walking up and down the line, giving each of them the once over, the guard yelled a command in Chichewa. Lengai translated: "Take off your hats!" The three boys blanched. As they complied, their hair falling down, Lengai, Dan, and the guard—whom they'd recognized from the summer before and recruited for their prank—burst into laughter.

They headed straight to Lake Malawi, once again coaxing the vehicles down the infamous twenty-one hairpin bends. The water had a calming effect on everyone's tattered nerves. A group of international students who had driven from London were camped nearby, and the two groups mingled, sharing road stories. These kids had chaperones and official drivers. At the end of the night, they got called to bed, whereas the STA crew stayed up, passing beers around, smug in their independence.

Dan's plan regarding Marte seemed to be working against his favor. She soon made it clear that she preferred Lengai. Competitive and jealous, Dan took it poorly, increasingly separating himself from the group to take photos. One night, he pulled Hayden aside to show her something in his journal about the romantic triangle. Hayden—who was somewhat detached from other group members, due partly to her age and her lack of romantic involvement with any of her fellow travelers—was tired of the way the situation was affecting Dan's moods and the group dynamic, but as a dutiful friend, she read what he'd written. When she handed it back to him, he told her that he planned to glue the pages together. "Let it serve as catharsis," she said, "and then maybe we can put this chapter behind us."

A few nights later, they found an outdoor disco thumping in the center of a small village. Dan introduced them all to *chipuku*, the acrid local beer, and sat at the bar with Ryan. Out on the dance floor, several group members made up silly moves. Amy and Jeff had a friendly flirtation going, though Jeff knew better than to initiate anything with Dan constantly reminding him, "She's only sixteen!" Tonight, they were joking and brushing up against each other as the group danced en masse. Amy considered it harmless and lighthearted. At the end of one song, Jeff took the plastic beads he'd worn throughout the trip and put the strand around Amy's neck. Then he went to get a drink.

When Dan noticed the necklace, he grabbed it and broke the strand. "What are these?" he yelled at his sister. Then he picked

up an empty beer bottle and threw it toward the wall, missing Jeff but startling everyone with the shattering glass. She was used to his overly protective nature, but a jealous outburst of this magnitude was ridiculous.

Her incredulity quickly found words. "You happy now?" Amy spat, pushing him off the dance floor and into the dark, deserted street.

"Listen, I know this whole thing with Marte is hard, but you're coming undone," she snapped standing above him, as he sank onto the ground. "And if you come undone, we all come undone. This trip was your idea; you have a responsibility to see it out. Why did you do this in the first place? Because you wanted to help the refugees. Well, you aren't helping anyone right now. Besides, from what I can tell, you aren't in love with Marte. You're just jealous of Legs. The grass always looks greener when you can't have it."

Her words stung. Not only were they completely true, but she'd never talked to him like this before. He was suddenly aware of her maturity. All he could say was, "You're right."

In the last week of the trip, Dan put a new sticker on Deziree's bumper: "Positive Vibrations." They needed the sentiment as they skirted the Mozambique border on their way to Blantyre. The area had a trashed, desolated look. The purpose of the trip, largely overlooked in the past several weeks, suddenly came into acute focus. In the face of the very immediate war, the frivolity of the lake and their disagreements became moot.

While the abandoned road was a chilling reminder of war's destruction, the camp provided a complex human view. When they arrived on July 31, three weeks after leaving the Kenyan coast, many of the group found Mwanza, the refugee camp, to be much bigger and better organized than they had anticipated. The civil war had been raging in Mozambique for more than a decade, and many of the children in the camp had grown up there, never having known another home. Rows of mud huts lined dusty lanes. A shelter for group meetings and cultural events was being built in the center of camp, and this is where the STA members slept for a few nights.

During the day, they scattered around the grounds to gather information about the refugees' needs and the work of various

aid organizations. Some visited the medical area, where babies were weighed and scant amounts of medicine administered. At another large hut, they saw a busload of new arrivals. Each one was given a blanket, a food bowl, a bar of soap, and a water container. Eventually, these newcomers would be assigned a small plot of land on which to build a hut, as well as a space in the community garden. For meals, the STA group ate with the refugees. The ubiquitous, simple corn mush gave them a new-found appreciation for the canned beans and spaghetti that had been their standard fare.

Despite the refugees' meager means and difficult situation—beyond anything the Westerners could imagine—they seemed imbued with life. Babies were passed from lap to lap. Elders maintained respect and order. They were connected, even content, in the face of upheaval.

At dusk the first evening, Dan sat on top of Arabella and donned his old-man mask. Immediately, he was surrounded by a hundred laughing, screaming children. Little boys, their arms stretched skyward, begged to join him. One at a time, he pulled up a new apprentice and then hid with him under a coat while transferring the mask to the boy's head. When they pulled off the coat and exposed the newly masked boy, the crowd erupted in waves of glee.

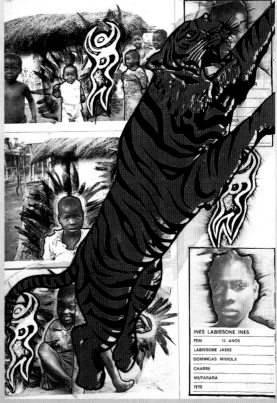

That evening, Hayden and Chris, hearing of a dance, followed the sound of drumming until they came to an open space where a large group had formed. They stood back and watched as two concentric circles, one of women and the other of men, moved through a series of pantomimes to the beat of enormous drums. One of the dancers led them gently into the circles, where they joined in, dipping and turning their bodies. As they

danced, Hayden and Chris realized what they were doing: reenacting the war in Mozambique and their fellow dancers' flight to Malawi.

☺ ☺ ☺

During the group's time at the camp and in Blantyre, the nearby town where most of the aid organizations were located, they split into pairs, with each team visiting two or three organizations. During these meetings, they tried to assess which would ultimately receive the STA donation. They wanted to find a group whose work could help the most refugees, and they wanted their contribution to be taken seriously.

On their second-to-last night in Blantyre, they gathered in the living room of an aid worker's house where they'd been invited to stay. After each pair reported on their impressions of the groups they'd visited—commenting on levels of organization, leadership, and willingness to work with STA—the group discussed what they thought were the refugees' greatest needs. It was a balanced discussion, with everyone taking part, sharing opinions and respecting each other's words. All antagonisms disappeared. Following a lengthy debate, Dan called for a vote. They decided that clean drinking water was most essential and that the bulk of their money should go to the Norwegian Refugee Council to build two wells.

That left Arabella, which they'd always intended to donate at the end of the journey. One organization had already turned down the battered Land Cruiser, claiming she was too rickety for their needs. Dan, affronted by the comment, left in a huff, claiming the vehicle was solid as a rock. But just outside the building, as he and Lengai tried to start up the engine, they got only a ghastly clicking and found she was dead.

"That's right, Dr. Eldon," Lengai replied in a curt deadpan, "solid as a goddamn rock." As surreptitiously as one could move a huge vehicle, they pushed her past the office of the man who'd just refused them, hoping to avoid notice and further humiliation. Soon after, Rob and Lengai worked to resuscitate the vehicle.

If they provided some funds for repairs and maintenance, the group felt that Arabella could be a reliable, useful vehicle for an organization short on transportation. They voted to give her to Save the Children. The remaining cash was earmarked for buying blankets.

Team Deziree Africa Exploration

Dan Eldon
Box 53441
Nairobi
Kenya
Fax 254-2-750131

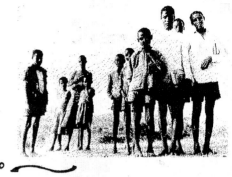

The "Oasis Deziree" and "Wadi el Arabella" built 1990

DEZIREE
DONATED BY
STUDENT TRANSPORT AID

ARABELLA
DONATED BY
STUDENT TRANSPORT AID

Above, the potable water wells that we donated to an island on lake Malawi. The pumps are shared by refugees and local inhabitants of the Island. Aprox. 7000 people use the two wells. They cost 1.500 $ U.S. each and were built under supervision of the Norwegian Refugee Council. They also built a children's hospital which we supplied with blankets.

Arve Danielsen, who accepted their funds at the Norwegian Refugee Council, was impressed by the group's planning and later recalled, "Being in Africa for many years I rarely met people like Dan, but I remember afterwards being thankful for having met him. It gave me faith in Youth." The donations were the trip's crowning moment and truly the end of the line. After a farewell dinner the next night, they began to disperse, a bittersweet affair. A few hopped on a bus back to Nairobi. Jeff and Roko had already left for South Africa. Eiji and Ryan took off for separate solo adventures. Each had a sense of accomplishment but was also ready for some breathing space. They exchanged happy farewells, jotting down addresses and promising to be in touch. Many sensed they would meet again, though they did not yet know when.

A small cadre continued onward in Deziree. Dan, Lengai, Marte, Akiko, and Rob drove the battered Land Rover back to Nairobi via a circuitous route. They headed south to Zimbabwe to visit Nancy Todd and her family, the people with whom Dan had stayed the summer before. For a week, they slept, watched movies on video, and recuperated. Dan had to explain to Nancy that although they'd had a brief romance before, he was now with Akiko, having returned to that relationship after Marte chose Lengai.

One day, Dan proposed a photo shoot in the family's empty swimming pool. He playfully directed them to create a spoof on the summer's events. "Imagine some literature for our safari company," he began, as the three girls rooted through Nancy's closet for costumes. "I see something sort of spicy, a bit naughty: Deziree Sex Safaris." Laughing at the title, they all got into the mood, pouting at his camera and baring extra skin. Dan would use the images from that day repeatedly in his journals, the girls in their skimpy dresses, Lengai bare chested.

When they finally turned toward Nairobi, a melancholy quiet overtook the group. No one wanted the safari to end. As Lengai drove through the dark night, Marte at his side, the others sat in the back. They occasionally passed someone walking with a load on his or her head in the murkiness of the dusty night. Dan felt the rhythm of the road underneath them and quietly chatted with Lengai, Akiko asleep on his chest. He'd never felt such peace. There in the Land Rover was everything he wanted.

151

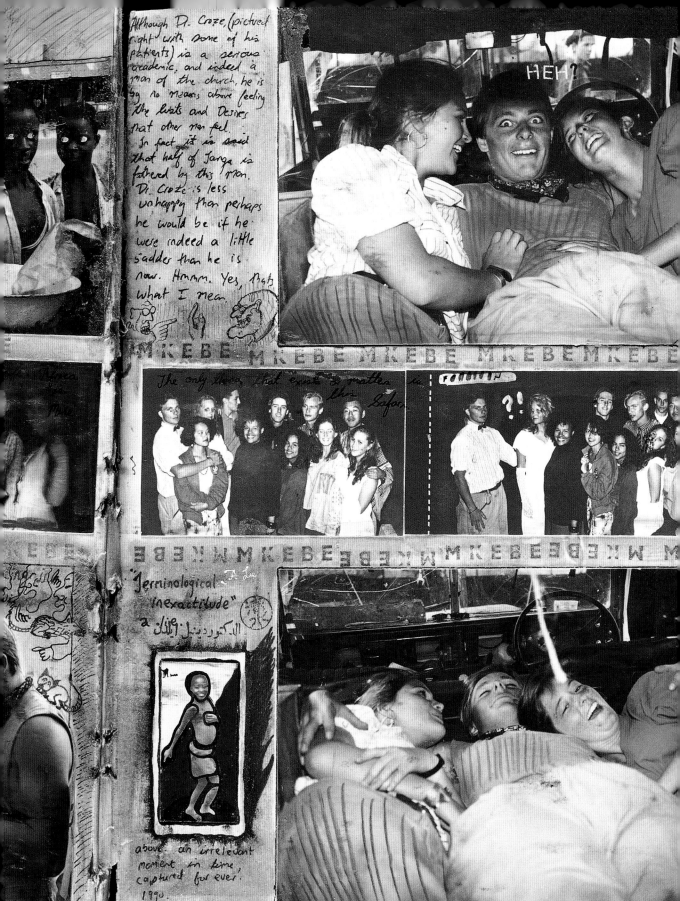

Although Di. Croze (pictured right with some of his patients) is a serious academic, and indeed a man of the church, he is by no means above feeling the lusts and Desires that other men feel. In fact it is said that half of Tanga is fathered by this man. Di. Croze is less unhappy than perhaps he would be if he were indeed a little sadder than he is now. Hmmm. Yes, that's what I mean.

HEH?

The only thing that exists to matter is this Safari.

FOREVER

"Terminological inexactitude" = A Lie

above 'an irrelevant moment in time, captured for ever.' 1990.

Dear Mum,

It is Sept. 18th and I am twenty years old. Well, its been quite a life so far and I want to say thank you for all the energy and input that you gave! For things like getting me the camera and making me excited about making things and building things and drawing things and writing things. I think that these are some of the things that I enjoy most about my mission on earth.

We just set up the dark room that you thought of getting all those years ago, and we are producing some good results already.

The safari went very well, as you obviously have heard already. I'll have to say that I learned alot some of it fun but some was almost a night - mare.

I'll have to be careful, because when the trouble started on the trip, I emotionally started a down-spiral that reminded me of those bad times when I was young. I didn't think that that side of me was still around, but it is in there somewhere.

I have almost finished a new journal - I have to start a new one for the big safari. I hear you are doing some good stuff on the bath room wall etc.

Dad is very happy but very busy with the 10th ann. exhibition. He has tons of women after him as usual.

You sound very well and doing interesting jobs

I love

Dan..

"Conflicts, bwana...

we were nearly flying upstairs"

The Kenya that most tourists and even many of its inhabitants know is a fertile land of mountains, lush coffee plantations, green valleys, riverbeds, and the exquisite beaches of the coast. But much of the country, approximately the northernmost two-thirds, is remote and arid, associated with bandits, famine, and Somalis who have stolen across the border.

Beginning in high school, Dan ventured northward alone, usually headed for Maralal. Geographically, the town is in the middle of the country, but its spirit is northern, making it sort of a rough-and-tumble frontier town. He'd take an upcountry *matatu* and disappear for a few days, relishing the sense of fading into the desertlike landscape.

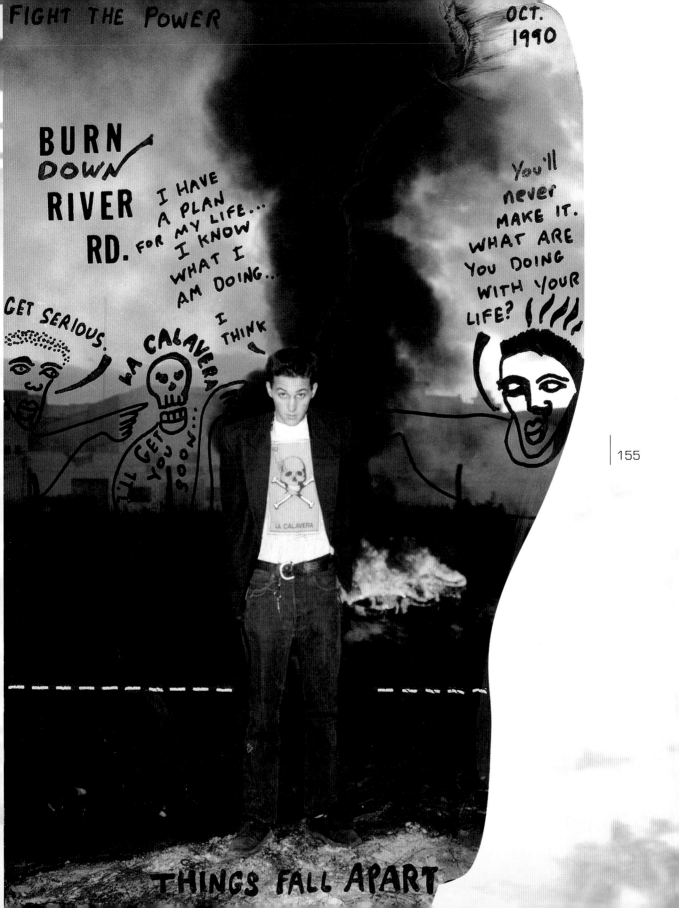

One of his heroes was Wilfred Thesiger, a British adventurer who had lived among the desert Bedu people in the mid-twentieth century and who has been described as "the first man to the last places." Dan underlined the following passage from Thesiger: "I had been an Englishman travelling in Africa, but now I could revert happily to the desert ways which I had learned at Kutum. For this was the real desert where differences of race and colour, of wealth and social standing, are almost meaningless; where coverings of pretence are stripped away and basic truths emerge. It was a place where men live close together. Here, to be alone was to feel at once the weight of fear, for the nakedness of this land was more terrifying than the darkest forest at dead of night."

Dan had been fascinated by the desert since he was a kid. He wanted to visit the American Southwest, and U2's *Joshua Tree* was his favorite album. His ultimate safari would be to cross the Sahara, and he'd considered it for a second STA trip. Kenya's desolate north country was a good alternative.

In the fall, after returning from Malawi and STA, he set off in Deziree for a week, alone save for a video camera and his notebook. It was a much different experience than the role of team leader he'd played during the summer. In the wide-open, windswept expanses between villages, he had plenty of time to think, contemplating his own intentions as an artist and traveler.

Northern Kenya Oct. 28, 1990 Frontier town.

Everyone is armed, things are sharp.

O.k. I finally have a lot to say, but I don't want to write the usual self-centered white man traveling in Africa story. I'm sick of films and books set in third world places about Euros floating around and showing the scene through their eyes. But I am a white man cruising around Africa, so I'm going to give you the usual self-centered crap.

My first thought has nothing to do with anything but not many of my thoughts do right now. When you have been driving for twenty-four hours straight and have not looked into a mirror for weeks except for your own dusty reflection on the speedometer glass, you run out of things to think about. So you start to think about new things.

I like things made of canvas, metal, wood, and steel, like Deziree. I'm sick of plastic. I don't want to start talking like some old man,

but I like quality. The only good thing about living in the olden days before the 1950s was that things really were made nicely. But again, I'm not saying that I want to go back in time or anything because people used to be sadistic animals. Old people always get off on how these days young people are dangerous rapists, drug addicts, and gangsters, which is true, but think about all the stuff they got up to. Only for them, they had it organized by the government. I mean think about it. What's worse? The gang situation in Los Angeles or World War II?

I had a discussion with my grandmother about it. She tries to tell me that these days things are uncivilized and dangerous, but I told her that back in her times, things were worse, like making black people sit in the back of the bus and using different toilets. Imagine? Now is the best time to live. Anyway, I was talking about quality. I got my hands on an FN self-loading assault rifle at one of the police checks today and fondled it extensively. I love things that click and slide into place and are well-oiled. The most seductive sound in the world is a well-greased rifle cocking into position.

I've only had guns pointed at me a few times but it always feels good—the ultimate test of "what do I say now." The final examination for the manipulator. Manipulation. Negative word, yes? But I think it's got a bad name, because many bad people are good at it. The concept itself is fine as long as the person uses it wisely. I don't know if I'm much of a writer. Anyway, writing is old-fashioned. Films are better. How could you ever hope to catch the sights and sounds of a moment with paper and these primitive scribbles, left over from the Roman Empire. Just video the damned thing. Too much room for distortion in writing.

I've got the video hooked up to the car battery, go into villages, record the people there and then show them themselves in black and white moving around inside a tiny box. Reminds me of something I read about a European filmmaker who took a load of film of some guys in a remote part of Ethiopia and then came back the next year and showed them the film. Unfortunately, one of the characters in the film had died during the year and then they see him moving around in the white man's box. Try explaining that.

157

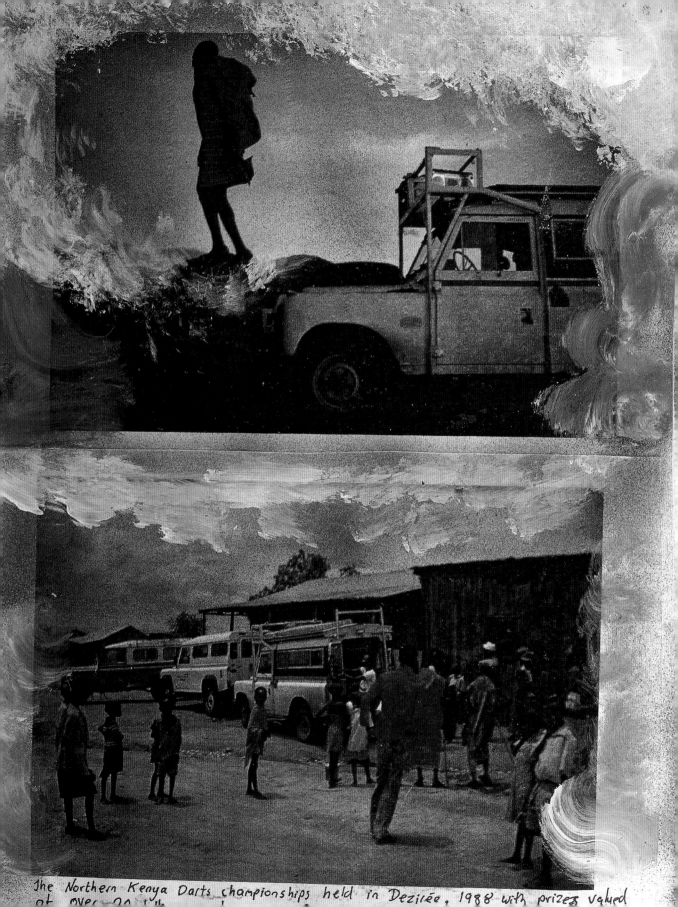

The Northern Kenya Darts championships held in Dezirée, 1988 with prizes valued
at over 20,000

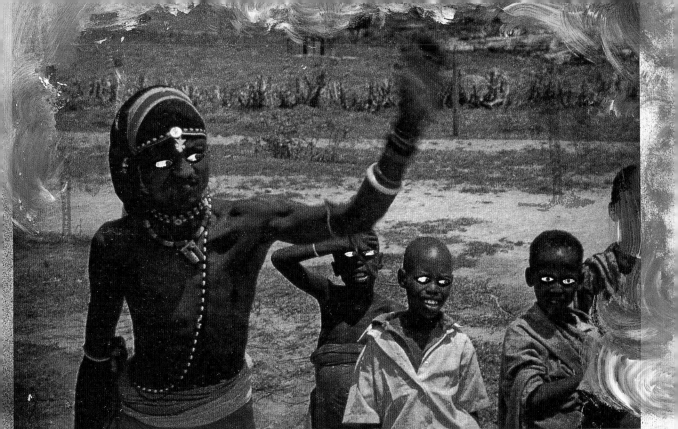

Warrior, who stalked the dart board like it was a wounded buffalo and hurled the dart like a spear. Old men tried their hand, but mainly kept in the background and enforced rules that they made up. Throwing stones at children to disperse the crowds of them was another chore I like it.. throwing stones at kids so they don't get hurt!

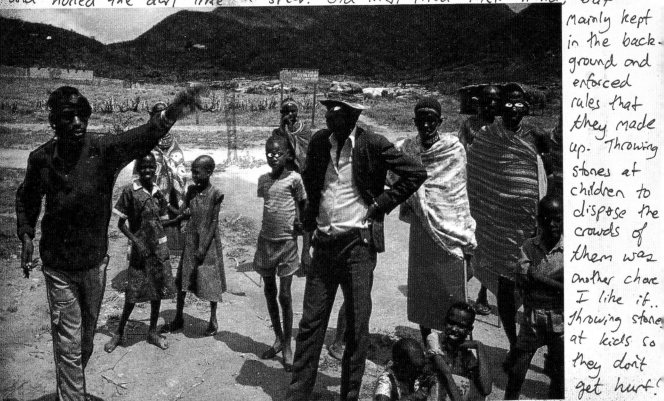

Even the admin. Policeman had a turn but the 20/- was won by a woman, much to the surprise/horror of all present.

in the east

Upon returning to Nairobi, Dan set up a darkroom in his father's new house and tried to get commercial photography work around Nairobi. He was making tentative plans to return to school after Christmas and considering college in London in order to be closer to Amy and his mum. Just thinking about the confines of a classroom, however, made him eager for an adventure. He decided to make good on a plan to visit Akiko in Japan. By November of 1990, he'd found a job teaching English in Tokyo and arranged to stay with some old family friends.

Of all the places he'd been to, Japan turned out to be the oddest. "I really feel like James T. Kirk on *Star Trek* on a weirdo planet," he wrote to his friend Laurie. The national tendencies toward conformity and cleanliness confounded him. There was none of the earthy liveliness that he loved about Africa, or the diversity of America. He didn't fit in with anyone: he clashed with his host family's rules and fought with Akiko. She had a new boyfriend, and here with her family and friends, away from the freedom of the safari, she seemed different.

After Africa, especially his time on the road, even the experience of going to the bathroom was a culture shock. In Japan, everything possible is done to make the bathroom a

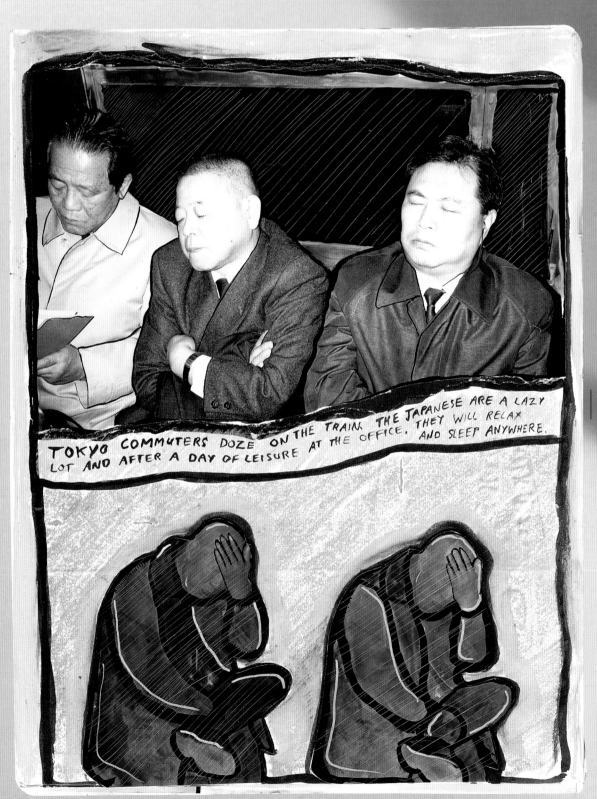

TOKYO COMMUTERS DOZE ON THE TRAIN. THE JAPANESE ARE A LAZY LOT AND AFTER A DAY OF LEISURE AT THE OFFICE, THEY WILL RELAX AND SLEEP ANYWHERE.

sanitary and pleasant place—in short, to help one forget its actual purpose. Automated toilets are common in many households, including Akiko's. They do everything from simulate the sound of the ocean to offer an air-dry option. For every feature, there is a corresponding button with kanji text. On Dan's first attempt to operate one of these contraptions, he pushed what he hoped would be the right button, only to have water begin shooting in every direction. In a mad effort to make it stop, pushing more buttons in the process, he managed to increase the flow of water. From the kitchen, Akiko's mother heard a series of muffled curses. He finally emerged, soaked and rather embarrassed—defeated by a toilet.

As in New York, Dan spent much of his time alone, roaming the streets. He discovered the closest thing to a slum Tokyo had to offer at that economically booming time, as well as the red-light district. But more common was his experience at Shibuya.

Shibuya is Tokyo's youngest, hippest neighborhood. It's also a sensory overload. Two-story video billboards hover over three corners of the main intersection, projecting music videos and commercials. In addition to enormous Japanese retail stores, there are American outlets like Starbucks and Gap, all with neon signs that would do the Las Vegas strip proud. And there are people. On foot. On bikes. People everywhere.

重要

The central intersection of Shibuya is also the entrance to a major subway station. In addition to the usual pedestrians, a glut of people often streams onto the street from the escalators below. As Dan stood there one day, taking in all of the colors, the riotous noise, the cars and bikes whooshing past, the traffic light suddenly changed. People were walking in every direction, coming and going from all four corners as well as diagonally across the square. As the sea of faces came straight at him, he was overwhelmed; he couldn't move. He fell to the pavement and sat there awhile as bodies brushed past before he could reclaim himself.

When he got back from Japan, he called Eiji and told him all about it—how odd it had seemed, how he'd felt like a complete alien for the first time in his life. They laughed together at the toilet story, and when Dan told him about Shibuya, Eiji laughed even harder, imagining Dan on his ass in the middle of Japan. Years later, he'd remember that story of the crowd and how Dan, for even a moment, was frightened by it.

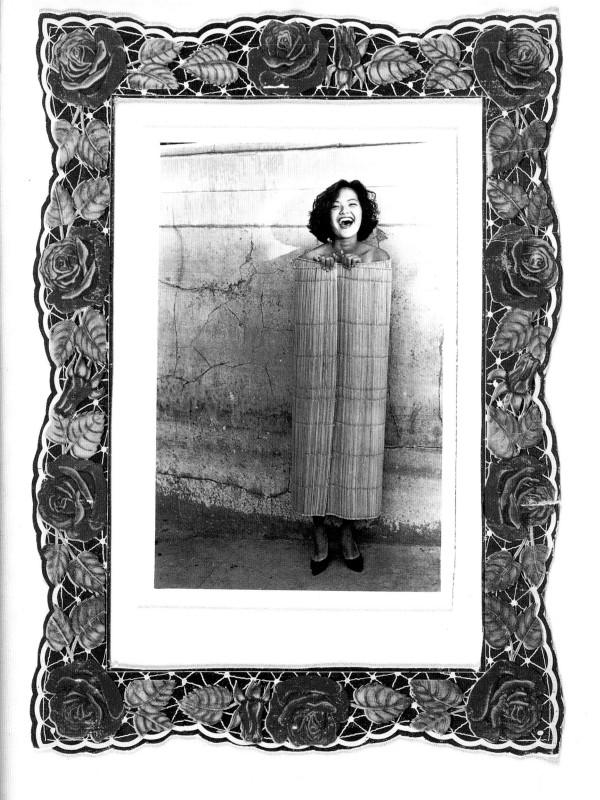

Vertical expression of horizontal desire:

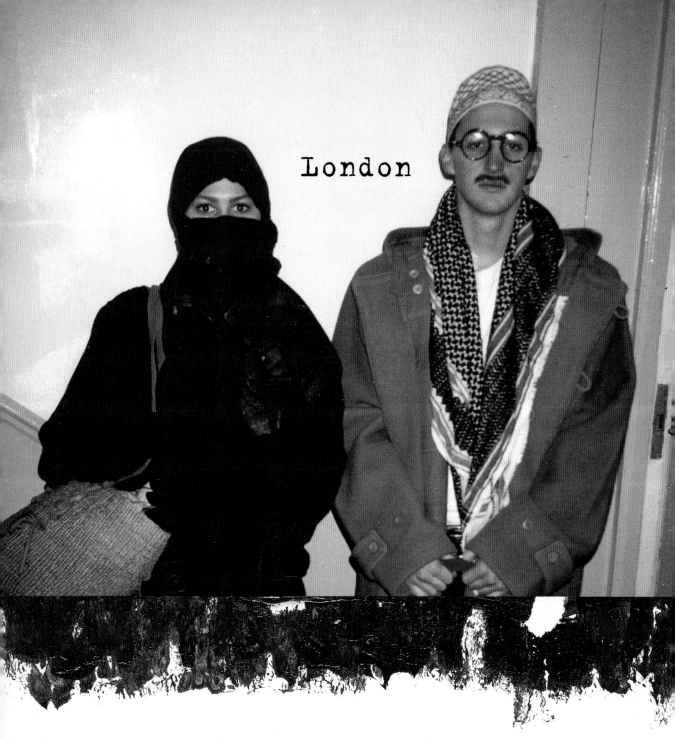

London

"Dan, sit at the head of the table," Gaby gestured, her sharp eyes taking everything in behind her large glasses. For days, she'd been cooking in preparation for Dan's arrival. *Ciftele cu bulion*, meatballs in tomato sauce, and *salatã de vînãtã*, eggplant salad, were among the dishes crowding the table.

Dan's eyes crinkled with pleasure at the great feast. "Grandma, this is fantastic!" he declared, bending down to squeeze her in a bear hug. He wasn't much for food, often subsisting on canned beans during trips, but he had several culinary loves, including chicken *tikka*, pepper steak, and his grandmother's Romanian delicacies. He knew the best part wasn't even on the table yet: a rich chocolate mousse still chilling in the refrigerator. As Amy was quick to remind him, being the only grandson had its perks.

Like any Jewish grandmother worth her salt, Gaby doted on him. Her husband, Bruno, who had died six years earlier, had also been charmed by Dan, and the two had bonded over the grandfather's art supplies. Although by day Bruno had been a high-ranking official at Shell Oil, in his heart he was an artist, and the basement of their large house served as his studio, filled with a dazzling array of paints, stained-glass supplies, and beads.

The house and the studio were the stuff of hard work but also good fortune. When Bruno was a young man in Romania, his burgeoning career with Shell Oil was halted when Hitler's army marched across Eastern Europe. As the Germans were entering Bucharest, he and several other Jewish co-workers escaped by boat, landing in Cyprus before making their way to Palestine. There he met up with an older friend who had run a shipping company. The man invited Bruno to his home, introducing the guest to his daughter, Gaby. The two were soon married. Michael, their first child, was born in Palestine, and later they had a daughter, named Ruth. When they moved to London three years after Michael's birth, Bruno was able to secure a job with Shell again, successfully working back up the ladder.

When Dan was little and still lived in London, his grandmother often looked after him and Amy. After moving to Nairobi, they'd visit Gaby and Bruno every summer, staying in London on their way to and from summer camp in Iowa. Often Gaby took them on a trip to visit a European city. Or she introduced them to art museums and theater. Dan especially enjoyed his grandparents' stories of family members strewn around the world.

Despite these frequent visits, Dan had an uneasy bond with the city that was his birthplace. He had definite connections: the British humor he'd inherited from his father, and his accent. But although he regarded himself as being more British than American,

he preferred the openness and vibrancy of the U.S. By contrast, England often struck him as lifeless, and he loathed the weather. Compared with Nairobi's perfect climate, the gray skies and drizzle sapped him of energy, putting him in a funk.

Beginning in January 1991, he was in London for six months, the longest he'd lived there since childhood. His ostensible purpose was to add a further patch to his academic quilt by attending Richmond College. More importantly, he wanted to be closer to Amy and Kathy. Being with Amy the summer before had reminded him how much he missed her. She had transferred to the American High School in London the previous year, and it had been a hard move—leaving behind her childhood friends, as well as exchanging their beautiful, comfortable house for a small flat shared with several women friends. It was hard for Dan too; the house in Nairobi had seemed much too quiet that fall. She was growing up quickly, becoming more of a friend and peer than a little sister.

Richmond is in southwest London, at the end of the District line on the tube, and nearly an hour away from Kathy and Amy's Maida Vale home. The little flat, which they shared with Mary Anne and her two daughters, Tara and Petra, was no place for a twenty-year-old guy, so he opted to live on campus. During the week, when not in class, Dan befriended people in the student commons or puttered in the darkroom. At first people found his outgoing nature odd. Barely out of adolescence, most of them presented a cool, detached demeanor. By comparison, Dan was disarmingly outgoing, comfortable with talking to anyone. His high energy and genuine curiosity in other people wouldn't allow him to take the slouching, hands-in-pockets approach.

Despite feeling caged in, he became a popular fixture on campus. Nights were spent working on his journals, a habit that forced one of his roommates, a Pakistani who was early to bed, to relocate. He and his other roommate, a French-Brit named Jean-Marc André whose mixed nationality was the norm at the international college, got on well, but Dan found few other people with whom to connect.

He enjoyed exchanging a few riffs in Swahili with the African students on campus. The lilts of their accents and stories of village life transported him back to Africa. In his dorm lived a Mozambican student whose name sounded like *babuji*, the Indian word for "father." "Hey *babuji!*" Dan would holler to him across the lawn in greeting. The man would erupt into laughter at the familiar word, pleased at the liberties Dan took with his name. Others soon adopted the name

for him, just as they did "Le Mec," Dan's nickname for Jean-Marc.

Dan and Jean-Marc both took photography and the two met often in the darkroom. Dan usually stayed longer to develop film that had nothing to do with class or to experiment with different methods. At the end of the term, when the instructor gave him a B-minus for digressing from the assignments, Dan was furious and demanded a written explanation, an approach that did not yield a change in his grade.

He also took economics, having signed up for it in hopes of augmenting his fund-raising and business skills. He had a knack for making money and enjoyed brainstorming financial schemes with both his dad and his maternal grandfather, Russell Knapp. But it took only a few weeks of wading through such concepts as supply and demand and elasticity for him to realize that the subject was not for him. It was too dry and could never have the same emotional, tactile pull of his journals and photography.

On weekends, he convinced Jean-Marc to follow him all over London. Cameras in hand, they took the tube to the British Film Institute, the seedier sections of Soho, Hyde Park, or the National Gallery, sometimes climbing onto rooftops for views of the sprawling city. Nights were spent with Amy and her friends, going to pubs and dance clubs. The girls dressed up, and Jean-Marc looked stylishly cosmopolitan. But Dan, with his trademark leather vest, white T-shirt, faded jeans, and necklaces and bracelets, managed to look the coolest of them all.

One weekend, he and Amy disguised themselves in full Arab garb for a visit to Lengai, who was still in college in Sheffield. When Amy appeared with her face mostly covered in a Muslim headdress, Dan burst into applause. "That's perfect! My god, I could just drop you off in Lamu and you'd blend right in," he exclaimed, alluding to the Muslim island off the coast of Kenya, which they often visited. They were quite pleased with themselves when they got to the train station, and Lengai walked past several times before finally recognizing Amy's dark brown eyes, just visible between the folds of black cloth.

Being around his mother came with particular challenges. Kathy had been gravely ill the year before with a rare auto immune disease affecting her spleen; worrying about her long-distance had been difficult for Dan. Yet the two were so alike that they often drove each other half mad when together too long. Back to her

167

full strength, she was engaged in a constant whirl of activity as she busily tried to learn the film business. Dan took great pride in her success and looked up to her very much, but he also cringed whenever she tried to direct him. She asked why he didn't show his photographs, and he said he wasn't good enough yet. Then she'd try to get him to make art for her walls and he'd demur, saying that it was meant for the privacy of his journals.

"Watching Mum's success and megamillion-dollar deals and multi-million connections sometimes makes me feel a little small," he wrote his father toward the end of the school term. "I forget what other people my age are doing . . . sometimes it makes me feel like 'what has my contribution to the world been?'"

In many ways, Dan was biding his time in London, living in his head as he dreamed up his next trip. Throughout the waning winter months, he'd courted his grandmother Gaby, trying to convince her to help him buy a new Land Rover in England. He made frequent trips to her apartment, lavishly praising her cooking and coaxing her to tell family stories. Eventually, she succumbed to his charms even though, much like his maternal grandparents, she was not entirely sold on his notion of education through travel. She would have been relieved to see him settle down into a four-year degree program with a tangible career on the horizon. Both Mike and Russ reassured her, however, that Dan would make the most of her investment.

With her help, he bought an old blue Land Rover, paying for it in part by taking portraits of the previous owner's new baby. To Dan, it was a piece of Africa, as good as a patch of blue sky, and deserving of a proper baptism on African soil. Unfurling a map on Amy's bed, he showed her the route he was envisioning for the two of them and Lengai that summer: after catching a ferry in southwestern England to Spain, they would head south to Morocco.

The trip was to be more than just an adventure. Inspired by STA, Dan sought a way to blend travel, charity, and his entrepreneurial tendencies. He wanted to buy jewelry and leather goods in Morocco and then take the Land Rover by boat to the U.S. Once there, he'd create a "mobile shop," selling his African wares on college campuses across the country from a tent connected to the side of the Land Rover. Amy was a little leery of the scope of the project, but she'd grown accustomed to Dan's ability to pull off the unthinkable.

One brisk weekend in May, Dan and Jean-Marc took the Land Rover, dubbed Big Blue, for a trial run. They headed down to Brighton and picked up Tara Fitzgerald from college. The spring grass seemed to glow in contrast to the dark, bruise-colored sky. Ignoring the gathering clouds, they cruised down country lanes, slowing only for the occasional herd of sheep or unexpected small village. Passing a foreboding Victorian girls' school, they stopped to give a teenaged student a ride to the nearest town. "We'll rescue you," Dan offered gamely with a wink. The girl shyly smiled back, holding the pleats of her plaid skirt down against the wind.

As they got farther down one lane, the road turned to mud. Dan pressed on; it was a Land Rover after all. Jean-Marc and Tara exchanged a worried glance but figured they were with a pro, until they heard the spinning wheels. "Ah, Christ! We're stuck!" Dan announced, half-pleased at the messy situation. They mulled over their options, noting the ever-darkening sky, when some hikers appeared out of the woods. As the men—burly Swedes it turned out—pushed them out of the mire, one of them called to Dan up in the driver's seat: "Where are you headed?" Peering over his shoulder, his foot on the gas pedal, Dan yelled back, "Casablanca!"

traces of hell

When the unknown person sitting at the table next to you leaves and it is an irritation, this is loneliness.
—Dan, from a pocket notebook he kept in Morocco

"Bint al Maroc"

Morocco drove Dan a little crazy. It was the same kind of crazy he'd been in New York. He was stuck in Casablanca nursing a broken-down Land Rover for nearly three weeks in the summer of 1991. The immobility, coupled with the maze of Casablanca's streets, seemed to close in on him. In a spiral notebook, he jotted down thoughts about the "travels and voyages of D. Eldon into hell." For nearly three weeks, he was alone, cut off from a familiar language and from friends. "Who cares what's going on?" he wrote. "I do. *Je suis en Maroc avec beaucoup des problèmes.*"

The journal he created from the images and artifacts of the Morocco trip is more unified than most of his other books. The pages build on each other and have a narrative flow of surreal images: peering eyes, animal carcasses, chickens cooped in a wall-papered room juxtaposed against the occasional soft eyes of a child. "Perversion Sexuelle d'un Adolescent" (a tagline he got from a movie then showing in Morocco) and "Fathers of black magic" are some of the repeated, cryptic phrases woven in and around the images. They are shadowy and grim, echoing the warren of dark streets and the mounting anxiety he felt as he waited every day for Big Blue's repair.

His days were slow, dulled by the thick heat. Bored and alone, he wrote in overly dramatic prose, describing the palm-lined boulevards and ostensible tranquility of the city.

Casablanca is an underworld, like a labyrinth of sewers where a melange of low-life swirl and collide. The very scum of the earth, thieves, whores, pimps, victims and carriers of every loathsome disease known to man, pickpockets, rapists, serial killers, child molesters, con men, poisoners, practitioners of voodoo and witch craft. . . .Who is in the center of this kaleidoscope of deprivation? I am. *L'étranger*.

I sit in the garage Speciale Afrique on an overturned engine block because the floor is covered with fish oil, gear box lubricant and sawdust. The garage is next to a shop that employs hundreds of young boys to hammer noisy metal objects all day. They are bullied and perhaps worse by the older employees. The sun bakes down on the tin roof twelve hours a day and the only time the air moves in the garage is when a gust of stale fish stench wafts in from the port.

☺ ☺ ☺

The trip had seemed full of promise in the beginning. Dan, Amy, and Lengai had set off in mid-June, about a month after that muddy day in Brighton. They had planned the trip as a summer-time escape from London, a chance to evoke the grand safari of the previous year.

"Bint al Maroc"

After driving south through Spain, the threesome stopped in Tangier and Fez. In the latter, famous for its little red hats, they haggled for hand-tooled leather belts, silver bangles, and a leather vest at the immense *medina*. Dan was captivated by the stalls: heaps of richly colored spices, car tires, religious relics, plastic bowls, birds dead and alive, fruit, and fortune telling. He especially liked the hennaed Berber women who came to buy gazelle's heads, chameleons, and various medicinal roots.

The merchandise they bought by the "donkey load" was to be the first stock for the mobile shop. As they stuffed it into bags and boxes and then headed toward Casablanca, they discovered that it all smelled strongly of cow dung. Amy and Lengai left a few days later with most of the stinky cache in tow, while Dan stayed behind to make more purchases and arrange for passage to New York. Before he could even get to the shipping office, however, Big Blue broke down.

Slow, hot weeks of waiting followed. He argued with mechanics and watched them work or rented a scooter and tried to explore. These attempts were often thwarted by persistent prostitutes and street urchins.

I rode through the slums and was mobbed by thirty children who pelted me with stones and stuck branches in the spokes of my tires. Later in the day, two teenage gang members grabbed me by my throat and only released me when I produced a canister of tear gas and waved it in their general direction. Today, I was approached by a young troublemaker who was interested in my camera. I again went for the C.S. gas but in my haste to free it, I discharged it onto my leg while it was still in my pocket. The assailant must have taken pity on the solitary European étranger, because when I had stopped writhing in agony, he was nowhere to be seen.

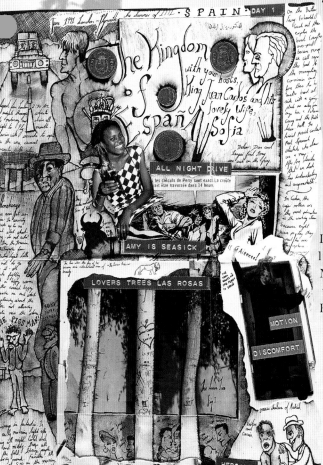

Dan was at his creative best when life was at its chaotic worst. Morocco was no exception, and the trip proved a creative boon. He had a new camera, a Nikon that he'd bought just before leaving London, and he shot many rolls of film. After returning home, he dedicated more than half of one of his journals to photos and collages representing the weeks he'd spent alone. Morocco images pop up elsewhere; he introduced them into earlier journals and inserted them into later ones.

In addition to picture taking, he brainstormed the future of the mobile shop and other fund-raising schemes. His goal was to raise money to help train refugees to do work by which they could support themselves, namely agriculture and crafts. As an African, he was interested in long-term solutions, not Band-Aids. He doodled

173

possible logos and titles for the project, such as "WHIPS: Wealth Injecting Aid Projects," and made random notes, naming possible connections and types of products. His astute marketing sense combined whimsy, sexiness, exoticism, and charity. One logo he considered for his wares: "Each belt has been illicitly transported through five international customs zones." Amassing merchandise such as safari boots, bangles, daggers, and leather coats, he envisioned launching a "multi-level marketing" program with "appeal to students and businessmen."

Weeks into the repair, the mechanic had finally assured Dan that the Land Rover would be ready by the next day, and he went in search of a final meal, hoping for anything but the ubiquitous couscous. At a small Italian restaurant, he ordered a gin and tonic. "I was the only person there and the waiter was an irritable fellow with furious eyebrows and a snarling mouth," he wrote later. "He gave me my drink and stalked back to the bar where he was watching the birthday celebration of King Hassan II on television with the volume up at 15. The glass was a tall one and it was almost full of gin. I added half an inch of tonic and drank it down. I ordered another and when it was half gone, so was I."

"Bint al Maroc"

He managed to lurch back to his hotel and collapsed on the bed, sweaty and nauseated under the slow, useless whir of the ceiling fan. After a restless night, during which he thought he might be ill, the morning light finally woke him: "I saw the sun rise like a ball of fire. It had a sinister look about it as it slowly hauled itself up the hazy dawn sky, like it was coming to punish, to burn, to consume in agonizing flames. By seven, it had roasted all the haze from the sky leaving it a shocking blue. At eight, it had started cooking the streets and rooftops and at nine it came in search of me."

He had lost too much time to take the ship and still get back to California in time for classes. Big Blue would have to wait for him in London until he figured out a way to get her across the Atlantic. For now, though, it was all he could do to pick his throbbing, damp head off the pillow and concentrate on getting down the hotel's rickety stairs in one piece.

SMUGGLERS BAZAR

EACH BELT HAS BEEN ILLICITLY TRANSPORTED THROUGH FIVE INTERNATIONAL CUSTOMS ZONES.

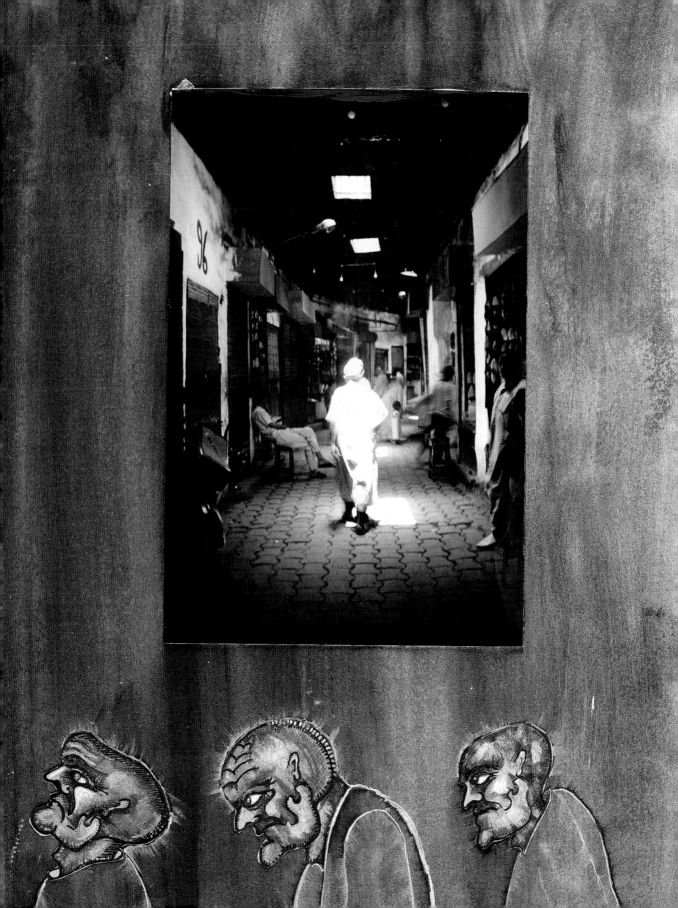

thanksgiving

The fall of 1991 served as an antidote to the perpetual overcast of London and the sultry, labyrinthine alleyways of Morocco. Having temporarily given up the mobile shop, Dan returned to Los Angeles to take a few classes through UCLA Extension. It proved to be his best American experience yet. He had lived in L.A. once already and had infinitely more confidence than he'd had in New York three years earlier. Nor was there the large-scale planning of STA to consume his attention.

Eiji, wearing a fake moustache and Coke-bottle glasses, picked him up at the Los Angeles International Airport in early September and was thrilled when Dan, the Master of Disguise, walked past without recognizing him. The two were to spend much time together that fall, exploring the city from Beverly Hills to South Central. One of their first stops was the Shangri-La Hotel in Santa Monica where Dan's mother and her friend Geoffrey Dudman were staying while in town to raise money for a feature film. Stashed in their room were three bulging, smelly boxes of belts and bracelets; Kathy and Geoffrey had brought the goods from England on the final leg of their illicit trip.

PLUNDERS OF
NORTH AFRICA

Dan transferred the belts and bangles to several garbage bags and heaved them into the trunk of his old brown Tempo; it was still running thanks to Hayden's long-term care. Without a place to live, Dan moved around town, spending a week with an old border from the "Eldon Hilton," a few days with Hayden's new boyfriend, and another few weeks with someone whose apartment-for-rent ad he answered. None of these proved to be the right arrangement. Each time he moved, he hauled the bags with him, stuffing the belts that snaked out of the top back inside. In an act that would save him money while testing his patience, he finally rented a room in a UCLA fraternity house.

Part of Dan's happiness that fall was that he was around so many of his friends. His mother was in and out town, treating him to dinners and introducing him to movie people, many of them eccentrics who amused Dan. Eiji was going to UCLA; Roko came down from Santa Barbara several times; and both Robert Gobright, STA's mechanic, and Tex paid him visits.

On September 18, Kathy hosted a group of Dan's friends at the Shangri-La to celebrate his twenty-first birthday. They were listening to an account of Eiji's birthday gift—a visit to a strip club the night before—when there was a knock at the door. Amy came dashing into the room, greeting Dan with an enormous hug. Kathy and Geoff had flown her over from London as a surprise; Dan was stunned and thrilled.

To celebrate properly, he called for a late-night safari to Tijuana. "It's always better to go somewhere than to not go somewhere," he announced, rallying the somewhat dubious group. In the dingy border town they witnessed a fistfight—much to Eiji's glee and Roko's horror, while Tex, who never drank, had the bad luck of being vomited on by a very inebriated stranger. Dan spent much of the night warding off unwanted advances toward Amy by strangers. At dawn, they drove back to the city, satisfied to have at least made an effort to seek adventure.

Dan took Amy on a sales outing. Why not go right to the top, he figured, so they took one of the heavy garbage bags of merchandise and headed for Rodeo Drive. Walking among the so-called beautiful people, with their Chanel and Armani bags, Dan held out an armful of the belts and approached passersby. He greeted everyone who walked by, sometimes yelling at a person half-way down the block. One clerk came running out of Gucci—surely,

Amy thought, to shoo them away or threaten to call the police—and handed Dan a crisp twenty-dollar bill for a belt.

Kathy and Geoff, on their way to a meeting, were driving by the Beverly Wilshire Hotel when Geoff glanced to the left and said, incredulously, "Aren't those your children?" Kathy lowered her sunglasses and burst out laughing at the sight of them selling things in such an outright African style on the chic boulevard; they might as well have been in Nairobi.

Throughout the fall, Dan worked hard at selling the contents of the seemingly bottomless plastic bags. He frequented Venice Beach, where he fit right in among the area's famously bizarre characters—roller-blading guitarists, muscle men, and assorted shysters. Every time he went, he played a different role, trying out accents and costumes. His favorite getup was a World War I leather aviator's helmet, complete with earflaps and goggles. Along with a bomber jacket, a pair of shorts, and his well-worn safari boots, he'd effect his strongest British accent, fluctuating between upper crust and Cockney. He adjusted his sales pitch according to the customer, flirting with the girls and upping the price for a wealthy man. He got anywhere from ten to forty dollars for each belt, plenty of money for his next, still undecided adventure.

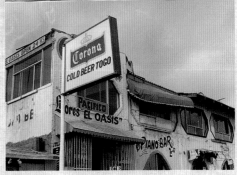

One afternoon, just after two bikini-clad women had invited Dan to a party, an African American cop approached him. "You know you need a license to sell on the beach," the man said, hardly able to keep a straight face at Dan's outfit and thinking to himself that the boy sure had skinny legs.

"Thank you for that information, sir," Dan said earnestly. "I bet your wife would love a few of these bracelets. Straight from Morocco—just two weeks off the boat!" Dan raised an expectant

eyebrow at the officer as he extended an arm rung with bracelets. The cop gave him just enough of a look to indicate he was amused by Dan's story.

"Indeed, I was just in Morocco, my friend," Dan said, turning on the charm. "Africa's largest market, denizens of black magic, sweltering boulevards…and these beautiful bracelets! For you, very, very cheap as you're doing a vital, civic duty."

The cop chuckled, convinced that at least the boy's hard-to-place accent and the smile were genuine. He asked Dan where he was from.

"Kenya. Nairobi to be exact. What about you? Where are your people from originally? They could be from East Africa; we could be related!"

The whole fall went like that: flirting with pretty girls, donning different crazy costumes and attitudes, interacting comically with American society. He had a heyday on Halloween, following around oddball characters with his camera while trying to keep up with Eiji, who had made a papier-mâché Martian head. He was a cultural traveler who saw the highs and lows of his surroundings as only a stranger can. Well known among the homeless near the beach, he stopped regularly to take their photos.

For Thanksgiving, he drove to Mexico. In a school paper he wrote two weeks later, he described the events from his African eyes, giving an entirely new meaning to "thanks giving."

☺ ☺ ☺

Thanksgiving

Before the Thanksgiving break, I tried to explain to my Japanese friend why I was sad. Everyone in the house was leaving or had left for happy family weekends at home, and my only relative in California is a third cousin from Romania who was cremated seven years ago. My friend suggested that I should go to Las Vegas, proving the fact that Thanksgiving is really not an integral part of the Japanese family calendar. I told him that that would be like listening to a Walkman in his ancestor's shrine or spending Christmas in a brothel, but I don't think that he really understood. Instead of Las Vegas, I decided to drive down to Mexico.

There were strong winds on the freeway and my little brown Ford Tempo with Iowa plates felt more like a rowboat on the open sea as I battled to keep her on course southwards down the mighty "Interstate 5." I began to imagine myself as Papillon, escaping from a Los Angeles that sometimes feels like a nightmarish penal colony. When I reached the border, the image was complete: the massive gates and walls of fortress America. Border Patrol guards, wearing cowboy hats and bandolier belts bristling with clubs, cuffs, stun guns, mace, and pistols scanned no-man's-land with enormous green telescopes to see through darkness.

The strange thing about the American Fortress border is that it is designed to keep people out. As I crossed into Mexico, I saw the faces of thousands of people who would do almost anything to get into America. America is such an exclusive club, and my first Thanksgiving lesson was that I am damned lucky to have pictures of me glued into two little blue books; one with an embossed golden eagle holding some arrows and the other with the rampant lion and unicorn of Her Majesty's Government. I am so lucky to have been born in the right place at the right time with the right parents. My life is so easy without even having to struggle for it.

My second Thanksgiving eye-opener came when I heard what happened just a day after I drove on the freeway: the worst car accident in history. The winds that I had fought on the way down had kicked up a dust storm that blew across the freeway and when the darkness cleared, seventeen people were dead, many injured and one hundred and four cars demolished. I do not believe in fate, but to see such carnage so close to home....

My weekend in Mexico was fantastic. Two days of gluttony, lust and beer drinking with lemon in it....I drove back to Los Angeles on Sunday night with a surfer I met. He was actually Persian and his family had decided to leave Iran after the Shah died. His father had worked for the Ministry of Finance so it seemed to him that it would be a good time to move the family to the United States and it would help if they took along with them a good part of the National Treasury.

I dropped him off at his girlfriend's house and then slept for the rest of Monday. At around 7:00 P.M. the surfer's girlfriend called me on the phone with an emergency. One of the dozen oysters that he had eaten in Mexico must have been bad and he needed to go to the hospital. There were two more problems: The girlfriend had no car and the surfer had no insurance. For someone who

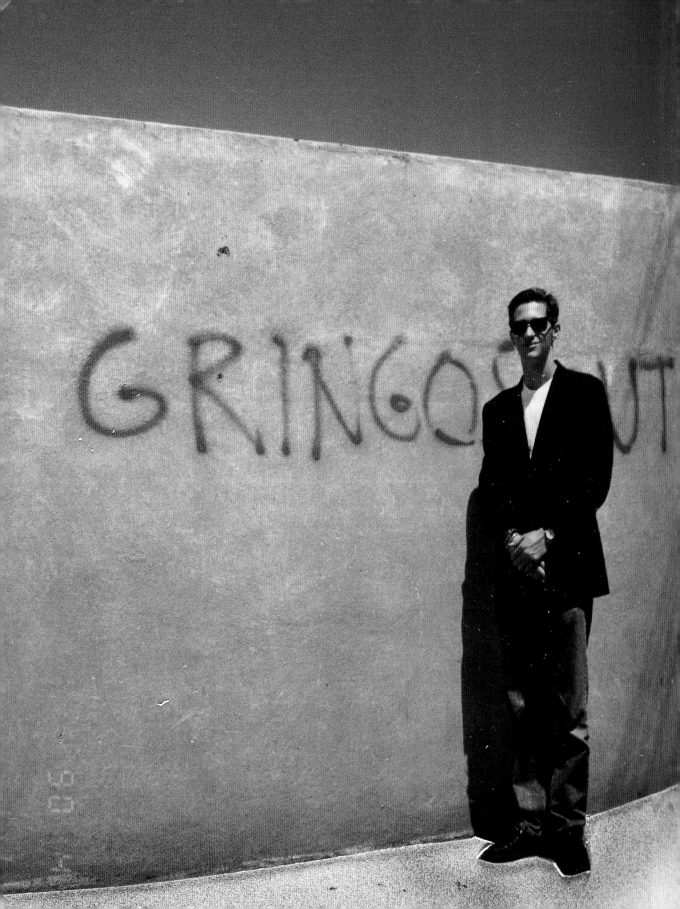

does not believe in fate, this double coincidence is almost too dismal to fathom. The chances of meeting someone in America with no form of motorized transportation and no medical coverage are astronomical.

I climbed into the brown Ford again and followed the now infamous Interstate 5 to pick him up. We called every hospital but all of them wanted huge amounts of money to repair my Persian's innards. I started a half-hearted argument with the UCLA medical emergency receptionist about the Hippocratic oath and basic human decency. The L.A. County Hospital in East Los Angeles is the only institution apparently that has ever heard of such an oath and that is where we arrived at 10:45 at night. I have grown up in Africa and am used to seeing rundown hospitals, but L.A. County looks like a cross between *M.A.S.H.* and the Battle of the Somme. I checked the patient in at the desk and picked him up six and a half hours later. During those hours I was taught my final Thanksgiving lessons.

I stood in the waiting room against the wall and braced myself for the horror. Every ten minutes a snarling, manacled convict would be led through, drenched in blood or crusty with vomit. Old Latina women wept in groups as children wandered around looking bewildered. Half of the people in the room were just homeless who came in with their shopping bags and rags and shower caps to watch TV and escape the cold. Everyone there was miles below the poverty level and here we were trying to get an oyster out of a Persian surfer.

I decided to make a collect call to my grandmother in Iowa to pass the time. She asked me if I was eating well and if I had heard about Magic Johnson and that us young people should be very careful these days. While I talked, the sheriff's department dragged three gang members past, screaming in Spanish. My grandma asked what all the noise was and how I was enjoying Los Angeles. I said the fraternity where I was living was a bit noisy, but I was enjoying my classes and I got an A- on my African history midterm. She said that they all missed me in Iowa for Thanksgiving and everyone sent lots of love and a big hug.

By Dan Eldon

185

heartland

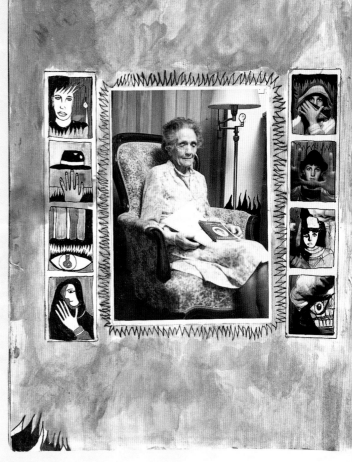

As other UCLA students were getting ready for a few weeks of downtime with family and friends over the winter holiday, Dan was headed for a month of dizzying travel, romance, and decision making. Even by his standards, life was more crowded than usual. When he took off for Nairobi, he had no idea that by February he'd find himself not back in Los Angeles as anticipated, but in a small town in Iowa.

His journey began by meeting up with Mike and Amy in Kenya and then flying together to India. Since Kathy's departure, the three had enjoyed annual adventures to such far-flung places as Greece and Romania. They all thrived on the challenges that travel presented, whether haggling with a street vendor or engaging in impromptu diplomacy with a shady airport bureaucrat.

Dan and Amy saw the trips as a chance to get their father away from his demanding schedule. Dan and Mike, cameras always in hand, spent much of their time seeking out just the right light, with Dan increasingly providing tips. They loved to photograph the locals, but their favorite model was Amy, who at eighteen was becoming a beautiful young woman. They were forever imploring her to smile just a second longer or to tilt her chin up just a smidge. In Jaipur, Dan coaxed her to the top of a narrow obelisk. "Whip your head around," he instructed. "You get up here and whip your head around!" she shot back, holding on for dear life.

Back in Nairobi, Dan and Amy caught up with old friends, among them Amy's friend Soiya Gecaga, home from boarding school for the holiday. The granddaughter of the first black president of independent Kenya, Jomo Kenyatta, Soiya was Kenyan royalty. She traveled first-class and was accustomed to being surrounded by beautiful things. She planned to attend a top-notch university and then law school. Dan quickly discovered that he liked to tease her, challenging her prim, orderly life, nearly as much as he liked to photograph her, with her long legs and lean good looks.

He dropped into Soiya's world like a bomb, keeping her up for a late-night rendezvous on his bedroom veranda, distracting her from her college applications, taking her to places on the backstreets of Nairobi that she'd never seen. She was smitten, but she also knew of Dan's reputation and was determined not to become another of his girls. Over the years, she'd seen Dan get what he wanted and she didn't plan to follow suit. Toward the end of their time together, both ready to leave Nairobi, she shut down from him emotionally. He was maddened, telling her that her "head kept overly strict exit visas" and he hadn't "even gotten near her first border town." The stubborn pair fumed, made up, and tried to consider what the future could hold.

After Soiya left, Dan flew to Moscow with Lengai for a quick adventure via the cheapest flight they could find: a frigid, overnight visit to Red Square and Lenin's tomb. Dan, unprepared for the cold with only a flimsy, autumn-weight jacket, darted from building to building, his hands burrowed into his pockets. They took a rickety Aeroflot plane on to London, where Dan met up with his mother. She showered him with gifts, a new blank journal, art supplies, and lenses he'd requested for his cameras.

They walked around London arm and arm, taking in the carousel set up every Christmas in Leicester Square, a favorite of Kathy's.

All the while they plotted, each talking about the next big plan. Kathy was hoping to produce a feature film set in Africa. It had been a long, thorny battle to get the money, but it now looked like filming would begin in the spring. She encouraged him to consider working on the crew. A job would surely be available if he could keep his schedule flexible.

Dan was overwhelmed by his options. "I want to do great things in my life," he wrote to Soiya, while on the airplane back to L.A. "I want the plane to land, so I can start. The only problem is where do I start. What do I do when I get off the plane to do great things? Is university the best place for me? Should I take off with my camera to El Salvador? Listen to what your heart tells you, you say. Well I'd like to rip the little bastard out and interrogate him with a 12-volt car battery."

☺ ☺ ☺

Deciding to try for the film job, he left UCLA for Cornell College in Mt. Vernon, Iowa, a small liberal-arts college known for its unorthodox scheduling. He called ahead to enroll in a psychology course and then, after a final skinny-dip off the Santa Monica Pier, his underwear lost on the beach as he splashed in the Pacific, he headed for Iowa.

Aside from the convenience it offered, going to school in Iowa made sense to Dan. He didn't care that few Americans can locate the state on a map, much less remember whether it's known for corn or potatoes. To him it was a place full of family and a sky nearly as large as the one in Kenya. His grandparents were in Cedar Rapids, just up the road from Cornell. He could live with his older cousin John, right around the corner from his aunt Carolyn, a block from campus. Camp Wapsie, where he and Amy had gone every summer since they were little, was about twenty minutes away.

"Well, well, well. Mt. Vernon, Iowa. The places that I end up," he wrote to his dad shortly after his arrival. "Quite a flight path: Nairobi, Moscow, London, Los Angeles, Mt. Vernon, Iowa. What would the CIA make of me? The town here is quiet. Very quiet.

The natives are mainly involved in small-scale agriculture, the trading of swine and sweet potatoes and such. I have found them friendly and quite harmless. The climate is not entirely unarctic, if you will excuse the double negative. I am acclimating to the conditions and am able to remain outdoors for fifteen to twenty seconds now."

Iowa in the winter was an entirely different place than the Iowa of camp. Immediately after moving into his cousin's rambling three-story house, he inherited several coats and sweaters to buffer him from the unaccustomed cold. Within hours, he'd lost his first pair of gloves. Other pairs, a scarf, and a set of house keys were soon to follow, prompting John, ten years his senior, to consider pinning them to his coat.

Dan enjoyed the well-appointed house—antiques and silk-covered armchairs in the living room, floor-to-ceiling bookshelves lined with art books, and a kitchen complete with china teapots and chafing dishes—but he tended to storm through, leaving clothes, papers, and dirty dishes in his wake. When the bedroom John originally gave Dan proved insufficient, he quickly colonized two more rooms. His journals and supplies, along with art books he nabbed from downstairs, covered several tables and much of the floor. He pushed together two odd-sized antique beds to accommodate himself and a girl he'd started dating after he and Soiya had agreed to have an open relationship. It was a homey, messy nest.

In contrast to the jet-lagged life he'd been living, Iowa was restorative. He and John spent many quiet nights together watching old movies. He worked on the journals ferociously, taking a few photographs of his girlfriend and cousins, but mainly dabbling with scraps hauled halfway around the globe from Japan or Africa. As he glued and drew, he'd play one of his mixed tapes; the Afri-pop was an exotic sound in the chill of the mid-western night.

Although he was an anomaly on the small campus, he was gracious about sharing his far-flung experiences. He greeted his professors and fellow students with an uncommon level of courtesy and genuine interest. As always, his schoolwork was whimsical, dictated more by his own interests than by actual assignments. He wrote a mock research report

189

titled "Sexual Conditioning" about the aphrodisiac qualities of the African hair oil called Yu. His professor, who received this mainly true account of one of Dan's trips to northern Kenya, along with a small jar of the hair-oil-cum-aphrodisiac, felt that while it did not quite fit the assignment, the paper was "nonetheless a delightful evocation of youthful exploration and spirit."

☺ ☺ ☺

Dan came naturally by his international flare. Russell and Louise Knapp, Dan's maternal grandparents, are beloved by their brood of grandchildren in large part for the adventurous spirit they developed late in life. Solid Iowans from Methodist families with long traditions of civic duty, they had never strayed far from Cedar Rapids when they were married in 1933. For their honeymoon, they drove only two hours away from their hometown before returning to their tiny newlywed's apartment.

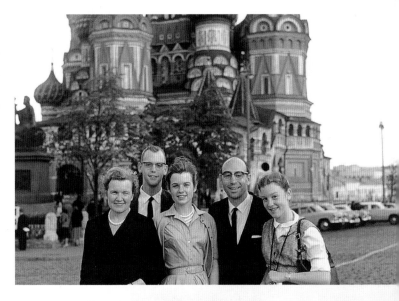

By 1960, they had four children, the oldest already married, and Russ's brokerage was a solid success. They'd lived for years in a spacious stucco house on a winding, tree-lined street—the kind of street where kids played kick-the-can at night and neighbors brought over cookies at Christmas. It was an easy place in which to curl up and never leave. But that year they made a risky, unconventional tour of fourteen European countries, taking their three youngest children along.

The trip was well choreographed by a local travel agent, who assuaged their concerns about visiting the newly erected Berlin Wall and the Soviet Union just weeks after Francis Gary Powers was put on trial as a spy. Everything went smoothly until a storm knocked the Soviet leg of the trip off schedule, forcing the family to make new arrangements and transforming them into independent travelers.

The experience—complete with an unsuccessful search for a bugging device in their Moscow hotel room and visits to the opening and closing ceremonies of the Rome Olympics—unleashed a great love for travel in all of them. Several years later, Kathy spent part of her junior year in high school as one of the first American exchange students in South Africa. As adults, three of the siblings lived in Europe and Africa for stretches. Their parents topped them all, visiting nearly seventy countries, including China, Zambia, Burma, and the remote Inca ruins of Machu Picchu in Peru.

Dan appreciated his grandparents' energy and their philanthropic contributions, both to himself and to others. He had had to convince them that the Year On and other less orthodox approaches to education were indeed educational, but once he demonstrated that he could pull off something as big as STA, he had their full support. He never hesitated to acknowledge the example they'd set, once writing to them: "Here in L.A. I see so many people who have wealth and abuse it, flaunt it, or waste it. I always am thankful to come from a family that is very successful but concentrates money on travel, education, health, and charity!"

When the call finally came from his mother that the film was indeed going to happen, Dan finished up his second college class and headed once more for the small airport in Cedar Rapids, an entourage of family members in tow. He hugged his grandparents good-bye and told John to take care of the boxes of art supplies and photographs he'd left. "I'll see you all soon," he announced, hoisting a duffel bag onto his back and walking onto the runway to catch the puddle jumper to Chicago. He'd returned his winter gear to John already, so the March wind blew his shirt close to his thin frame, as he gulped a last breath of Iowa air before scrambling up the stairway.

a lion's tale

The boys ran all over the cabin, springing their nine- and ten-year-old bodies in every direction: onto the stiff bunk beds, at each other, and occasionally into the bushes just outside the door. Jeff, the senior counselor, had yelled at them to put down their weapons—pillows and stuffed animals—but this hadn't stopped them from flying about, creating a kiddie moshpit.

Jeff was impressed by their ardent attempts to stay up late and break the curfew, but his patience was wearing thin. He looked across the cabin at Dan, the younger counselor who had just finished his junior year in high school, and raised his eyebrows. "Got any suggestions?" he seemed to say. Dan had already tried his broom trick. He'd turn a broom upside down, using the handle as a sword, and joust the boys into bed, yelling at them in some fanciful combination of Swahili and guttural Japanese. The kids were all so impressed by the act, which they took to be genuine, that it stopped them in their tracks and settled them down.

Not tonight.

Dan was sixteen that summer and could remember his own attempts to break curfew during his years as a younger camper. He had been coming to Camp Wapsie since he was ten. Every summer, he and Amy flew on their own from Kenya to London, where their father's parents met them at the airport before they continued on to Cedar Rapids, Iowa. After a happy reunion with "Umpa and Mamo," their maternal grandparents, they were trundled off to camp, where they stayed for a few weeks with cousins and friends from the previous summer. It's a small camp on a sleepy bend in the Wapsipinicon River. Most of the kids, many of whom return year after year, come from nearby Iowa towns or neighboring states. New York is a faraway dream for most of them; Kenya is as distant as Mars.

With their accents and outrageous stories of Masai and giraffes, Amy and Dan were an exotic curiosity. Dan reveled in his foreigner's reputation. He brought along bracelets and trinkets to share. When he passed someone walking between the rough-hewn cabins, he'd shake his or her hand, leaving a small, carved wooden animal in the person's palm. At night, sitting around the campfire, he'd take a colorful *kikoi* from his own neck and put it around a friend's shoulders. He brought a mischievous side to his role as cultural ambassador. When younger kids asked naïve questions, such as, "Are there any bathrooms in Africa?" he

would play along: "Absolutely none." One summer, he managed to convince the entire camp that *konnichiwa*, Japanese for hello, meant "You're an asshole." Hordes of giggling, blond school kids yelled the word at each other with glee for weeks. "KONNICHIWA!"

Tonight, though, he and Jeff were having no luck. A soft touch, barking orders, and humor had all failed to rein in the rambunctious crew in Elm Cabin. Quietly, Dan reached into the pocket of his well-worn jeans and pulled out a little pouch. Jeff watched him carefully untie it, turning its contents over in his palm a few times. As Dan continued to pay special attention to the object while ignoring the kids, several campers took notice. "What's that?" one freckled boy demanded. "It's hair!" another boy exclaimed, coming close to Dan. Within minutes, the entire cabin had gathered around him.

"It's hair from a lion's mane," said Dan, holding up the ash-colored ball of fluff for closer inspection. "If you sit down, I'll tell you how I came to have it."

For the next quarter hour they sat in rapt attention as Dan told them about climbing over the Ngong Hills and down into the Rift Valley with a pair of Masai *morans*. He described their spears and ornate costumes, as well as the way they could walk at high speeds for hours on end without tiring. And then, with a healthy smattering of Swahili, he described the hunt for a ferocious lion that had been terrorizing the Masai's *shamba* for months. The lion had killed three boys already and had to be stopped.

The room was completely still as the story came to a climax: a chase through the dry, cutting grass; spears flashing in the high afternoon sun; the lion dead at their feet; and Dan clipping a chunk of hair from the beast's enormous head. "I'll carry this with me forever as good luck," he said, allowing the boys to pass it around the room like a holy relic. When they climbed quietly into their beds, their minds still roaming the Kenyan bush, Dan said a short Masai prayer over the cabin and turned off the light.

Walking out into the humid night, amid the dance of fireflies, Jeff turned to Dan. "That was amazing! Thank god you got them to quiet down."

Dan just smiled and said nothing. "So," Jeff continued, feeling a bit foolish for having to ask, "Did that really happen?"

Dan nodded, his grin broadening, "Total bull, my friend. Utter and total bull. But a good tale, don't you think?"

193

nargus kapuri pan

Dan had been working hard on the film, *Lost in Africa*, during April and May of 1992, both cursing and relishing his role as third assistant director. "It sounds much better than it is," he'd explained to his father. "You know, you hear 'director' and you think, 'Wow! Big shot!' But really you're just a lackey, running around doing everyone else's shit work."

He was up at dawn to copy call sheets and distribute them under the cast and crew's hotel doors. The rest of the day was a mad dash of odd and odder jobs. He quieted people on the set—not the dreamed-of scenario of bellowing "Quiet on the set" to the immediate crew, but running around to everyone remotely in earshot and telling them to shut up for god's sake we're filming. He delivered coffee, parked cars, and held a parasol for a finicky American actor. Once in the late afternoon, the director changed the script and decided that camels were needed for the morning shoot. The task was given to Dan, who spent the evening on a scavenger hunt. When he finally located seven of the notoriously temperamental beasts, securing them with their handler for the night, he slept with them in the bush near the set so they wouldn't run away.

Before returning to Kenya, he had looked forward to working with his mother, but that hadn't happened. As associate producer, she was embroiled in a dispute with the executive producer, and each day was more about politicking than movie making. Being more engaged in the business end of the film, she tended to steer clear of the set. Aside from the never-ending intrigues involved in making a film, it had been emotionally draining for her to be in the country again. Every road seemed to hold anguished memories and prickly ghosts; even happy recollections were difficult.

Just before she left Kenya, Dan visited her at her hotel bungalow. Opening the door, Kathy was caught off guard by an enormous bouquet of flowers blocking the person in front of her. From the familiar bracelets, she could see it was Dan. Her face lit up in a radiant smile as she stepped forward, taking the flowers in one hand and grabbing her son by the back of the neck with the other so she could kiss both of his cheeks. "Ahhh! Bella!"

"Madame Producer, I've come to whisk you away from all things silly and mundane!" he told her with a brief bow. "Tonight, I am your host and we will put this ridiculous movie business behind us."

They set off in Deziree with the boom box playing a Martin Luther King Jr. speech: "I have been to the mountain top . . ." Dan hollered the words along with the great man, signaling to his mother that she should listen carefully. It was Dan's way of letting her know that while the past few years had had difficult moments, she should head toward happier times. He didn't like her being in the midst of the politics and money issues that

Stills from "Laila" The murder scene filmed at the Croze's glass blowing studio.

came with making a movie; he wanted her to write again and make art, work that inspired her.

"I'm taking you to my favorite place. You'll love it!" he yelled over Deziree's rumbling engine as the good doctor faded into a Miriam Makeba song. Kathy sensed that while Dan enjoyed dining on pepper steak with Mike at the oh-so-proper Muthaiga Club, he had something a bit less refined in mind tonight. She checked to make sure there wasn't a can of beans in the back that he might stop and heat up at any second. Once he'd taken a high-ranking member of the American Embassy staff to lunch by driving the woman around the block, stopping in a parking lot, and taking out his camp stove to heat the beans—a spontaneous lunch for two.

They started down River Road, a colorful, sometimes seedy area that had been Dan's haunt since high school. It was a balmy night and Nairobi's downtown streets were nearly empty. They pulled up to a corner restaurant, Nargas Kapuri Pan, and Kathy smiled at the memory of the first time she'd been there. She was working on the last book in her series of *Eating Out Guides to Kenya*, for which she'd reviewed almost four hundred restaurants, from the fanciest to the most modest roadside *samosa* stand. Nargas Kapuri Pan was definitely on the modest end of the scale. She didn't want to

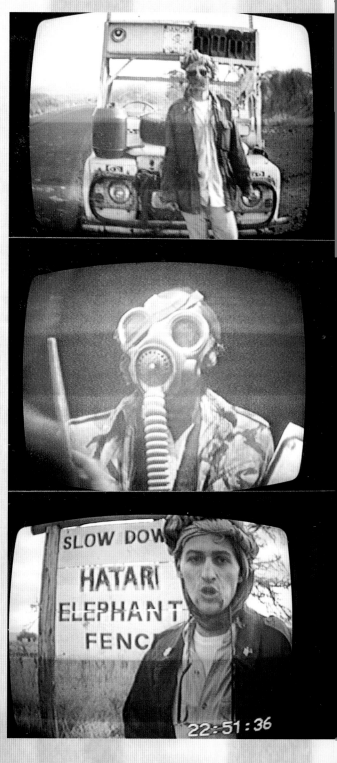

ruin Dan's pleasure at introducing her to a "new" spot, so she kept quiet.

It didn't work. As soon as they entered the plain little one-room shop, with its simple wood tables and straight-backed chairs, the owner immediately burst from behind the counter, having recognized her red hair and smiling face. "Kathy Eldon! How happy I am to have you here again! Come, you must sit down!" he gestured wildly for the single waiter to fetch some Cokes.

After they'd been treated as royally as the tiny restaurant could muster, Dan looked at her and laughed. "I should have known better. Is there a single restaurant where they don't know you?"

The chicken *tikka* and *chapatis* arrived, and the two got down to the business of catching up. Dan told her how great working on the film had been. He'd borrowed a video camera from a crew member and had started making a small film of his own that he hoped to use to get into film school. "I'm calling it *Leila*. It's the story of a young Somali girl who comes from the north country and is tempted by city life," he explained, all the while heaping the sweet, tender chicken onto the *chapatis*.

Kathy thought the story line sounded all too familiar but let it pass. The important thing was that he was making a next step toward school. She was always challenging him, peppering him with questions about his future: When would he go back to school? What skills was he learning to run his own photography business? What contacts had he made that could be useful? He didn't like to be pushed. He had his own agenda and often it didn't correspond perfectly with hers. Rather than heading into this thorny territory, she asked who he had cast as the lead. "Well, that was something else I wanted to talk to you about," Dan said. "It's Neema. You know, she had a small part in your film."

Kathy had hardly talked to the girl, but she remembered her clearly. Neema had been chosen not for her acting abilities, which seemed minimal, but for her looks. Tall with beautiful, chiseled features and mocha-colored skin, she bore a striking resemblance to the model Iman. As Dan continued, it became clear that he and this young woman had begun a relationship. While he was always passionate about his girlfriends, he also tended to have a girl in every port. Now he sounded more smitten than she'd heard him for a long time. She listened as he waxed about how Neema needed him, having been through hard times.

199

Nargus Kapuri Pan

"If you end up being a famous director, you'll have to thank Meryl Streep in your Oscar speech," she teased, trying to get him to refocus on fond family memories. It was a reminder of the night he'd spent as an extra on the set of *Out of Africa* in 1984. Wearing a costume of proper Victorian knickers and white shirt, he'd played an exuberant boy at the Nairobi train station and had to run into the great American actress fifteen times. Later, the film's director, Sydney Pollack, had come to lunch. The entire event had made a big impression on him.

"No, you're wrong," Dan said leaning forward, his eyes creased into a devilish smile. "When I give my speech, the first people I'll thank are my parents for giving me my first camera, heaps of art supplies, respect, and constant love. Dad for a love of nonsense and you for your Rolodex." He'd always been unusually good about crediting her and Mike. Still, the words were nice to hear and made her blush with pride. She couldn't deny that he was irresistible; no wonder the girls all adored him.

"What about Amy?" she continued the joke.

"Well, of course I'll thank her for understanding my true role as the superior sibling and taking her rightful place in the back of the car!"

Just then the proprietor returned with a plate of *pan*, the little betel-nut leaf rolls filled with spices that the Indians chew as digestives, holding them in the sides of their cheeks for hours. On Kathy's visit years ago, the same man had offered her a "very special *pan*" that had made her head spin. She'd felt herself floating up to the ceiling before going outside to throw up near the car. "The cheapest high in Nairobi," she'd written in her review, bringing in more business than Nargus Kapuri Pan had ever seen before. The man seemed to remember, as he had a little grin on his face and said, "No worry. Sweet *pan*. Very good, very mild."

Dan and Kathy tried their best to pay the bill but the man wouldn't hear of it. Their mouths full of *pan*, they headed outside, arm in arm. "What should we do next?"

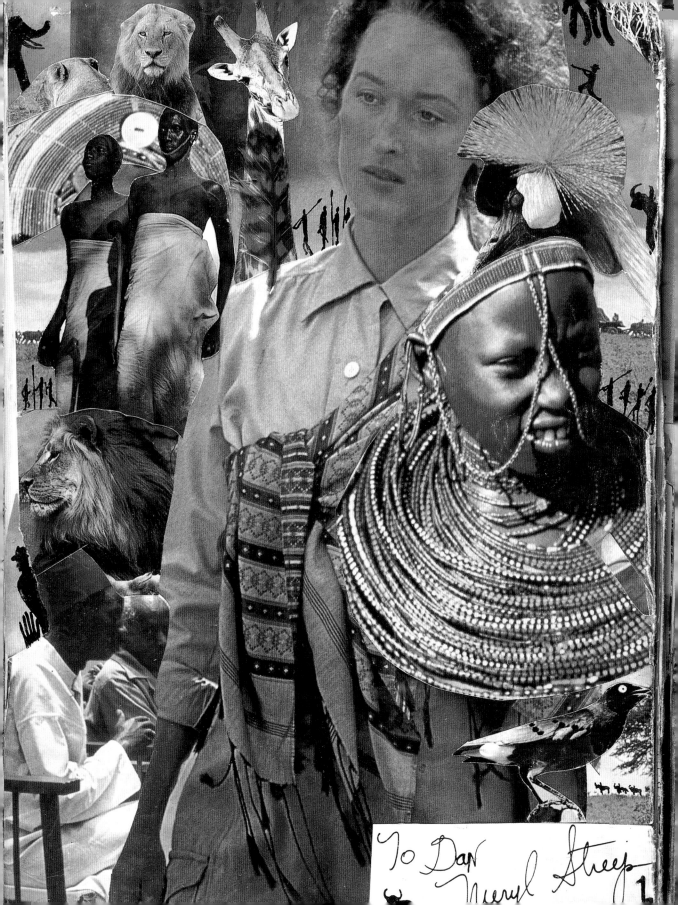

To Dan
Meryl Streep

1

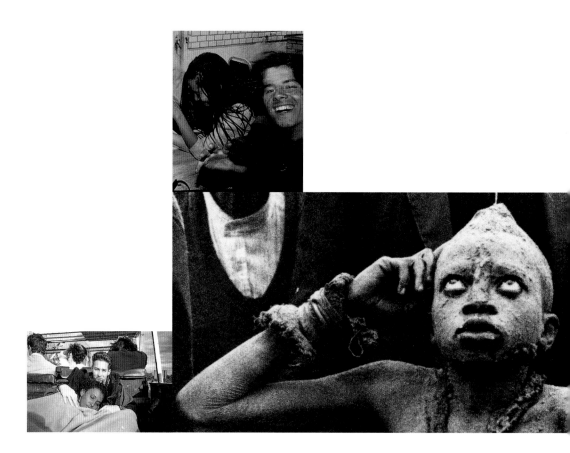

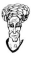

intermission

Between May and July of 1992, Dan lacked a clear path. As usual, he filled the void with a host of schemes. Some of the crew members from the film had encouraged him to apply to UCLA's film program and had promised him letters of recommendation. He wanted to establish a photography studio in Nairobi and to do more photojournalism.

His unsettled state was heightened by being in the midst of a house full of guests. Unlike those from his childhood, most of these visitors were his own rather than his parents'. A photography friend, Guillaume Bonn, was in and out of the Eldon Hilton that summer. Jeffrey Gettleman and Roko Belic, two of Dan's STA friends, also crashed there, halfway through their year-long trip around the world. Aside from their scruffy appearance and rather ripe odor—they'd seemingly failed to bathe since leaving the U.S.—Dan was happy to have them around. They had a video camera with them and Roko, a film student, was making a documentary of their trip. The threesome spent one afternoon making a silly spoof of the recent Oliver Stone film *JFK* about the Kennedy assassination. In the Nairobi version, Dan switched accents, playing both a British secret agent and a Texas ranger involved in a highly sensitive mission to solve "the disappearance of Jeffrey Gettleman." The spoof ended with him dropping his pants and wading out into a stream in his boxer shorts to fish out Deziree's front grill, which had fallen off the night before.

As part of his film project, *Leila*, Dan took Roko down to River Road one morning to set up a video camera. Roko was apprehensive about having the expensive equipment in the somewhat downtrodden area. It would have been easy for a street kid to have grabbed the camera and run off. Dan kept telling him not to worry, that the situation was fine. They spent about a half hour filming, with Roko becoming more confident and relaxed. Just when Roko had put any potential danger out of his mind, Dan suddenly yelled at him, "Let's get the hell out of here!" They took off down the street in a near run. Roko made a final glance over his shoulder to see a group of kids and young men forming where they'd been working; it was hard to decipher, but a new tension was in the air. Climbing back into Deziree, Roko asked how Dan had sensed the slight but crucial shift in the mood of the crowd, and Dan explained what he called his theory of kinetic energy: "It's like a balloon that keeps filling with air and expanding. Eventually, there is no more room for the air in the balloon and POP! You can get yourself out of a lot of tough spots if you understand this."

On another day when Dan was filming alone on River Road, he focused his viewfinder on two policemen who were far off down the street. He kept filming as they approached, catching the moment when they realized they were part of his video, their faces becoming pinched with anger. Just before they could reprimand him, Dan sighed and made an annoyed gesture to the camera.

"Get out of the way, would you? Can't you see I'm filming here?" he said, shooing them as though they were troublesome children. The men's anger quickly turned into apologies and they moved along, leaving Dan with the footage he wanted.

All of the street scenes were for *Leila.* Jeff and Roko had high hopes for Dan's work; they nearly worshiped him, having been inspired by both his creative streak and his wanderlust. But sitting in the Eldon living room, they watched the video in silent horror. It wasn't merely "youthful"; it was a simplistic, amateur job that failed to exhibit its maker's wild imagination or the skill of his photography. Seeing that Dan was proud of his work, they hid their disappointment.

Dan may have been partly blinded because of his growing devotion to the film's star, Neema. Of Somali descent, she had grown up in Kenya, where her father had been the town councillor for many years. Dan was captivated by her beauty and her insouciance. Picking her up for a date, he used to wait while she and her girlfriends slowly prepared to go out. She loved teasing him, and, in many ways, he loved being teased. He had a fondness for femininity, and sometimes gave other women friends a hard time if they didn't dress up enough or wear a touch of perfume. He was very aware of the attention Neema attracted from other men. She was beautiful and heads turned for her. Dan liked to fancy himself her protector, but she often proved that she could take care of herself.

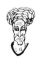

The two had enjoyed their romance, taking brief trips with friends and going out on the town together, until late June when Dan found himself in the middle of an unpleasant triangle of women. Since the previous Christmas, he and Soiya had been corresponding. With Soiya finishing boarding school in the U.S. and Dan in transit between California, Iowa, and Kenya, they'd kept alive the relationship that had begun during the previous winter vacation. At Dan's prompting, they'd agreed to an arrangement that allowed each to date other people while they were apart. It had seemed like a sensible, mature idea, but they were jealous people and their understanding was already backfiring.

The last straw came on the morning of Soiya's graduation, when she received a letter from Dan telling her about Neema. Her anticipation of the good times they would share that summer were

dashed. Furious and hurt, she determined to return home sooner than planned and catch him at his game.

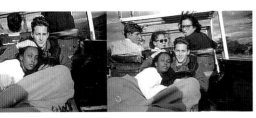

Meanwhile, Laurie, Dan's friend from high school, with whom he had spent time while in New York and had seen during several shorter visits in the States, also made an unexpected visit to Nairobi. Although she and Dan had been romantic only during the short periods when they'd been in the same place, she hoped that eventually they could have a longer-term commitment. Maybe a surprise appearance would be the needed spark.

It was like a scene from a bad movie. Laurie and Soiya, who only then were realizing each other's existence, and Neema, who knew nothing of the other two, were in and out of the Eldon house. While Soiya confided in her old friend Amy, Laurie cried on Mike's shoulder, and Neema felt hurt by Dan for having kept her in the dark about his other commitments. She had no interest in an open relationship and was surprised that Dan would consider it. Dan was miserable. He hated to disappoint anyone, and he was in a lose-lose situation, unable to charm himself out of an awkward spot—a rare occasion.

Dan vacillated between Soiya and Neema, trying hopelessly to appease both of them. Eventually, he and Neema reconciled and spent the rest of the summer together, while he and Soiya settled back into friendship. At the same time, Dan was working more seriously than ever before as a photographer and was seeing some initial success. During Jeff and Roko's stay, there was a student riot in Nairobi, during which two travelers—a pair of Brits with whom Jeff and Roko had planned to travel south in a rented Land Rover—were injured when stones were thrown at their Land Rover. Dan photographed them afterward, and the images made it into *The Nation*, Kenya's principal newspaper. Some photographs he took of a circumcision ceremony in western Kenya were also purchased by the paper. The powerful, stark shots showed an adolescent boy, the son of Mike's new cook, Erastus, covered in ash and being led from a river, the coldness of which was meant to anesthetize him before the painful rite of passage. Once published, the images helped Dan make a name for himself in Nairobi's small photojournalist circle.

At his father's encouragement, Dan had gone to *The Nation* to show his work. He had been to the office many times as a kid, tagging along with his mum when she worked for the newspaper as a restaurant reviewer and feature writer. He loved the boisterous, open newsroom, with typewriters chained to the desks and reporters yelling across the room to each other. When he was a teenager and his skills were strong enough, his photos had accompanied some of her articles. He knew many of the reporters, and several recognized him immediately on his return, happy to see Kathy's son grown up, camera still in hand. Sam Ouma, the paper's photo editor, had been supportive of Dan's interest in photography throughout the years and was now glad both to publish his work and to give him advice.

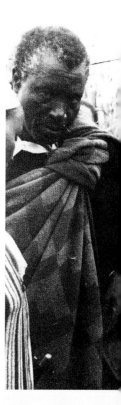

With his exposure in *The Nation*, Dan was able to pique the interest of Reuters's Nairobi bureau chief, Jonathan Clayton. When Dan first went to the office, located in an unsightly gray office building next to a vacant lot where petty thievery mixed with the amplified exhortations of an evangelical preacher, he met a writer named Aidan Hartley. Kathy had given Aidan his first job six years earlier, when he was just a little younger than Dan was then. Now Aidan was curious about her son and invited him out for a beer.

As the two discussed Dan's options for the future, Aidan told him that for anyone who wanted to be a journalistic photographer, the decision was a no-brainer: Africa was the place to be. Many of the biggest names in the business were working nearby or would be coming soon. The wake of the cold war was finally reaching the continent. As the Americans and Soviets had cut back on their long-entrenched defense spending, governments elsewhere had rapidly changed in response. In some cases, as in South Africa, it was for the best. But two of Kenya's neighbors, Sudan and Somalia, were undergoing very different overhauls in the chain of command.

Since 1969, Somalia had been led by Siyaad Barre, a corrupt dictator. He had a dual plan for modernizing the country, the first part of which he called "scientific socialism." He viewed himself as part of a triumvirate—Marx, Lenin, and Barre—and gladly accepted military assistance from the Soviets. The other part of his strategy was to eradicate the Somalis' entrenched tradition of tribalism. All Somalis derive from six clans, which are further delineated by multiple subclans. Barre went so far as to outlaw clan loyalty, though he could never wholly erase such

an ancient system; it merely went underground. Prior to colonization and the overlay of Western governmental organization, the clans were the organization; they were the ostensible law of the land, providing what little form of protection was possible in the 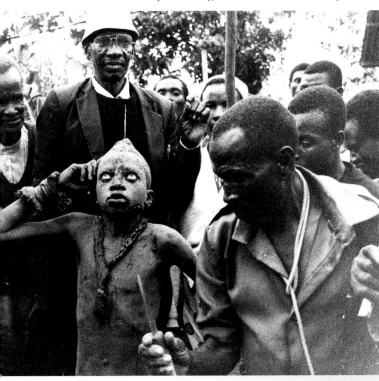 harsh world of these nomadic peoples. One of Barre's goals was to reunite the Somali people, who had scattered among several nearby countries. In the late 1970s, he tried to capture part of neighboring Ethiopia, where a large number of Somalis lived. Not only did he lose the war, but his old Soviet allies sided with Ethiopia. Given cold war politics, Somalia became a ball that now bounced to the United States for protection in the form of financial aid and military assistance. Clan tensions, long held in check, simmered to the surface throughout the 1980s. In 1988, when Barre finally signed a peace accord with Ethiopia, civil war erupted in the north. As clan-based guerrilla groups multiplied throughout the rest of the country, with each one claiming its own domain, the dictator tightened his hold on Mogadishu—the only part of the country still fully under his control—bringing Barre the nickname "The Mayor of Mogadishu."

By December 1990, fighting reached the capital. While two warlords, Mohamed Farah Aidid and Ali Mahdi Mohamed, fought over the city, Barre retreated to the countryside. There he would have seen the full destructiveness of his policies: the fertile interior had been ravaged by years of battle; farmers no longer had equipment or seeds and had themselves been attacked by rebels. (Aidid's and Mohamed's clans were nomadic and regarded farming as a disreputable livelihood.) Somalia's food production system, once relatively strong, had been obliterated, a situation that was only heightened by the country's longtime overreliance on outside aid. By the spring of 1992, a small number of aid workers and

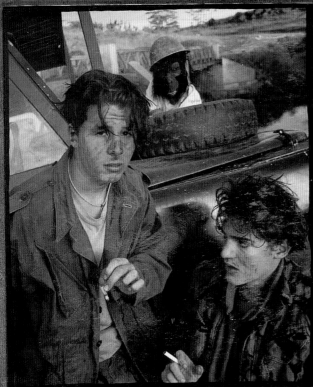

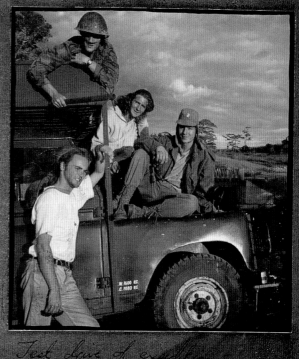

Test drive of expedition
vehicle for Southern Africa.
Aus. Jeff, Ross, Don and ?

"FILTHY OVERLANDERS"

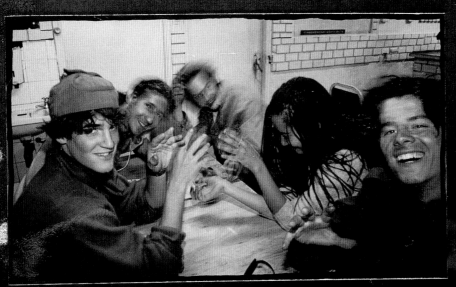

"GREASY CHAPATIS"

journalists who had been in the country's interior began to share disturbing news: a famine was under way.

At the time Aidan and Dan were sharing a beer in June of that year, Aidan had already been covering the conflict for several months. Although no one was listening yet, he sensed the story would soon explode, especially as the famine became more wide-spread. In Aidan's mind, Dan could go back to California and deconstruct *The Godfather* for the thousandth time with a bunch of would-be filmmakers in some university classroom, or he could stay closer to home and do real work, work that would get into the newspapers. Within a three-hour flight from Nairobi, one could be in the midst of five or six different war zones, not the least of which was Somalia. Now that was reality.

Dan knew about Somalia. He'd followed the news reports when he'd been in Iowa that winter, writing to his dad that it seemed as though "Somalia and Sudan have moved into our guest bedroom" —alluding to the refugees streaming into northern Kenya as a result of the two brewing civil wars. It was becoming a bigger story every day since he'd returned home. Yet another of the Eldons' houseguests—a former Miss India and burgeoning pho-tographer who had landed on their doorstep after meeting Kathy in London—had flown up north and photographed the refugee sit-uation. After seeing her pictures, Dan decided to follow her lead.

Aid organizations were heading north every day; it was easy and inexpensive to bum a ride. The photos Dan got in one afternoon in Wajir, a northern town with one of the largest camps, made him begin to realize the enormity of what was happening in Somalia. It was a reminder of the camps he'd seen in Mozambique, although this situation was much fresher, the scope even greater. In that earlier situation, he had helped by raising money that had gone to build wells. He was getting a small inkling that maybe this time his photographs could help.

Sitting across from Aidan, hearing his stories of the many trips he'd already made into the crumbling country, Dan knew he needed to see more. His fall plans for college were like puffs of smoke quickly vanishing from view as he leaned onto the table and asked, "When can we go?"

mog

Dan and Aidan flew into Mogadishu a few weeks later on July 5, 1992, catching a UNICEF flight, a twin-prop plane that made the trip in about three hours. From the sky, the city looked deceptively inviting. Turquoise coastal waters lapped onto coral beaches. Gleaming white buildings and green scrub dotted the landscape. From land, though, that this was an illusion became evident.

Dan had been in Johannesburg and Nairobi during major political rallies and had driven through the heavily mined Tête Corridor in Mozambique, but this was his first experience in an urban war zone. Mog, as the journalists called it, was largely decimated after having served as a battleground for nearly two years. Most of the destruction was the handiwork of heavily armed militia with AK-47s, rocket launchers, and grenades. (The country's vast weapons supply came from the United States and the former Soviet Union, previous Barre supporters.) The rudimentary skeletons and foundations of apartments, shopping centers, and government buildings made craggy lines against the horizon. Every standing building was pocked with bullet holes; any open space had sprouted into either a garbage dump or a refugee camp. An intense odor emanated from the city, a result of the refuse, heat, and general decay.

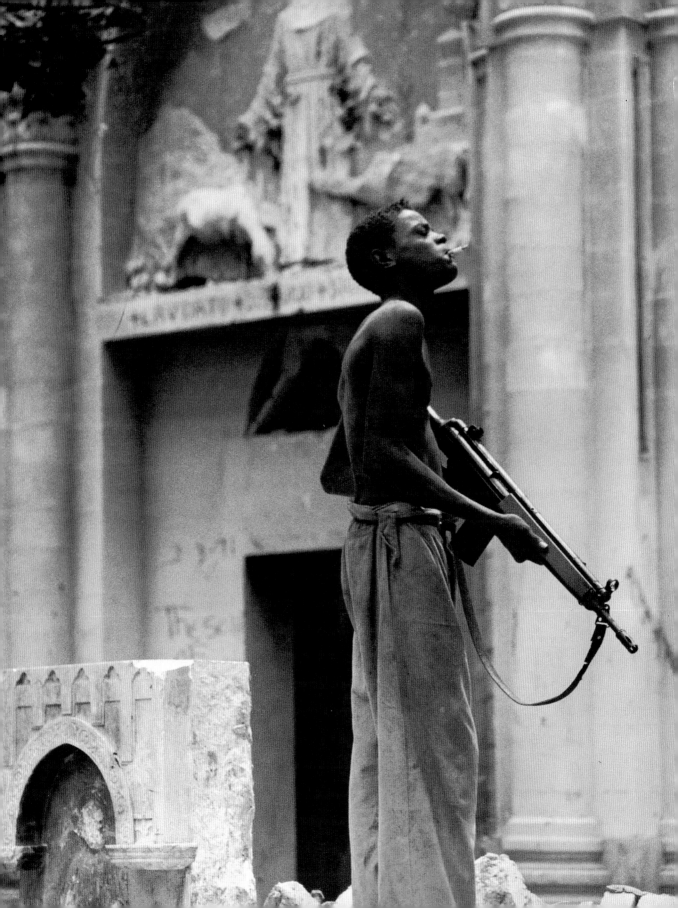

Mogadishu had never been as bustling as Nairobi, but it once had charm. Its ocean breezes, palm tree–lined streets, good cuisine, and lovely architecture—the latter being the remnants of the former Italian colonialists who had called the city Mogadiscio—lent it an Arabia-meets-the-Italian-Riviera feel. By the time Dan arrived, only the faintest echoes remained of the city's former character. A sign advertising photocopies hung askew from the side of one dilapidated building, the coral paint peeled away and studded with bullet holes. Salvaged telephones, air conditioners, and computers—some still brandishing United Nations stickers—sat in useless piles at the market. Such items had become luxuries that were outrageously out of reach for people whose basic concern was food. Besides, they were irrelevant in a city without electricity and where telephones no longer worked because looters had unearthed every inch of copper phone wire.

After securing a truck, complete with a driver and armed guards, Dan and Aidan drove into the city toward an area known as the "Green Line." It had been the old part of town—called Hamarwein before the war—where the Italians had built white-and-rose-colored buildings, attractive banks, and government offices. Now it was a no-man's-land, which had been so heavily and frequently fought over by warring factions that it was nearly barren, separating the northern and southern sections of the city.

Nearby was the great cathedral, one of the largest churches in Africa until it was set fire in late 1990. There were gaping holes in the immense, towering ceiling, and the steeple had fallen into the road, lending it a Gothic air of decay and disrepair. The heads on the statuary—Jesus, the apostles, and Mary—had been blown off, and some lay shattered at the figures' stone feet. The pews were gone, hacked up for fuel or building materials. Even the former bishop's body had been exhumed, and his rings and gold teeth scavenged.

The charred sanctuary served as an impromptu meeting place for teenage gunmen. Like kids hanging at the YMCA on a sultry summer afternoon, they were bored and in search of action. Instead of basketballs, these kids were toting AK-47s and grenade launchers. The setting may have given some people pause, but Dan immediately took out his camera to capture the surreal juxtaposition of the holy and the profane. He went right up to one of the kids, a bare-chested boy with a semiautomatic clutched in one hand and a lit cigarette dangling lazily from his lips, the trail of smoke leading heavenward toward a bas-relief of Jesus covered with graffiti.

The photos Dan took did not capture the entire story of what happened next. They failed to record the moment when the kid turned and pointed the gun at Dan.

Aidan and the other journalist who had joined them in the cathedral, veterans of several wars, were alarmed. "Jesus, get this kid away from me," the other reporter muttered, referring to Dan, not the boy with the gun. Any experienced war photographer knew better than to point a camera in an armed man's face, much less an armed kid's. You got your photo, but you did it much more surreptitiously than Dan was doing. He was a newcomer, unaware of such unwritten rules. Besides, although he had verbal agreements to show his pictures to both Reuters and *The Nation* when he returned, he was still shooting mainly for himself.

As Dan and the boy stared at each other, gun and camera poised, the cathedral was momentarily still. Dan moved quickly—some would say much too brazenly—reaching into his pocket to grab his old-man mask. By the time it was on his head, the small crowd was so astounded by his unanticipated move that they all laughed. The kids, including the menacing gunman, were soon trying on the mask, sticking out their tongues, the redness of which was highlighted against the pasty white rubber surface. The charged mood, similar to what Dan had felt on River Road when he and Roko had run from their filming site, had been transformed into laughter by Dan's sheer wit.

Back in the truck, the older journalists gave Dan a quick lesson on what he'd just done wrong, instructing him on how to get a picture without drawing attention to himself. They had to admit, however, that the mask trick was a new one.

Moving farther south in the city, they crossed paths with famine victims. As the situation in the country's interior and northern region had grown more severe, many people were walking to Mogadishu in hopes of finding help. They trekked for days, often losing weakened family members en route. Their destination was the feeding centers, operated by various aid organizations, set up in vacant lots throughout the city.

Aidan called to their truck's driver to stop so they could lift a man into the back of their vehicle. He was laying in the middle of the road, too weak to continue and only barely alive. His bones, like fragile sticks, could be seen below his dry and shriveled skin. They took him to the International Red Cross feeding center,

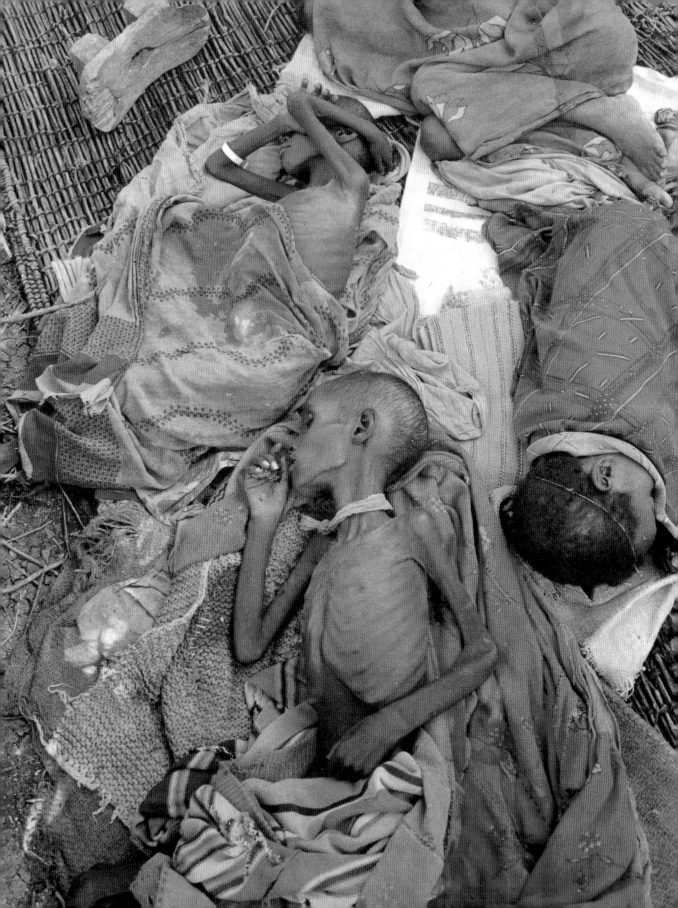

entering through the compound's rusted gate entrance. During their tour of the facility, which was staffed by a potpourri of international workers, Aidan interviewed one woman and Dan took photographs of her. As they would each do again and again in the coming months with countless other victims, they tried to form a story of how she had come to this desperate situation.

That night, Dan and Aidan stayed at the International Medical Corps compound. Since Mogadishu wasn't long on operational hotels, bedding down with aid groups was common practice. The IMC, a group of mainly American doctors and nurses, operated a trauma unit in one of the city's hospitals, working extremely long hours in conditions that would make any hospital administrator blanch with horror. They knew how to unwind, though, and were quick to share their food and alcohol with guests. After dinner, they gathered around the VCR to watch a scratchy tape of *The Bonfire of the Vanities*, a tale of 1980s greed and excess in New York City.

After four more days of investigating the city, including attending a press conference introducing the first fifty United Nations observers to arrive in Mogadishu, Dan and Aidan returned to Nairobi. Once he developed his photos from the trip, Dan created a collage for Aidan and presented it to him over a beer at the Carnivore. "With mixed thanks for giving me my first exposure to the horror," it read on the back. Aidan took it, pleased to have the memento but aware of its mixed message.

If Aidan was having any doubts about introducing Dan to the world of war reporting, Dan alleviated them by asking if there were any more trips north planned. The two had been to Sudan the previous week, where another war was waging, but Dan was eager to return to Somalia. The situation there was quickly heating up, just as Aidan had sensed it would. As the result of the work of a small cadre of African-based journalists, there was increasing awareness and public outcry about the famine. Major newspapers were shifting frontline column space to the tragedy, awakened by the deaths of more than a thousand people a day. Boutros Boutros-Ghali, the Secretary General of the United Nations, had recently said that the world was "fighting a rich man's war in Yugoslavia while not lifting a finger to save Somalia from disintegration." That would soon change and Dan would be there.

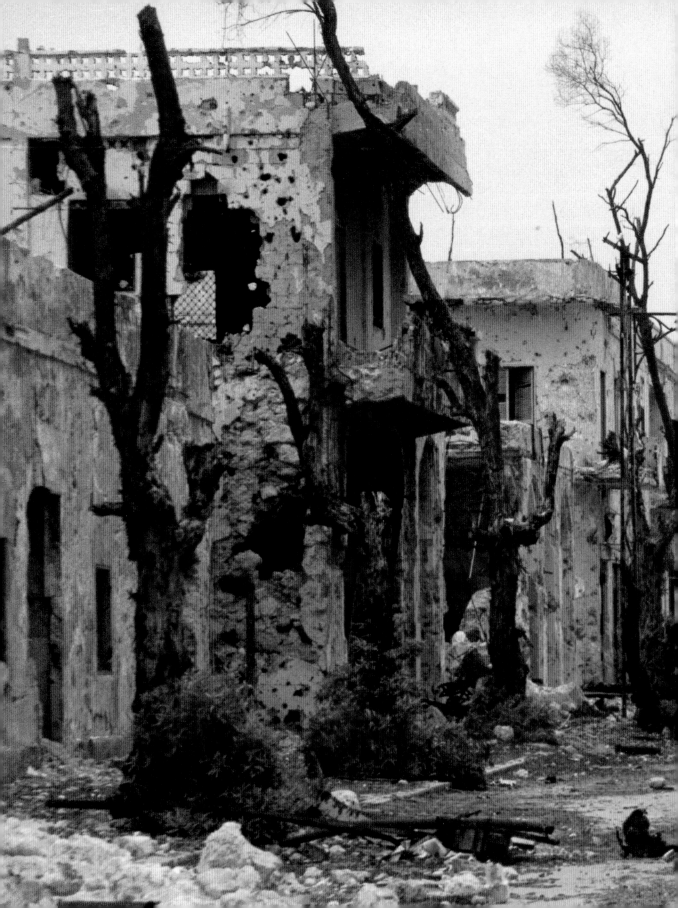

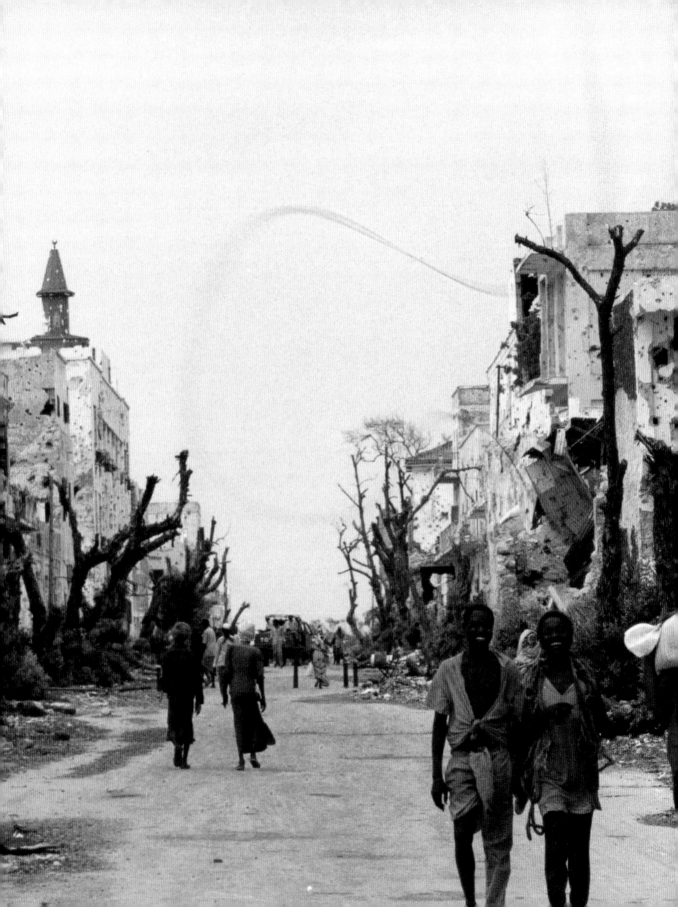

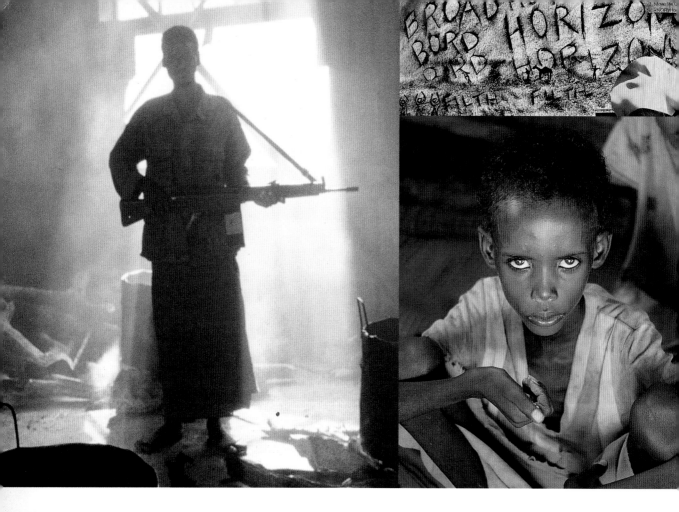

There is little difference between being lost and exploring.
—Dan's mission statement

darkness

In the coming months, Dan was in and out of Mog on a regular basis as a freelance photojournalist. As more money and food was sent to Somalia, he saw the effect of his and his colleagues' work. His effort bore personal fruit as well, as other photographers and editors noticed his photographs. Still, he was at the bottom of an increasingly large pool of journalists, a hierarchical group who dole out esteem based on how many wars one has covered and where one has gotten a byline.

Dan was a self-taught photographer—he'd taken but a few random classes—who faced a steep learning curve in a difficult situation. He positioned himself well, though, learning something from everyone he met, whether he had to charm the information out of an older hack or play it dumb. His skills quickly blossomed. He mastered the T-1 machine that transmitted pictures to Nairobi or London, then listened while a faraway editor provided tips over the phone. He became good at developing photos in the confines of a small bathroom, a rigged darkroom shared with other photographers. His years of travel served him well out in the field as he figured out just the right mix of bluster and deference to carry him through dicey situations. "I always try to be polite and friendly, because it is harder to shoot at a smiling face," he wrote for a Nairobi-based photography magazine. "When I do get spotted, the most important challenge is not to show fear."

To make himself look important, he carried all sorts of "official" papers, many of them phony, and a smattering of ID cards, a trick he'd learned from border crossings. Feigning ignorance was another ploy. On one flight into the hotly contested Mogadishu airport, where clans fought each other for control of airstrips and charged exorbitant landing fees to every incoming plane, his passport was snatched by an AK-47–toting boy who demanded ten dollars for a special stamp. Dan quickly grabbed the document back, pretending that he didn't understand what the boy was saying and gave him a cigarette in return for his confusion.

But Dan understood more than many of the journalists in town. Having grown up in Kenya, he and Aidan were rarities in the mainly Western press corps. The Somali language and customs were less foreign to them; they had more respect for and interest in the local people. Dan's cultural know-how gave him added clout despite his age and rookie status. He was one of the youngest journalists in Somalia, but that was relative because most of his colleagues, as well as the aid workers, were in their mid-twenties and early thirties. They were his kind of people too: well-traveled individuals who got itchy when they were home too long, people with good stories about close scrapes and risky predicaments.

In addition, Dan's boyish fascination with war—a predilection he hadn't outgrown since he and Lengai had played action games in the gorge—was being fully fed. Being in the midst of guns and uniforms left him somewhat wide-eyed. He got a kick out of riding on the "technicals," the gun-laden, sawed-off pick-up trucks in which the militias traveled, and he accrued gear and weaponry to add to the colorful collection in his bedroom back home.

The whole experience gave him a high, but like most highs, it had a corresponding low. The famine, which was only beginning to be addressed fully by a growing UN humanitarian force, was omnipresent. When Dan wasn't interviewing gun-crazy kids or UN staff, he was often in a refugee camp or at a feeding center, photographing women and children—the hardest hit—with distended stomachs and dazed expressions. Initially, they suffered painful cramps that left children wailing with misery; then as their bodies lost strength, they could only emit whimpers before succumbing to utter exhaustion and death. Sometimes Dan returned to the camp in search of someone he'd photographed before, only to find the person was already dead.

Nairobi was only hours away from Mogadishu, but it felt like a world apart. It was nearly impossible to come back to the comforts of home-cooked meals, afternoon tea, and a clean bed and be able to explain what he'd seen. Alone in the darkroom, he watched the starving, hollow faces come into focus, floating in the developer. They hardly looked human, though in the red glow of the small room he forced himself to confront them and see fully what he couldn't always let himself see while on the job.

By October, Dan's initial excitement for his new job had waned. He had been in Somalia for nearly a month straight in September without a break—too long. Feeling shell-shocked and longing for comfort and respite, he decided to take the money he'd made thus far from Reuters and visit Neema, who was living in Norway with friends. He needed to talk with a woman about the horrors he'd seen, he told his mum before leaving.

Since the summer, he'd grown only more obsessed with Neema. Because of her Somali heritage, he felt he recognized her face everywhere among the girls and young women of Mogadishu. One girl, whom he could not photograph because the scene was so awful, especially reminded him of her. It made the fact that the girls' feet and hands had been blown off all the more horrifying to him. His small room in the house that Reuters rented was adorned with photos he'd taken of Neema during the summer, and he spent many dull press conferences writing her letters, most of which he never sent.

Despite his longing, he received only wisps of information from Norway. She had moved there in August on a whim, following a

Norwegian girlfriend who was attending college. When she left Kenya, Dan had proposed the same open relationship he'd had with other long-distance girlfriends, but she wasn't interested. The few letters that she wrote to Dan in Somalia confirmed that she missed him and thought of him often, but by October she'd also met someone else, a man whom she found to be funny and interesting. This inflamed Dan's jealous and stubborn streaks, the same parts of him that had doggedly and blindly pursued Marte during the STA trip even after she'd chosen Lengai.

Having yearned for Neema for so long, he was determined to win her back. When he told her about his plans to visit Norway, her reaction was mixed: sometimes she wanted him to come; sometimes she thought it was a bad idea, given the other man she was dating. In an unsent letter he wrote to her: "I don't care even if you have forgotten me. I'm going to shake your life so hard that you'll remember me soon enough."

When Neema didn't meet him at the airport in Oslo, asking him to take a shuttle instead, he was hurt and viewed it as a bad initial sign. The next day, she introduced him to her boyfriend. Dan was devastated by the situation and left to wander the city alone. Its clean orderliness felt utterly foreign to him after the chaos of a war zone. The thinning autumn light and cool air, more reminiscent of the dreariness he associated with London than anything African, did nothing to buoy his spirits. He needed to talk and laugh; instead he was consumed by jealousy.

In an extension of the summer's debacle, Dan experienced the fallout of an open relationship from a different vantage point. His presence confused Neema, who although committed to her new boyfriend, still had feelings for Dan. They spent some nights together, having a good time in a club or café. Despite wanting to meet her boyfriend, when confronted with the reality of the situation, he sulked, becoming angry and petulant at her seeming rejection. At one point, maddened by Neema but unable to leave altogether, he visited Marte in the west coast town of Bergen. She tried to coax him into talking or eating, neither of which interested him. His natural curiosity was gone and his energy sapped. "Norway is so damn clean, I just want to piss on it," he snarled. She tried taking him sightseeing, but even in a tiny seaside town, he managed to find some Somalis to talk with. Be it the war or Neema, his mind was clearly elsewhere.

221

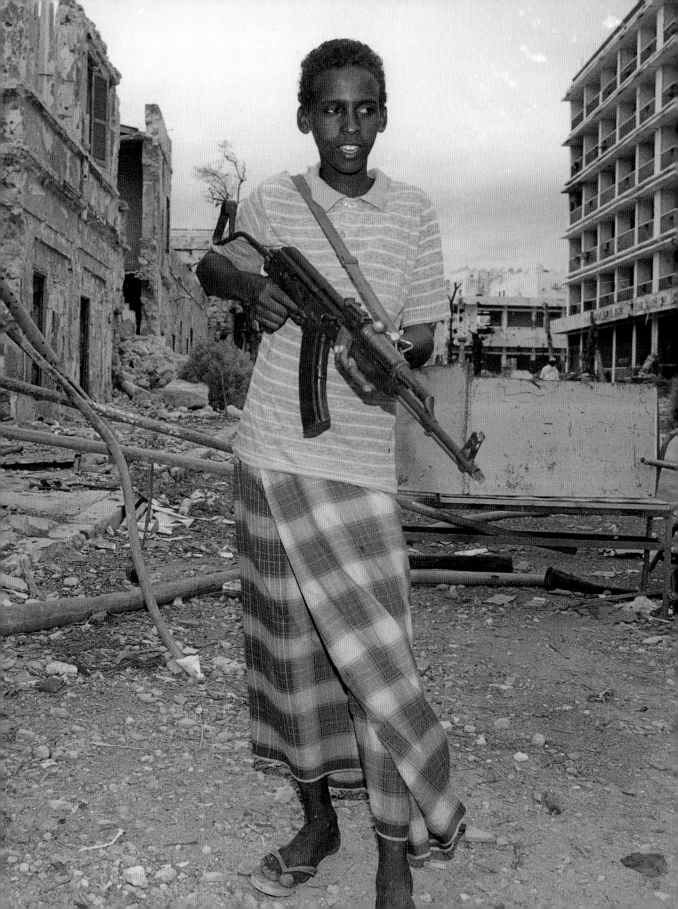

He left Bergen to accompany Neema to Stockholm, where she had to go to get a new passport. They'd planned to be alone for the week, figuring out their differences once and for all. But unbeknownst to them, Stockholm was hosting a Kenya festival, and a friend was in town for the occasion, wanting to spend time with Neema. In some of their scant time alone together, Neema begged Dan not to return to Somalia; if there was any chance for them to be together, she couldn't stand the danger. But he was committed to returning and couldn't accept such a provision. Then, she told him, she would stay with her Norwegian boyfriend.

When Dan finally left the country, he was no less in love with Neema, just more certain that their relationship would never work. He'd come to Norway for comfort but left unsettled, exhausted, and depressed. "I feel so lost and destroyed and ashamed to be myself," he wrote in another unsent letter. "I try to think of how I used to be just a few weeks ago in Somalia. I could deal with any fear and danger. Even with a crowd of crazed gunmen threatening to kill me, I could calmly ask them for a cigarette. It is a mystery to me how one girl can make me so weak."

He flew through London and stayed with his paternal grandmother for a few days. When his longtime friend Tara came to visit, Dan scooped her up in an enormous hug, as though hungry for some simple contact. They'd known each other since childhood and were accustomed to meeting for short periods, able to catch up quickly before one of them had to fly back to England or Kenya. Dan always shared his journals with her as a point of reference.

They sat in the darkened bedroom with his suitcase ominously in front of them. Inside were his photographs of Somalia. "I want to show them to you," he began, but was unable to finish the sentence, much less make the requisite move to unlatch the case and take out its contents. The photos stayed locked up as their ghostly images danced in his mind.

It was November 5, Guy Fawkes Day, the holiday when kids make effigies of England's most famous traitor and go door to door to ask for "a penny for the Guy." With the chilly autumn air and nighttime festivities, it is similar to Halloween, though the fireworks and bonfires provide a Fourth of July quality as well. As he and Tara walked through the streets that evening, with Dan huddled under his too-thin jacket, he jerked uncontrollably at the pop and crack of

random fireworks. When a car backfired, he reflexively ducked down. Tara had never seen him frightened before. Now she saw that he lived with fear in Somalia; it came with the job.

On his last day in London, he went to his mother's apartment. She had returned from a trip to the States that morning and was eager for several days with Dan as they'd planned. He'd heard news, however, that the Americans might launch an intervention in Somalia. He needed to return, and they would have only an hour together.

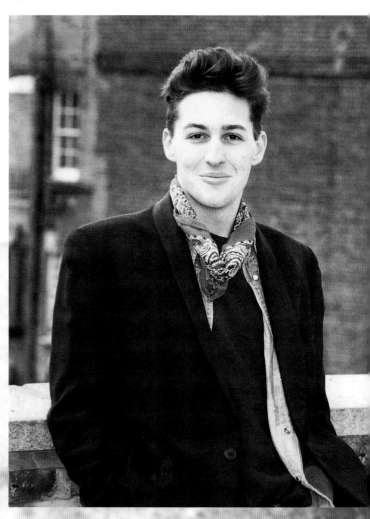

Appearing with two pizzas in hand, he greeted Kathy with his usual crooked grin, though he looked pale and haggard. She found him to be tense and jumpy and was surprised to see him smoke, a habit she knew he'd dallied with but had always hidden from her.

Where to start with so little time? They had been on shaky terms for the past several months. Not knowing of his work for Reuters and *The Nation*, she'd sent him a motherly letter, worrying about his plans for the future. Pointing out "contributions" she'd made to his many travel and art-related projects, she'd wondered what movement he was making toward supporting himself. Incensed by the image she'd painted of him lounging about his father's house, Dan sent her a brusque reply, ticking off his multiple jobs and paychecks.

They were wary, unsure what to say. After listening to his account of Norway, Kathy took the first step, suggesting that Neema had behaved inappropriately. The comment triggered Dan's ire. For the

first time, he yelled at his mother, unleashing the frustration he'd experienced during the past month in Norway, as well as the pain he'd sponged up in Somalia.

"You're lucky you have experienced such passion," she told him. "Most people never know what it is to love so deeply that you feel you'll die from the intensity of it. It's better to have loved and lost."

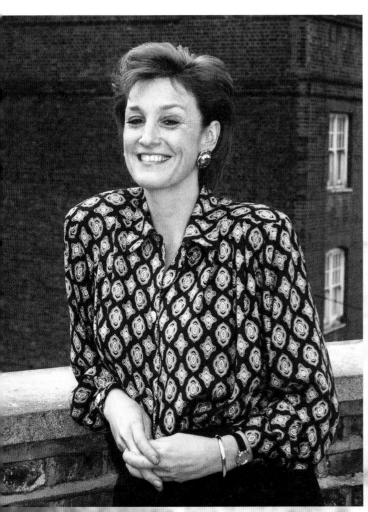

He cut her off sharply. "I'd rather have loved and won." When his anger cooled, he told her that he didn't know what was happening to him. The things he'd seen—that girl without any hands or feet, a mother and baby shot through with one bullet— were so horrible that he couldn't photograph them, and no one would buy them even if he did. The things he was saying, his entire state, worried Kathy. He was changed, though she wanted to think it was temporary.

After he and Kathy climbed onto the roof of her apartment building to take portraits of each other— Dan promised to send her copies as soon as he had them—he left for the airport. They hugged each other hard despite leaving much unsaid. They both knew there would be further talks. Kathy saw how her leaving the family years earlier was affecting Dan's romantic relationships. She sensed that his possessiveness and jealousy could be tied up with his sense of her betrayal. She saw too that he had yet to make any such connection. They had only scraped the surface of what needed to be said. "Next time," she thought.

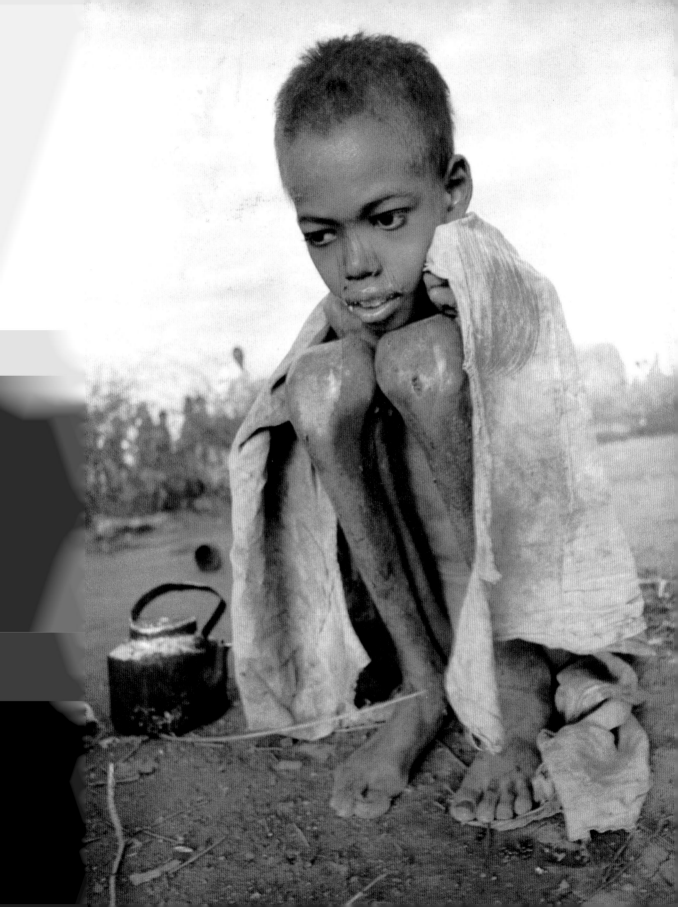

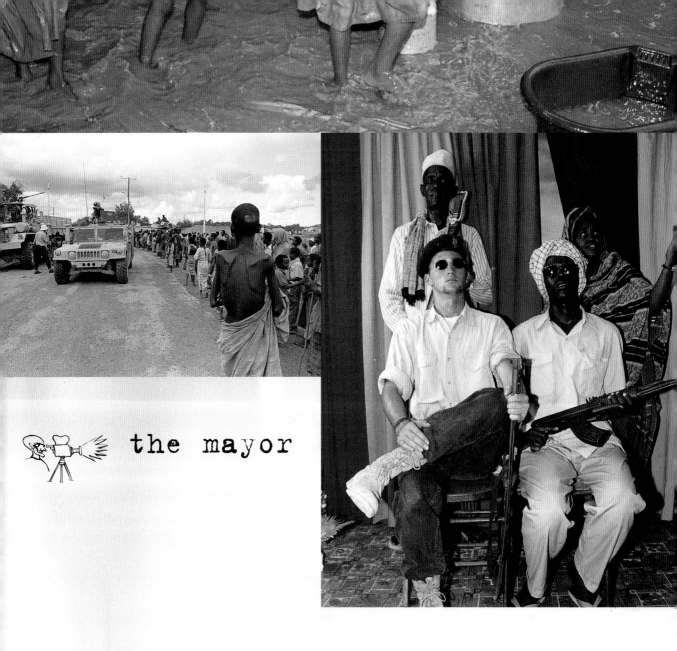

the mayor

War is nasty; war is fun. War is thrilling; war is drudgery.
War makes you a man; war makes you dead.
—Tim O'Brien, *The Things They Carried*, 1990

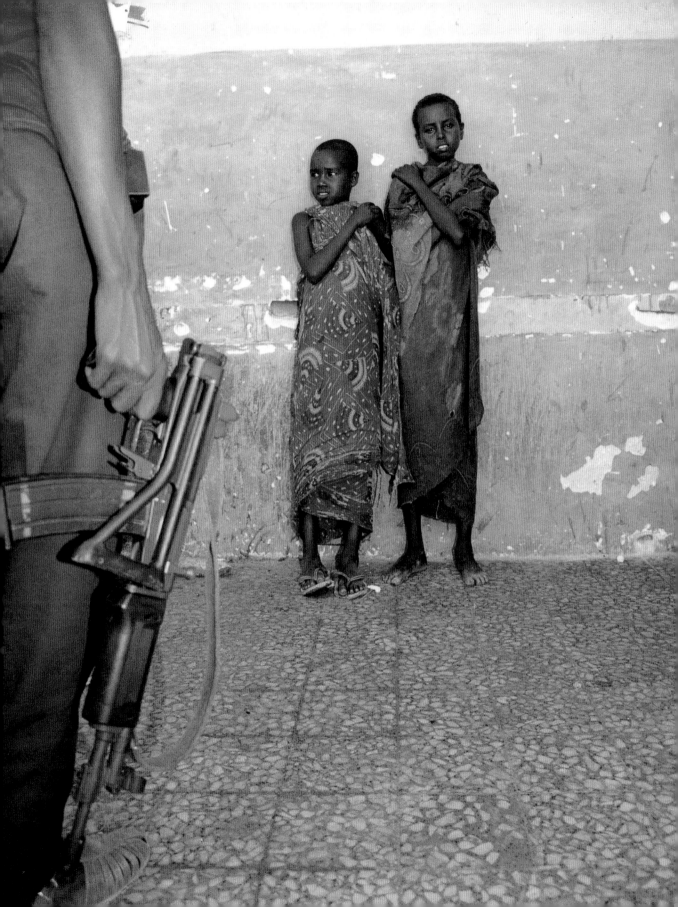

Despite the food storehouses that had accumulated in Mogadishu
—piles of maize, beans, and flour—people continued to starve.
The refugee camps and feeding centers were still brimming with
huddled, frail bodies in the fall of 1992. Only a fraction of the
food that had been sent since journalists had begun drawing atten-
tion to the famine was being directed to the intended recipients.
Armed clan members raided the vast majority of food relief flights
upon landing. Trucks carrying the precious cargo inland were hi-
jacked. Aid workers were assaulted, forced to provide food, supplies,
and medical care. At a time when war was also ravaging Bosnia,
many aid workers and journalists considered Somalia to be the
more dangerous venue in which to work, a power keg of irration-
ality where doing one's job was sometimes all but impossible.

The United Nations called on its members to provide military
forces to assist and protect the humanitarian operation; the food
did no good if it couldn't get through. President George Bush, in
the final weeks of his presidency and still basking in the widely
perceived success of the Gulf War, heeded the call, ordering twen-
ty-five thousand American troops to Somalia. In preparation for
the Americans' arrival, all of the major *warcos* had descended on
Mogadishu. Arriving with their bottled water, Patagonia gear, and
big attitudes, they tended to boss around the likes of Dan, who
was now even lower on the totem pole than before. He was put to
work assisting Reuters's top people, developing photos and
gophering equipment.

Aidan recalls an afternoon at the house where he and Dan were
staying in late 1992, when one of the out-of-towners arrived on
the scene: "Dan and I had settled into life there. We had a routine.
It was late afternoon after the heat of the day and Dan was chew-
ing *qat* as he went about checking his photo equipment. He was
wearing a maweis sarong and Somali hat made of woven sisal—
similar in look to what clubbers wear these days—and he had vari-
ous talismans and junk about his person. He had quite clearly, as
the colonials would have said, gone native. This producer for one
of the U.S. networks turns up that afternoon off a flight. He's a
NooYoika, dressed in black, very snappy with people and obviously
scared of the 'anarchic' Somalis. A phrase of journalese at the time
was that 'qat-crazed gunmen' were tearing the country apart—and
he had clearly read that on the plane over and thought it's gonna
be loik da Bronx. We were stringers and we felt increasingly
bored with the arrival of staff hacks who were over-paid and on
three-day trips so late in the story. Anyway, the TV man comes in

with his North Face rucksack and bottled water. He is confronted by Dan, long-striding it like Groucho Marx room to room, jerking his head around, with a swollen cheek of *giz'aa*. Green quid spills from the corner of his mouth. The TV man looks at him wide-eyed. He asks: 'What are you on?' Dan looks at me, back to him: jerk jerk. 'Er, fifty dollars a picture. And you?' Then strides off."

Since his first trip in July, Dan had been at the bottom of a small pyramid of reporters who treated him a bit like a kid brother but who recognized his growing skill. It riled him now to be at an even lower rung, relegated to gopher duties and developing the higher-ups' film or mixing chemicals. Sometimes he lied to them that he didn't know how to do something in the darkroom and would take off on his own to shoot. Aidan could only laugh in commiseration at his frequent complaints, knowing that the luminaries would be gone soon enough, off chasing the next big story.

The Americans' arrival was hardly a state secret, although they acted as though it were. When Navy Seals landed on a Mogadishu beach under a full moon on December 9, 1992, they were all in black, their faces greased for nighttime camouflage. They crept up the beach on their bellies, guns readied. But Aidid's gunmen were nowhere in sight. Rather, a posse of journalists had gathered, poised and ready with cameras, flash bulbs, and video equipment. The young soldiers were annoyed and unnerved by the circuslike atmosphere that was neither the war-torn city nor the famine site they'd prepared for. Instead it was a movie set and they were the actors. Nearby, all three major American news anchors were on cue, ready to dispatch the story to morning television audiences back home.

Dan had never seen anything like it and found the absurdity of the situation funny. He spent the night ferrying equipment between the beach and the Reuters house. As he drove the late-night, deserted streets, an American helicopter shined its lights on him, ominously poised to shoot. It frightened Dan that the supposed savior could have actually been behind his demise.

After the Americans "secured" Mogadishu, Dan and Aidan followed them west to Baidoa. They had been to the so-called City of Death on many previous occasions. Like most of the trips they'd taken outside Mog, whether by plane or by car, it was a relief to be away from the trash-ridden, pockmarked city. Cruising on the near-empty roads, playing music and joking with their guards, felt like a holiday. They sometimes played a game on these trips,

making up nicknames for people they knew. Somalis love nick-names; they took an adolescent delight in highlighting a person's less flattering attributes: the bald one, the fat one.

It was easy to pretend they were in northern Kenya on safari as they streaked along in the open-air truck; they even got used to the guards' omnipresent guns. But at the end of the line there was Baidoa, or Bardera or Adale, reminders of the real reason they were there. These places were eerily silent, wanting of the sounds of animals, children, or people at work. The only noise was that of starving people trying to hold on to life—something that makes surprisingly little sound. As people, like the Somalis in these camps, fall further into a state of starvation, sleep and extreme exhaustion take over; small children may whimper, but there is little energy to be expended on anything more boisterous.

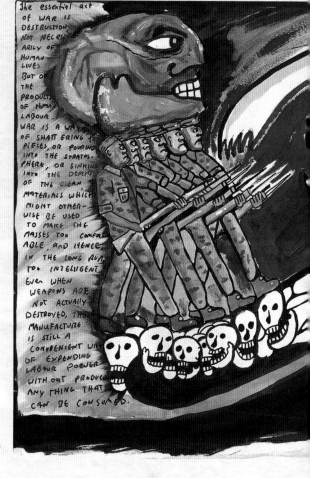

During these earlier trips, Dan and Aidan had learned that one of the best ways to get a sense of the severity of the famine was to ride on the trucks that slowly circled the refugee camps at dawn, picking up the people who had died overnight. During the summer of 1992, it was not unheard of for more than a thousand people to die in Baidoa on a single day.

As they drove into the City of Death with the Marines, it could only feel like progress. Even with the media circus surrounding the event, Dan and his friends were relieved to watch the beefy soldiers who heralded from Backwater, Oklahoma, and Whoknowswhere, Alabama, unload literally tons of food for wait-ing aid workers, now under the protection of heavy cover. For once, a food delivery was made without interruption by armed clan members. As much as many of the journalists smirked at the American military's theatrical entry into Somalia, they took

pride in having instigated their arrival via their reporting. It appeared that real good would come of it. And after all, it was Christmastime; one wanted to believe that Somalia's suffering was about to ease.

☺ ☺ ☺

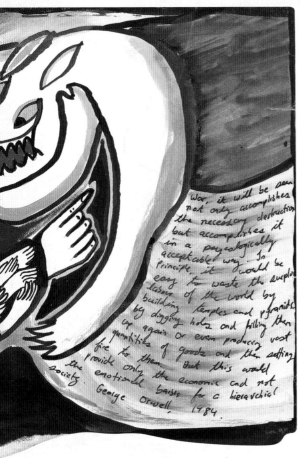

"Christmas without kids or little sisters is a bit of a flop really." Groggy, his hair sticking straight up and a light beard on his chin, Dan had quickly tied a *kikoi* around his waist and come downstairs to make this announcement to his father before proceeding back to bed. Despite the cookies the cook had made or the wrapped presents, many of which had come via airmail from London and Iowa, Christmas was on hold until Amy's arrival.

He was home for several weeks of R and R, his first respite from Somalia since returning from Norway. Dan was eager to immerse himself in home life, casting the tragedy aside for awhile. He spent New Year's at the beach with Lengai, Soiya, and Marte, who was in the country with her family. They were silly together, with he and Lengai doing impersonations and cajoling the girls into posing for a set of photographs of the four of them together, a supposed four-way sex romp in which neither Soiya nor Marte could keep a straight face.

He and Soiya were trying to find their way again. He had called her at school just after his return from Norway, saying that he realized now how poorly he had acted the previous summer. "What goes around comes around," he told her, sounding truly contrite and miserable at his own situation. Soiya had been forgiving and was even more so now that she saw him in person and realized what a toll Somalia was taking on him. He looked gaunt; his energy was depleted. He had shown her some of his photographs, and she'd been horrified, never having seen such suffering despite her

upbringing in a neighboring country. At the beach, they kept things light and got along so well that Soiya joked about how combative their relationship had been in the past. "After what I've seen, I don't think there's much worth arguing about any more," Dan replied.

When Amy arrived, they went to Lamu for a family getaway. The two kids convinced Mike to take a few puffs on a joint and then fell into fits of laughter as they watched him consider whether it had any effect. Dan and Amy talked late into the night. He told her about his fiasco with Neema, indicating that he was still confused and hurt by it, although he felt better than he had in months. Amy tried to make him smile and laugh, keeping his mind off darker events. During one serious conversation though, when he questioned what he was doing in Somalia and sounded lost, she reminded him of his desire to help people: "That's why you went. If you go back, that's the main thing you need to keep in mind."

Dan was regrouping, contacting old friends and writing more and longer letters than was usual for him. He apologized to Laurie for the previous summer, much as he had with Soiya, and reconnected with his long-ago Australian girlfriend Saskia. He also wrote several-page letters to his mum, Eiji, and Hayden. In these, he shared the excitement and pride he took in his Reuters work: "All my years of taking silly pictures and making journals of safaris and trips is beginning to bear fruit." But more so, he expressed the hurt and confusion of the past months, what he called "a black cave of depression."

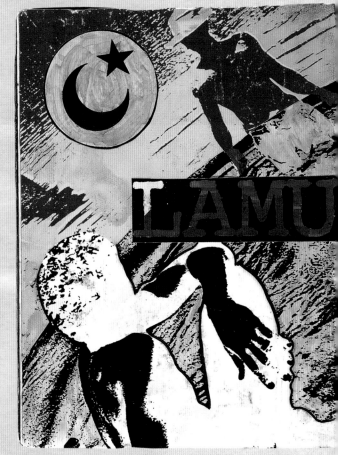

Somalia was the first blow. I saw so many terrible things and had so many situations where people fucked with me and shot at me.

When I came out after one month, all I wanted was to go somewhere quiet and fun and be loved and love. I went to see my girlfriend in Norway and she played with my head—loving me half the time, then treating me worse than a stranger the next. I left after a month in a total depression....I wonder if you would recognize me. On the outside I am pretty similar, but my head feels shaken up and changed, so much that sometimes I don't know what I like or don't like, or what I think is something Dan does or doesn't do.

Back home in Nairobi, after his trips to the coast, he got out his latest journal. He had started the book the previous spring when he'd arrived back in Kenya for work on the film, but had been too busy in recent months to pay it much attention. As was his custom, he had dated the inside cover and written his address. In September, he'd gone back and added a note: "This volume does not contain information, images or reflections on trips to Wajir, Bunesia, El-Wak, Uganda, Sudan, (Southern) Somalia. Those trips were of a serious nature and would not be compatible with the mindless, inane follies that this book focuses on, even though they occurred concurrently to the above-mentioned events."

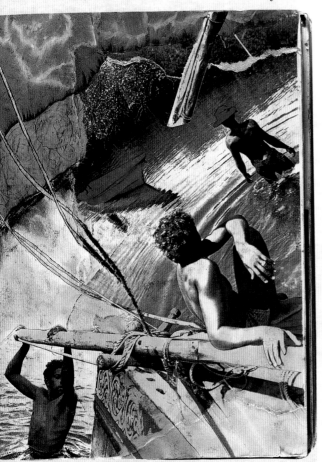

Now he worked on them again, gluing in photos from his recent weeks in Kenya: Soiya running on the beach with kids; Marte sunbathing with the Team Deziree boom box propped next to her, still covered with paint and stickers from their trip of more than two years ago. The final photos were dark, hardly good shots, but he liked them and included them anyway: Dan and Lengai, perched side by side on a sand dune during sundown.

☺ ☺ ☺

Jan. 21, 1993

Dear Mum,
I just sent you a letter a few days ago and the biggest news since then is the arrival of these postcards. Now comes the hard part. I can either make $6,000 or lose $900—or anything in between. I'm going on a day trip for Reuters tomorrow—Northern Kenya to check out refugees—the gov't has threatened to throw them out. It has been so good having Amy here—it makes me more relaxed and happy than anything (even *qat!*).
Lots of love,
Dan

With the arrival of the Americans, Dan's marketing skills were reawakened. Suddenly, there were thousands of people in Somalia with money and nowhere to spend it. He designed a series of postcards made from his photographs—images of the "Green Line" and the boy in the cathedral. They sold so well that he designed several T-shirts and planned a book. One of the shirts read "Thank you for not looting" and showed an AK-47 with a red line through it. Dan talked a Marine pilot into shipping the first boxes to Mogadishu—saving him the expense—and found it terribly appropriate when they were promptly looted upon arrival at the airport.

The book came out later in the spring. It highlighted his photographs and was accompanied by snippets of text describing his experience during the past months. Although he wrote candidly, he no longer sounded like a rookie.

After my first trip to Somalia, the terror of being surrounded by violence and the horrors of the famine threw me into a dark depression. Even journalists who had covered many conflicts were moved to tears. But for me, this was my first experience with war. Before Somalia, I had only seen two dead bodies in my life. I have now seen hundreds, tossed into ditches like sacks. The worst things I could not photograph. One Sunday morning, they brought in a pretty girl, wrapped in colourful cloth. I saw that both her hands and feet had been severed by shrapnel. Someone had tossed a grenade in the market. She looked serene, like she was dead, but the nurse said that she would survive. It made me think of the whole country. Somalia will survive, but what kind of life is it for a people that have been so wounded. I don't know how these experiences have changed me, but I feel different.

Covering a war, as many correspondents are quick to say, is often dull. For the five percent of a day that offers intense excitement, it is necessary to spend the other ninety-five percent waiting around. The postcards, T-shirts, and books kept Dan busy. Through the sale of his wares, he made more contacts than ever, increasing the number of people he could count as friends when in a pinch. Anyone and everyone was a potential customer—a corporal from New Mexico, a reporter from Japan, the head of an Irish aid organization. He made rounds to chat up personnel from the various UN troops, jotting down orders in his pocket notebook—"Italians 25, Norwegians 40, Aussies 15"—right next to shutter speed recordings and potential picture captions.

On visits back to Nairobi, he made frequent trips to the industrial area, checking on the printing of his next product. He taught Peter Lekarian, his adopted Masai brother, how to drive in order to help him make runs to the airport. Tara Fitzgerald, who was staying at the Eldons' house throughout spring and summer, and his father were also recruited to help the burgeoning business.

While some of his journalist colleagues in Mog disapproved of Dan's scheming, considering it an affront to the purpose of their work, many more wore his T-shirts proudly and sent the postcards home. They found him to be clever and resourceful. Not bad for a rookie.

By late winter, the mood in Somalia was shifting. The initial elation at the Americans' arrival had worn off. Yes, the famine was over and people were getting food, but the militias had not been disarmed and the cycle of violence and corruption was continuing unchecked. Most news agencies had significantly pared down their staffs in the country. In the eyes of those controlling column space, it had become a monotonous story in a place that rarely draws top Western headlines. Mogadishu was also increasingly dangerous, perhaps the most dangerous place in the world for a journalist to work at the time. Some correspondents even volunteered for positions in Bosnia to avoid going to Somalia. Dan was different from many of his colleagues in that he was wholly comfortable on African streets. He was one of few journalists who frquently roamed the crumbling maze that Mogadishu had become. Venturing into tea shops, he sipped the strongly brewed sweet

liquid with old men. His guards taught him how to swear in Arabic, and when would-be thieves came at his camera, he disarmed them with expletives: "Your mother fucks with camels!" He found pretty girls to photograph, even in the midst of war, and visited the notorious Bakara market, where freshly looted computers with UN stickers still adhered to the hard drives were available, along with every imaginable weapon, including many cold war relics. Few Westerners would go to the market, considering it a hive of shady characters and jittery nerves, but Dan went and even managed to take some photos. On one visit, he bought a *dik-dik* and took it back to his room, taking pity on the tiny antelope that was being sold as food.

He got the most pleasure from spending time with children, entertaining them with his old-man mask or a Trojan helmet with horns he sometimes wore. Many of them knew his name and ran to greet him as he made his rounds, sometimes even seeking him out at the gates of the hotel where he lived. Dan brought them candy and teased them in their own language, bringing smiles to faces sorely out of practice at such gaiety. He worried about them, seeing them as the true victims of the long, grisly war.

He also differed from many other foreigners in that he genuinely liked the Somalis and respected their culture. As a Kenyan, he knew them to be clever. In northern Kenya, for example, one can go into the smallest, plainest village and find a Somali running a successful business. They are astute entrepreneurs, but their extreme pride is interpreted by Westerners as haughtiness. And the blood-for-blood nature of clan culture, summed up so well in the oft-quoted Somali proverb— "Me and my clan against the world; me and my family against my clan; me and my brother against my family; me against my brother"—further baffled many outsiders. In the midst of the anarchy and famine to which the Somalis had brought themselves, it was easy to scratch one's head and think that such hubris had brought on such a mess.

Dan's peers admired not only his sense of humor and understanding of local customs but also his common sense. "I don't like bang bang," he told one friend, alluding to the penchant some *warcos* had for seeking out gun battles. On at least one occasion, he chose to stay back at the hotel during a sniper attack. He was careful of his friends too. At a large rally, he was photographing from the top of the Reuters truck when he spied Donatella Lorch, a *New York Times* correspondent, in the crowd. "Get up here with

me!" he yelled to her, and then gave her a hand up, saying it was much safer.

Dan had many friends—and several nemeses, particularly those who disagreed with his side business or found him sloppy and overly youthful. He had several mentors, though, including Mo Shaffi, a veteran Reuters videographer who had been a fixture in the Nairobi news community for years. Dan traveled with Shaffi often, especially after Aidan left in April to cover the war in the Balkans. The older journalist was known for his gift of gab and trademark handlebar moustache. Dan trusted his sensibilities and asked him for advice about which photos to wire back to Reuters or how to deal with office politics, and fondly called him *"babuji,"* an Indian diminutive for father.

Dan earned his own nickname during a road trip to the interior. He and Aidan were playing the old game with their guards, applying yet a new round of sobriquets to their friends back in Mog. One of the Somalis pointed at Dan and laughed, "You, you're the Mayor of Mogadishu!" As usual, it was not entirely a compliment as the name had been used for the country's ousted ruler, Siyaad Barre. Still, in a backward way, it honored Dan's renowned presence in the city. Over time, it would stick.

The days of news organizations renting enormous villas—CNN even had a pet camel in its compound—came to a close by the spring. It was too costly and had grown too dangerous. Dan and his Reuters colleagues Shaffi and Hos Maina left their house and moved into the Sahafi Hotel.

The Sahafi had been set up the previous fall by a Somali businessman named Mohamed Jirdah with money he had received from the Associated Press and NBC. In just a week, he had refurbished a hotel to house the onslaught of journalists (*sahafi* means "journalist" in Arabic). The larger news organizations quickly grabbed blocks of rooms, and by January, at the height of the story, the place was so packed that people were sleeping on mattresses in the lobby.

The hotel was strategically located at a traffic circle known as K4, which meant it was four kilometers from the airport. The American military had encouraged the journalists to join them

239

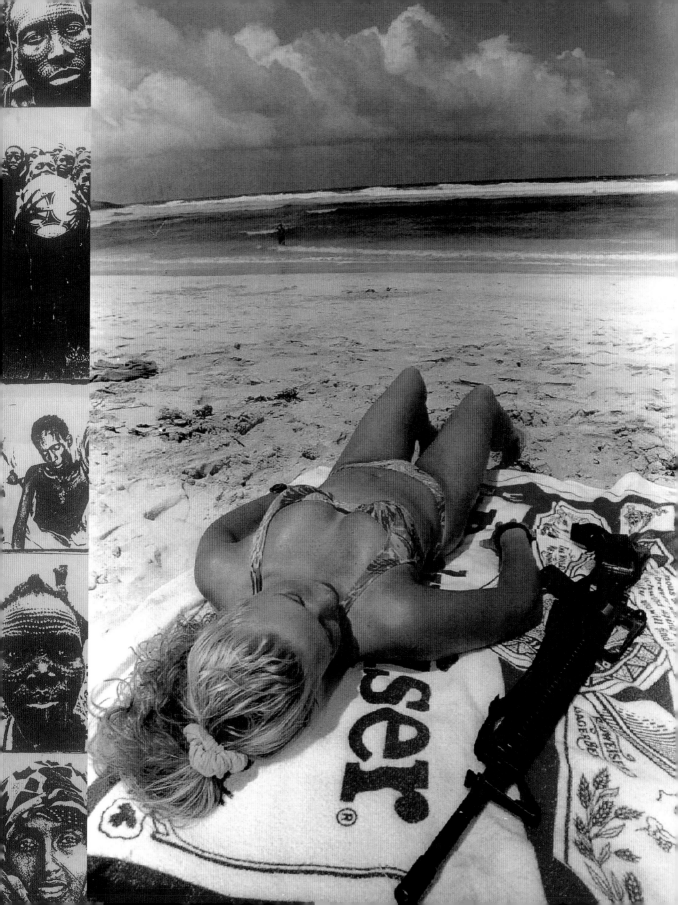

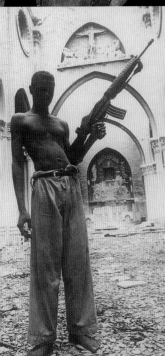

in compounds outside town, arguing that it would be safer. But the journalists opted to stay at K4, where they could be nearer to the heart of the story: the hospitals, refugee centers, and spontaneous fighting in the urban streets. There was safety in numbers, however, and like the Reuters team, many organizations came to live at the Sahafi.

One afternoon, Dan was hanging out in the hotel's lobby, chatting with Mohamed, the hotelier who came to be much loved and respected by his guests. Dan had already changed out of his jeans and boots and was wearing a *kikoi* around his waist and a pair of flip-flops. Two Somalis had come to the gate minutes earlier, hawking their wares— some intricately woven baskets, ostrich eggs, and sarongs. Most of the journalists steered clear of the traveling merchants, but Dan often found something he liked, and that day he had bought a sarong, thinking he'd give it to Amy.

As he refolded the cloth, the hotel doors opened and an unfamiliar face appeared. A young woman with shocking red hair, pale skin, and freckles climbed the small flight of stairs to meet him. She was newly arrived in Mog, she explained, and had been sent to the Sahafi from her news agency to collect a videotape from a cameraman; the ride alone had unnerved her. She introduced herself—"I'm Ruth Burnett."

Dan's eyes twinkled with delight at the neophyte. She was covered in sweat and clearly terrified. "Hello Ruth Burnett," he smiled, giving her hand a strong shake. "I'm Dan Eldon."

Ruth excused herself to go to the bathroom. She tried to daub the sweat from her face—the result of fear as much as the inconceivable heat—but the effort proved hopeless. Dan was still standing there when she reappeared, continuing to look amused. Much to her annoyance, she noticed that there wasn't a drop of sweat on the lanky young man who looked to be roughly her age. "I can't even pretend to be cool!" she said, laughing at herself, and launched into a lengthy explanation about how not only had she never been in a war zone, but she'd hardly been a journalist. "I'm about as green as they come," she sighed with great self-deprecation.

Dan listened attentively and then leaned in, "Listen Ruth, this is what you do: You think to yourself 'What a great job I have!' And then you take a deep breath, open your eyes, look around you, and never never show them fear or that you don't believe in yourself. And I don't just mean the Somalis, I mean us. You cannot walk into a room of journos and announce that you're terrified, that your knees are knocking. It's just not cool."

Not expecting a pep talk that afternoon, she laughed at his words. She also knew he was right. Taking a deep breath, she gathered her bag, climbed the stairs, and headed toward the cameraman's room Dan had directed her to on the next floor.

"Ruth," Dan called cryptically as she made her way up, "I'll see you on the roof!"

He might as well have been dubbed the Mayor of the Sahafi. The hotel was like a college dorm, complete with long, cafeteria-style tables in the dining hall, romances and feuds, drugs and booze. As at any war hotel, its occupants engendered a curious combination of competition and camaraderie; the same people who drank together in the evenings were trying to beat each other out for stories and bylines during the day. Making the front page of major international newspapers, as Dan was doing by spring, brought genuine praise and barely contained envy. Dan was in the midst of it, blasting his little boom box at meals or showing a pilfered, scratchy copy of *Pretty Woman* on the Reuters video monitor.

Unlike college life, however, people were up early—something to which Dan grudgingly became accustomed. Photographers especially had to catch the few hours between dawn and the time, around eight o'clock, when the sun became too bright to shoot. The rest of the morning was spent trying to sniff out the next story by visiting hospitals, aid organizations, and the "offices" of militia leaders. One hoped that during these rounds a decent story would materialize in the form of a gunfight or a loquacious aid worker with interesting anecdotes to share. Because of his ease in moving through the city, Dan was adept at collecting leads that would hold him over when real action was slim.

In keeping with its Mediterranean heritage, the city fell into a lull over lunch. Dan would return to the Sahafi to print his film, sharing a darkroom with other photographers who had to nag him about being more careful with the chemicals. There was often a struggle for the satellite telephones and fax machines shared by various news organizations. The only windows that allowed the right position for satellite transmission were those in the bathrooms on the east side of the building, requiring someone to climb on top of the toilet and tape the cable to the outside.

Dan would often return to the Reuters office, a room in the Shahafi, to find Donatella already on the phone. "This is our phone," Dan would mouth to the animated Manhattan-born reporter, ambivalent to her seniority. As she continued her conversation, she'd scrawl on a piece of paper, "Yes, but we pay you dearly for it!" alluding to the fact that the *New York Times* basically rented phone time from Reuters.

Around three o'clock, the city began to pop with action. Kids who had been chewing *qat* all day—the addictive, mild narcotic that provides a buzz similar to No-Doze was as widely used by Somali militias as cigarettes are by Western troops—were brimming with macho confidence. The extreme heat was at its worst, making people irritable. All it took was a simple traffic accident or a rogue grenade to snap nerves and unleash a round of violence. This was when Dan was often out, hustling T-shirt business, visiting tea shops, dropping into the houses of various aid organizations.

Evenings were the best. Without electricity, the city shut down. After dinner—camel meat on pasta with a lemonade-like beverage and mangoes for dessert—the journalists climbed to the hotel roof where a blessed breeze swept in from the ocean. Bottles of wine and Scotch made the rounds, as did *qat* and joints. Various reporters tried a hand at peace negotiations by ruminating on just how the U.S. and UN were screwing up. As they grew giddy from the buzz and exhaustion, they sang TV theme songs and did impersonations of other colleagues and political leaders.

The journalists were virtual prisoners of the hotel at night as the city streets were too dangerous to roam. After stories were transmitted and equipment was cleaned—the sand was unremitting—there was little to do to stay occupied. The only places to hang out were the bleak cafeteria and the small, spare bedrooms—each of which looked like the other, save for the occupants'

243

knick-knacks. (Dan, of course, outdid everyone else, covering his room with military gear, Somalia artifacts, and photographs.) By default, then, the roof was the poshest part of the Sahafi; it even had a tattered recliner that someone had lugged up the stairs. Given the hotel's central location, its vantage point was perfect for observing gun battles and helicopter movements around town, although that could make it dangerous too. One afternoon when Dan and a friend were on the roof, chewing the fat, a stray bullet whizzed between them, narrowly missing both men. They looked at each other with shock for a moment and then broke into laughter; sometimes delirium was the only way to deal with war zone stress.

In many ways, life at the Sahafi was like a safari, with its intense friendships formed quickly in the face of chaos. It was an immobile, larger, older version of STA. As Dan told his father often during the phone conversations they shared every few days, "Don't worry. I'm in my element here."

The first news was that the Germans were flying in fifteen hundred troops—an event worth photographing. By the time Dan and his colleagues Liz Gilbert and Patrick Muruiri arrived in the western town of Belet Huen via an expensive charter plane, the numbers were rumored to have fallen greatly. But at 7:30 A.M., there were no Germans yet in sight, just a gaggle of reporters. Without the sea breeze of Mog, the heat was hideous. While the other hacks huddled under an airplane wing for shelter, Dan and his friends had come prepared with sheets and a blanket to create a makeshift shelter from the sun.

"I'm just going to beat you again," Patrick smiled, as Liz handed him a deck of playing cards. They settled into another round of the ongoing lessons he'd been giving her in Kenyan poker, a game wholly different from the version played by the rest of the world. As Patrick shuffled the deck, Dan rummaged through his bag and produced his boom box, a cassette tape of *The King and I*, and two of his custom-designed T-shirts. "I'll be right back," he said, as he sauntered across the runway in the direction of a Canadian camp.

Minutes later, he returned with a wide grin and four Canadian Meals Ready to Eat in hand. "Those T-shirts just keep coming in handy," Liz said, teasing Dan at his never-ending bartering. The

morning was growing late and their stomachs were beginning to rumble; with no sign of the German plane yet, they could be there for hours more. The MREs were definitely a welcome sight. They laid the silver pouches on a sunny stone, and when they grew hot—almost immediately—Dan flipped them as though he were working the grill in a diner.

Across the runway, they watched a man struggle with a large plastic bag. He was sweating mightily in the ghastly heat as he carried the bag among the group under the airplane wing. People peered in at the contents and then hesitantly fished out something.

Just as the threesome under the tent were digging into their piping hot lasagna and chicken chow mein, the man came huffing toward them. While he reached into the bag, Dan allowed his dark glasses to slide down his nose to see what might appear. "Camel burger?" the man offered, presenting a chunk of greasy, gray flesh. "No thanks," they demurred in unison, unsure whether they should offer the man some of their brunch. Before they could decide, he was off, slumping under the weight of his bag. "Poor bastard," muttered Dan as he turned up the volume to listen to the song his mum had taught him years ago, "Whenever I Feel Afraid."

☻ ☻ ☻

The American mission, officially titled UNITAF but dubbed Operation Restore Hope, appeared to be a success at first. Working with the United Nations UNOSOM troops, which included soldiers from twenty-eight nations, they established effective feeding programs and brought a modicum of order to Somalia's anarchy. By spring, though, there was increased tension between the clan groups and the visiting soldiers. The famine had effectively been halted, after having taken three hundred thousand Somalis with it, and the outsiders' purpose for being there was less clear.

In May, UNOSOM expanded its mission beyond providing humanitarian assistance and called for "nation building." Disarmament of the Somali people became a chief goal. Despite pleas from aid workers who had labored under the constant threat of violence for months, the Americans had decided against disarming the Somalis back in December, thinking it would interfere with peace efforts. Not surprisingly, the warring clans viewed the policy change as a threat to their power. Concurrently, the UN made bumbling attempts to foster democracy, requiring Somalis to organize various

citizen groups that had to fulfill gender and ethnicity quotas. Most of these efforts failed due to their outsider's ignorance of and lack of respect for Somali customs, engendering further ill will.

Simmering hostility gave way to all-out violence on June 5, 1993, when twenty-four Pakistani soldiers were killed and about fifty more injured. They were conducting a weapons search at Radio Mogadishu, which, in addition to being the warlord Aidid's primary anti-UN propaganda vehicle, was also a weapons site. The dead soldiers—who were Muslim and thought to be relatively safe from attack—were horrifically mutilated, indicating the deep wrath the Somalis had for the foreigners in their midst.

It was the largest death toll of UN peacekeeping troops in a single event since 1961, and it produced a sea change in the mood of the beleaguered city. The Somalis' anger was palpable and growing. It was no longer aimed at only whites or the military but at all foreigners, including the many black African aid workers and journalists. No one, not even Dan, felt comfortable in Mog anymore.

The UN used the Pakistanis' deaths to launch a new and more extensive attack against Aidid. Although there wasn't any substantive evidence, the UN Security Council accused the warlord of instigating the attacks and issued an emergency resolution calling for the apprehension of those responsible for the massacre. On June 17, Admiral Howe, the American in charge of UNOSOM forces, added fuel to the fire by offering a $25,000 reward for Aidid's capture. Leaflets advertising the reward were posted around the city, like something out of the Wild West. Most of the journalists found the leaflets to be absurd, signaling Howe's obsession with Aidid. Dan pulled one off a wall and tucked it into his journal the next time he was home.

In May, Mike Eldon was in a car accident and suffered serious injuries—five fractured ribs and a collapsed lung. Dan made several visits down to Nairobi to visit him in the hospital. To get in after hours, he donned an American military uniform he'd acquired in a T-shirt exchange, affected his best Texas drawl, and told the night clerk that he was delivering X-rays for the highly fictitious Dr. Ramachandra. The whiff of pizza emanating from his "X-ray" delivery box never hit the man's nostrils by the time Dan sped past him to his father's room.

During these visits, Tara, who was staying at the house for a few months, sometimes tried to convince him to go out to Peter's Masai *boma*. Dan always refused, saying he'd had enough roughing it at the Sahafi; smoky tea and goat's milk held little appeal. Instead, he preferred his own bed, where he collapsed in sleep, making up for the edgy stress- and *qat*-induced high he lived on in Somalia. Tara thought he looked good, despite the circles under his eyes; he was certainly more handsome than ever. To ease the boredom in Mog, he had taken up weight lifting, rigging a make-shift bench press in his hotel room by draping flak jackets over the ends of a broomstick. The effect was visible: he was no longer a skinny, gangly kid, but a lithe, muscular young man.

Despite the exhaustion, Dan was in high spirits. On June 21, a photograph he'd taken of a helicopter hovering over a bombed-out street had made a double-page spread in *Newsweek*. It was an enormous success for someone so young and new to the profession. Although he'd steadily improved throughout the year, gaining more attention, with this one photo he'd leapt ahead several steps in the pecking order of the small band of photojournalists who covered wars worldwide from their rucksacks.

His mother was in New York when the magazine appeared on the racks. She and Geoffrey were passing by a newsstand when they stopped to browse. He saw the byline first, pointing it out to Kathy, who let out a small shriek of surprise. She quickly recruited the man working the stand to help them go through all of the newspapers and magazines, amassing a pile of publications in which Dan's work appeared. Dashing across the street to a phone booth, she breathlessly called the Reuters office in London. After explaining who she was to a reporter on the other end, she said, "Listen, I can't reach my son in Somalia, but please let him know his mum has seen the magazine and she's so, so proud! He'll be terribly embarrassed, but I had to call." The man laughed, assuring her that his own mother had once done the same thing.

When Dan was next in Nairobi in late June, he called her, scolding her for her motherly exuberance: "Mum, I'm trying to look like an old professional here," he said with eye-rolling aplomb. He told her that he was thinking beyond Somalia, still considering film school. He did not mention, however, that he had talked to the Nairobi bureau chief about being reassigned to a different story elsewhere in the world, possibly Bosnia. Along with his

Reuters colleagues—Shaffi, photographer Hos Maina, and sound-man Anthony Macharia—he wasn't getting enough time away from Mogadishu. The colleagues were paying a heavy price in fatigue and stress. But he didn't tell his mother any of this. Nor did he mention to her that he was becoming eager to go on safari—far away from the endless cycle of corruption in Somalia. He'd begun making notes about possible destinations: Cuba, Nepal, the Sahara.

The reports since the June 5 attack had heightened Kathy's concerns for her son's well-being. He sounded so much better than he had in months—more mature, balanced, and confident. He was coming into himself in a fashion that amazed her. Yet Somalia was an impossible place; there was no way it was good for him to have been there so long. She would be relieved to have him out of there for good, and took any opening he provided her to breach the subject. "Perhaps it's time you left? Don't you think your luck is running out?" she asked.

Dan's response was emphatic: "Don't ask me to leave. It's an important story, mum, and it's not over yet. I have to go back."

She was quiet for a moment, remembering back to when she'd left the family and told Dan about her visit to Delphi: *know thyself.* Measuring her words, she told him that she was proud of him: "No matter what, you're leading the life of your choice." Then, as he did every time they talked, Dan told her not to worry about him—he wasn't going to die. He had had similar talks with his father, who knew better than to ask if he was coming home to stay, lest his son snarl at him. But Dan assured both of his parents—along with Amy, Soiya, Tara, and all those who worried about him—that he'd be fine; he knew everyone and was careful.

The rest of that late-June visit was spent on errands and connecting with old friends. Dan went downtown to see Sam Ouma, *The Nation*'s photo editor, who had often provided him with advice. Much to Sam's amusement, Dan arrived in full gear: *kikoi*, khaki safari hat, flak jacket, combat boots, and a Somali sword tied to his hip. The boy looked to be having too much fun. Dan also straightened his unruly bedroom, a nearly unheard-of bit of housekeeping, and drove out to the Crozes' house to see Lengai's mother, Nani. The two had had a trivial running quarrel that he wanted to clear for good. On his last evening at home, he took Tara to say a final good-bye to her childhood home, which was being sold. It was a difficult parting for her, as she was now living in England and

Cry Uncle!

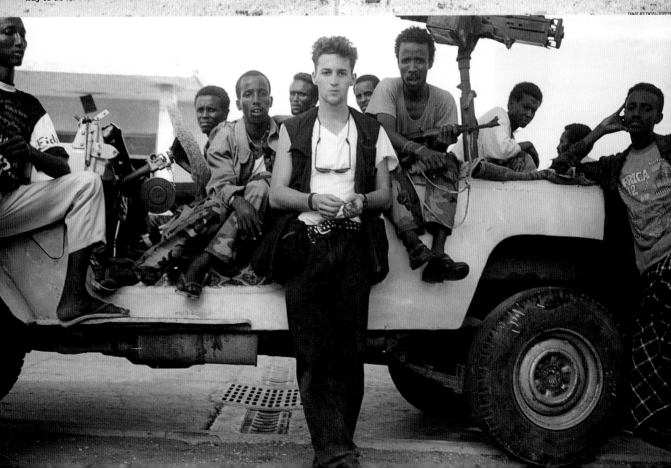

Only five weeks after leaving Somalia, American forces were back taking care of unfinished business. And the Pentagon was preparing to send 300 U.S. soldiers on an ill-defined mission to Bosnia's neighbor, Macedonia. The rest of the world still wants Uncle Sam to play global cop—but is this any way to do it?

DAN REDON—REPE

associated the house with her ties to Africa. "I'll help you buy it back one day and we'll turn it into a disco," Dan joked, as they sat on the stairs, his arm around her slim shoulder. He then declared the rest of the night Operation Restore Hope to Tara's Life. They stayed up all night, and at parties and bars he ran into old friends, including Neema. She had something to tell him: she was getting married in several weeks to her Norwegian boyfriend. Nearly a year after his visit to Norway, Dan still didn't have things with her completely settled in his head. While he took her news politely, wishing her the best, it was not what he'd been hoping to hear just before returning to Mog, where her photo still hung on his wall.

Soiya called from London and he encouraged her to come for a summer safari. "*Haraka!*" he yelled over the line. His old friend Tex, with whom Dan had been out of touch, happened to call from a phone box just before leaving for Tanzania for several weeks. They spoke briefly, with Dan indicating his desire to get out of Somalia—"this might be my last trip"—when the line cut off. Tex didn't bother calling back, figuring he would talk to Dan a few weeks later when they were both back in Nairobi. Maybe they'd go on safari; it had been too long.

Things were surprisingly quiet in Mogadishu. The journos were grumbling that they hadn't had a decent story in weeks. As a treat, several got lobsters for dinner one night—an easy delicacy to come by because the nomadic Somalis detest shellfish. On the rooftop, Dan shared a tall glass of Scotch with Donatella while the German AP reporter Hansi Krauss, who had arrived in Somalia just weeks earlier after having covered Bosnia, jokingly enumerated why the Balkans was a better war. He had been on the roof for a while reading a paperback novel—pulp fiction set in a war zone—having developed the habit of staking out the sole reclining chair before anyone else appeared. Donatella was leaving for Nairobi the next day and said good-bye to them at the end of the night. Dan and Hansi would be back within a few days as well, and they made tentative plans to see each other.

Desperate for pictures, Dan spent the next afternoon where the action was: the beach. UNITAF and UNOSOM had secured a strip of sand, turning it into a surreal California scene, complete with lifeguards. He snapped away at several curvy blond Marines toting weapons, clad only in bikinis. After showing the proofs to several

male colleagues, he sent the images via satellite that evening, sensing correctly that they'd make the papers the next day.

On the morning of July 12, a small group of journalists was gathered on the roof of the Sahafi, grumbling about the slow pace and drinking their coffee—awful instant stuff that hardly did the job. Dan was among them, saying his good-byes. His bags were packed and ready. With Hos already in from Nairobi to relieve him, he'd soon leave for the airport to negotiate a ride.

At the same time, another meeting was taking place. A group of elders from Aidid's clan had gathered in a house—the residence of one of the men—not far from the Sahafi. It was an enormous, old Italianate villa surrounded by white walls and with an interior courtyard—very much like the grand houses the news organizations had been renting the previous fall and winter. It was located on one of the city's wide boulevards that had turned dusty and potholed in the war. Women and children busied themselves downstairs and in the courtyard, while servants shuffled in and out of the upstairs room, bringing morning tea to the guests. The men were somber. They had grown weary of the war and wanted to find real peace. The morning's agenda was a discussion of how Aidid, who some of them thought had grown too brash, might be convinced to talk to the UN. They had made inroads with several African UN workers and were now forcing wider a small but crucial opening that might lead to some kind of settlement.

It was supposed to be a secret meeting, but unbeknownst to the men, someone had tipped off American forces. A horde of Cobra helicopters hovered over the house, enormous low-flying black beasts that buzzed and swooped. At 10:15 A.M., as the powerful machines began to unload their arsenals, Operation Michigan commenced. For the next seventeen minutes, the pilots focused unremitting TOW missiles and cannon fire on the residence. As people ran from the house, they were shot at from overhead, caught in the cage of fire created by the Cobras.

The swarm of helicopters and plumes of black smoke broke the city's quiet. More journalists streamed onto the hotel roof to get a better view of the fiery spectacle. What the hell was going on?

Several filmed the bombardment, stunned by the extreme show of force. They debated the target of this unprecedented demonstration of firepower. When, finally, it was silent, a debate arose about whether to go or not. Should they leave immediately or wait a bit? On one hand, many of them dreaded the chaos and grisly scene they were sure to find. On the other, this was obviously news and no doubt the biggest thing that had happened in Mog in weeks. "Let's just have breakfast," Dan joked, knowing that ultimately the group would have to go. Shaffi, who had been in another part of town when the bombing started but had rushed back to the hotel, was now filming the smoldering skyline from the roof. "We'll go later," he told Dan; it wasn't safe to go to the airport now anyway. "We'll get the pictures, but not now. This afternoon."

Dan agreed to the plan, but just then a truck swung into the Sahafi's drive. The group on the roof moved downstairs, sensing that news was imminent. Dan was one of the first out of the hotel, and he was taken aback by what he saw: correspondent Scott Peterson covered in blood. Scott had just come from the ravaged house, escaping the crowd with a machete wound to the head. While Dan and Hansi helped him to his room to clean and bandage his wound, Scott described what he'd just witnessed. "Be careful out there," he told them. "It's fucking dangerous today."

Another truck soon pulled up. The men who got out were from Aidid's Somalia National Alliance (SNA). They wanted the journalists to follow them, to record the carnage that the Americans had caused. In tense moments such as this, it was common for the journalists to negotiate with the clansmen for protection. Shaffi asked what security the SNA could give the journalists. "We'll give you full protection. We'll go with you," was the reply. Shaffi looked at his colleagues, Dan and Anthony. "What do you guys think?" They both agreed that it seemed fine, it was the kind of arrangement they'd made many other times.

The SNA truck went first, followed by three pick-ups: the Reuters crew, along with Hansi of AP, was in the lead, followed by the AP truck, and then a group of Italian reporters. Others were to follow soon. Shaffi rode in front with the driver; Dan, Hos, Anthony, Hansi, and their two gunmen were in back. As they made their way, Dan yelled to Shaffi to ask whether it was wise to be the first car. Shaffi requested the driver to slow down, but the other trucks did not pass them. It seemed that no one

wanted to be in front. Sensing Dan's fear of the situation, Shaffi told him, "I'm pretty sure that if I die today, it won't be by a Somali bullet."

As the helicopters continued to circle, the Reuters truck reached the charred compound. Shaffi quickly asked Anthony for an extra battery, thinking he might need it should they become separated, and shoved it into his breast pocket. In front of them, the once-elegant villa was now a sagging hulk. More striking to the men in the truck, however, were the people who had gathered. At least several hundred people had come from nearby neighborhoods to survey the destruction, packing themselves into the compound's courtyard.

"The journalists are here," one of the SNA soldiers shouted. "Let them pass." A clear pathway opened immediately, allowing the truck just inside the gate, where it came to a halt. As the journalists got out, they walked toward two pick-ups parked between them and the house. People were piling the bodies—many of them burned, contorted, and ravaged by the heavy artillery—in the trucks' beds. Everywhere they looked, the journalists saw bodies being carried. Bloodied, torn bodies were slung over shoulders, pushed in wheelbarrows, or carried in crimson, damp bed sheets. It was the bloodiest scene the five men had seen in Mogadishu. Although the UN would later claim that twenty people were killed and two injured in the house attack, the Somalis put the number at seventy-four dead and more than two hundred injured, including many women, children, and the elderly.

The five journalists began working quickly and in unison. Rather than fanning out, as is customary, they stayed together, taking shots in quick succession, eager only to have the job done so they could leave. One man pulled a drape back from a body, but Shaffi told him no, leave it; such details would only take more time.

Coming up behind them, the trucks of other journalists were held back by their guards, who sensed the powder keg of emotion in and around the compound. Shaffi, Dan, Hansi, Anthony, and Hos didn't yet notice their absence. Only a few minutes had transpired from the time they'd started shooting to the moment when Shaffi saw a man pick up a stone. "What are they doing here?" the middle-aged man yelled, gesturing at the clump of journalists. "The Americans are killing us from above and now *they* come to take pictures. They work for the Americans."

253

The shift of energy was immediate. "A blink of an eye," Shaffi would say later. The Somalis in the compound—whose great pride was injured by the violation of their loved ones, and who were grief-stricken and shocked, frustrated at their own endless suffering—shifted their attention to the five strangers in their midst. Following the man's lead, they began to shout, their voices surrounding the journalists and sounding an alarm.

"Babuji, let's get out of here," Dan said, making a sideways glance to Shaffi. "Yes, let's go!" the older man replied, turning off his video camera.

They walked quickly toward the gate, the two pick-ups partially blocking their way and causing a bottleneck. On the other side, their truck, their driver, their safety was gone. The four tried to get into another truck, but it took off. Behind them, Shaffi struggled with his camera, refusing to hand it over. When he too reached the place where the truck had previously been parked, he saw Dan and the others race away down the boulevard. He tried to get into a different truck but was thrown to the ground by the women inside. The crowd converged on him, a sea of shouting, angry faces—many of them women. They kicked him from every angle, some of them jumping on him. Finding energy he didn't know he still had, he leapt up and fled.

One of the American helicopters hovering overhead spotted a lone figure running on the ground below. "He's white," the pilot said, radioing back to base to get permission to descend and pick him up. But word came back that all of the military personnel from Operation Michigan were accounted for. Stay in the air. While the pilot regretted the order, he also thought the man was gaining distance from his pursuers.

Unaware of the pain from the beating he'd just experienced, Shaffi continued running down the street. The sun was glaring. The flak jacket he, like the other journalists, was wearing that day, was heavy, but he didn't dare take it off. He kept hoping to spot Dan or one of the others. But instead he saw a man with an AK-47 trained right on him. He heard five or six bullets in succession. One grazed his hand. Another ricocheted off his breast pocket, hitting the large battery Anthony had given him in the truck. When had that been? Just ten minutes ago?

A stone struck Shaffi as he continued to struggle forward, tearing the skin on his face. Through the blood, he could see Anthony and Dan for just a moment as they ran quickly down a nearby street

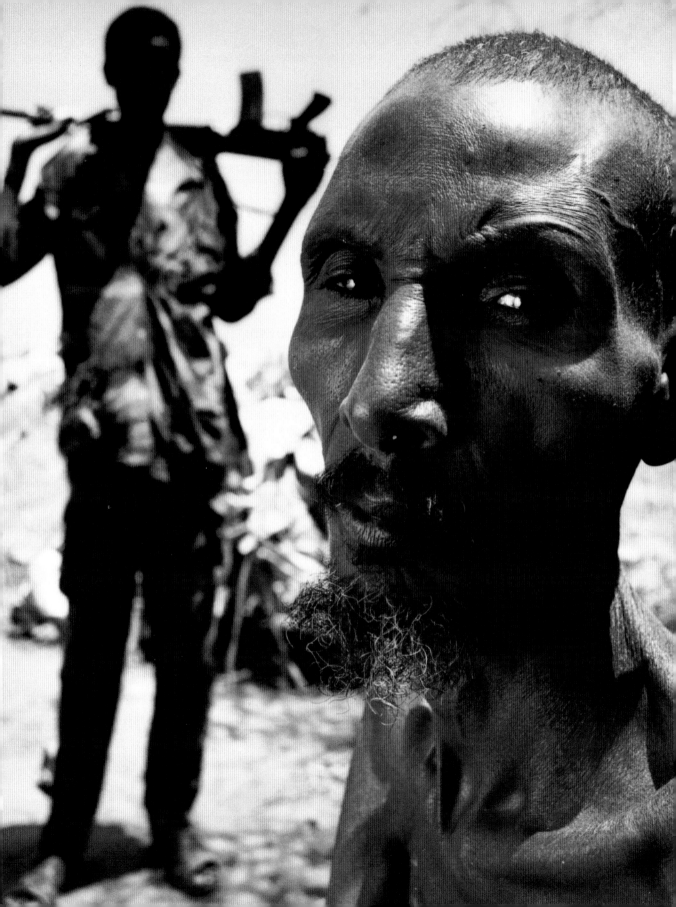

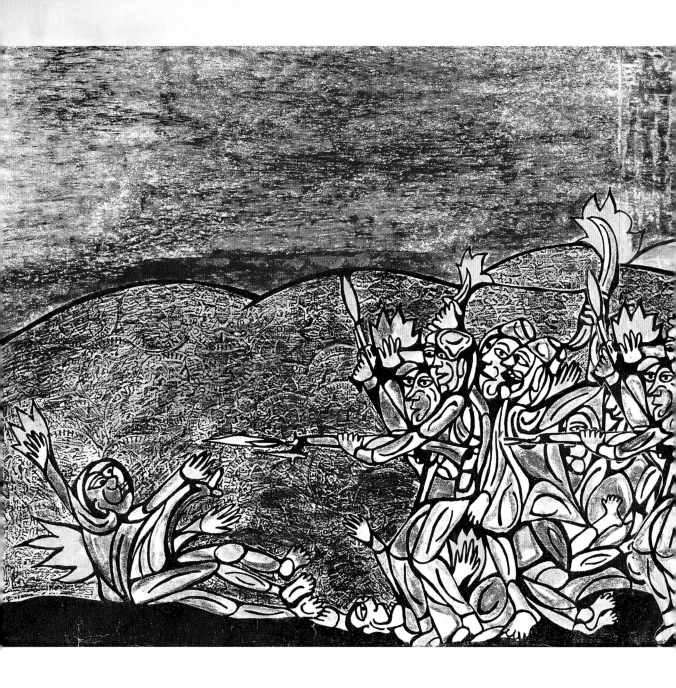

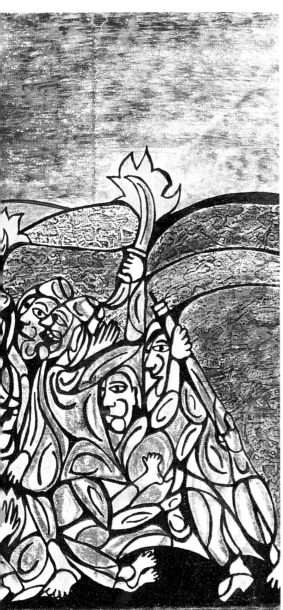

and turned a corner. By the time he caught up to where they'd been, he found only Dan's flak jacket in the road. "Smart boy," he thought, knowing that he could run faster without it.

Dan kept running, becoming separated from Anthony in the chaos. The route back to the hotel was hard to find, even though he'd surely been here before. He was working from instinct, taking turns when he thought they led away from the burned-out house. There was the buzz of the Cobras in the sky and the whooshing, sped-up sound in his ears that one gets when running. It was slow-motion and superfast all at once. His legs pounded hard, and it seemed that fewer people were behind him. Feeling more confident, he rounded another corner only to be met by another group of people who must have splintered off. With no place to turn, his legs and heart giving way, he fell to his knees. Now he would talk—just as he had so many times before. He'd implore the crowd, find that one person who might help him. Before he could speak, a stone hit the back of his head and he lurched forward. There was no time to beg or make another plan. The machete blow came next and he was gone.

257

celebration

It was hot and sunny when Amy arrived for her summer job in
Mexico City; much like Kenya, she thought. She had finished her
freshman year of college a little over a month before and had
spent the first few weeks of break at an internship in San Francisco.
She and a friend had found jobs in Mexico City that they hoped
would help them hone their Spanish skills. They were sharing a
small apartment, though by July 12 they'd hardly unpacked.

A few hours north, Kathy was once more at the Shangri-La with
Geoff. A stack of videos from their film project was scattered on
the dresser. The last few months had been all teeth gnashing and
hair pulling as they'd tried to raise the money that would allow
them to complete the project. Now they were reshooting several
scenes.

Farther north in Washington state, Hayden was working at an
environmental consulting firm. She was recently married—a fact
that Dan had commented on with amazement and respect in a
recent letter—and financially strapped. To save money, she parked
in free, one- and two-hour spaces every day, frantically running
out from her office throughout the day to move her car.

To the east, Roko and Jeff were spending another summer painting
houses just outside Chicago. It was the same work that had paid
for their STA journey and the trip around the world they'd taken

the previous year. Up on the scaffolding, the radio playing as they worked, they thought about where they had been the same time last year. In July, they'd been in Nairobi with Dan. He'd shown them that amateurish film. And then he'd gone off to Somalia. They'd received several postcards from him during the winter, but no news for a while.

Across the Atlantic, Lengai had a week left of classes at Sheffield in England and then his final exams. He'd soon be done—an architect. He'd written an uncustomarily long letter to Dan sometime back but hadn't heard anything. They would talk soon enough in Nairobi. He hoped Dan could get away from his job and go on safari.

Nearby in London, Soiya was running last-minute errands, getting ready for her trip to Nairobi. She'd booked a flight just hours after her last conversation with Dan and looked forward to surprising him.

And then to Nairobi. After more than a month of recuperating from the car accident, Mike was preparing to return to work. He was still a bit stiff. Dan was due home the next day, and already he could feel the anticipation build in the house. The cook, the *askaris*, Dan's driver, Tara, and Peter—they all used his return as an excuse for a celebration, even though the return visits took

place every two to three weeks like clockwork. Mike smiled to himself. He had to admit that he too celebrated whenever Dan came safely home.

On her second day back in Nairobi, Donatella picked up a friend, a *Newsweek* correspondent. They drove to the local video store to peruse the choices, knowing that all of the tapes would be scratchy, some of them even breaking off abruptly before the film's actual end. Waiting to pay for the Woody Allen film they'd finally chosen, they watched as CNN broadcast on the television. "The Americans have launched an attack against warlord Mohamed Aidid," came the report, as the video showed Cobras swarming over a part of town that Donatella knew to be crowded, not too far from the Sahafi.

Settling into the film back at her house, Donatella still couldn't believe that after weeks of sitting in Mog with nothing happening, there was suddenly a story. *I leave for one day and there's a story!* About a half hour into the film—it was indeed quite scratchy, but it was sure nice to see New York—the phone rang. On the other end, Donatella could just make out the voice of a friend in between frantic sobs: "They're all dead! They're all dead!" It was a mantra that Donatella would gradually unwind, discovering its hard truth.

Shaffi alone had lived. He'd watched the others run in front of him, chased in several directions. With their younger legs, they will live, he'd thought, and I will die. But he'd been spared miraculously, while Hansi, Hos, Anthony, and Dan had been killed by the vengeful, impassioned crowd. Because of the American helicopter that had hung over the area where Dan was running, his was the first body to be recovered.

Back at the military hospital, Scott Peterson was being treated for his head wound when Dan's body arrived. The awful task of identification fell to him. The Somalis continued to swarm, and Hos, Anthony, and Hansi were not retrieved or identified for two days.

News of the event came in chaotic spurts. The Americans, International Red Cross, and Somalis were all reporting wildly different numbers of dead and injured. While the Americans portrayed the scene as a military headquarters, with only top leaders

among the dead, the Somalis said it was a residence and that many women and children had been there. The presumed primary target, Aidid, had not been in the house.

The Nairobi journalists were among the first to know. When Donatella got the phone call, Mike and the rest of the family were still unaware that anything had happened. She and other journalists convened at a hotel bar they often frequented. They were stung, shocked. Already, though, Donatella was planning how they must go to Mike's house once the news broke.

After Scott's positive identification, the information snaked up the Reuters chain of command. Just before Mike was leaving for a lunch meeting, the Reuters senior manager, Graham Stewart, called from Cyprus with the news: it appeared that Dan was dead, but they didn't have a final confirmation. Mike decided to go to his meeting rather than wait by the phone; perhaps by going on normally, he could stave off the worst. But in another hour, his meeting was interrupted by a call from Tara. Reuters had called again.

It took awhile to track down Kathy. An entire network of relatives tried to locate her. Finally, at 7:00 A.M., in Los Angeles, her brother-in-law Charles Wellso reached the Shangri-La.

In turn, Kathy had to locate Amy. Because she'd only just arrived in Mexico, she had yet to call her mother with contact information. Several hours later, Amy was at work when her friend took a phone call. Kathy told the girl the news first, wanting her to be prepared. The girl looked pale and somber as she handed the phone to Amy.

All day, it was like that—a row of dominoes falling over—as the news carried through phone lines, television, and newspapers, waking people out of bed, stopping their days, upending their worlds. At her office, Hayden went out to move her car to a new space. The radio happened to be on as she started the engine, and she heard the announcer say that four journalists had been killed in Mogadishu. For a moment she froze, thinking of Dan. She somehow knew it was him, but then made herself forget it, going on with her day. But late that night, while doing laundry, her old friend Twumasi called. It was unexpected—he was in Ghana, and they hadn't spoken in ages. She shrieked with excitement but just as quickly went silent, suddenly making the connection to the radio report.

Up on their scaffolding, under a canopy of midwestern oak and elm trees, Roko and Jeff heard a similar news report. They too had thought of Dan but assumed he'd be fine. It would be another crazy story their friend would have to tell them when they next met. Getting home late that night, Jeff's parents were already in bed. A single light shone on the counter, and he could see a small yellow Post-It note with his mother's handwriting. "Call Hayden."

Nairobi is not an easy place to get to at a moment's notice. It took nearly a week before everyone who was able to travel had arrived at Jomo Kenyatta Airport in jet-lagged, cried-out heaps. Many others could not leave commitments at home or raise the money for the expensive plane ticket.

Friends converged on the house. Led by Donatella, the journalists had come first. William, their old cook, who had not worked for Mike for several years, was there. He'd been in a downtown mall when he'd seen a newspaper. Stunned, he'd gone immediately to the home of his old employer, staying for days, trying to be useful. Evelyn Mungai, whom Mike had been seeing for several months, greeted people and helped to make plans for the memorial service. The term *memorial*, however, was quickly jettisoned; it was the wrong word. In keeping with Dan's spirit, it would be a celebration of life.

Dan's friend Guillaume Bonn sorted through negatives and photographs, trying to organize the work Dan had left in disarray. Others went through the pile of international newspapers that had collected, clipping news coverage of the July 12 events. A photograph of Dan surrounded by children, taken months earlier in Baidoa, was splashed across the cover of the *Times* in London.

It had been gray and uncommonly cool in Nairobi through most of June and into July, but on the morning of the celebration, the sun shone brilliantly for the first time in weeks. As friends and family made their way to Kipenget's land on the edge of the Ngong Hills, they were embraced by a warm, light breeze. More than a hundred people gathered, sitting on the burnt, dry grass. They peered out at acacia trees dancing on the light green plains.

Mike began by saying, "Friends, so many friends. I think there are perhaps only three people here today who I don't know." But there

were definitely a few who were new faces to him and Kathy. All week, and for weeks after, people unknown to them but who had been helped by Dan appeared out of the blue. Many were small-time entrepreneurs to whom Dan had provided funds, such as a would-be *matatu* driver in need of a vehicle. They learned their son had been giving money to William since the cook had left the household, and he'd also paid for Peter to take driving lessons and get a license.

In Dan's honor, they all appeared. High on a hill, overlooking the ceremony, sat a group of *matatu* drivers. Masai, many of whom had known Dan through his frequent visits to Kipenget's, dotted the crowd, their red *kikois* flapping in the wind. Faculty from ISK had come, along with old high school pals. A large segment of the journalism community from Somalia and beyond was there. Aidan flew in from Bosnia. Dan's cousins, including John, with whom he'd lived in Iowa, had made the trek. Sitting bravely next to Mike was Dan's grandmother Gaby and her sister Odette.

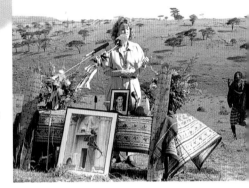

As the wind whipped scarves and neckties, speaker after speaker rose to remember Dan. At the small podium, propped next to bouquets of flowers, was one of his silly costume hats, a Viking helmet that he'd worn in Mog, and his photograph of the gun boy in the cathedral.

Mike, recalling his son's humor and zest for life, reminisced about their evening by Lake Malawi and the time, just weeks earlier, when Dan had delivered the pizza to his hospital room. "It is already quite an effort to step back from the emerging myth to the son I have known and loved and respected for twenty-two years."

Stories were heaped on the pile for nearly an hour, while a hawk soared overhead. "Dan himself was always very busy and didn't even have time to go and eat his midday meal," William told the mourners in Swahili, gesturing with his hands for emphasis. "When his work was over, if he felt hungry, he'd go to eat, but he wouldn't stop working just because it was time to eat. But he looked out for other people. Although he didn't worry about these things for himself, he'd ask, 'William, are you tired or hungry?'" Journalist friends—many of them in a grief-induced stupor— recalled the charm and bluster Dan had brought to his job. Hours later, they would go for dinner together, drinking many strong

dawas, and then proceed to a club where they danced until dawn, crying and laughing themselves into exhaustion.

That morning, before the ceremony, Kathy had walked in circles around the garden behind Mike's house, wondering what to say. She was wearing one of Dan's safari jackets for warmth. Reaching into the pocket, she had found a folded-up photograph of herself. He carried it with him always, Shaffi later told her. There was also one of the tiny notebooks in which he wrote down photo captions and T-shirt orders. She scribbled but a few words on a blank sheet: "Dancing, laughter, live fully..."

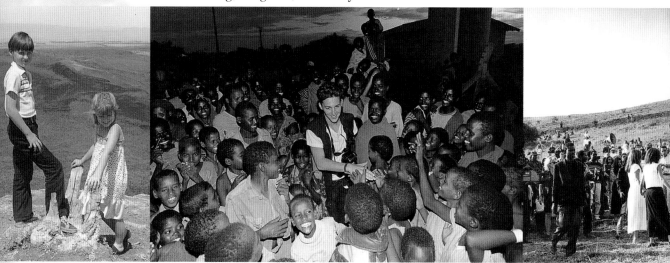

With her red hair fluttering in the breeze, she said that Dan was no saint. "He was one of the messiest people who ever lived," she laughed. And he'd known darkness as well as joy. Just recently he'd told her of the things that he couldn't bring himself to photograph in Somalia; they were too awful.

She remembered a song he liked by Cat Steven: "You're only dancing on this earth for a short while" went the lyrics. "What Dan would want us all to remember," she said, "is that you may have only a short while to dance, but you *choose* your dance. You choose the music for your dance. You dance proudly. You dance loudly. You dance with creativity and vigor, and joy, and most of all you dance with love." As she spoke, she was smiling broadly and strongly—though inside she was crushed, and the next years would be dark ones.

Amy struggled to read a letter that Lengai had sent; he was still in England, unable to get away from his final exams. Then she, Tara, Soiya, and several other friends and relatives lit torches, plunging them into a bonfire that had been built on the hills. The flames took immediately and danced as they climbed high into the sky. Wearing dark glasses and the cowrie shell necklace Dan had given her for her high school graduation a year earlier, Amy looked upward, her mind and heart shattered in a way she could never have anticipated.

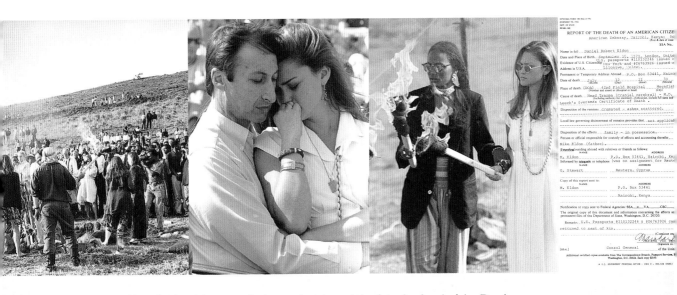

Dan had said several times that he wished to be buried in Deziree one day, standing upright like a Viking in his ship. The Land Rover had been his shelter and his companion; she'd taken him far from home but always brought him back. A few days before the ceremony, Mike had called a mechanic in town and said that, whatever it took, he needed Deziree up and running. The man had come through; she'd set out in style only to collapse midway. In the middle of the ceremony, as Mike spoke, she was towed into the bowl of earth where they were gathered, making a grander appearance than anyone. She may not have been operational—no one but Dan knew all of the tricks to keep her going—but her windows were clear, per Dan's mission statement: "The most important part of vehicle maintenance is clean windows so if you are broken down you will enjoy the beauty of the view." Indeed, you could see right through them out onto the beautiful expanse below.

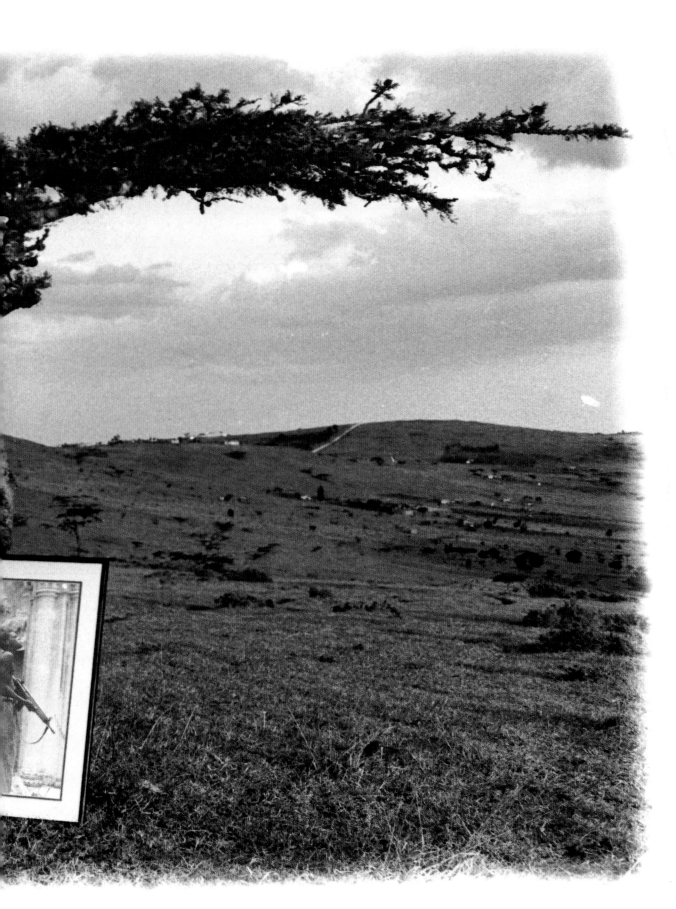

afterlife

Minutes after Dan's death, I was contacted by the Associated Press to comment on my son. Speaking to the matter-of-fact journalist typing my comments on the other end of the telephone, I blurted out the first words that came into my head. "He was a bright light that shone for a very short time." I didn't have time to tell her that Dan, though bubbling with energy, creativity, and mischief, somehow managed to ignite fires in those he met, challenging them to dream big dreams and overcome their deepest fears. The sudden extinguishing of Dan's light came as a brutal reminder to those who knew and loved him—that life is precious, and sometimes, far too short.

Dan's memorial Celebration of Life on the edge of the Great Rift Valley in Kenya was an agonizing time for his friends, colleagues, and family, as we sought to deal with the immensity of our loss. After Dan's cousin Amy scattered his ashes on Kipenget's parched land, we had to return to our homes around the world. Since then, many of us have struggled to find meaning in the deaths of Dan and his colleagues. The results have been positive, creative reflections of Dan's brief life.

In an effort to deal with his grief, Mike, and his future wife, Evelyn Mungai, plunged into plans for a visionary youth center in Nairobi where young people could learn to solve problems, work as team members, and develop leadership skills. Struggling to find a name for the center, he remembered what Dan used to say when challenged to clean his cluttered room. "Don't think of it as a bedroom, Dad," he would reply, a crooked grin crawling across his face, "Think of it as my depot."

So Mike dubbed the Rotary Club–sponsored center The DEPOT, The Dan Eldon Place of Tomorrow, and installed Dan's desk, artifacts, photos, and art supplies in a room within a rambling estate just outside Nairobi. Since then, more than six thousand young people, from street children to young professionals, have benefited from The DEPOT, the theme of which is to inspire young people to fulfill their potential. The DEPOT's talented facilitators have taken the programs all around East Africa, and a satellite DEPOT has been created in the Blazer Safe Haven, a youth center in South Central Los Angeles.

Mike now spends much time helping young Kenyans to think constructively about themselves and their lives, often drawing on Dan's vibrant example. He organized a multimedia exhibition of Dan's art, which he describes as one of the most joyous experiences of his life. Also, through the Kenya-US Association, an annual Dan Eldon Award has been presented to high-

achieving Kenyan students who have excelled in extramural activities, particularly in community service.

Amy chose a different route to deal with her pain. Grief-stricken after Dan's death, she dropped out of college in January of 1994, working as a waitress in New York and volunteering in the cancer ward of the Children's Hospital. At the end of the summer, she enrolled at Boston University's College of Communications, determined to tell "stories that matter." During this difficult period, Amy and I talked almost daily, struggling to keep each other's spirits up. One day, a year or so after Dan had been killed; she called me in tears, devastated to think that she was losing her clear memories of her brother. I was having the same problem. Inspired by the sight of a Native American hooped Dreamcatcher over my bed, I said, "You can make an Angel Catcher!" "What's that?" she asked. "It's a book to capture memories, thoughts, and feelings about Dan," I answered.

A few months later, Amy flew to Los Angeles, carrying a black bound journal filled with poems and stories, photographs and drawings about her beloved brother. Her book inspired us to create a journal for other people who have lost someone they love. Entitled *Angel Catcher: A Journal of Loss and Remembrance* and published by Chronicle Books, it is designed to help people work through the grieving process while capturing the essence of someone they love. The journal was the first in a series of three books in the "Catcher" series dedicated to helping people use the challenges in their lives to help them grow.

During her senior year at BU, Amy was asked to write a proposal for the film she most wanted to make. She outlined a documentary about journalists who risk their lives to do their jobs. The idea was unexpectedly picked up by the president of TBS, who "green lit" a two-hour documentary for the network. Immediately upon graduation, Amy flew to Los Angeles to begin working with me on the film, which was to take her to six countries as she interviewed such journalists as CNN correspondent Christiane Amanpour and the BBC's Martin Bell. On a harrowing trip into Mogadishu, I joined Amy and Mohamed Shaffi, the only survivor of the July 12 tragedy, on a visit to the burnt-out shell of the house where the journalists and Somalis were killed. Our guide was a young Somali woman, scarred by the bombing, who had lost her sister in the UN bombing. Together we shared the pain and injustice of a tragedy that had robbed so many innocent people of those they love.

We are proud that our Emmy-nominated documentary, *"Dying to Tell the Story,"* directed by Kyra Thompson, was voted best documentary on television by the National Headliners Association and is now being shown in schools of journalism and photography around the world. We were deeply saddened when Carlos Mavroleon, a talented young cameraman profiled in the film, died a year after our film was completed, while on assignment in Pakistan for *Sixty Minutes*. Mohamed Shaffi and AP photographer David

Gutenfelder, who were among the seven journalists profiled, have also been wounded, reminding us yet again of the constant threats faced by those who strive to bring us the truth.

In 1999, Amy and I produced a CNN documentary profiling five young people representing the Colombian Children's Peace movement, which has twice been nominated for the Nobel Peace Prize. Together with the Season for Nonviolence, we helped organize a rollicking "Jam for Peace" event for more than one thousand disadvantaged youngsters in Los Angeles. We have had the joy of seeing the film adopted by UNICEF for translation and distribution to many countries around the world. We are now producing *Global Trek: In Search of the New South Africa* hosted by Amy for PBS, with the objective of creating greater awareness of the world among young audiences. We passionately believe that the answer to many of the world's problems is to help children become "agents of peace" in their own schools, neighborhoods, and communities. Only then can we hope to stop the insidious cycle of revenge that rips apart families, cities, and nations.

After Dan's death, I also found purpose in my life by committing myself to the task of using the life of Dan and his journals to inspire young people to be more aware of—and involved in—the world around them. I tried very hard to interest publishers and filmmakers in the concept of a book of Dan's work. After three years of banging my head against many brick walls, I was discouraged and bruised. It was only after the publication of an article I wrote in *Doubletake Magazine* that Chronicle Books expressed interest. The very talented editor Annie Barrows worked with me on the book, finishing it just in time to give birth to a baby girl (who arrived three weeks early on Dan's birthday). The enthusiastic reception of *The Journey Is the Destination* led to exhibitions of Dan's work in galleries and universities on four continents. This year, the curator of photography at the Los Angeles County Museum of Art has asked that we donate to LACMA Dan's journals, until now housed at the Cedar Rapids Museum of Art.

The journalist community responded to the death of the four journalists with an unlikely partnership between news rivals Reuters and the Associated Press, who commissioned a book of photographs, *Images of Conflict*, taken by the three dead photographers. An exhibition of the same name featuring photographs by Hos Maina, Anthony Macharia, and Dan, has since traveled to ten countries and is now permanently housed at the European Freedom Forum in London.

The scale of the tragedy focused the attention of the international news community on the dangers faced by their colleagues working in war zones. We worked with Columbia and Duke Universities to initiate seminars to explore issues of press safety and responsibility. At a 1994 seminar titled "The Journalist's Role in Peace and War" at Columbia, changes in UN policy were announced that enabled UN helicopters to pick up nonmilitary people. Had that edict been in place before July 12, 1993, the four journal-

ists could have been saved by the UN helicopter, which hovered over them as they ran from the mob.

John Owen, director of the Freedom Forum's European Center, working closely with the Rory Peck Trust, CNN, and the BBC, has launched the first subsidized safety training and first-aid program for freelance journalists. It also meant that, for the first time, freelancers who had taken the course were able to afford less expensive life insurance before heading out to cover dangerous wars and conflicts.

Owen and the Freedom Forum have also underwritten a groundbreaking study of the psychological distress that may be affecting journalists covering war and famine stories.

In 1995, the Freedom Forum's Newseum in Arlington, Virginia, was the site of a memorial to honor the memory of journalists who have died while on assignment. I was privileged to share the podium with Hillary Clinton at the dedication of the soaring glass memorial, etched with more than one thousand names of dead journalists. While preparing my speech, I found one of Dan's hand-written school papers, which included a quote that I thought embodied the questing spirits of the dead journalists. Dan attributed the quote to the great American philosopher Ralph Waldo Emerson: "The one thing of value is the active soul, free, sovereign, unencumbered. This every man is entitled to, this everyone holds within him, but in almost all men, it is obstructed and as yet unborn."

My morale is kept high by the fact that almost every week, I receive a letter or an e-mail from someone whose life has been touched by Dan. I now have an enormous binder that is bursting at the seams with letters from those who knew Dan, including old friends, teachers, and fellow travelers. Some of the most touching letters come from young people who never knew Dan, but who have learned about him from *The Journey Is the Destination*, and write to tell me how deeply the book has touched them. Many claim to have changed direction in their lives, tearing off ties and flinging away laptops as they take on new challenges, some choosing to go on safari, others determined to begin a journal of their own. A letter, written by Stephanie Roy, a junior at Colby Sawyer College in New London, New Hampshire, sums up the feelings of many: "As I looked through Dan's book again and again, I found myself imagining that I was on his magical safaris, meeting people and seeing things I would never have gotten the chance to see by sitting around in my little New England town. Dan became a role model for me, in a sense changing my view on the world. His story made me realize that no time is too soon to start changing something, whether it is in the world, or simply in yourself."

The knowledge that Dan's soul remains as active as ever in the hearts and minds of young people around the world has made it easier for us to endure the loss of his physical presence. Besides, we are kept busy with the

ever-growing tribe of "friends of Dan." We receive regular updates from elephant researcher Cynthia Moss on "Eldon," a naughty adolescent male elephant growing up in the Amboseli Game Park. We hear stories from teachers using Dan's book to encourage Detroit-based gang members to tell their own stories, and of pre-schoolers and senior citizens who learn about journaling through *The Journey Is the Destination*. Reports come in of commercial designers, artists, filmmakers, and advertising executives who display the book on their coffee tables. Dan would be proud. To encourage other young journalists, the Overseas Press Club of America has launched a scholarship in Dan's name, while Amy and I have started the Creative Visions Foundation, which offers seed grants to filmmakers, journalists, and other creative people for socially conscious projects. In August 2000, we were invited by photographer Flynn Larsen to visit an arts center in a particularly down-trodden part of downtown Los Angeles. Navigating our way through the Inner City Arts Center's forbidding steel gates, we were stunned to discover an oasis of bubbling creativity inside. We were particularly pleased to see Flynn's award-winning photographic exhibition of self-portraits drawn by disadvantaged third graders, funded by one of our grants.

Dan would be proud of so many of his old friends. Daire O'Reilly, the first to plunge his torch into the fire at the Celebration of Life, saying, "this is to commemorate the sparks Dan lit in others" is now an AIDS worker in Africa. Daire wrote recently to say that he had founded the "Dan Eldon School" in an impoverished Angolan village. Dan's fellow journalist Aidan Hartley is working on humanitarian issues in Kenya, and his childhood friend Tara Fitzgerald travels across East Africa, focusing on the ever-growing population of refugees. Marilyn Kelly has spent years working in harsh conditions, helping some of the most impoverished people in Africa. Soiya Gecaga, on leave from a job as a lawyer in England, spent several months volunteering with AIDS babies in Kenya. Likewise, many members of the STA team are volunteering, traveling, and communicating a powerful message of hope and compassion, all in their own ways. One of the newest members of the global network is Charles Tsai, a young producer who created an award-winning short documentary, *The Art of Life*, about Dan for CNN's *Newsroom*. Inspired by the message of his film, he abandoned his old life, set sail on "Semester at Sea," and has never returned to Atlanta.

I feel very lucky to have met two talented young educators, Jennifer New and her husband, Andrew Epstein, who tracked me down at an exhibition of Dan's work and offered to create an exciting daneldon.com Web site. I loved their work, which appropriately used Dan's life as the "inspiration, not the destination." When we needed someone to research and write this book, Jennifer was the obvious choice. Despite having to interview scores of people scattered around the world; reviewing thousands of photographs, books, and articles; and studying drawings, school papers, fifteen hundred journal pages, and miscellaneous artifacts, Jennifer has been amazing,

working with energy, enthusiasm, and total integrity. Joe Donnelly and his creative design team at Buckboard 11 have been equally passionate in their efforts to translate Dan's art into a dynamic new visual style. We are most grateful to the brilliant work of Alan Rapp, who as a young editor, was the first person to draw the attention of Chronicle Books to Dan's work in *Doubletake Magazine*. For the past three years, Alan has worked tirelessly to create this book, which we hope will inspire people to activate their souls and pursue "Safari As a Way of Life."

Seven years after the horror of "Bloody Monday," I feel a new sense of peace, knowing that the sparks Dan lit in others, both before and after his death, will continue to burn ever more brightly around the world. I close now with quote often attributed to Ralph Waldo Emerson, which I found scrawled on a slip of paper in one of Dan's jackets soon after his death:

"To laugh often and love much;
To win the respect of intelligent people and the affection of children;
To earn the appreciation of honest critics and endure the betrayal of false
 friends;
To appreciate beauty;
To leave the world a better place, whether by a healthy child, a garden
 patch, or a redeemed social condition;
To know that even one life has breathed easier because you have lived.
That is to have succeeded."

—Kathy Eldon

273

acknowledgments

In September 1997, my husband, Andrew, and I were visiting the San Francisco area from our home in Iowa. The day before we left on a backpacking trip, I browsed through a bookstore in the city and stopped at a bold cover that showed a young man holding animal skulls and staring challengingly into the camera. The inside pages of collage were even more intriguing. I went back to the hotel and told Andrew all about it, wishing that we had both the money to afford it and the space in our backpacks to take it along.

He surprised me, going to buy *The Journey Is the Destination: The Journals of Dan Eldon* while I was at a meeting. For the next several days, as we camped along the California coast, we studied the images again and again, riveted by the curious life of their creator. We are educators and much of Andrew's work, especially, has been with students who have dropped out of high school. When we'd lived in Seattle, we'd created a writing program for these kids focused on the personal essay. The message of the program was this: Your life has value; you have interesting, meaningful stories to tell. Seeing Dan's art, we knew that it would speak directly to young people who too often felt their own lives were not important.

Our ideas quickly grew. We wanted to create educational materials using Dan as the launch pad. But how to reach Kathy Eldon, Dan's mother, who had written the lovely introduction and acknowledgments in the book? She had alluded to the Cedar Rapids Museum of Art, but we immediately dismissed that it could be Cedar Rapids, Iowa, the town just a half hour north from our own. Dan had lived in Kenya and London; this must be another Cedar Rapids.

A month passed. The days grew shorter and colder, and one afternoon Andrew came home bundled in gloves and a scarf with an issue of the local newspaper in hand. He opened it up to show me an ad: Kathy Eldon was speaking at the Cedar Rapids Museum of Art in conjunction with a show of Dan's photography that weekend!

We had recently started our own business doing educational consulting and curriculum design and our business cards were done that Friday. On Saturday, with several of them tucked into our wallets, we went to see Kathy Eldon speak. My first impressions were of her tall frame, red hair, and smiling face. She was elegantly dressed and very comfortable in her role addressing the sizeable crowd. As she spoke, we learned first that she'd grown up in Cedar Rapids (across the street from where friends of ours live). It was also clear that she wanted to reach as many young people

as possible. "Dan is the inspiration," she said, "not the destination." Suffice it to say, we and Kathy were thinking along the same lines and it didn't take long for us to hatch a plan for an educational Web site.

By the summer of 1999, when Kathy came to Iowa with Alan Rapp, her editor from Chronicle Books, to look at Dan's journals and assess what might be used for an upcoming biography, I knew much more about Dan Eldon. I'd studied two bulging binders that included everything from his school work and report cards, to letters from girlfriends, and sympathy notes from the likes of Jimmy Carter. Andrew made a wonderful meal for Kathy and Alan, during which we discovered more connections. On that same trip to San Francisco two years earlier, while Andrew had gone to buy the book, I'd visited the offices of an online magazine where, on that very weekend, my first nationally published essay appeared. One of the editors I met during my brief meeting turned out to be Alan's girlfriend.

It was odd and amazing and exactly the kind of thing that frequently happens in The World Eldon. I tell this story because it is the one I know best. But there are many others, all of which demonstrate the way in which serendipity, fate, karma—call it what you will—continually come together around Dan and his family.

The people have made this project a pleasure, an adventure, and the best kind of learning experience for me. So many of Dan's friends and family members talked to me about their memories of him—sometimes for hours—sharing stories, dates, smells, and colors with a writer who has never been to Africa, much less a war zone. As I spoke with people whose teenaged photos I'd seen in the first book, I could hear their own children playing in the background. Others, still infused with wanderlust, squeezed in conversations before taking off for Mongolia or Congo. They patiently answered e-mail after e-mail, responding to my late-night queries as I tried to imagine the streets of Mog or a Tanzanian village from the middle of an Iowa winter.

I am blessed that my first book was about a person who had such a loving "karass." While obviously a book is no substitute for the body language, quirky humor, and tousled hair of the real person, I hope that it will help to keep Dan's presence alive for those who knew him. "Every time I talk about him, I lose a bit of him," one friend told me early on. I knew what she meant. And yet she and many others generously told me stories and scraped their memories, in order to remind people who never met Dan how one person truly can make a difference.

My thanks begins with Dan's close-knit, extended family. His cousins John Wellso, Amy St. Onge, and Laura Miller, his aunt Carolyn Wellso, and all three of his surviving grandparents—Louise and Russell Knapp and Gaby Eldon—recalled Dan at various ages. Friends from childhood and high school helped me to piece together the boy who early on showed signs of

being unique. Long Westerlund, who sent many long and wonderfully detailed messages, was especially helpful, as were Pete Mohau, Carla Benson, and Claudius Pratt. Jeff Worden kindly called collect from Nairobi. Laurie Diaz Litonjua, Lengai Croze, and Saskia Geissler shared much-cherished memories. Amy Branch and Jeff Oaks fondly described Camp Wapsie—just up the road from my home. Ex-*Mademoiselle* staffers Emma Kuehen Halik, Kay Spears Gibson, and Kati Korppijaakko told me about Dan's days in New York.

After reading a draft chapter about STA, Jeffrey Gettleman told me, "You were on that trip. You should have been on that trip." It was late and Jeff may have wanted to say a nice thing in order to get to sleep, but it was one of the highest compliments I could receive. It meant so much because the STA trip has been the part of Dan's life that's most compelled and moved me. It's the kind of experience that not only do I wish I'd had, but from which I think most young people could benefit hugely. All of the STA members with whom I spoke impressed me again and again, not only with their love for Dan but with how they've used the energy and vision from that summer, incorporating it into their adult lives. Elinor Tatum, Eiji Shimizu, and Marte Ramborg all provided information by phone and e-mail, sometimes dredging their closets and attics for memorabilia. Marte even located Arve Danielsen, the man from the Norwegian Refugee Council who, in turn, wrote me a kind account of his memories of Dan and the group. I had the pleasure of meeting Chris Nolan and Ryan Bixby in person, as well as Hayden Bixby Nichols, Jeffrey Gettleman, and Roko Belic, who were especially invaluable. Each responded to countless queries and read parts of the book, Hayden with an eye toward African culture, and Jeff with an impeccable editor's sensibilities; he steered me to the right course gently and wisely a number of times. And Roko, well, Roko is a spark just in himself. I've kept his message above my desk and heeded it whenever I can.

Jean-Marc André remembered Dan at Richmond College, while Aby Algueseva and Vinnie Nayeri recalled him at Cornell College and UCLA, respectively. Soiya Gecaga told me about the Eldons at different times, and was especially generous with her memories of her and Dan's sometimes stormy, yet special relationship. Twumasi Weisel offered vivid stories from several periods, as did Geoffrey Dudman. Mike Powell, a name and number I found in one of Dan's journals, provided useful information about several of Dan's exploits. Tara Fitzgerald was priceless to my understanding of Dan, the Eldons, and Kenya, but especially in her memories of Dan in Nairobi during his final months. Thanks also goes to her mother, Mary Anne Fitzgerald, whose books *Nomad* and *My Warrior Son* aided my understanding of Kenya.

Another group without whom this book would have been utterly impossible was Dan's journalist friends. Their professionalism, finely crafted words, and well-adapted senses of humor made the hardest section of this book a bit lighter. Scott Peterson's *Me Against My Brother*, which handily came off the press just as I was entering the Somalia section, gave me a much

greater appreciation for both the extreme danger and the motivation of war correspondents. Keith Richburg's *Out of America* also painted a vivid portrait of Somalia in the early 1990s. Aidan Hartley and Donatella Lorch were tireless in their correspondence with me, both wanting to make sure the story that affected their lives so deeply was told correctly. Although this is an abbreviated telling compared to all that happened, I hope it does justice to the complex events. I also relied on letters sent to the Eldons from journalists Ruth Barnett, Liz Gilbert, and Alexandra Avarkian and thank them for their thoughts. I am humbled by Mo Shaffi, who eloquently and graciously shared his account of July 12, 1993; if only it had been the last danger he'd seen.

Alan Rapp took a chance on me and I hope I never let him down. He gave me space and served as a patient sounding board. Thanks to Jasen Emmons and Anne Duibisson for writerly advice. Erin Perry and Alison Fast were instrumental in putting together the nuts and bolts of this book; both are organizational wizards. Sandy Barkan, Zoe Donnell, and Lisa Kusel provided eyes to other parts of the world, as well as support. John Njue served as Swahili translator and Kenya guide from my living room sofa. Marcel Cairo, Bronwen Hughes, and Jan Sardi traveled a similar investigative road and their work and perceptions paved the way.

Much appreciation goes to my close friends and family. Hannah took me on much needed daily walks. Megan Knight listened to every up and down of the project, and read many pages, pen in hand. It's a better book because of her. Andrew bore the brunt of the myriad emotions the project evoked, cooked deliciously, listened to every new draft, and waited at the airport after each trip to Los Angeles. He is my inspiration and I am forever grateful to him for splurging on that book back in San Francisco.

Mike, Kathy, and Amy Eldon trusted me with Dan's story. Mike and I have never met in person, but we logged hours on e-mail and when I bought a fax machine, the very first message that whirred through in the middle of the night was from Nairobi. He has been a stickler for details; I've come to appreciate his eagle eye and desire for this to be done right. Amy and Kathy let me commandeer their home, filling tables and sofas with journals and photos. It was fun, even giddy work at times, but having that much of Dan's energy unleashed in a small space also took an emotional toll. Amy was an astute, calm presence, though it was her unexpectedly wicked humor that made me laugh when I needed it most. Finally, my gratitude to Kathy for sharing her energy and optimism, along with her trust. Thank you, bella.

To all others who have kept Dan Eldon alive in their hearts, whether they knew him personally or have discovered him via his art, your enthusiasm has been an inspiration to all of us. May your numbers increase as the spark travels.

—Jennifer New

277

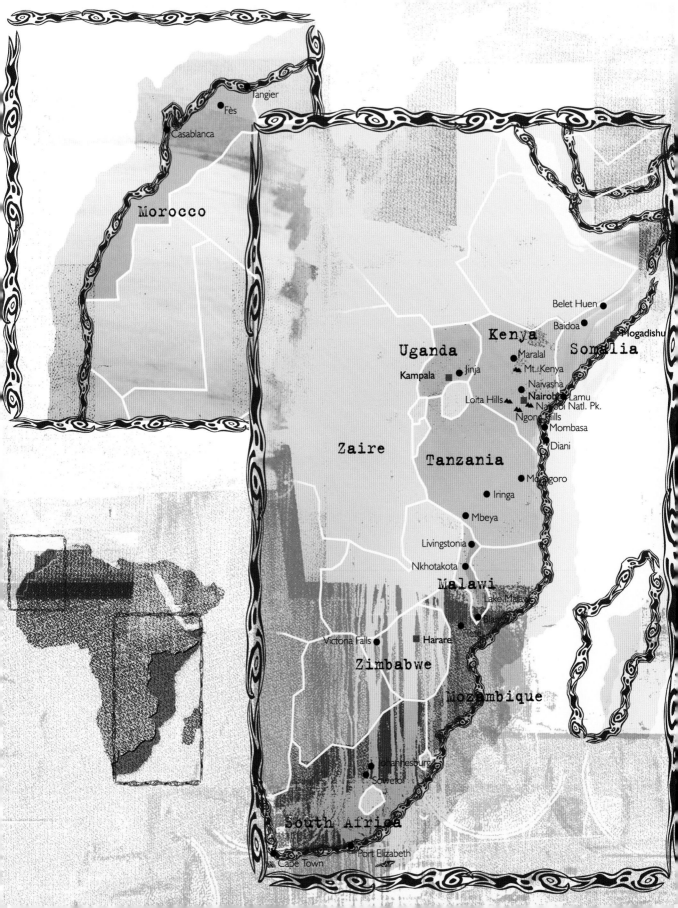

Glossary

askari — guard, Swahili
babuji — father, Arabic
boma — Masai encampment, Maa
bwana — mister, sir, Swahili
chai masala — tea with milk and spices
chapati — flat wheat bread
chipuku — beer made of fermented corn
dhow — one- or two-masted Arab sailing vessel; the eye of the *dhow*, a star
 over a crescent moon, is a protective talisman for travelers
duka — shop
emorata — circumcision, Maa
enshalla — fated, Arabic
haraka — hurry, quickly, Swahili
kanga — decorative sarong worn by women, Swahili
karibu — welcome, Swahili
Kibera — Nairobi slum
kikoi — printed sarong worn by men, Swahili
Kikuyu — Bantu-speaking people who form Kenya's largest ethnic group
magendo — black market, corruption
Maralal — town in north central Kenya
Masai — nomadic pastoralists of east Africa
matatu — van-like vehicles that serve as a form of mass transportation in
 Kenya, especially in Nairobi
mganga — witch doctor, Swahili
mjomba — maternal uncle
moran — warrior, the age group for Masai boys, Maa
muezzin — in Islam, the official who proclaims the call to prayer
mzungu/wazungu — European person or people, Swahili
pan — Indian delicacy of lime paste and crushed areca nut wrapped in
 betel leaf, Hindustani
panga — curved, broad-bladed knife, Swahili
qat — also called *khat mirra*, a leaf chewed for its mildly narcotic qualities
Samburu — ethnic group, closely related to the Masai
samosa — flaky, stuffed, deep-fried pastry
shamba — farm, garden, Swahili
sulfiria — ceremonial drink of hot goat's blood
Swahili — also called Kiswahili, Bantu language spoken either as a mother
 tongue or as a fluent second language on the east coast of Africa
Tusker — common Kenyan beer
warco — war correspondent, colloquial
wazimu — madness, delusion, Swahili

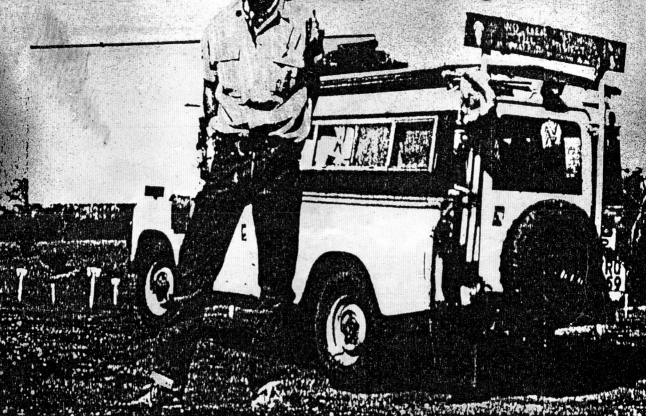

DEZIRÊE
SAFARIS
1957 & CO.

Zimbabwe 5c | Zimbabwe 1c | Zimbabwe 1c

index

285

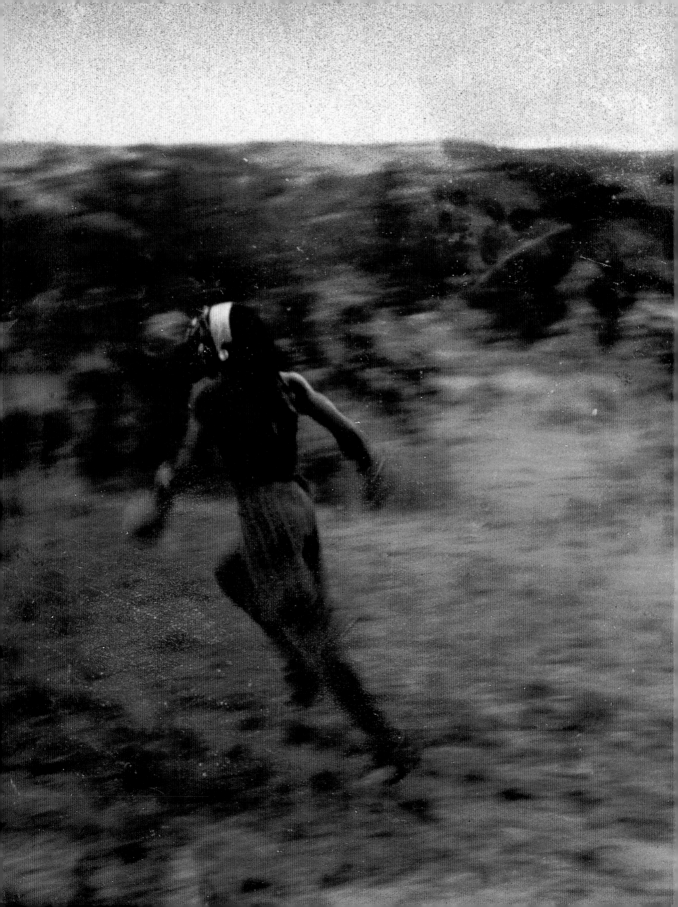

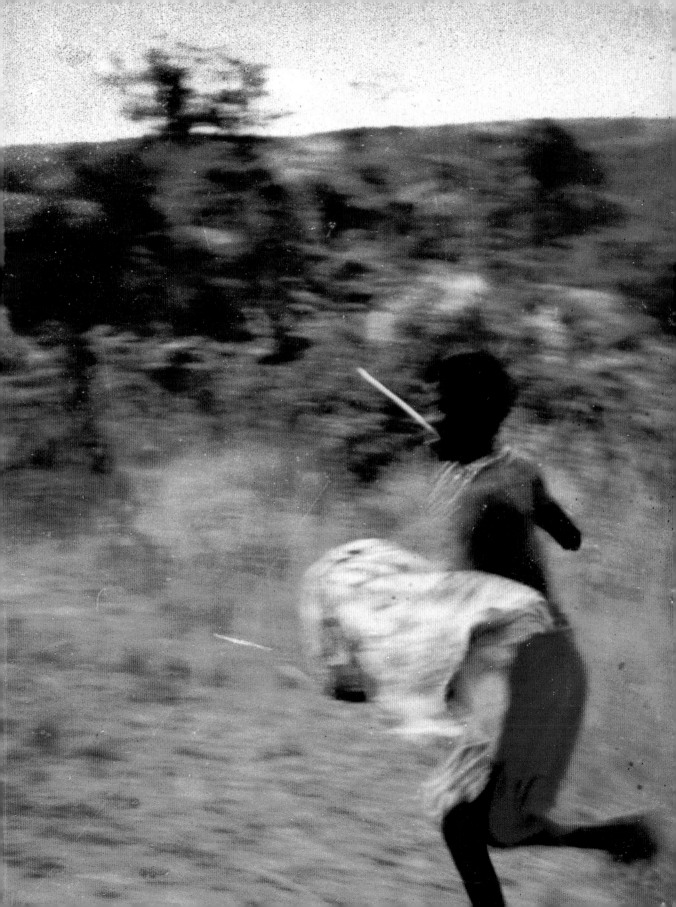

"Vague memories of a long lost Safari"

The RIVER of Mbagathi

Dan Eldon
March 1992